REWRITING CONCEPTUAL ART

Critical Views

REWRITING CONCEPTUAL ART

Edited by
Michael Newman *and* Jon Bird

REAKTION BOOKS

Published by Reaktion Books Ltd
79 Farringdon Road, London ECIM 3JU, UK
www. reaktionbooks.co.uk

First published 1999

Birgit Pelzer's essay was translated
from the French by Robert Vallier.

Photoset by Goodfellow & Egan Publishing Management
Printed and bound in Great Britain by Biddles

British Library Cataloguing in Publication Data
Rewriting Conceptual art. – (Critical views)
1. Conceptual art 2. Conceptual art – Influence
I. Newman, Michael, 1954 – II. Bird, Jon
700
ISBN 1 86189 052 4

Contents

Notes on the Editors and Contributors

MICHAEL NEWMAN is Principal Lecturer in Research at Central Saint Martins College of Art and Design, The London Institute. From 1994 to 1998, he was Head of Art History and Theoretical Studies at the Slade School of Fine Art, University College London. He holds a doctorate in philosophy from the University of Leuven, Belgium. Newman has written extensively on contemporary art, as well as theoretical and thematic texts on modernism and the relationship between criticism and philosophy.

JON BIRD is Professor of Art and Critical Theory at Middlesex University and a tutor in the Theory Department at the Jan Van Eyck Academie, Maastricht. He has published extensively on contemporary art and cultural theory and has curated exhibitions, including Leon Golub's forthcoming retrospective at the Irish Museum of Modern Art, Dublin. Bird was a founder editor of the journal *Block* and a co-editor and contributor to the 'Futures' series of conferences and books.

ALEXANDER ALBERRO is Assistant Professor of Modern Art at the University of Florida. He is also the editor of two anthologies, *Conceptual Art: A Critical Anthology* (1999), and *Two-Way Mirror Power: Dan Graham's Writings On His Art* (1999), and is preparing a book, *Deprivileging Art: The Politics of Conceptual Art*, for publication.

STEPHEN BANN is Professor of Modern Cultural Studies at the University of Kent. He has published widely in the field of contemporary art, and was co-editor of the anthology *Interpreting Contemporary Art* (Reaktion, 1991). Bann also authored the introduction to the catalogue of the exhibition *Global Conceptualism* currently touring North America. His present field of research is the interaction between printmakers, painters and photographers in nineteenth-century France, a study which forms a sequel to his *Paul Delaroche: History Painted* (Reaktion, 1997).

DAVID CAMPANY is an artist and Senior Lecturer in the History and Theory of Photography at the Surrey Institute of Art and Design. He is currently conducting doctoral research with Central Saint Martins School of Art in photography and the reproduction of art. Recent publications include 'Art Photographed:

Some Notes on Painting and the Book' for the exhibition catalogue *Postcards on Photography* (Cambridge Darkroom). An essay on Campany's public art practice by Cynthia Rose will appear in *Trade Secrets* (forthcoming).

HELEN MOLESWORTH is Assistant Professor of Art and Curator of the Amelie A. Wallace gallery at SUNY at Old Westbury. Founding editor of *Documents*, a journal of contemporary visual culture, Molesworth has published extensively on modern and contemporary art, including feminist issues.

PETER OSBORNE is Professor of Modern European Philosophy and director of the graduate programme in Aesthetics and Art Theory at Middlesex University, London. He is also an editor of the journal *Radical Philosophy*. Osborne is the author of *The Politics of Time: Modernity and Avant-Garde* (1995) and editor of *A Critical Sense: Interviews with Intellectuals* (1996) and *From An Aesthetic Point of View* (forthcoming). He is currently preparing a book on Conceptual art.

BIRGIT PELZER studied philosophy at the universities of Louvain, Cracow and Heidelberg. She is Professor of Modern Aesthetics and Philosophy at the Ecoles Supérieures d'Art Plastiques St-Luc et Erg, Brussels. Pelzer has published widely on literature, feminism and contemporary art in monographs, catalogues and periodicals.

DESA PHILIPPI is a writer and art historian based in London. Her art criticism has appeared in *Artforum, October, Artscribe International, Art&Design, Third Text, Parachute* and the *Oxford Art Journal*.

ANNE RORIMER specializes in post-war art, with an emphasis on the 1960s and '70s. A former curator in the Department of Twentieth-century Painting and Sculpture at the Art Institute of Chicago, she has published widely on Conceptual art and was co-curator of *Reconsidering the Object of Art: 1965–1975*, organized by the Museum of Contemporary Art, Los Angeles, in 1995–6.

PETER WOLLEN is Professor of Film Studies and chair of the Department of Film and Television at the University of California, Los Angeles. He is the author of *Signs and Meaning in the Cinema* (1969), *Raiding the Icebox: Reflections on Twentieth-Century Culture* (1993) and *Singin' in the Rain* (1993).

WILLIAM WOOD is a critic and art historian with numerous publications on contemporary art. He has held editorial posts with *C magazine, Vanguard* and *Parachute*, and has taught at the Slade School of Fine Art, London, and the University of British Columbia, Vancouver.

Introduction

JON BIRD AND MICHAEL NEWMAN

This book is not a history of Conceptual art. It does not make any claims to a geographically comprehensive coverage and it does not advocate a conceptual-type approach to art practice as superseding other approaches or definitively breaking down the barrier of the aesthetic. So what are our aims in compiling this collection of essays? As the title suggests, the book looks at ways in which Conceptual art is currently being 'rewritten', gathering together, for the first time in a single volume, contributions from a number – although by no means all – of the younger art historians who have been researching the movement and are beginning to publish, as well as pieces by critics and historians who were contemporary with, or followed closely on, the development of the movement. We have also attempted to indicate the importance of the extension of the history of Conceptual art (or 'Conceptualism' in its broader sense) to include centres other than North America and Western Europe; indeed, to recognize its local specificity and its global reach – a project that has already been pursued on a larger scale by the important exhibition *Global Conceptualism: Points of Origin, 1950s–1980s*, initiated by the Queens Museum of Art, New York, in 1999.[1] Furthermore, the process of 'rewriting' is one of reflection and reinterpretation, leading to a reassessment of historical and critical evaluations in the context of new insights from both theory and practice. The trace of Conceptualism in contemporary work is addressed here, as well as essays which review a specific moment in the narratives of Conceptual art, or reconsider the significance of particular artists and their relationship to media forms, institutions and sites for practice.

The increasing importance in both art practice and the expanding field of studies in visual culture of the museum as an expression of national, cultural and ideological interests, of strategies and techniques of classification and modes of display, and of the interrelationship between the institutions and contexts in which artworks are located, is reflected in

essays by Jon Bird, William Wood and Michael Newman. Bird's essay on
Robert Morris's 1971 Tate Gallery retrospective examines an early
moment in Conceptual art's critique of social and cultural value systems
and the possibility of a different kind of relation between work and
viewer, and emphazises the porousness of the categories of Conceptual
art, Minimalism and performance. William Wood focuses upon the ten-
sions between the ephemerality or 'everydayness' of the objects of, in this
case, English Conceptualists, and the recuperative powers of institutional
display – here *The New Art* exhibition at the Hayward Gallery in 1972,
and Michael Newman's account also considers, through the example of
Joe Scanlan's *Nesting Bookcases* (1998), the paradox that Conceptual
art's desire to dissolve the autonomous status of the aesthetic object
could be made visible only through the institutions and discourses of art
itself. Newman connects Scanlan's 'generic object' Bookcase to the
Modernist design vernacular of Charles and Ray Eames's 'rocking chair'
and to Marcel Duchamp's 'ready-mades', and the figure of Duchamp –
specifically, his 'rediscovery' in the 1960s – is crucial to any rewriting of
Conceptual art. David Campany, in his essay on the relation of reproduc-
tion to the page, also stresses the contradictory status of the museum or
gallery, with its emphasis upon the primacy of vision, as the privileged
location for encountering works of Conceptual art – a location that was
extended to André Malraux's 'museum without walls', the discourse of
art history. Duchamp prefigures Conceptual art's 'linguistic turn' for
Campany, a move which is investigated for its philosophical status in Peter
Osborne's analysis of the relations and differences between Sol LeWitt,
Joseph Kosuth and Art & Language. Osborne argues that 'all art after
Duchamp ... might be said to be distinctly "philosophical" in nature', and
it is both the challenging and the critically reflective aspects of
Conceptual art that characterize the approach taken by the essays in
Rewriting Conceptual Art.

An essential part of the project of Conceptual art was to demolish the
distinctions between art practice, theory and criticism. Indeed, it can be
argued that Conceptual art might also be said to have transformed the
practice of art history through its rigorous self-reflexivity, its engagement
with the issue of how language frames practice and, in particular, the
influence of feminist approaches to questions of history, gender and the
body. In this respect, Mary Kelly's canonic *Post-Partum Document*
(1973–9) not only provided an important model for practice, it also sug-
gested ways in which text and image could combine to produce new
meanings for art and for the understanding of subjectivity and social con-

struction. Kelly's psychoanalytically informed practice is frequently opposed to other feminist artists of the 1970s who were attempting to find new inscriptions of the feminine in work that asserted an empowered or empowering sexual or social (female) body and Helen Molesworth re-examines three examples of feminist practice – Kelly, Judy Chicago's *The Dinner Party* and Mierle Laderman Ukeles's *Maintenance Art Series* in order to relocate feminist debate in relation to issues of the public and the private in terms of political economy. In general, the shift enacted through Conceptual art opened one important pathway for the analysis of visual signs and meanings which now constitute the broad field of visual culture. In this respect, the moment of Conceptual art transformed not only the subsequent possibilities for art but also the way in which we understand art generally, including the art that preceded it: as Roberta Smith argues in her New York Times review of the *Global Conceptualism* exhibition, Conceptualism 'is the shifting terra infirma on which nearly all contemporary art exists' (25 April 1999).

Any attempt to accommodate such a diverse and disparate ebb and flow of texts, objects, media, exhibitions, performance, bookworks, etc. within a general rubric immediately confronts the problem of competing definitional terms, Conceptual art, Conceptualism, Post-Object Art, Art-as-Idea, Theoretical art, Dematerialization, etc. all suggesting both affinities and subtle differences in emphasis and interpretation. The first uses of the term 'Conceptual' applied to the visual arts are attributed to Ed Keinholz in the late 1950s and to Henry Flynt, a member of Fluxus, in 1961, but the term does not enter art-world discourse substantively until almost a decade later, in a number of canonical exhibitions, texts and publications. These include Seth Siegelaub's and John Wendler's New York *Xeroxbook* show (a Xeroxed catalogue with works by, among others, Carl Andre, Robert Barry, Joseph Kosuth, Sol LeWitt and Robert Morris); *When Attitudes Become Form*, curated by Harold Szeeman at the Kunsthalle, Bern, and the Institute of Contemporary Arts, London, in 1969 and subtitled by Szeeman *Works – Concepts – Processes – Situations – Information*; vol. 1, no. 1 of *Art-Language: The Journal of Conceptual Art*, May 1969; and Donald Karshen's exhibition *Conceptual Art and Conceptual Aspects* at the New York Cultural Center, April 1970, which included 29 artists from seven different countries. However, as the catalogue for *Global Conceptualism* makes clear, what constitutes the 'canon' of Conceptual art has to be put in the context of its specific geographic and cultural histories. For example, as Stephen Bann points out, Conceptualism in Italy is mediated through the curatorial and critical

activities of Germano Celant, who coined the term 'Arte Povera' in 1967, and later glossed it in the title of his important exhibition *Arte Povera: Earthworks, Impossible Art, Actual Art, Conceptual Art*. Bann's essay demonstrates the way in which Giulio Paolini's work, in its thoughtful reflection on the history of Western art, differs from the reductivism of much Anglo-American Conceptualism and connects it with an Italian context that also includes Italo Calvino and Umberto Eco. Conceptual art's cosmopolitan history and the ways in which different cultural and political traditions and avant-gardes impact upon local concerns are also emphasized in Alex Alberro's study of Conceptualism in Latin America, while Desa Philippi concentrates on the 'existential dimension' of Conceptual art in Eastern Europe.

An inquiry, either figural or letteral, into the ontological status of the art object – its formal and material variety or, alternatively, its actual disappearance – is what characterizes the varied activities of artists in the period from the late 1960s to the early 1970s, critically summarized by Lucy Lippard in her collection of essays *Six Years: the Dematerialisation of the Object* from 1966 to 1972.[2] Lippard's term implies a logic of subtraction as the materiality of the art object is systematically reduced or redefined, and the concept 'art' and the context increasingly carry the burden of meaning. No single term can adequately describe the various formal and theoretical investigations pursued by artists during this period – from Robert Smithson's 'non-sites' to Mel Bochner's 'measurements', Bruce Nauman's lead plaques and quotidian performances to Richard Long's 'walks', Joseph Kosuth's 'definitions' to John Baldessari's 'commissioned paintings' in which authorship is demythified. What we have instead are certain shared or overlapping characteristics, marked by a divide in practice between what has been labelled either 'synthetic' or 'analytic' Conceptual art. (Kosuth made a disparaging distinction in the second issue of the American journal *The Fox* between 'Theoretical Conceptual Art' and 'Stylistic Conceptual Art', seeing the former as a 'critical practice' and the latter tendency as a 'deterioration of the movement'.) David Karshner, in the statement accompanying his exhibition preferred the expression 'Post-Object art' to describe 'a complete break from formal esthetic considerations', sharing with Kosuth an emphasis upon the philosophical-like nature of the work: 'The idea of art has expanded beyond the object or visual experience to an area of serious art "investigations".' Slightly earlier, the editorial of the first issue of *Art & Language* differentiated Conceptual art from all previous avant-gardes as a break with the perceptual – the form in favour of the idea: 'Initially what

Conceptual art seems to be doing is questioning the condition that seems to rigidly govern the form of visual art – that visual art remains visual.' The same issue printed Sol LeWitt's 35 'Sentences on Conceptual Art' which convey a more nuanced and experiential relation to the object of art.[3] Besides the attack upon the visual, *Art & Language* also referenced another key concern and defining characteristic of much Conceptual art, a self-reflexive inquiry into art's linguistic structure, a procedure which, it was claimed, could itself be an artwork. Similarly, in 1967, Kosuth had begun to produce his 'definition' series – dictionary definitions photographically reproduced, enlarged and mounted as art objects – and he published a key manifesto of Conceptualism, 'Art After Philosophy', as a three-part article in *Studio International* in 1969. To an extent this comes under the rubric of Conceptualism's challenge to the traditional location and identity of the artwork. By detaching art from medium specificity, Conceptual art enormously extended the sites in which it could be found, and Anne Rorimer considers the way in which some American Conceptual artists used the page as a site not for the representation of their work but for the work itself.

As Peter Wollen has argued,[4] given the later dominance of Structuralist and semiotic theories of signification, it is odd that the analytic references made by most British and American Conceptual artists in this period were primarily to examples drawn from linguistic philosophy, specifically A. J. Ayer, Wittgenstein and Quine, and to the philosopher of science Thomas Kuhn's *The Structure of Scientific Revolutions*. Peter Osborne argues in this collection that only analytical philosophy, which combined the authority of the classical tradition with a scientific inquiry into its own truth claims, could offer the linguistically oriented Conceptual artists a vehicle for 'recoding "art" as "philosophy"'. This move coincided with a turn to theory that represented both a quest for critical rigour (implied was a rejection of the traditional distinction between practice and theory – previously the role of language in the visual arts had primarily been the domain of philosophical aesthetics on the one hand, and art history or criticism on the other) and a search for 'models' (disciplinary exemplars which might provide an analogy for art as an investigative and cognitive pursuit). Thus Kuhn's formulation of major developments within science happening as a result of 'paradigm shifts' suggested an appropriate theorization for the claims being made for Conceptual art's break with all previous avant-gardes.

The distinction between Conceptual art – the movement – and 'Conceptualism' – a tendency or critical attitude towards the object as

materially constituted and visually privileged – is far from precise and frequently breaks down in the work of artists who deliberately crossed genres and media forms. This is further complicated by the independent developments and strategies adopted in different countries and such factors as the relations between the artist-subject and the social formation, the dominant and residual aesthetic traditions against which Conceptual artists reacted, the hegemonic role of art and educational institutions and their relation to official ideologies, and the social movements and historical forces in their global and local manifestations that acted upon and against aesthetic avant-gardes. These varied pressures and possibilities are reflected in a number of the essays in this collection. In general, however, a change in approach from the object to the concept, the privileging of language or language-like systems over pure visuality, and a critical attitude towards the institutions and structures of the art world, which included the increasing commodification of art and a questioning of the social role and responsibilities of the artist, can be evidenced in one form or another in all the manifestations of Conceptual art. Briefly, this can be expressed as a decisive break with the visual tradition of painting and sculpture and as either a critical continuation or a fundamental disruption of the main tenets of Modernism, depending, of course, upon which version of Modernism is being cited. Whichever narrative is favoured, what accompanied these shifts was a very different role and a new set of demands placed upon the spectator. No longer construed as a passive receptacle awaiting aesthetic illumination, Conceptual art proposed an informed and critically active audience who were expected to work in order to fully engage with the objects, texts, installations, etc. that were Conceptualism's products. Thus the re-emergence of Duchamp in the 1960s and the increasing significance accorded to his work in the narratives of Modernism, and the relevance of artists from the Russian avant-garde, particularly Tatlin and Rodchenko, provided the theoretical and historical ground for claims for Conceptual art as the 'last avant-garde'.

Two movements precede Conceptual art and are closely associated with its development – Fluxus and Minimalism. (Another, earlier group – the Situationist International – haunts Conceptual art's initial period and Peter Wollen suggests a link though a shared fascination with maps and mapping – particularly in the work of Douglas Heubler and On Kawara.) Something of the diversity of Conceptual art practice can be explained by these antecedents in their diametrical opposition – the former, an international movement which stressed the ephemeral and everyday in performances which anarchically derided the aspirations of bourgeois taste and

culture, the latter primarily North American, object-based, permanent and austere. Some artists – for example, Robert Morris – bridge both movements (he left Fluxus in 1994), but in general Fluxus activities were influential in the early 1960s. Minimalism, primarily 3-D structures based on simple polyhedral forms, industrially produced in single or serially repeated units which, in Robert Morris's terms, 'create strong gestalt sensations', persisted in tandem with – and in some accounts were inseparable from – Conceptual art well into the 1970s. Sol LeWitt's proto-Conceptual or Minimal works are logically comprehensible permutations of a basic mathematical equation expressed in a 3-D or graphic form, an idea that need be only 'interesting', not theoretically or philosophically challenging. What connects Minimalism with Conceptualism is a shared emphasis upon the 'framing' of the work – that is, the application of a system for production which might be either mathematical or linguistic – and the repositioning of the work-spectator relation, thereby drawing attention to another aspect of framing, the institutional context for reception. For some artists this resulted in practices that critically interrogated aspects of the social and political structures that legitimated the production and circulation of works of art as bearers of economic and symbolic capital – for example, Daniel Buren's interventionist critiques of painting and Hans Haacke's investigations into the relations between aesthetic and cultural value.

If many of the Minimalist artists engaged in the writing of theoretical texts – for example, besides LeWitt, Robert Morris consistently reflected in published articles on the phenomenological and philosophical aspects of his and others sculpture, Robert Smithon wrote a number of essays developing the themes of his installations and earthworks, Donald Judd had a period of critical reviewing – mostly these addressed the conceptual basis for practice or employed text as an alternative medium. What distinguishes (some) Conceptualists is a focus upon the linguistic and semiological conditions and presuppositions that underlie our understanding of art. During the 1970s, as the implications of post-Saussurean linguistics penetrated the academy, affecting most of the humanities disciplines, Conceptual artists adopted the interpretive frameworks of semiotics and Post-Structuralism, reading the work of art as a sign competing for recognition in the cultural and ideological codes of a society. The fundamental impact of feminist theories, particularly analyses of patriarchy and psychoanalytic theories of sexual difference, inflected art practice towards issues of representation and subjectivity, a move which tended to produce oppositional positions – arguments over essentialism versus the discursive.

The typical form that this aspect of Conceptualism adopted was 'photo-text', a relation of word and image that owed much to Roland Barthes's writings on film and photography, although the nature of the relation varied considerably, from Victor Burgin's notion of 'complementarity', as in *Work and Commentary*, (1973) to Dan Graham's photojournalistic layout *Homes for America* (1966). The emblematic status of Dan Graham's magazine intervention for the generation of artists that followed the formative period of Conceptual art is discussed by David Campany, who also argues that it is an uncontainable work for any art-historical discourse that attempts to frame its complex play with photographic and aesthetic genres.

With the increased capitalization of the art market in the 1980s, and the consequent demand for object-based art, Conceptual art – now including a second generation – found itself in opposition to 'new image painting' and the so-called 'transavantgarde', the return to traditional genres, to visual delectation, and to the marketing of national groupings of artists. The opposition by artists such as Sherrie Levine and others included in the *Pictures* exhibition of 1977 at Artists' Space, New York,[5] to these conservative modes, which rejected even the critical reflexivity of Modernism, had to come to terms with the processes of cultural recuperation of Conceptual art itself by the market and the museum, as can be seen in Benjamin Buchloh's key article of the period, 'Figures of Authority, Ciphers of Regression'.[6] It was in part due to Buchloh's approach to Conceptual art and the repressive situation in which it found itself, as well as his foregrounding of the example of Marcel Broodthaers, that the turn towards institutional critique was taken, prompting and in turn supported by a turn towards museology by art historians. Broodthaers's work appeared to shift between a Fluxus-type parody of institutional ideologies and the making of objects which, in Buchloh's account, travestied 'the radical achievements of Conceptual art'. By contrast, in her essay on Broodthaers, Birgit Pelzer makes a powerful argument for a psychoanalytical approach to 'the place of the subject' in relation to language in his work through a Lacanian reading of Broodthaers's relation to Mallarmé.

If, on the one hand, from the point of view of an avant-garde project, Conceptual artists and their supporters were fighting something of a rearguard action, then at the same time critical approaches to issue-based art on a more micro-political level, involved in feminism, anti-racism and local struggles, were continuing to develop. Alongside new image art, a second generation of Conceptualists emerged, concerned with the decon-

struction of originality, with replication and with simulation. This also marked a shift in emphasis towards a reconsideration of popular cultural themes and media forms (for example, the work of Barbara Kruger, Martha Rosler or Jeff Wall), and a more fully developed institutional critique which extended the projects of Haacke, Buren and Broodthaers to include the role of the museum in legitimating gender and racial hierarchies (the work of Fred Wilson, Lothar Baumgarten and Louise Lawler). This second-phase reinvigoration of Conceptual art is characterized by further reflections on the status of the object, the framing of the artwork and the broad set of cultural and social relations which determines the conditions of production and reception of art.

By the early 1990s a third phase began. The vein of new image art became exhausted at a point when the market once again went into recession, and when it revived, it found new ways of commodifying the kind of art that had developed from Conceptualism, through photography and other forms of documentation, and through limited-edition film prints and video copies. At the same time there emerged internationally a third generation of artists influenced by Conceptual art, including Douglas Gordon, Renée Green, Liam Gillick, Mark Dion, Group Material, Gabriel Orozco, Stephen Prina, Marysia Lewandowska, Tracy Emin, Felix Gonzalez-Torres and Antonia Fraser. This third generation, who came to prominence in the 1990s, their work in film, video, photography, text and installation vastly overshadowing work in traditional media and therefore representing in effect the market triumph of Conceptualism, has coincided with the historicization of the movement through a number of key exhibitions, beginning with *L'art conceptuel, une perspective* (ARC, Musée d'Art Moderne de la Ville de Paris, 1989) and including *Reconsidering the Object of Art: 1965–1975* (Museum of Contemporary Art, Los Angeles, 1995–6) and *Global Conceptualism: Points of Origin, 1950s–1980s.* Tony Godfrey suggests that recent Conceptual art has tended to abandon the broader investigative procedures of earlier conceptualisms to concentrate upon the experiential and autobiographical.[7] One particular strand has focused on issues of identity and representation, often defined through a Foucauldian lens of regimes of visibility and power/knowledge. Thus Sophie Calle's obsessive monitoring of unknown subjects, Willie Doherty's photo-text and video installations documenting Northern Ireland's colonial history, Mona Hatoum's video conversation with her mother and Gillian Wearing's encounters with strangers incorporate and reinterpret earlier conceptual strategies. While the first two moments of reception have tended to involve the opposition of

Conceptual Art and approaches based on it to other modes, whether Modernism or new image art, the third moment (perhaps because it occurs at a time when Conceptualism has become all-pervasive if not dominant in the art world) has tended to assert internal distinctions – for example, between analytic Conceptual art and the more performative and processual approaches, and between self-reflexive Conceptual art and the more issue-based global Conceptualism.

Research on Conceptual art is currently taking place at a time when its initiators are still present yet their initial achievements are at some historical distance, while at the same time an enormous amount of new material is becoming available. The collapse of Communism and the liberalization that has taken place in a number of Latin American countries have made a great deal more documentation and information available than hitherto, and provided access to the work of Conceptual artists either little known or completely unknown in Western Europe and North America. At the same time, the shift of the economic centre of gravity towards the Near and Far East has increased the representation from those countries in international exhibitions. Another change is that interest in the artists of or directly formed by the period of 'classic' Conceptual art has shifted, generally from hardliners like Joseph Kossuth and Art & Language, on the one hand, to artists whose work has a greater involvement with subjectivity, such as Dan Graham and Sophie Calle, to artists whose work seems to fit with the current theoretical interest in nomadism, such as André Cadere, or anthropology, such as Lothar Baumgarten or Susan Hiller. In the case of On Kawara, Conceptualism takes an existential turn, and a more poetic slant is given to the use of Conceptual techniques by Alighiero e Boetti, John Murphy and, above all, Marcel Broodthaers. It is notable that some of the strongest mid-career artists working today, such as James Coleman, began as Conceptual artists. And among the best younger artists today are those who have responded most intelligently to the challenges posed by and in the wake of Conceptual art. At the same time, medium-specific approaches are themselves irredeemably affected by Conceptual art, whether they draw from it or – increasingly rarely – oppose it. All these strands of the third moment of reception – historicization, internal critique, differentiation, inclusiveness and expansion – are reflected in *Rewriting Conceptual Art*.

Siting the Page: Exhibiting Works in Publications – Some Examples of Conceptual Art in the USA

ANNE RORIMER

The many artists embraced under the rubric of Conceptual art have questioned, reinterpreted or totally abandoned the traditional categories of painting and sculpture. In doing so, they have redefined the nature of the rectangular, flat picture plane and the volumetric object in space. Conceptual work, generally speaking, is characterized by the independent use of language and/or photography in place of paint or conventional 'art' materials; alternative representational systems such as maps or numbers; the media of film and video; and/or performative means. Site-specific installation, wherein a work's context gives rise to its content, is also often a significant aspect of Conceptualism. Furthermore, in a variety of instances as suggested by a cross-section of works realized in the years between 1965 and 1975, the page or pages of a book or magazine take the place of the traditional exhibition space.

With the belief that a book should enjoy the same status as the physical exhibition premises of a museum or gallery, Sol LeWitt maintained that, in his work, 'The wall is understood as an absolute space, like the page of a book. One is public, the other private.'[1] LeWitt first made a drawing directly on the wall for a group exhibition at the Paula Cooper Gallery in October 1968. By 1969 he had further arrived at the idea of creating 'a total drawing environment' by treating 'the whole room as a complete entity – as one idea'.[2] Since then he has produced numerous wall drawings in exhibition spaces throughout the world. Each results from the artist's predetermined instructions, which are carried out – often by one or more assistants over a period of days – according to the stipulations of the plan, which also serve as the work's title. Thus the pen and ink drawing *All Combinations of Arcs from Corners and Sides; Straight, Not-Straight, and Broken Lines* (1973) takes the form of a room environment as per its

instructional content. This scheme, adapted to a particular space, results in a configuration of linear elements that, upon execution, becomes enmeshed with the background of the supporting walls of the existing exhibition enclosure.

The pages of a book by LeWitt engender a visual narrative of form, line and/or colour that, like the wall drawings, follow the provisos of their title. Because of their scale, configurations derived according to the work's preset plan are thus 'read' differently within the context of a book from the way they are experienced on a wall. 'Straight, not-straight and broken lines using all combinations of black, white, yellow, red and blue, for lines and intervals', for example, constitutes the publication *Lines & Color* (1975). Free of representational association, colour and line in this work change their respective relationship to each other from one page to the next.

With the publication of *Statements* (1968), Lawrence Weiner similarly enlisted the book as an alternative presentational context.[3] This palm-sized publication was considered by both the artist and the exhibition's organizer/publisher, Seth Siegelaub, to be the only space for this particular display of 24 works. Over the last three decades, the pages of books have offered Weiner, as LeWitt, a presentational context for the display of works whose material is language. In 1968 Weiner reached the conclusion that language, being an independent representational system, could exist on its own as the material of a work's construction and therefore that it was possible to forgo the physical construction of any particular work. Before this moment in Weiner's development, sculptural works that the artist had drawn up in advance in accordance with penned descriptive phrases were meant to be built as he had specified. Weiner has recounted that what might be considered the official turning point in his approach to sculpture occurred when he was in the process of installing a piece for the now historic outdoor exhibition *Carl Andre, Robert Barry, Lawrence Weiner*, conceived by Chuck Ginnever and organized by Seth Siegelaub, which was held on the grounds of Windham College in Putney, Vermont. Having placed his work, entitled *A SERIES OF STAKES SET IN THE GROUND AT REGULAR INTERVALS TO FORM A RECTANGLE – TWINE STRUNG FROM STAKE TO STAKE TO DEMARK A GRID – A RECTANGLE REMOVED FROM THIS RECTANGLE*, in a vulnerable location, he later found it had been damaged. Because the sculpture had been initially formulated in language, Weiner determined that, paradoxically, its permanence was ensured. Despite the physical damage it suffered, the piece remained linguistically intact as testimony to a mate-

rial object, for which, as a linguistic construction, it could stand in at any time.

Soon after this Weiner devised the statement that has accompanied presentations of his work since 1969. It reads:

The artist may construct the piece.
The piece may be fabricated.
The piece need not be built.
Each being equal and consistent with the intent of the artist, the decision as to condition rests with the receiver upon the occasion of receivership.

By means of this statement, the artist stipulates that the actual, physical realization of any one of his works is not a requirement but an option left open to the discretion of any perceiving subject, including the artist. *RESIDUE OF A FLARE ON A BOUNDARY* (1969), for example, was implemented by Weiner under the auspices of the Stedelijk Museum, Amsterdam, during the exhibition *Op Losse Schroeven: Situaties en Cryptostructuren (Square Pegs in Round Holes: Structures and Cryptostructures)* in the spring of 1969. The same year, *A SQUARE REMOVAL FROM A RUG IN USE* (1969) was physically constructed in the home of collectors who had purchased the piece. At their request, Weiner came to their residence in Cologne, Germany, and cut a square section out of the rug. He thereby created a lacuna rather than, more typically, adding a new *objet d'art* to their collection.

Although works by Weiner may in principle be materially constructed, in all cases they must first be registered in the mind's eye. Because of the manner in which they are embodied in language, they are never conclusive descriptions subject to one static mode of being construed. Infinitely open-ended, they have the potential for being visualized and/or realized in count-less ways and contexts. Thus *MANY COLORED OBJECTS PLACED SIDE BY SIDE TO FORM A ROW OF MANY COLORED OBJECTS* (1979) does not dictate either the number or the colours of the objects in question, or the length of the row or, for that matter, what the objects could be. Unlike a traditional painting or sculpture, works by Weiner may be presented anywhere, in any format, or they may simply be spoken. Furthermore, they are not confined to being shown in any one place at any one time and may take an indefinite number of presentational forms, either within or outside conventional exhibition spaces or, quite simply, on the pages of a book. As Weiner observed early on in connection with the open-ended, linguistic nature of his production, 'When you are dealing with lan-guage there is no edge that the picture drops off. You are dealing with

something completely infinite.'[4] Depending on the type of lettering used and its placement, and depending on factors contributing to the nature of a work's given context, each installation or insertion into the design format of a book yields a visually different presentational result. The use of language as medium to create specific pieces with unspecified readings that have the innate potential for ubiquitous placement frees Weiner's work from sole reliance on a particular space or on spaces designated for art. Avoiding dictatorial pronouncements or authoritarian expression, it is able to fuse semantic content with either an institutional or a paginal context.

Before turning from poetry to his performed works of the late 1960s and 1970s, Vito Acconci had defined the page as an area in which to act. In his 'notes on poetry', he defines words as props for movement and the page as a thing, a container, a map and a field for movement.[5] His last works of poetry, as he describes it, were done 'in a poetry context, were "poetry events": the occasion was a poetry reading – I used props (an audio recorder, the walls of the room or the chairs in that room) – the attempt was not to read from a page but to read the room'.[6] Alternatively, his 'first pieces done in an art context were ways to get [himself] off the page and into real space'.[7]

In Acconci's poems of the middle to late 1960s, the page offered itself as a space for the display of verbal transactions rather than one where, in poetry, it is typically hidden behind the play of words, turns of phrase or verbal description and, in art, it is covered by pictorial illustration. His appropriation of familiar phrases from their circulation in the culture and deliberate recourse to found sequences or compilations of words were significant aspects of his subsequent turn from poetry to art. A poem of 1968 entitled 'Installment (Installation): Move, Remove' reads:

What is placed here is the last entry of Webster's Third New International Dictionary, page 2662 –
zyz.zo.ge.ton /,ziza'je,tan / n, cap (NL, fr. Zyzza, genus of leafhoppers in former classifications (prob. of imit. origin) + Gk *geiton* neighbor): a genus of large So. American leafhoppers (family Cicadellidae) having the pronotum
– with the last six words removed.[8]

The poem, omitting the last six words from *Webster*'s definition of 'zyzzogetan', is considered by its author to be a verbal installation – a group of words and letters that have been lifted from one context and placed in another. Acconci's poetry is premonitory of his ensuing installations, which depended on the artist's real-life activities or room-based constructions featuring himself as a visible or audible presence.

Concerned for the last two decades with the architectural works he calls Pavilion/Sculptures, many of which have resulted in major outdoor commissions, Dan Graham began his career with his seminal *Works for the Pages of Magazines*. From 1965 until 1969 he defined the magazine page as a site of display through a variety of different means, having recognized that works of art depend on the economic support of an exhibition space as much as they do on the literal 'backing' of its walls. When he briefly ran his own gallery in 1964–5, he had experienced the economic realities behind the idealized and purportedly neutral 'white cube'.[9] As he has written, 'The fall after the gallery failed I began experimenting myself with works which could be read as a reaction against the gallery experience, but also as a response to contradictions I discerned in gallery artists.'[10] By placing works in magazines, he substituted the ideational space of the magazine page for that of the enterable exhibition space.

Graham's early work *Schema* (1966) comprises information that makes it possible for the page to cite itself as a site: that is, the content of the work and its context in a publication coincide in so far as the former serves as a self-referential inventory of the latter. The content of the work comprises a list of all of the facts pertaining to the specific published format in which the page is bound. The formal characteristics and verbal content of the work are derived from the constituent elements of the particular page's format. Wherever it is published, the work lists its characteristics (size of page, type of paper stock, number of adjective, etc.). Consisting of printed material and information *on* a page, the work defines itself as being one and the same as the materially present page.

Another of Graham's earliest magazine pieces, *Figurative* (1965), appeared on page 90 in the March 1968 issue of *Harper's Bazaar*, where it is bracketed by two advertisements, one for Tampax and the other for a Warner's bra. A column of numbers, printed vertically down the centre of the page and cut off at top and bottom to conform to its size, evidence the dollar and cent amounts paid for 30 or so inexpensive items. Since the numbers are not totalled, they represent only themselves and not a final sum. Graham had submitted this portion of a lengthy cash-register receipt to the magazine's poetry editor with the idea that, coming at the end of the buying process, it would function not so much as a poem but as the reverse of an advertisement. The receipt was arbitrarily placed and titled by the editorial staff and not by Graham himself. Signifying the result of a commercial exchange, it contrasts with the ads, which signify the potential for such an exchange. Irrespective of its specific layout on the page in association with other items, *Figurative* is anchored within the

volume that contains it. A kind of 'anti-ad',[11] it resists being merchand-
ized as a precious and purchasable or saleable object and replaces trad-
itionally composed figuration with functioning numerical figures.[12]
Significantly, representational material and presentational method are
fused in that the work is simultaneously shown on the surface of a page
and in the context of a magazine.

 'The Domain of the Great Bear', researched and written by Mel
Bochner and Robert Smithson, and published in *Art Voices* in the fall of
1966, also rests on the principle that a periodical offers an alternative
place of display. Eliminating the once firm division between the defining
characteristics of an artwork versus those of a magazine article, it delib-
erately eludes typecasting as one or the other. The subject matter of this
work/illustrated article about the American Museum of Natural History
and Hayden Planetarium in New York carries the reader from the cosmic
heights of planetary movements to the bathos of institutional settings.
Because of its unusual design layout (including a reproduction of a sign
with a hand pointing to 'SOLAR SYSTEM & REST ROOM'), it strikes a
different note from typical expository contributions to art journals with-
out forfeiting its discursive character as an essay. Clearly separating itself
from the texts of critics, art historians or artist writers, the article departs
from standard expository practices in its deadpan delineation of institu-
tional absurdities. Bochner and Smithson's text makes visible the correla-
tion between the sublime and the ridiculous and brings thoughts about
the infinity of the universe down to earth in all of its corporate splendour.
The IBM logo above the museum's 'Astronomia Corridor' pictured in one
of the accompanying photographs is, of course, not lost on the essay's
authors. Text and images, including a rendering of a dinosaur watching a
bollide and a motley group of shivering bears standing in front of the US
White House, reinforce one another, while the work's final words sum-
marize its overall tone: 'A chamber of ennui. And fatigue. It is endless, if
only the electricity holds out.'

 Until his untimely death in 1973, Smithson consistently questioned the
hard and fast separation between sculpture and writing. Although leaving
these disciplines more or less intact, his work signalled the potential por-
ousness of the linguistic category of literature versus the material cate-
gory of sculpture. In his many writings – quite separate from his so-called
'Nonsites' of 1968 and the earthworks of the early 1970s, such as *Spiral
Jetty* (1970), for which he is especially famous – words are often employed
to create analogies between the metaphoric and the material, between the
mental and the physical, and between language, art and the materiality of

the earth. Although they are information-bearing, printed, textual docu-
ments, Smithson's published pieces none the less present themselves as a
form of hybrid between an artwork and a standard article.[13] 'The
Domain of the Great Bear', however, forcefully sought to push such
hybridity in the direction of a new breed of aesthetic production.

In a group of works categorized by the artist as 'The Second
Investigation' (1968/9), Joseph Kosuth proposed an overt confrontation
between art and non-art systems and contexts. Previously, in his 'Art as
Idea as Idea' series (1966–8) belonging to his 'First Investigation', Kosuth
had substituted linguistic definition for pictorial depiction by means of
definitions taken directly from the dictionary and enlarged in the form of
a photostat. Pertaining to language, their content is the signifying process
as this manifests itself as both the subject and the object of its own
inquiry. Each of the numerous dictionary definitions asserts itself as that
which it describes, whether this be a noun such as 'water', adjective such
as 'white' or an abstract quality such as 'nothing', 'normal' or 'meaning'.
By virtue of the capacity of language to be what it is and what it is about
simultaneously, the meaning embodied in the definition succeeds in lend-
ing 'depth' to the work without falling into any kind of pictorial illusion-
ism. The artist has explained: 'I felt I had found a way to make art without
formal components being confused for an expressionist composition.
The expression was in the idea not the form – the forms were only a device
in the service of the idea.'[14] The dictionary definitions bring into relief the
idea that art is fundamentally about ideas and that they, in turn, are about
art rather than about emotive subject matter or technical skill and
virtuosity.

The advertising spaces found on the pages of newspapers and maga-
zines and used in 'The Second Investigation' offered a new context for the
placement of an artwork. Kosuth's noted text of 1969, 'Art after
Philosophy', stipulates that 'a work of art is a kind of *proposition* pre-
sented within the context of art as a comment on art'.[15] Based on this rea-
soning, the artist was able to go outside the art context to locate his work
in the world. As he later wrote in 1974, such works initiated 'an increased
shift of locus from the "unbelievable" object to what was believable and
real: the context. Objects or forms employed became more articulations
of context than simply and dumbly objects of perception in themselves.'[16]

For the realization of 'The Second Investigation', Kosuth anonymously
published sections from the 'Synopsis of Categories' at the beginning of
Roget's Thesaurus in the advertising spaces of public media from different
countries, such as billboards and handbills, as well as in the advertising

Joseph Kosuth, *'Synopsis of Categories': CATEGORY ONE 'EXISTENCE'*, from Artforum (January 1969).

Joseph Kosuth, Swiss newspapers containing information for '*1. Space (Art as Idea as Idea)*', 1968, as seen in the catalogue for the exhibition *When Attitudes Become Form* at the Vereins Kunsthalle, Bern (1969).

pages of newspapers and magazines. *Roget's* 'Synopsis of Categories' lays out hierarchies of linguistic taxonomy that have been absorbed into a published public context in which, categorically by themselves, their meaning is put in question. As part of a work of art, however, they hold their own within the artist's meaning system. Advertising available in most newspapers and magazines provided Kosuth with a decidedly non-art context for the insertion of text. A single work consists of a section from the 'Synopsis of Categories', such as Category One pertaining to Existence, which is printed on page eighteen of the January 1969 issue of *Artforum*. When necessary, moreover, the artist sometimes used more than one ad space to accommodate all of the parts of a lengthy category within a single publication.

In the 1969 Bern exhibition *When Attitudes Become Form*, newspapers containing works from 'The Second Investigation' were exhibited together as a group under the title *Spaces (Art as Idea as Idea)*. In his catalogue statement, Kosuth maintained:

The new work is not connected with a precious object – it's accessible to as many people as are interested; it's nondecorative – having nothing to do with architecture; it can be brought into the home or museum, but wasn't made with either in mind; it can be dealt with by being torn out of its publication and inserted into a notebook or stapled to the wall – or not torn out at all – but any such decision is unrelated to the art.[17]

As Kosuth himself thus pointed out, the use of spaces in magazines and newspapers made it possible for him to avoid the creation of an autonomous object of commercial worth, just as it had allowed Graham to circumvent the spaces in which art objects are sold. Having claimed and inscribed portions of a meaning system consisting of hierarchies of linguistic taxonomies into the non-art context of media publications, he proposed the idea of a new equation between art and the world. Moreover, he set up a confrontation between an abstract, linguistic system and the linguistic information normally pertaining to sites of promotion, and in this way interlocked the two.

Seeking to discover methods by which to circumvent the creation of three-dimensional material objects slated for museum display, Steven Kaltenbach produced a series of twelve works that appeared in the advertising section of the issues of *Artforum* starting in November 1968 and ending in December 1969. Not unlike Kosuth, he used the advertising pages of *Artforum* as an alternative exhibition context. As a group, his advertisements interject themselves into the non-art territory of an art magazine

where gallery exhibitions for the month are announced. The first advertisement consisted of the phrase 'Art Works'. The second, in the next issue, was a lozenge shape based upon Richard Artschwager's 'blp', for which the artist was famous at the time for installing in a great variety of locations, treating it as a small, unsigned form that could be used to punctuate any space. In his appropriation of Artschwager's 'blp', which in *Artforum* is inscribed with the name of the American folklore hero 'Johnny Appleseed', Kaltenbach emphasized *his* act of recontextualization.

Other pieces in the *Artforum* series consist of succinct and sometimes suggestive phrases, such as 'Expose Yourself', or statements like 'You Are Me'. Their language is engimatic and provocative, offering an incursion into the weightiness of critical dogma found in art magazines. Semi-subversive and basically antisocial injunctions play upon the 'forum', so to say, in which the 'ads' have been placed. Made to be eye-catching, in a non-traditional sense, these works were aimed to fly in the face of convention in terms of conventional modes of aesthetic operation: with respect not simply to visual decoration but also to social decorum. They provoke – and are provocative – by enjoining viewers, for example, to 'Smoke' or 'Tell a Lie'. Even the injunction 'Teach Art', juxtaposed and included with the magazine's advertisements for forthcoming exhibitions – which presuppose that art is mainly something to be sold – may be thought of as being, if not subversive, at least out of line with the rest of the material on the page. Kaltenbach's ad pieces in *Artforum*, in the manner of his earlier works, counter expectations regarding the traditional forms and function of art.

Very differently from Graham's, Kosuth's or Kaltenbach's use of magazine pages, two works by Robert Barry of 1969 and one by Michael Asher of 1975 deal with the page itself as a material, two-dimensional entity that is one of a number of hinged, repeated elements forming part of a book or publication. Otherwise unrelated, both artists have defined the page in terms of its physicality. Barry's works are located in the magazine *0–9*, 6 (July 1969), edited by Vito Acconci and Rosemary Mayer. Asher's is in *Vision*, 1 (1975), published in San Francisco.

For his part, Barry claimed two kinds of spatial intervals between pages, although in each case they function as mentally delineated spaces just as much as physical ones. His two *0–9* pieces are listed in the magazine's table of contents as 'The Space between pages 29 & 30' and 'The space between pages 74 & 75'. In the first instance, Barry defined the fixed, minuscule and thus invisible space between the two sides of a single page, which, to all intents and purposes, has no volumetric presence. In

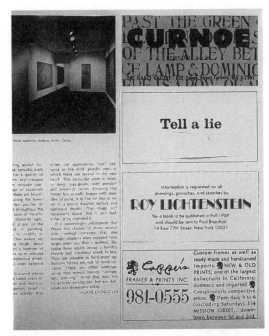

Stephen Kaltenbach, *Tell a Lie*, from *Artforum*
(February 1969).

Stephen Kaltenbach, *Start a Rumor*, from *Artforum*
(March 1969).

Stephen Kaltenbach, *Teach Art*, from *Artforum*
(September 1969).

the July issue of *0–9*, page 28 contains the end of a project by Bernar
Venet. On the reverse, the opening of Dan Graham's essay 'Eisenhower
and the Hippies', begins on page 29. A separate freestanding page, there-
fore, does not exist, but the space claimed by Barry may be imagined and
understood concretely as both a reality and an idea.

In the second of Barry's *0–9* contributions, the space – between pages
74 and 75 – is a changeable and accessible one. The amount of space fill-
ing the angle between the two pages depends upon whether the magazine
is fully or partially open or whether it is closed. It is therefore a flexible
space and may actually be perceived when the magazine is opened to these
pages. Like others of Barry's works of the late 1960s, such as those from
the 'Inert Gas' series or the 'Carrier Wave' or 'Radiation' pieces, the work
cannot be seen or possessed in the manner of a traditional material
object, but must be understood as an idea, despite the fact that the two
kinds of spaces are present in actuality.

For his contribution to the first issue of *Vision*, along with a number of
other artists who were invited to participate, Michael Asher glued his two

alloted pages – pages 42 and 43 – together. His name is included in the table of contents, and his work is between a drawing by Doug Wheeler and a text by Bruce Nauman, 'False Silences'. The reader/viewer sees only the contributions of Wheeler and Nauman, but is aware of the slightly greater thickness of Asher's two-cum-one page. By virtue of having glued his assigned pages together, Asher drew attention to the physicality of the real page as opposed to taking its background surface for granted. He thereby incorporated the reality of the physical space that exists between two pages into the content of a work that took cognizance of and embodied its own context. In a comparable manner to the works that define his prodigious career, he treated the reality of the given exhibition space simultaneously as an object of inquiry and as the resulting art object. Both commenting on and physically making evident the palpable reality of publication space, Asher's work for *Vision* considers the page as a site for art in an absolutely literal manner. In reverse of Barry's 0–9 piece, which deals with ideas about space via the page as a fact and concept, Asher's work addresses the question of the page as a factual material entity in and of itself.

As opposed to works that define the page as an alternative exhibition site within the context of a publication or as an area that literally and/or conceptually occupies or contains space, pieces by Adrian Piper, Douglas Huebler and Donald Burgy are predominantly concerned with regarding the page in terms of its propensity to be a meaning-bearing surface. At an early age and date Adrian Piper had begun to explore ways to explicitly foreground herself as both the subject of and an object in her work. Over the last two decades, that work, which addresses racial stereotyping and xenophobia,[18] issued from her analytic consideration of the principles enunciated and demonstrated by LeWitt in 1967. In 1968 Piper noted her ever-increasing 'sympathy with the position on art taken by Sol LeWitt',[19] and the fact that she was then 'interested in the construction of finite systems . . . that serve to contain an idea within certain formal limits and to exhaust the possibilities of the idea set by those limits'.[20] *Untitled* (1969), published in the sixth issue of 0–9, deals with the extant magazine page. Piper's page is not an idea like Barry's *The Space Between Pages 29 & 30/74 & 75* in the same issue but is taken for granted as an existing site. It possesses a grid drawn and numbered from 1 to 12 across its top and from 1 to 31 from the top to the bottom of its left-hand margin. On two accompanying pages, all of the grid's possible coordinates are listed. 'In the listing of rectangles, horizontal coordinates precede vertical coordinates,' she specifies from within the work. In addition to the grid, the work con-

sists of two other pages that present numbers typed in twelve columns: from '(1, 1)' through to '(1, 31)' in the first to '(12, 1)' through to '(12, 31)' in the last. As further noted, the 'listing system (below) is based on exhaustion of horizontal coordinates'.[21] The page in this instance is covered from top to bottom and left to right by numerical figures that follow a strict 'pattern' of logic and also serve, in effect, to 'fill' the page systematically and self-referentially.

From his one-person exhibition in November 1968, organized by Seth Siegelaub, until the end of the 1970s, when he again shifted his manner of working, Douglas Huebler used a combination of language and photography. His numerous 'Location', 'Duration' and 'Variable' works, realized over the period of a decade, rely on the complementary systems of photographic representation and linguistic statement. Photographs with or in lieu of other forms of documentation accompany the artist's signed, typewritten statements that structure the work as a whole. The ensemble of photographs supplements language; each photograph alone presents just one of myriad possible points of reference in the real world, as opposed to presenting a single, aesthetically chosen view. Snapshots document what the statements recapitulate as the artist's scheme for mapping the parameters of the work. In tandem with his use of photography as a 'duplicating device', as he termed it, Huebler's written statements serve as a straightforward notation of procedures that exempt the artist from imbuing his art with personal markings or hierarchical compositional form. Functioning as co-dependent representational systems, language and photography in Huebler's work steer the viewer towards possibilities for seeing disparate and otherwise unperceivable facets of reality from more than one angle at once.

Huebler's 'Drawings', begun in 1968, pointedly address the power of language to dictate the nature of perception. For example, the texts for the 25 drawings published in what has come to be known as the 'Xeroxbook', published in December 1968 by Seth Siegelaub and John W. Wendler, serve as a caption or subtitle to describe the point/points – or line/lines, as the case may be – shown above them.[22] The first drawing self-referentially states what it represents: 'An 8½" x 11" Sheet of Paper'; and the second: 'A Point Located in the Exact Center of an 8½" x 11" Xerox Paper'. Ensuing wordings are more provocative, such as: 'A and B Represent Points Located 1,000,000,000 Miles Behind the Picture Plane'. The 'Drawings' engage viewers in sceptical thought by means of statements that tell them what it is they are seeing, whether it be empirically verifiable or not. They demand, therefore, the reconsideration 'of the experience of any phenomenon after it has been processed by language'.[23]

The page in Huebler's 'Drawings' acts as a factual and phenomenological ground for language, with its paradoxical representational ability to go beyond the surface on which it exists while remaining integral to it. Similarly, for Donald Burgy in *donald burgy in the center of art and communication, december 1973*, a thin spiral book published in Buenos Aires, the page looks at itself and away from itself at the same time. Furthermore, it overtly incorporates the viewer within its content, on the one hand, and, on the other, within the context that the viewer considers referential to his or her 'self', as well as to the characteristics of the page *per se*. Signing the following statement printed at the top of the first page of the book, the artist states:

EACH PAGE IN THIS SERIES CONTAINS ONE OR A CHOICE OF SEVERAL STATEMENTS WHICH IDENTIFY THE PAGE IN ITS CONTEXT. THE OBSERVER'S CHOICE OF IDENTITY FOR EACH PAGE, WHETHER IDENTICAL TO THE PARTICULAR STATEMENT OR NOT, RE-IDENTIFIES THE OBSERVER AND HIS CONTEXT.

At the bottom of each of four ensuing pages, the following texts are printed in English (and in Spanish on four other pages):

THIS PAGE EXISTS IN SPACE AS A QUANTITY OF STORED ENERGY
THIS PAGE EXISTS AS THE BEGINNING OF A FUTURE SEQUENCE OF ENERGY TRANSFORMATIONS ULTIMATELY TERMINATING WITH THE END OF TIME.
THIS PAGE EXISTS AS THE END OF A PAST SEQUENCE OF ENERGY TRANSFORMATIONS ULTIMATELY ORIGINATING WITH THE BEGINNING OF TIME.

And finally on the last page:

.THIS PAGE IS UNIVERSAL: TO SOME DEGREE ITS PROPERTIES ARE PRESENT IN EVERYTHING.
.THIS PAGE IS UNIQUE: TO SOME DEGREES ITS PROPERTIES ARE DIFFERENT FROM ANYTHING ELSE IN THE UNIVERSE.
THIS PAGE IS NEITHER UNIVERSAL NOR UNIQUE.
THIS PAGE IS BOTH UNIVERSAL AND UNIQUE.

Burgy's pages here embrace the spectator within their expansive temporal and spatial frame of reference, while they point to themselves as entities that are simultaneously conceptual and concrete.

Works bound into a publication and/or bonded with the printed page give evidence of the comparable yet varied methods of Conceptual art,

with its primary goal to eradicate illusionistic representation and autono-
mous materiality. Such works are not treated as a subsidiary or related
illustration to a written text, as in earlier *livres d'artistes*, but are the very
text *per se* – whether this so-called text be a visual or verbal or a linguistic
and/or photographic manifestation on a page. No longer simply a surface
for the flat representation of text and/or image but also an exhibition site
or self-reflexive surface, the page has come to be defined as a possible
alternative to the museum or gallery space, along with the other alterna-
tives to traditional painting and sculpture that the artists considered here
– and also their contemporaries – took part in establishing during the
period commencing after 1965.

Mappings: Situationists and/or Conceptualists

PETER WOLLEN

When I was first asked to write about the relationship between the Situationist International and Conceptual art my immediate reaction was one of considerable scepticism. I could not see at first how they had anything much in common. To begin with, the project of the Situationist International preceded the beginnings of Conceptual art by a whole decade – the founding issue of the SI journal was published in 1958, while the path-breaking *Xeroxbook* show organized by Seth Siegelaub and Robert Wendler took place fully ten years later, in 1968. As I have argued elsewhere, Conceptual art took off as an art movement only in the following year, 1969. The foundation of the SI, in contrast, coincided closely with the first 'Happenings' in New York and the first stirrings of the Fluxus group in North America. Of course, it would be possible to argue that Fluxus, in particular, was itself a crucial predecessor of Conceptual art and, indeed, that there was a definite historical overlap between them, but the Situationists had a quite different kind of artistic history, one that derived principally from the post-war break-up of Surrealism and the appearance of a spectrum of successor movements such as CoBrA and Lettrism, which in turn split into a competitive array of small, even minute, post-Surrealist groupings.

While I can see that some of the tendencies within Conceptual art might seem to have converged politically with the Situationist International – itself an explicitly Marxist group – the Conceptualist movement as a whole stayed broadly within the limits of the art world, even though many artists became personally involved in the Civil Rights Movement, anti-war activism and feminism, or became interested in various new currents within Marxist theory. The Situationists, on the other hand, under the leadership of Guy Debord, consciously left the art world

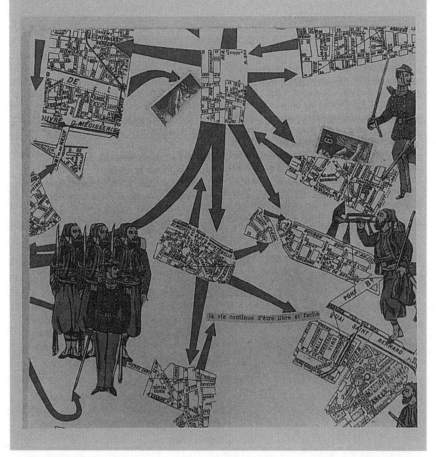

Frontispiece

Guy Debord, "Life continues to be free and easy," c. 1959, collage of text, postage stamp, and hand-colored figures of soldiers pasted over a portion of Guy Debord and Asger Jorn's screenprint The Naked City (1957), Rijksbureau voor Kunsthistorische Documentatie, The Hague. Made as part of Debord's correspondence with his situationist colleague Constant, the piece was a tiny gem of situationist potlatch (art created as a gift) and détournement (art composed from "diverted" aesthetic elements). Its layering of allusions—to colonialism, war, urbanism, situationist "psychogeography" and playfulness—was dizzying.

Guy-Ernest Debord, *Life continues to be free and easy*, c. 1959, collage pasted over a portion of Debord and Asger Jorn's *The Naked City, Illustration de l'hypothèse des plaques tournantes en psychogéographique* (1957) and posted to Debord's friend Constant.

behind and mutated into a primarily political and philosophical group-
ing, a vanguard '*groupuscule*', whose 'artistic' contribution to the events
of 1968 was restricted to painting slogans on walls. This kind of activity
may have been salutary in itself – and it eventually contributed to the
punk graphics of an artist such as Jamie Reid – but it was clearly not an
'art practice' of the kind that the more politicized elements within
Conceptual art veered towards, such as the Art & Language movement or
the group gathered around *The Fox* in New York. The Situationists con-
sciously cut off all their past ties with the art world and turned instead
towards ultra-left politics, calling for revolutionary mass struggle, and to
developing their own political theory. The single exception to this was
Guy Debord's own work as a film-maker, which was largely related to his
theoretical work on the 'Society of the Spectacle' and its reception, and
very different in its intent from, say, the structural films of Michael Snow
or Hollis Frampton, which could plausibly be seen as cinematic analogues
to Conceptual art.

As I pondered all this, however, I was struck by one strange overlap
between the interests of the Situationists and those of the Conceptual art
movement: their fascination with maps, not only as a form of document-
ation but also as a form of design. If I could understand this common
interest in cartography, I somehow felt, I might be able to uncover a sub-
merged shift which linked the two movements, a pointer towards subter-
raneously shared artistic and cultural strategies. Maps, after all, are a
form of graphic art, one which is particularly complex but inevitably car-
ries with it a certain perspective on the world around us. Maps, it has
often been pointed out, convey information in visual form, just like other
forms of visual art, but they do this in a particularly complex way. They
always have a threefold character, involving a subject, data relevant to that
subject and a theme which orients our understanding of it. As Denis
Wood has proposed, in his sketch of a rhetoric of cartography, maps typ-
ically involve the use of five distinct types of semiotic code: iconic, verbal,
tectonic, presentational and temporal. The 'iconic code' refers to the way
the map presents a visual analogue, scaled down and projected, which
matches the subject of the map and its topography. The 'verbal code' is
used to label the various features of the map and sometimes to add com-
ment or further information. The 'tectonic code' covers the various ways
in which information is symbolized – different types of lines used (dotted,
broken, etc.), areas of colouring or shading, the symbols used to indicate
special features, such as crossed swords for ancient battlefields or clusters
of slanted lines in rainstorms. The 'presentational code' covers the ways

in which display and design features, not integral to the map itself, provide a meta-language to convey its import. Finally, the 'temporal code' shows how features, such as the weather or epidemics, change over time.

A map, in fact, can be viewed as a complex type of semiotic text with many possible frames of reference (political, medical, meteorological, demographic, military, etc., etc.) and many different purposes. In fact, it is precisely because maps are needed for such a wide variety of purposes, covering such a wide variety of topics and uses, that they have developed such intricate and complex semiotic features. To read a map and to understand why it looks the way it does is also to understand its underlying goal. As I began to think about the specific differences between the kinds of maps and mapping used by the Situationists and those used by a wide range of Conceptualist artists, it became clear to me that these differences were directly related to their differing goals. In the case of the Situationists, maps were overwhelmingly used in the context of their critique of post-war forms of city planning, predominantly rationalist and functionalist in their approach, dividing the city into functional zones and demolishing whole neighbourhoods in order to construct 'modernized' but socially and psychologically destructive new traffic systems.

In sharp contrast to the dominant planning ideology, the Situationists developed three principal theoretical ideas of their own – those of the *dérive*, psycho-geography and unitary urbanism. The *dérive* referred to an experimental technique of 'transient passage through varied ambiances', a kind of chance wandering from area to area, in the hope of finding provocative interlocutors or strange and moving encounters. Psycho-geography referred to 'the study of the specific effects of the geographical environment, consciously organized or not, on the emotions and behaviour of individuals'. Unitary urbanism was the theory of the combined use of the arts and techniques for the construction – or preservation – of environments in which the *dérive* and psycho-geographical experiments would prosper. In fact, all three of these concepts were actually pre-Situationist in origin. Gilles Ivain's pioneer *Formulary for a New Urbanism* was actually written in 1953 (although it was first published in the S.I. journal fully five years later, in 1958). Guy Debord's *Introduction to a Critique of Urban Geography*, which launched the idea of 'psycho-geography', first appeared in *Les Lettres nues* in 1955 and his *Theory of the Dérive* appeared in the same journal the following year (republished in the second issue of the SI journal in 1958).

As Simon Sadler points out in his indispensable book *The Situationist City*, these ideas first originated in reaction against city-planning schemes

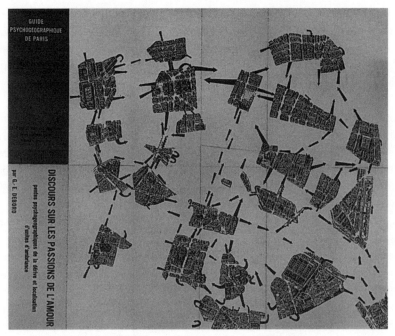

Guy-Ernest Debord, *Guide Psychogéographique de Paris – Discours sur les
passions de l'amour, pentes psychogéographiques de la dérive et localisation
d'unités d'ambiance*, 1956.

for the modernization of Paris which threatened the old bohemian areas
on the Left Bank in which the future Situationists themselves were then
living – and indeed many other neighbourhoods which they frequented
and to which they felt strong emotional attachments. These schemes, for
example, eventually brought about the destruction of the old market area
(*les Halles*) in order to replace it with a transportation hub and a shop-
ping mall. For this reason, the maps used by the Situationists were pre-
dominantly maps of Paris (or, in the case of the important Dutch and
Danish groups, maps of Amsterdam and Copenhagen). For instance, in
1956, Debord, working with his Danish colleague Asger Jorn, produced a
folding map, the *Guide psychogéographique de Paris*, subtitled '*Discours
sur les passions de l'amour, pentes psychogéographiques de la dérive et
localisation d'unités d'ambiance*', followed the next year by another
jointly produced psycho-geographical map of Paris, *The Naked City*, as
well as a screenprinted book, *Fin de Copenhague*, with text and imagery
collaged together from magazines and newspapers acquired at a single
Copenhagen news-stand. Two years later, in 1959, Debord and Jorn col-
laborated again, this time on *Mémoires*, a retrospectively psycho-

geographical account of Paris. This book, unlike the first, contains col-
laged chunks from maps, as well as texts and illustrations. Both works, I
should add, also have a strongly cartographic appearance due to the drib-
bled lines of coloured ink which link the images, as canals or a river might
link landmarks within a city.

The two psycho-geographical street maps of Paris produced by Debord
are both collaged from two pre-existing Paris maps – the extraordinary
1956 *Plan de Paris à Vol d'oiseau*, drawn by G. Peltier, and the 1951 *Guide
Taride de Paris*, a conventional street atlas. The Peltier map shows the cen-
tre of Paris, with the two diagonal axes crossing at what seems to be a
point very close to where the Mona Lisa hangs in the south wing of the
Louvre. All the buildings, parks, bridges, stretches of river, etc., are
depicted from a point of view apparently located high over Paris to the
south of the area mapped, with the perspective adjusted so that there are
no distortions. Debord and Jorn cut sections out of this map, chosen on
psycho-geographical grounds from the areas immediately north and
south of the Seine just to the east of the Louvre and then pasted these
together as if they were islands, joined by prominent red arrows which
point directions from one zone to another across an empty space –
reminding us, as Michelle Bernstein had suggested in 1954, that a *dérive*
through one zone could best be continued by taking a cab to another and
then starting again on another tour. As Bernstein noted:

Only taxis allow a true freedom of movement. By travelling various distances in a
set time, they contribute to automatic disorientation. Since taxis are inter-
changeable, no connection is established with the "traveller" and they can be left
anywhere and taken at random. A trip with no destination, diverted arbitrarily
en route, is only possible with a taxi's essentially random itinerary.

The second map, based on the Taride guide, covers the same area of Paris
but is less ornate in its design. It might be useful, at this point, to return to
the five cartographic codes which I mentioned above. The iconic code is
heavily marked in the *Guide psychogéographique*, which is based on a
bird's-eye view of the city representing not only the street lay-out but also
the buildings, bridges, monuments, clumps of trees and other features
which are enclosed by those streets. In *The Naked City* there is a street
plan alone. The verbal code in both maps is divided into two elements –
the conventional lettering of the original map, concentrating on street
names, and the lettering of the map's title, added by Debord. With the
Guide, this characterizes the purpose of the map directly as psycho-
geographical and presents it as a kind of love letter to selected neigh-

bourhoods within the city. With *The Naked City*, on the other hand, the title directs us back to Jules Dassin's film of the same name, a drama-documentary about detectives in New York. As Sadler points out, this could be construed as claiming a certain investigative role for the *dérive*, seen as a process of evidence-gathering, as the strollers researched 'the condition of contemporary Paris', perhaps with the city planners in mind as guilty wreckers of the precious ambiences they were mapping. *The Naked City* also has a subtitle, reading '*Illustration de l'hypothèse des plaques tournantes de psychogéographie*', a phrase which refers to the Situationist claim that the neighbourhoods they loved were pivotal zones (*plaques tournantes*) in the sense that they linked the wanderer to neighbouring zones with which they shared an emotional affinity.

The tectonic code in these maps has two unconventional features – the stereometric perspective of the *Guide* and the red arrows which feature in both the *Guide* and *The Naked City*. The bird's-eye view, I would suggest, directs us to the idea of 'unitary urbanism', giving us a sense that, seen from above, each fraction of the city is integrated, through the red arrows, with all the others, thus creating an ideal unity which exists in contrast to the everyday fragmentation of the city and which is based, not on traffic planning schemes, but on what we might call elective affinities. The presentational code designates the *Guide*, through its status as a folding map, as a critical variant of the tourist guide, designed to be carried in a pocket while exploring the city – while, of course, substituting the image of psycho-geographer for that of typical tourist. The street-atlas connotation of *The Naked City* has a similar, if less marked effect. The durational code, I think, is particularly important as we consider these two maps. First, of course, there is the date of the maps themselves, produced at a time when Paris was beginning to undergo a process of massive change as the planners assumed control. As Sadler points out, from the early 1950s onward Paris began to undergo a process of reconstruction unprecedented since the time of Haussmann. The two Situationist maps both commemorate the old Paris and issue a warning against future trends, sadly unheeded. Looked at today with hindsight, they assume an elegiac quality, probably intended even at the time of their making.

There are a few comments I would also like to make in relation to three other maps which were important to the Situationists. The first of these is a map 'plotting all the trajectories effected in a year by a student inhabiting the 16th Arrondissement', first published in Chombant de Lauwe's massive *Paris et l'Agglomération Parisienne*, vol. 1 (1952), a book which deeply influenced Debord. This shows all the routes traversed by a single

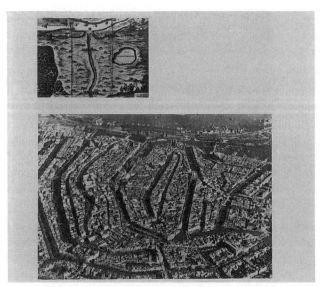

Map of the Land of Feeling, 1656, reproduced in *Internationale Situationniste*, 3 (1959).

An Experimental Zone for the Dérive: the centre of Amsterdam, which was systematically explored by Situationist teams in April–May 1960, from *Internationale Situationniste*, 3 (1959).

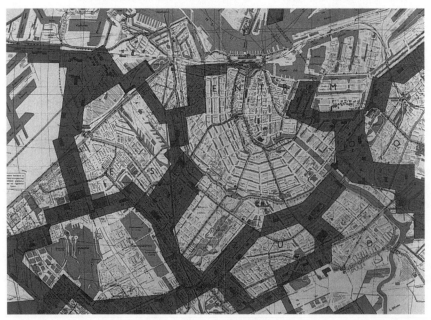

Constant, *New Babylonian Sectors Superimposed upon a Map of Amsterdam*, c. 1963.

student within a year, dominated by a single thick triangle with, at each apex, his domicile, the place he went for piano lessons and the School of Political Science lecture room. Debord discussed this map in his *Theory of the Dérive* (1656), pointing out how it illustrates 'the narrowness of the real Paris in which each individual lives', a narrowness to be opened up by the Situationists's use of *dérive*. The second is a 1656 *Map of the Land of Feeling*, reproduced in the third issue of the SI journal in 1959, as an illustration accompanying an unsigned article on 'Unitary Urbanism at the End of the 1950s'. Clearly this map presents, in cartographic form, the relationship between the passions and the lived environment suggested by the whole concept of psycho-geography. Thirdly, there is the map by the Dutch Situationist, Constant, of his massive New Babylon project, depicting the outlines of an aerial city, floating above the undisturbed traditional neighbourhoods, which strides on the stilts, so to speak, over the very same city centre of Amsterdam illustrated in the SI journal, an area favoured by the Dutch Situationists for their own *dérives*. Here the temporal code, though still referring us to the future – almost to a kind of science-fiction future – is utopian rather than elegiac, a mapping of hope rather than despair.

What emerges from a consideration of these maps is that they were presented in a double context – that of a pessimistic critique of contemporary society, combining defiance with elegy, and, at the same time, that of an optimistic utopian futurology, combining a basically Hegelian teleology with a resolutely buoyant utopianism. This strange manic-depressive timbre of Situationist thinking, always passionate, but veering between highs and lows, affected Situationist cartography as well. In this respect, it is very different from the cartography favoured by Conceptual artists, which was much more distanced from issues such as city planning or urbanism, much less activist in its mentality, although Conceptual artists sometimes also used city maps for purposes which might almost be called psycho-geographical. Let us look, for example, at the maps used by such key Conceptualist artists as Douglas Huebler and On Kawara, as well as a second-generation Conceptualist, Fiona Templeton, all of which involve the mapping of a city and the tracing of an itinerary within it. These maps, however, differ in significant respects from the Situationist maps, not only because they are unconcerned with any critique of city planning, but also because the itineraries which they trace are conceived, in terms not of psycho-geography but of a specifically artistic concept of 'performance'. With the exception, perhaps, of Templeton's work, the passions, in Debord's sense, are no longer at play. Instead there is a kind of

scientificity, an almost clinical mind-set, based on an obsession with theo-
retical methodologies for documenting behaviour.

Conceptual art maps began appearing in 1968, at the very outset of the
movement. That year saw both the launch of On Kawara's *I Went* series in
Mexico City and Douglas Huebler's *Site Sculpture Projects* such as *42nd
Parallel Piece* and *Windham College Pentagon*. Kawara's work involved
tracing an itinerary on a Xerox taken from a city map, using a red ball-
point pen. The number of maps in any one sequence depended on how
many days he spent in each particular locality until he departed, and the
pages were sheathed in transparent plastic and put together in a loose-leaf
binder. Like other similar series produced by On Kawara, such as *I Met* or
I Read, *I Went* was a form of self-documentation, which used maps
because the behaviour documented traced the artist's trajectory through
the city. These were not *dérives* because although some may have been
random strolls, some of them were clearly not – as, for instance, the jour-
ney he made to the airport on leaving or his walk to the end of a promon-
tory overlooking a lake with, I would suppose, a fine view. In effect,
Kawara's series form part of a kind of elaborate diary or personal journal
which uses the semiotic system of mapping alongside that of verbal text.
The theme of these maps, rather than an experience of the city as such, is
the experience of On Kawara's own life, one aspect of which involves
moving around within a particular city.

Huebler's maps, in contrast, are about the nature of art itself. His *Site
Sculpture* pieces, for instance, instantiate a particular geographical site,
marked on a map, as the site of a particular sculpture. Thus his *42nd
Parallel* piece is defined by him as follows: '14 locations ("A" through "N")
are towns existing exactly or approximately on the 42° parallel in the
United States. Locations have been marked by the exchange of certified
postal receipts sent from and returned to "A" – Truro, Massachusetts.'
The full piece consisted of the defining statement, plus the map, with the
parallel and the fourteen cities marked on it, together with the postal
receipts and other ancillary documents, including two city maps.
Obviously, the main impact of this piece consists of Huebler's radical
redefinition of the term 'sculpture' to include such constituent elements
as postal receipts or maps. *Another Site Sculpture* project, *Windham
College Pentagon*, executed the following month, consisted of removing a
small quantity of dirt from five points (A, B, C, D, E), each of which was
located about one and a third miles from a designated central spot located
on the college campus, and then setting the five collections of dirt in epoxy,
each in a five-sided shape which would form a small pentagon isomorphic

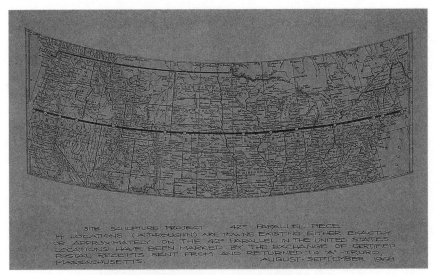

Douglas Huebler, *Site Sculpture Project – 42° Parallel Piece*, September 1968.

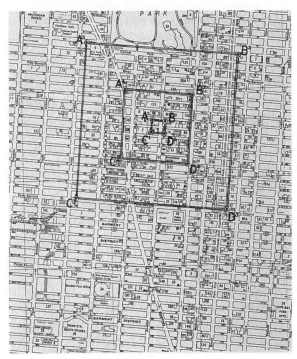

Douglas Huebler, *Site Sculpture Project – Variable Piece #1*,
New York City, August–September 1968.

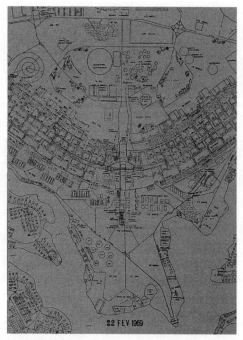

On Kawara, *I Went*, 21 February 1969.

with the pentagon created by the sites A, B, C, D and E. The finished piece consisted of the five-sided shape, two maps locating A, B, C, D and E, as well as five Polaroid photographs of the sites. While this piece retained an element of conventional sculpture (the shapes), these were not part of the finished piece, since they were returned to the earth. Huebler did, however, consistently use maps as a site for drawing, adding a performance-related diagrammatic feature – a pentagon, for instance, an arc or three concentric squares.

At much the same time, however, Huebler executed two other projects – one of which, conceived in 1968, used a Shell road map to document a proposed round-trip drive to be made between Haverhill, Massachusetts, and Rochester, Vermont, and back again, using a route marked on the map by Huebler, which might be followed either clock-wise or anticlock-wise, according to personal preference. The piece would consist of the map plus 'whatever is seen when the trip is taken'. In his 1969 *Location Piece No.1*, Huebler's work included an American Airlines system map showing, among other features, the route flown between New York and Los Angeles. Huebler himself took this flight and photographed out of the aeroplane window what he designated as 'the airspace over each of the

thirteen states' which were crossed by the plane. For this piece, he pointed his camera 'more or less straight out of the aeroplane window (with no "interesting" view intended)'. The piece thus consists of the photographs plus the map. In both of these pieces, Huebler documented an actual trip or journey, thereby moving closer to the Situationist aesthetic of the *dérive*. Unlike the Situationists, however, Huebler presented his journeys completely dispassionately. Far from having any psycho-geographic content, the journey is seemingly bereft of any emotional content or any interest in the landscape as an aestheticized object of the traveller's gaze. As Huebler has noted, his work 'forecloses the possibility that its subject can be regarded as just another aestheticized object of consumption'. In this respect, he went even further than the Situationists in rejecting any form of visual pleasure.

In discussing his use of maps, Huebler specifically recalled the time he spent as a non-commissioned intelligence officer on Peleliu Island in the South Pacific during the Second World War, attached to Marine Air Group II. There he:

wrote the group's diary, which was a daily account of the details and results of our ongoing bombing strikes against the islands of Koror and Babelthaup . . . On a number of occasions I accompanied pilots on observation flights in order to determine if targeted anti-aircraft gun positions had been either destroyed, or moved, as was often the situation. Whatever new information we brought back was displayed on our large map with coloured push pins, and that information played an important role in the intelligence briefings delivered before each strike

Huebler notes that the verbal briefing combined with 'the several kinds of visual imagery provided by the map' to convey 'a mental picture' to the mind of each pilot, 'so that he would know what he would expect to see' during his mission. Searching, many years later, for 'alternative methodologies' that he could use in his art work, Huebler 'began to sense the significance of the map as a most essential kind of conceptual model'.

Maps, Huebler noted, 'include both "aspects of time" and culturally developed "propositions of language"'. Put another way, he was interested in both the iconic code and the verbal and temporal codes involved in making and understanding maps. The tectonic code was also relevant through the choice, say, of magic marker to show the round-trip route on the map prepared for *Rochester Trip* (compare the red arrows on Debord's map). The presentational code was one which directed the viewer to look at the map in the context of art, rather than military strategy (an approach sometimes favoured by Debord, who was an avid reader

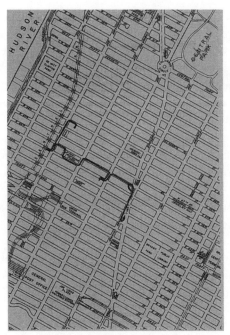

Fiona Templeton, *You – The City, Manhattan
Itinerary*, May–June 1988.

of Clausewitz) or a critique of urbanism. Maps, together with verbal
language, could be used to convey the conceptual elements of his
project as an artist – actions performed in a specific location for a specific
period of time. They were thus a necessary element both for planning
many of Huebler's pieces and for documenting them. From an ensemble
of verbal, photographic and cartographic data, the 'viewer' could then
conceptually reconstruct the actual performance – which involved a
programmatic journey in the real world 'outside of my studio', as
Huebler insisted, rather than a traditional studio-bound way of making
art. In this way maps created a new frame of reference for art, whose pos-
sibilities were subsequently explored by artists such as Richard Long or
Hamish Fulton, renowned for their programmatically mapped walks and
journeys.

Templeton's work, *You – The City*, was a piece produced in New York
City in 1988 and repeated in various other cities. She describes it as a
'play', albeit of an experimental kind, but it would normally be regarded
as a kind of interactive performance piece. The audience at any one per-
formance consists of one person (the 'client') who checks in at a starting

location and is then directed from one interlocutor or companion to another, who form a kind of human chain passing the audience from one interaction to another. These interactions also structure a physical journey that lasts until the client reaches the final destination and the play ends. As in Huebler's *Rochester Trip*, a map is included in the published play text but the route it traces is structured not by an arbitrary protocol but by a series of human encounters, as with a Situationist *dérive*. In fact, it could be argued that Templeton's piece is located conceptually somewhere between Debord and Huebler – as with Huebler, the itinerary is predetermined but, as with Debord, it consists of a series of chance meetings with 'clients' who arrived, one by one, as audience but ended up turning into performers as they were manipulated by actors who already knew the script – chance meetings, that is, to the 'client', while in reality each encounter had been carefully planned and scripted by Templeton. For the artist, the point was to create a situation in which an 'intended' structure (the script) encountered an 'unintendable' or unpredictable one (the client's response).

The map, like the script, is clearly programmatic, like Huebler's maps, but it determines only one dimension of the play. Templeton's map falls within the tradition of the map made in conjunction with an artist's 'happening' or 'event'. Thus, nearly 30 years before, Wolf Vostell, who obviously loved the look of maps, had used a loosely painted map of Cologne to advertise his 1961 *Cityrama* event and a Paris bus map for his *Petite ceinture* happening in July 1962, a bus trip which he turned into an art event by suggesting that the participants 'keep a look out for the acoustic and at the same time optical impressions' available on their trip, paying particular attention to the sight of *décollages trouvés*, 'walls with placards torn or hanging down', thus foregrounding within the cityscape a form of chance visual composition (or decomposition) which he himself consciously favoured and practised as an artist.

Later Nam Jun Paik drew a map of *FLUXUS Island in Décollage OCEAN*, which is in the tradition of the maps for *Treasure Island* or *The Lord of the Rings*, but showing the location of such odd and fantastic features as the site where 'The jewel box of wife of Syngman RHEE is buried here and lost', 'the ministerium for developing the electronic television', 'the cinemathek of all the censored parts in the 20th century' and 'the pyramid higher than Egyptian pyramid, made of AUTOMOBILE WRECKS (10,000)'. Perhaps the two most interesting map pieces within the world of happenings, décollage and fluxus, however, were Yoko Ono's 1962 *Map Piece*, to which I shall return, and Chieko Shiomi's two *Spatial*

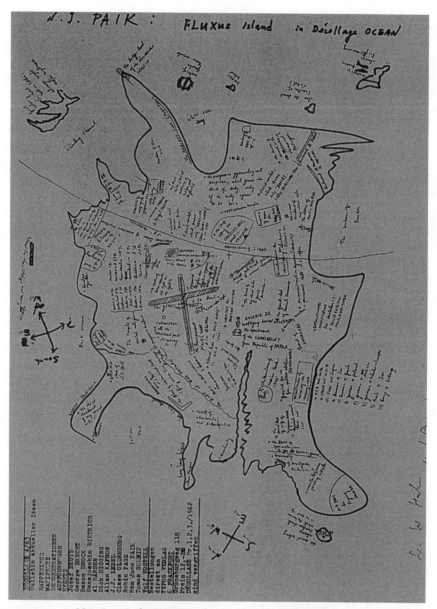

Nam June Paik, *FLUXUS Island in Décollage OCEAN*, 1963.

Poems of 1965 and 1966. Yoko Ono's piece took the form of a verbal instruction, reading as follows:

Draw an imaginary map. Put a goal mark on the map where you want to go. Go walking on an actual street according to your map. If there is no street where it should be according to the map, make one by putting the obstacles aside. When you reach the goal, ask the name of the city and give flowers to the first person you meet. The map must be followed exactly, or the event has to be dropped altogether. Ask your friends to write maps. Give your friends maps.

Both of Shiomi's poems included maps, one of them (no.2) designated as 'folding'. The first poem runs as follows: 'Write a word (or words) on the enclosed card and place it somewhere. Let me know your word and place so that I can make a distribution chart of them on a world map, which will be sent to every participant.' In the same vein was Alighiero e Boetti's 1968 *City of Turin*, a photocopied city map with the residences of the city's artists (at least those known to the cartographers) marked with a line and their names written in crayon. This map, like Chieko Shiomi's, is also a form of 'distribution chart' which gives the whereabouts of the artists themselves rather than of their works. Such maps are quite conventional in cartographic terms but they originate as an art project and their underlying theme, mapping a sector of the art world, is an unconventional one.

Finally, I want to comment on the use of maps by three artists, all of whom confront issues of cartography itself, rather than using maps as a form of documentation. The first is an Art & Language map, created in 1967 and labelled 'Map to not indicate Canada, North Dakota, Straits of Florida, etc.', showing only two unidentified areas, which look like American states. Its effect comes from the idea of cartography as representing a form of non-representation and subtraction rather than of comprehensive representation and addition, as new regions or features are discovered, surveyed and included. In general terms, the Art & Language map falls within the category of what Peter Gould and Rodney White have called 'mental maps' – such as those representing 'The New Yorker's Idea of the United States of America', which shows Manhattan as larger than California, or 'How Londoners see the North', which shows a gigantic London and a road system that ends before you reach Scotland, shown as located in dog-sled country north of the Arctic Circle. In the art world its distant predecessor was the Surrealist map of the world which omitted the United States completely and included instead a vast Papua. Unlike this map, however, Art & Language's radical subtraction drew our atten-

Agnes Denes, *Isometric Systems in Isotropic Space – Map Projections: The Snail*, 1974.

tion to the process of map-making rather than the content. In contrast, Agnes Denes's uncanny maps of the world are mathematically distorted to represent it as it would be if it were shaped as a cube, a doughnut or a pyramid, rather than a spheroid, forcing us to focus on the technique of map-making and the way in which it can alter our mental image of the world, subverting the power of the mathematical grid, forcing us to re-evaluate our whole sense of reality.

In contrast to these maps, which ask us to re-examine the assumptions which determine our mental representations of the world, the maps used by Newton and Helen Mayer Harrison are functional, goal-directed and set in a context that makes no distinction between work in art and work in ecology: the map is both an aesthetic object and a tool for developing land-use policy. Thus their 1985 *Lagoon Cycle* uses huge panels as a means to display a series of maps which, along with other materials, including a poetic and dialogic text, serve as visual aids designed to pro-voke a train of thought which starts from the problems surrounding the development of a viable aquaculture for crab farming in Sri Lanka. The Harrisons' aim, it seems, is to provoke thought about the shifting rela-tionship between man and nature, seeking to find a constructive way for-ward in the idea of participating in a dialogue with nature rather than addressing it with a unilateral anthropocentric monologue. The function of maps within this dialogic work is to focus our attention on specific locations that provide examples of failed policies towards the natural

environment and to propose an alternative set of constructive uses for the future – a future which we might characterize, with sympathy, as unashamedly 'utopian'.

It is the political dimension of this work, of course, which brings us back to the Situationists. For the Harrisons, however, it was the balance between human needs and the rural environment rather than the equally precarious relationship between human needs and the urban environment which concerned Debord and his comrades. As with the Situationists, the Harrisons used maps for a purpose, one which erased the line between art and politics in an unprecedented way. In an essay published in the catalogue for *The Lagoon Cycle*, Michel de Certeau wrote of map-making as a way of envisaging a possible future, casting cartographic temporality in the mode of future possibility – utopian, perhaps, but not counter-intuitive like Denes's maps. De Certeau reminds us that early Renaissance maps combined the realistic with the fabulous and encourages us to consider how cartographers and artists alike have repeatedly ventured into what we might call fantastic mapping, citing as

Helen Mayer Harrison and Newton Harrison, *The Sixth Lagoon, On Metaphor and Discourse* (panel 6), 1980.

Norman Daly, *Llhuros*, 1972.

an example artists' maps of imaginary countries (such as Norman Daly's 1972 map of Llhuros). Maps can serve both as political tools and as stimulants for the imagination; linked together they can delineate a utopian form of vision shared by Situationists and Conceptualists alike, one which offers us new ways of thinking about the world in which we live and, as a result, new ways of thinking about changing it. In their book *Mapping: Ways of Representing the World*, David Dorling and David Fairbairn note how 'resistance mapping' can change our conception of the world, citing Doug Aberley's contention that, as maps have increasingly become instruments of power, non-specialists must begin to create their own resistant counter-maps. Despite all their differences, both Situationists and Conceptual artists can be seen as pioneers of resistance-mapping, challenging the orthodoxies of power through an alternative cartography.

3

Conceptual Art and/as Philosophy

PETER OSBORNE

It is difficult to bungle a good idea.
 Sol LeWitt

Nothing marks the gulf separating the Conceptual art of the late 1960s
and early 1970s from its post- and neo-Conceptual progeny of today more
strikingly than their respective relationships to philosophy. Indeed, one
might be tempted to claim that it is in the intimacy of its relationship with
philosophy – an intimacy at times verging on complete identification –
that the specificity of Conceptual art resides, were its formation not so
multiple and complex, despite its relatively brief life, as to refuse any such
straightforward definition. Philosophy has been deployed too often as a
weapon in the wars between Conceptual artists to be used unproblemat-
ically either as one of the criteria for the conceptuality of a work or as a
neutral medium for debate about it. In this respect, even to raise the ques-
tion of the relationship of Conceptual art to philosophy as an issue
through which to re-examine the idea of Conceptual art is already to
court the danger of situating oneself on one particular side of a series of
factional divides. Yet it is precisely here, I shall argue, in its divisive,
polemical role within the Conceptual art community, that the importance
of philosophy for Conceptual art lies, including its less explicitly or
directly philosophical manifestations.

 The very formulation of the problem is peculiar. For what does it mean
to specify or delimit a particular kind of art with reference to its determ-
ination by another cultural field? Not a particular position within that
field, it would seem – a particular philosophy – let alone a particular phi-
losophy of *art*, but philosophy itself, philosophy as such. What does 'phi-
losophy' stand for here? Pure conceptuality, pure thought, pure reason,
perhaps? Or the historically developed and institutionally structured
space of philosophical positions and possibilities which make up the pro-
fessional *field of philosophical production*, at any particular time, in any

particular place, in Bourdieu's sociological sense of the term?[1] Certainly, there were (and are) Conceptual artists with highly invested, if deeply ambivalent, relationships to the discourses of professional philosophy; while others remained oblivious to its charms. Yet either way, whether the idea of philosophy is broadly or narrowly construed, the determination of a mode of artistic production by a philosophical form would seem to place it in opposition, in principle, to the established conception of 'art' in its modern European sense as *sensuous particularity* or *aesthetic*, bugbear of the Western philosophical imagination since Plato.[2]

This is, of course, the point: the shock, the scandal, the attractiveness and the enduring radicalism of the idea. Conceptual art is not just another particular kind of art, in the sense of a further specification of an existing genus, but an attempt at a fundamental redefinition of art as such, a transformation of its genus: a transformation in the relationship of sensuousness to conceptuality within the ontology of the artwork which challenges its definition as the object of a specifically 'aesthetic' (that is, 'non-conceptual') or quintessentially 'visual' experience. Conceptual art was an attack on the art object as the site of a look. That Conceptual art appears now as one particular kind of art among others is testimony to the fact that its moment has passed, that its challenge has faded. That a large amount of the art amidst which it appears differently from the way in which art appeared before Conceptual art attests to its enduring effect. Moreover, that both the intension (meaning) and the extension (reference) of the term 'Conceptual art' remain so hotly disputed registers the fact that there is unfinished business here to conduct.[3] Part of this business concerns the precise sense in which Conceptual art might be said to be a specifically 'philosophical' art; indeed, in which *all* art after Duchamp (or at least, after the renewed reception of Duchamp in the 1960s – 'Duchamp' is largely a retrospective effect of the 1960s) might be said to be distinctively 'philosophical' in nature.[4]

It is important in this respect to distinguish two different levels at which disputes about the relationship between Conceptual art and philosophy have been conducted: the level at which those advocating an expansive, empirically diverse and historically inclusive use of the term 'Conceptual art' confront the champions of narrower, analytically more restricted, and explicitly 'philosophical' definitions; and the lower – and often more heated – level at which the latter dispute among themselves about the precise character of such definitions and the meaning and implications of their related practices and inquiries. I shall refer to those who advocate an expansive, empirically diverse and historically inclusive

use of the term 'Conceptual art' (such as Sol LeWitt) as *inclusive* or *weak* Conceptualists. I shall call those championing more restricted, analytically focused and explicitly philosophical definitions (such as Kosuth and the British group Art & Language) *exclusive* or *strong* Conceptualists.

Exclusive or strong Conceptualists have tended to hog the critical limelight, for two reasons: first, because of the categorial extremism of their positions (they push hardest against the limits of the established notion of art); second, because of the affinity of their artistic practices to the practice of criticism. The relationship between Conceptual art and philosophical discourse in the USA and Britain in the late 1960s and early 1970s was dynamic, wild and not infrequently paradoxical. That there was a relationship at all was the result of changes in the relations between art practice and art criticism which took place in the first half of the 1960s, prior to the emergence of Conceptual art, strictly speaking, as a self-conscious form. On the one hand, these changes were an integral part of the development (and crisis) of Greenbergian Modernist criticism in its interaction with new – especially 'Minimalist' – work. On the other hand, they were an effect of broader changes in educational provision, the social function of the arts and politics in advanced capitalist societies. They involved both an increasing emphasis within art-critical discourse upon definitional questions about the essential nature or legitimate form of artworks, and a growing willingness on the part of artists themselves to engage in such discourse, both as a productive resource for practice and as a means of maintaining control over the representation of their projects within the art world. This quickly led to an erosion of the division of labour between critic and artist which had emerged in Europe during the second half of the nineteenth century and had been consolidated into the professional practices of the US art world in the period immediately following the Second World War. Its most radical effect was an expansion in the notion of art practice (and hence, the artwork) to include – at its limit – the products of all of the artist's art-related activities.

The crisis of Greenbergian criticism (essentially a crisis in its medium-based conception of the artwork, its 'specific' Modernism) thus simultaneously registered a crisis in the ontology of the artwork and established the conditions for the resolution of this crisis through the renovation of the romantic ideology of artistic intentionality in a radically new, critical-discursive guise. Philosophy was *the means* for this usurpation of critical power by a new generation of artists; the means by which they could simultaneously address the crisis of the ontology of the artwork (through an art-definitional conception of their practice) and achieve social con-

trol over the meaning of their work. As such, Conceptual art represents a radical attempt to realign two hitherto independent domains of the cultural field: artistic production and philosophical production. More specifically, it involved an attempt directly to transfer the *cultural authority* of the latter to the former, thereby both bypassing and trumping existing forms of art-critical discourse. In this respect, Conceptual art is a classic example of strategic position-taking within a regional domain of the cultural field ('art'), aimed at a redistribution of the positions constituting that domain as a relational structure of possible actions.[5]

The discursive conditions for this transference of cultural authority were established by Greenberg, in the idea of Modernist art as a self-critical art which explores the definition of its medium. (This notion of self-criticism was already an explicitly philosophical idea, borrowed directly from Kant's *Critique of Reason*.) The social conditions lay in the expansion and transformation of art education during the 1960s, in a context of growing cultural and political radicalism. The generation of New York artists who came to prominence in the 1960s were the first group of artists to have attended university. Their reaction against the anti-intellectualism of the prevailing ideology of the art world – which was at once a reaction against its social conservatism – was profound. The result was a double-coding of 'philosophy' across the two cultural fields – artistic and philosophical – which introduced a constitutive ambiguity into the position of philosophy within the artistic field itself. Thus, on the one hand, philosophy functions within the artistic field as a specific form of artistic or critical *material* or productive *resource* for a practice the logic of which is supposedly autonomous or immanently artistic. On the other hand, philosophy retains its own immanent criteria of intellectual adequacy as itself a relatively autonomous cultural practice. That is, one may judge the adequacy of the philosophical ideas in play in the art world both 'strictly philosophically' and from the standpoint of their contribution to the transformation of artistic practices. The idea of Conceptual art, in the exclusive or strong sense, is the *regulative fantasy* that these two sets of criteria might become one. The practice of strong Conceptualism was the experimental investigation – the concrete elaboration through practice – of the constitutive ambiguity produced by this founding double-coding.

Only a certain kind of philosophy could have played this role: namely, an analytical philosophy which combined the classical cultural authority of philosophy, in the updated guise of a philosophical scientism (logico-linguistic analysis) with a purely second-order or meta-critical conception of its epistemological status. For only a meta-critical conception of

philosophy allows for the *recoding* of 'art' as 'philosophy' while leaving its artistic status intact; rather than, like Hegel (or Danto), presenting them as competing modes of representation and hence conceiving of Conceptual art as the *end of art*, to the precise extent to which it involves art becoming philosophical.[6] 'Art after philosophy', in Kosuth's sense, is very different from 'art after the end of art' in Danto's, despite their apparent similarities. The scientist self-image of such philosophy was a crucial factor in the cultural logic of the exchange. For Anglo-American analytical philosophy offered a radically different art-educational ideal, and with it a new image of the artist as an intellectually rigorous creator; more intellectual, in fact, than the increasingly beleaguered critic who would aspire to pass judgement on the meaning of the work. Such an image was at once a challenge to the prevailing image of the artist as an creative individual and cultural outsider and the means for its reconstruction on newly intellectual grounds. For the romantic sense of outsider-dom could be displaced on to the otherness of philosophy to the prevailing art world and art-educational culture, allowing for the reproduction of certain characteristically 'artistic' (and often distinctively gendered) traits in the medium of their negation of the established form. In the British context, this dynamic was subsequently reinforced by the intellectual and political culture of Marxism, within which the image of the artist-as-political-activist was overlaid upon that of the artist-as-philosopher to produce a new (and often self-righteous) version of the artist-as-outsider. The artist-as-outsider became the artist-outside-of-'art'.

The structure of this rich and contradictory relationship between an art calling itself 'Conceptual' and philosophical discourse in the USA and Britain in the late 1960s and early 1970s may be traced, schematically, through the escalating philosophical investments of three canonic figures: Sol LeWitt, Joseph Kosuth and the British group Art & Language. This procedure should not be taken to imply that these are the most important Conceptual artists of their day; or that their work is in some way archetypical of Conceptual art more generally. It is not. Rather, these are the figures in whose work the question of the relationship of Conceptual art to *philosophy* stands out in sharpest relief. Any more comprehensive elaboration of the notion of Conceptual art will need to situate this aspect of its history in relation to a much wider set of determinants.[7] Which is not say that such an elaboration might not itself be, ultimately, philosophical in form. LeWitt, Kosuth and Art & Language represent three degrees of investment of Conceptual art in 'philosophy'. A brief comparison of the

form and effects of these investments will lead us towards a provisional judgement on the significance of philosophy for the idea of Conceptual art.

As a movement, Conceptual art is conveniently dated from the publication of Sol LeWitt's 'Paragraphs on Conceptual Art' in *Artforum* in the summer of 1967. Lewitt's essay was not the first to identify a particular kind of art as distinctively Conceptual: an art in which 'the idea or concept is the most important part of the work'.[8] The Fluxus artist Henry Flynt had written about concept art – 'of which the material is *concepts* as the material of e.g. music is sound' – several years previously, in 1961.[9] Indeed, in George Maciunas's 'Genealogical Chart of Fluxus' (1968), Flynt is credited with formulating the idea as early as 1954. However, it was only with LeWitt's 'Paragraphs' that the idea achieved an extended critical thematization, and it was via LeWitt's 'Paragraphs' that it took hold in the US art world as a unifying framework for the self-understanding of an emergent body of work. One reason for this was the breadth and inclusivity of LeWitt's construction of the category, in contrast to the proliferation of more restricted, lower-level critical terms, such as 'Minimalism' (derived from 'Minimal art', coined by Richard Wolheim in 1965), 'primary structures, reductive, rejective, cool, and mini-art', all of which LeWitt explicitly rejected as 'part of the secret language that art critics use when communicating with each other through the medium of art magazines'.[10] LeWitt's theorization is an exemplary defence of the standpoint of the artist against the critic, within the medium of criticism.

However, if LeWitt's essay marks the beginning of Conceptual art as a movement – however variegated and diffuse – it nonetheless reflects on the structure of an existing set of practices which had previously been understood in a variety of alternative ways. (LeWitt is still predominantly categorized as a Minimalist, in fact.) In this respect, it is a transitional text and LeWitt is a transitional figure. 'Paragraphs on Conceptual Art' is a distillation of the immanent logic of an object-producing, though not object-based, practice which evolved, primarily, through the exploration of the effects of self-regulating series and systems of rules for decision-making about the production of objects out of preformed materials. As Robert Morris put it, 'Permuted, progressive, symmetrical organisations have a dualistic character in relation to the matter they distribute. . . . [They] separate . . . from what is physical by making relationships themselves *another order of facts*'.[11] For Morris, who retained a Greenbergian

notion of truth to materials, this was problematic. For LeWitt, on the other hand, art was a privileged means of access to this other order of facts which cannot be accessed directly in the same way. This explains the limited role attributed by the text to philosophy: 'Conceptual art doesn't really have much to do with mathematics, philosophy or any other mental discipline . . . The philosophy of the work is implicit in the work and is not an illustration of any system of philosophy.'[12] Nor was LeWitt's Conceptualism linguistic in orientation. Flynt had argued that 'since *concepts* are closely bound up with language, concept art is a kind of art of which the material is language'.[13] But LeWitt's art ideas were as much *numerical* as linguistic. He would thus maintain the independently critical, rather than artistic, status of his analysis of Conceptual art, despite his famous insistence that 'the idea itself, even if not made visual, is as much a work of art as any finished product'.[14] 'These sentences comment on art,' his later 'Sentences on Conceptual Art' (1969) concludes, 'but are not art.'[15] The idea here is the idea *of* a work of art; not a second-order idea *about* what a work of art is. The latter is criticism, which, though it may contribute to the production of an art idea, is not one itself as such. In so far as there is philosophy in LeWitt, then, it is in his art and his criticism in qualitatively distinct forms.

Still, despite its origins in his own artistic practice, the idea of Conceptual art outlined in 'Paragraphs' had implications far beyond anything Lewitt was himself producing as art at the time. 'Conceptual' in comparison to certain other, superficially similar, works also often labelled 'Minimalist' (by Morris, for example), LeWitt's art appears as no more than 'proto-Conceptual' when set beside later, more single-mindedly conceptual work. One reason for this is that, despite his gestures in the direction of a purely ideational interpretation of the artwork, LeWitt is actually ambivalent about object-hood. On the one hand, while declaring the look of a work to be its least important feature, and thereby downgrading its physicality in relation to its idea, the essay nonetheless continues to treat the work's physical reality as a condition of its existence: 'It is the process of conception *and realization* with which the artist is concerned.' On the other hand, the remark that 'the idea itself, even if not made visual, is as much a work of art as any finished product' suggests that the physical reality of the work is not merely unimportant, but optional. But this is misleading, for LeWitt continues, 'All intervening steps – scribbles, sketches, drawing, failed work, models, studies, thoughts, conversations – are of interest. Those that show the thought process of the artist are sometimes more interesting than the final product'.[16]

What this reveals is that LeWitt is not really thinking ontologically about art's object-hood here at all; even if we consider the object intentionalistically, as an idea. Rather, more simply, he is concerned to valorize the intellectual element of the process of its production, which he associates, psychologistically, with the workings of the artist's mind. What looks like an exclusively *ideational* redefinition of the object, in conflict with the recognition that it requires some physical presence, is actually, more restrictively (and also, perhaps, more materialistically), a *psychological* one: 'A work of art may be understood as a conductor from the artist's mind to the viewer's.' LeWitt's proto-Conceptualist Minimalism is thus both ontologically dualistic (idea and object inhabit different realms) and a variant of Realism in its understanding of ideas as mental events. This explains his distance from the predominantly anti-psychologistic forms of logico-linguistic analysis which would preoccupy later Conceptualists. Conceptual art, for LeWitt, is not theoretical but 'intuitive' – for all the apparent formalism of the ideas behind his own work. It is for this reason that he insists upon the 'mystical' rather than the 'rationalistic' character of such art, describing it as constituted by 'illogical judgements'.[17] Thus, while LeWitt may have pushed Modernist reduction one stage further than Judd (from reduction to 'medium' to reduction to 'object-hood' to reduction to 'idea'), his psychological realism forbids the strictly Conceptual reading of 'art as idea' which his 'Paragraphs' nonetheless inevitably evokes. It is thus not surprising that LeWitt would soon be challenged by a more exclusive, more formally philosophical, type of Conceptualism laying claim to the idea of 'art as idea' as its own.

It would be a mistake, though, to distinguish LeWitt from these later Conceptualists on the basis of the philosophical resources they deployed alone. Adrian Piper, a staunch defender of an inclusive LeWittian Conceptualism, not only went on to study analytical philosophy, but became a professional philosopher, while continuing her career as an artist. However, she did not thereby become what I am calling a strong or an exclusive Conceptualist. For while she used (and continues to use) her philosophical work in her art – often making work directly about her philosophical reflections – her philosophical interests are not in the concept of art itself, but in the broader metaphysical notions of space, time and selfhood, the experience of which her art explores. (Initially, in a formal LeWittian manner; subsequently, in more social and political contexts, characterized by her interests in feminism and the politics of race.) For this LeWittian strand of Conceptualism, it is the *infinite plurality of media* that the idea of Conceptual art opens up which is the point, not the

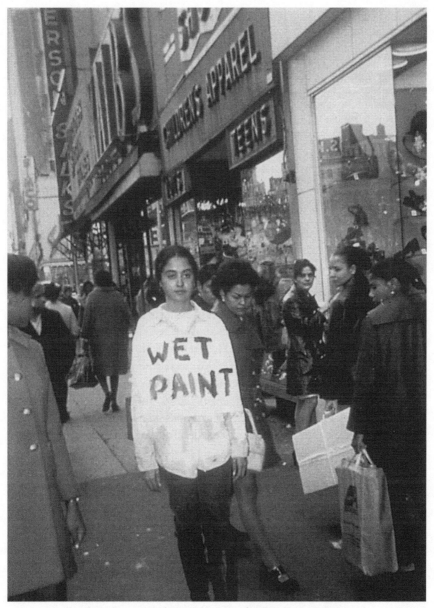

Adrian Piper, *Catalysis III* (street performance), August 1970.

exploration of that idea itself, directly, as art. As Piper puts it, 'If we have
to be concerned with one particular concept to be a conceptualist, some-
thing's gone badly wrong!'[18] Lewitt never considers the relationship
between the ideational and physical aspects of the object, ontologically,
in its specific character as 'art'. Indeed, the concept of art, as such, in its
generality, plays little role in his thought. The distinctive feature of
Kosuth's brand of analytical or strong Conceptualism, on the other hand,
is its exclusive focus on the concept of art: its *reductively art-definitional*
or *definitively philosophical* conception of art practice. It is at this point
that a quite general engagement with art as a practice of manifest ideas
(and hence only a very broad alignment of art with philosophy, as a disci-
pline of conceptual ideality, like mathematics) is transformed into a par-
ticular engagement between modernist criticism (with its concern for the
self-critical dimension of art as an autonomous practice) and a determi-
nate state of the Anglo-American philosophical field.

FIRST-DEGREE PHILOSOPHY: JOSEPH KOSUTH

Lewitt's essay established the discursive conditions for Kosuth's formul-
ation of his own ideas about Conceptual art, but these owe more to
Duchamp and Reinhardt than to LeWitt himself. They owe most of all
to A. J. Ayer. Kosuth's Conceptualism takes up the functionalism of
Duchamp's meta-artistic interventions and, discarding their residual
anti-art negativity, reinterprets them in terms of a new linguistic posi-
tivism. It thereby extends the 'linguistic turn' characteristic of post-war
Anglo-American philosophy into the field of artistic production in an
ostensibly rigorous manner.

Being an artist now means to question the nature of art ... The function of art as
a question, was first raised by Marcel Duchamp ... The event that made conceiv-
able the realization that it was possible to 'speak another language' and still make
sense in art was Marcel Duchamp's first unassisted readymade. With the unas-
sisted readymade, art changed its focus from the form of the language to what
was being said. Which means that it changed the nature of art from a question of
morphology to a question of function. This change – one from 'appearance' to
'conception' – was the beginning of 'modern' art and the beginning of 'concep-
tual' art. All art (after Duchamp) is conceptual (in nature) because art only exists
conceptually. ... Artists question the nature of art by presenting new propositions
as to art's nature.[19]

So runs the famous passage in 'Art After Philosophy', the serial essay first
published in *Studio International* in 1969, in which Kosuth set out his stall

for a purely conceptual art. In it we find a transition from the negative questioning inherent in the aesthetic indifference of Duchamp's ready-mades to the positive 'investigations' of Kosuth's distinct brand of Conceptual art: a transition from the wide-eyed surprise of 'This is art?' to a new way of claiming 'This *is* art.'

Kosuth transformed the *abstract* negation of the aesthetic conception of art performed by the anti-art element of Duchamp's ready-made into a *determinate* negation. He thereby transformed the *in*determinacy of Duchamp's generic conception of art into the determinacy of a new positivity: 'propositions as to art's nature'. Kosuth's 'pure' or 'theoretical' Conceptual art aspires to make a *new conceptual positivity* out of Duchamp's negations. As such it is dependent upon a quite particular philosophy of language.[20]

The institutional conditions for this radical transcoding were established in the long, slow process of the reception of Duchamp's works into the art institution: in particular, the direct designation as 'art' of an object which had become so only as the result of a complex series of events surrounding its previous rejection (*Fountain*) – what we might call the *positivization of the ready-made* – in conjunction with a whole array of new artistic developments which had taken place in reaction to American-type painting, involving a massive expansion of artistic means. This process effected a separation of two elements hitherto conjoined in the founding conflation of formalist Modernism: *aestheticism* and *autonomy*. The former was rejected; the latter embraced. Duchamp's attack on the aesthetic definition of art was recouped within the institution by a generic conception of art which retained the notion of autonomy. Kosuth had already encountered a similar notion of autonomy within Modernism, in Ad Reinhardt's understanding of monochrome painting as 'art as art'. In the wake of LeWitt's essay, Duchamp's ready-mades were interpreted by Kosuth as an inversion of the logic of Reinhardt's understanding of monochrome painting: from the idea of 'art as art' to 'art as idea (as idea)'.[21] The crucial doubling registers the artistic enactment of the meta-artistic idea.

Kosuth received Duchamp's ready-made into the context of Reinhardt's Modernist idea of art as *autonomous* and hence *self-referential*. This is the second of the great conflations of formalist Modernism, separated out by Kosuth from the first (the conflation of aestheticism and autonomy) and in this case maintained: the conflation of autonomy and self-referentiality. Ayer's logical positivist philosophy of language provided Kosuth with the means to think self-referentiality without the

aesthetic. The positivism of Kosuth's understanding of Conceptual art is a consequence of the dual context of his joint reception of Duchamp's work and LeWitt's essay: Reinhardt and logical positivism. For whereas Duchamp had maintained, 'There doesn't have to be a lot of the conceptual for me to like something. What I don't like is the completely nonconceptual, which is purely retinal; that irritates me'[22] – just as LeWitt had described the concept as no more than 'the most important aspect' of a Conceptual work – Kosuth and others came to aspire to the *completely*, autonomously and self-referentially, conceptual: 'new *propositions* as to art's nature'.

Works of art are analytical propositions. That is, if viewed within their context – as art – they provide no information whatsoever about any matter of fact. A work of art is a tautology in that it is a presentation of the artist's intention, that is, he is saying that a particular work of art *is* art which means, is a *definition* of art. Thus, that it is art is true a priori (which is what Judd means when he states that 'if someone calls it art, it's art').

For Kosuth, Conceptual art is an art which *recognizes* that 'art's "art condition" is a conceptual state' – that is, that 'objects are conceptually irrelevant to the condition of art'. It is an art which is 'clearly conceptual in intent'.[23]

 'Art After Philosophy' is one of the more technically confused philosophical statements about art. Yet it is exemplary – indeed, constitutive – in its illusion. In particular, it is an excellent illustration of the dependence of analytical or strong conceptual art upon specific (often highly problematic, but also inadvertently socially representative) philosophical standpoints: in Kosuth's case, the triumphant linguistic reductivism of a now long-discredited logical positivism. The *propositional* positivism of Kosuth's idea of art derives directly from A. J. Ayer, whose writings provided the medium for the translation of the formalist idea of autonomy as self-referentiality into the idiom of the analytical proposition. (After Wittgenstein, Kosuth assures us, '"Continental" philosophy need not seriously be considered'.[24]) At the same time, however, this propositional positivism is combined with a *psychological* positivism stemming from Kosuth's individualistic reading of Duchamp's nominalism – similar in many ways to Lewitt's stress on intentionality. For while the semantic positivity of Kosuth's idea of art appears to move decisively beyond LeWitt's psychologism, it is in fact held back, and tied to it, by his inflated conception of the stipulative power of the individual artist: art as 'a presentation of the artist's intention'. It is this combination which leads to the

exaggeration of the cultural authority of the artist's critical discourse, characteristic of a certain sectarian Conceptualism; an exaggeration which is at once theoretical, strategic and opportunistic. It took the ultimate form of the attempt to efface the categorial difference between art and criticism in the polemical presentation of critical discourse as itself art, in the journal *Art-Language*, for example. There are thus three main components of Kosuth's conception: *linguistic reduction, psychologism* and *the collapse of the distinction between art and criticism.*

Kosuth's self-understanding is marked by a fundamental equivocation about language. In search of an anti-aestheticist model for artistic autonomy, Kosuth hit upon the *analogy* of tautology: 'art is analogous to an analytical proposition.' However, he lacked the resources to think the analogical and this soon collapsed into identity: 'Works of art *are* analytical propositions.'[25] Kosuth thus simultaneously introduced and foreclosed the issue of the semiological character of visual art, by abstracting from all questions of medium, form, visuality and materiality, while nonetheless continuing to pose them, implicitly, in his presumption of art's difference from other forms of signification. This is not a presumption that Kosuth has ever been able to redeem, theoretically. Yet this was in part his point: as the heir to empiricism, linguistic philosophy is antimetaphysical, and philosophy of art was to be no exception. Rather than philosophy delineating art's realm, this was to be the job of art itself, in each instance, 'presenting new propositions as to art's nature'. By presenting different visual means of signifying the same propositional content, Kosuth's early works aim to demonstrate the independence of conceptual content from signifying form, in such a way as to make this show of independence into a (independent) propositional content of its own: Art as Idea as Idea. But what allows for these objects to be read in this way: as presentations of propositions about art's nature?

It is at this point that Kosuth's propositional positivism starts to break down. For in his account, an individual work of art – a material object – becomes 'a kind of proposition' within 'art's language' (rather than an object of aesthetic appreciation or a cultural object of some other kind) only when it is presented within what he calls 'the *context* of art'.[26] Yet the model of meaning to which the idea of an analytical proposition is tied is resolutely *anti*-contextual. The early Kosuth was thus forced to neutralize the contextualism in his own position in order to preserve the semantic purity of his Conceptualism. This is the function of his psychologism and the associated regression to the prioritization of artistic intention. For Kosuth, 'the context of art' (so rich in Duchamp) is reduced to no more

than a space set aside for the realization of the artist's intention. Ultimately, it is the artist's intention that the work be understood as 'a comment on art' which makes it 'art'.

'This is a Portrait of Iris Clert if I say so', reads the famous telegram sent by Robert Rauschenberg to his dealer, Iris Clert, in 1961, as his contribution to an exhibition of portraits – simultaneously enacting and parodying this position. 'If someone calls it art, it's art', Donald Judd declared in 1965, rather more straightforwardly, as if bored by the obviousness of it all. And in 'Art After Philosophy', Kosuth quotes this phrase of Judd's twice. But who is the 'I' or the 'someone'? And how do they 'say' it or 'call' it? Kosuth's answer to this complex institutional question is a simple one, modelled on the persona of Duchamp: the 'I' or the 'someone' is an artist and an artist is someone (anyone) who 'questions the nature of art'. 'Art' is the product of the stipulating power of the individual artist, the individual questioner into the nature of art. The artist as author, in the sense of formative creator, is replaced by the (meta-)artist as nominator of artistic status. The death of the author becomes 'the birth of the artist as self-curator'.[27] This was one of the ways in which Duchamp's ready-made was received in the USA in the late 1950s and early 60s: in terms of an individualistic (indeed, voluntaristic) artistic nominalism. However, there was a crucial difference between Kosuth's situation and that of Duchamp (or even Rauschenberg, whose tongue, like Duchamp's, stayed in his cheek). For Kosuth, along with others of his generation, lacked a pre-established artistic persona, such as Duchamp had derived from his period of infamy as a painter. Their practice of self-curation was thus faced with the additional task of constructing an artistic persona from scratch. Hence the importance of the critical, self-legitimating philosophical writings of the first generation of Conceptual artists to the status of their work as 'art': as guarantors and guardians of their right to nomination. The authority of philosophy was used to establish a right to nomination. Without this critical supplement, their nominations are unlikely to have been able to sustain their claims to legitimation.

It is the combination of Conceptualism and Intentionalism in Kosuth's conception of art which undermines the distinction between the work and the artist's critical discourse. For having established the legitimacy of the work as art through the analogy with propositional content, it was only a small step to making a similar claim for the discourse about it, since it too, paradigmatically, questions the nature of art. Art becomes the product of the artist's 'total signifying activity'.[28] Hence Seth

Siegelaub's reversal of the distinction between 'primary' and 'secondary' information which allowed for the exhibition catalogue to take precedence over the exhibits:

. . . when art does not any longer depend upon its physical presence, when it has become an abstraction, it is not distorted and altered by its representation in books and catalogues. It becomes *primary* information, while the reproduction of conventional art in books or catalogues is necessarily *secondary* information. For example, a photograph of a painting is different from a painting, but a photograph of a photograph is just a photograph, or the setting of a line of type is just a line of type. When information is *primary*, the catalogue can become the exhibition *and* a catalogue auxiliary to it, whereas in the January, 1969, show [held at 44 East 52nd St., New York, curated by Siegelaub] the catalogue was primary and the physical exhibition was auxiliary to it . . . it's turning the whole thing around.[29]

But can the aesthetic dimension of the object be wholly disregarded in the drive towards 'propositional' content? Can the philosophical meaning of the work actually be wholly abstracted from its material means? Or, to put it another way, can the constitutive ambiguity characteristic of the deployment of philosophy within the artistic field ever be finally resolved? One can be forgiven for doubting it. Especially in the light of the palpably aesthetic qualities of Kosuth's own work at the level of typography and design.

Kosuth's work attacked the aesthetic definition of the artwork in the name of linguistic meaning. According to Kosuth, art is a question not of morphology but of function. This distinction is reflected in his distinction between a 'stylistic' Conceptualism which has failed to rid itself of residual morphological characteristics (in which Kosuth includes Robert Barry, Douglas Huebler, and Lawrence Weiner – the artists with whom he was shown in Siegelaub's January 1969 show) and a 'purer' Conceptualism to which his own work, early Art & Language (Atkinson and Baldwin) and On Kawara are taken to belong. Yet his own work functioned largely by placing language *within* the visual field. How can visual representations of language be purified of the pre-aestheticized structures of handwriting and typographical design? Just as by the 1960s the products of Duchamp's early acts of aesthetic indifference had acquired a recognizable aesthetic dimension, so one is forced to conclude with Jeff Wall that:

Kosuth . . . presents the vestiges of the instrumentalised 'value-free' academic disciplines characteristic of the new American-type universities (empiricist sociology, information theory, positivist language philosophy) in the fashionable forms

of 1960s advertising . . . In this sense conceptualism is the *doppelgänger* of Warhol-type 'Popism' in its helpless ironic mimicry, not of knowledge, but of the mechanisms of falsification of knowledge, whose despotic and seductive forms of display are copied to make art objects.[30]

In fact, directly contrary to his own self-understanding, we might say that Kosuth enacts an *aestheticization of logical positivism*. His categorical distinction between 'pure' and 'stylistic' Conceptualism cannot be sustained. The question is not how to *eliminate* or *reduce* the aesthetic dimension of the object (its morphological characteristics) but how, in each instance, critically to regulate the play between 'aesthetic' and 'conceptual' terms. As the institutional history of the documentation of performance pieces and temporary works shows, it is an irreducible dimension of the logic of the artistic field to present visual form, however attenuated or seemingly irrelevant.

Kosuth used logical positivist philosophy of language as a guillotine to eradicate the aesthetic dimension of the artwork. Art & Language, on the other hand, increasingly became caught up in the intellectual seductions of analytical philosophy as a self-sufficient cultural practice. If Kosuth conceived art philosophically as propositional in nature, he nonetheless continued to produce object-instantiated work as the means for the communication of his propositions. Art & Language took a step back, withdrawing to the immanent investigation of the logical structure of language itself. In this respect, one might say, they were truer to the idea of art as investigation than Kosuth himself.

PHILOSOPHY TO THE SECOND DEGREE: ART & LANGUAGE

It is a perilous journey returning to the dense prose and contorted intellectualism of the now distant and strange world of the first six issues of the journal *Art-Language* (May 1969–Summer 1972). Like documents of a lost civilization, they demand and resist interpretation, appeal and repulse, in equal measure. One finds oneself searching for a key, only to be reminded that in this case the search *is* the key, and that they were no more immediately intelligible in their own day than they are today.[31] Intellectual difficulty, severity of expression, obsessive formalization, disjunctiveness and incompleteness are all important aspects of the writing practice of the Art & Language group, along with a certain aggressive self-deprecating humour. Subcultural solidarity in the appreciation of difficulty for its own sake has long been central to the appeal of professional philosophy to outsiders. And this was a group who rapidly

fell in love with the rituals and techniques of rigour characteristic of logico-linguistic analysis in the Anglo-American manner. The substantive point, however, is that, unlike Kosuth, Art & Language appreciated the open character of philosophical inquiry as an ongoing task. For Kosuth, philosophy was essentially a set of *positions* – positions enabling of artistic practice, perhaps, but fixed positions nonetheless. With the keenness of the convert, Kosuth thought he knew what art was: propositions as to art's nature. Delving a little deeper, Art & Language wanted to know what propositions were, and that turned out to be somewhat more complicated than A. J. Ayer had led Kosuth to expect.

Secondly, Art & Language sought to explore 'the possibilities of a theoretical analysis as a method for (possibly) making art'. (The parenthesis is typical of their prose.) That is, they were interested in the idea 'that an art form can evolve by taking as a point of initial inquiry the language-use of the art-society'.[32] In particular, they were mesmerized by the formal possibilities of various systems of meaning, in which the radical openness of purely logical possibility appears to have functioned as a utopian metaphor for the artistic and the social alike. This, then, was not 'art as philosophy' but philosophy as the possibility of a new kind of art, and hence a new kind of society; perhaps even philosophy itself as a mode of Conceptual art. However, by the fourth issue of the journal (November 1971) the expression 'so-called conceptual art' had begun to appear, alongside some fairly scathing philosophical remarks about Kosuth, the 'American Editor' of the second and third issues, once Conceptual art had established itself as a curatorial category.[33] Art & Language's own claim to the name Conceptual art would largely come later, as part of a self-serving – indeed, self-promoting – revisionist historiography of the movement.

The pursuit of philosophy, within its own terms, as the possible basis of a new kind of art practice simultaneously placed the group closer to the practitioners of the philosophical field – as co-workers in its enterprise – and distanced them from it, in so far as the 'publication' of their activities was conceived as a form of art practice, insulating them from the legitimating (and delegitimating) mechanisms of the philosophical field itself. In other words, philosophy was culturally recoded according to the parameters of the artistic field, however deviant it may have been within it. In line with the cultural logic of autodidacticism, the group thus identified with institutional philosophy at the level of its investment in certain intellectual techniques, but disidentified at the level of its social form (professionalism). This led to a series of contradictory stances,

regarding linguistic elitism, for example, creating a highly strung ambiva-
lence relieved only in alternating bouts of critical aggression and defen-
sive self-parody.[34] It is important to remember, though, that the formative
context here was art-educational (with its connections to student poli-
tics), rather than the New York gallery world of Kosuth's 'investigations'.
The parody was thus closer to the po-faced absurdism of Situationism
than to the cool irony of the art world.[35]

These tensions were mediated through the development of the idea of
an Art & Language conversational community (much like the community
of investigators in C. S. Peirce's pragmatism), but the tensions between
the philosophical, social, and artistic dimensions of the project made this
a utopian quest. The pursuit of technical philosophical advances in
logico-linguistic analysis at the level of the collective action of an artistic
community could only be (and was retrospectively rationalized as) the
metaphorical performance of a necessary failure. Meanwhile, the prob-
lem of the visual dimension of public display, which vitiates Kosuth's self-
understanding, was to arise again as soon as the Art & Language project
moved out of the spaces of its own community dispatches into the inter-
national art world. Like Kosuth, Art & Language rapidly acquired a
'look', which conveyed a quite different social meaning to the one they
intended.[36] In this regard, the *Documenta Index* of 1972 (a massive cross-
referential index system mapping relations of compatibility, incompati-
bility, and lack of relational value between its terms) is not the 'summary
work of Conceptual Art' which Charles Harrison has claimed it to be
(characteristically condensing the history of Conceptual art as a move-
ment into the history of Art & Language),[37] but it is the summary work of
Art & Language themselves in their development from 1968 to 1972. As
such, it marks both the culmination and the demise of strong
Conceptualism: the fantasy of the resolution of the constitutive ambigu-
ity of philosophy's double-coding. Henceforth, the irreducible constitu-
tive role of the visual in artistic meaning would be acknowledged as the
basis for a variety of new, frequently more directly political, artistic
strategies, which would continue the battle against the Modernist ideol-
ogy of pure visuality in new, simultaneously 'visual' and 'conceptual'
forms.

THE VANISHING MEDIATOR

What, then, are we to make of this odd philosophical interlude in the his-
tory of contemporary art which I have called exclusive or strong concep-
tualism? It is tempting to treat it as either an aberration or a sideshow: an

alien intrusion into the art world that has somehow managed to hijack large amounts of critical and art-historical space, vastly disproportionate to its significance, to the detriment of other kinds of Conceptual art. But this would be a mistake. The historical significance of an art practice bears no necessary relation to the statistical weight of its practitioners or the temporal span of the practice. It depends more on its catalytic and constitutive effects upon the meaning of subsequent practices than on its ability to endure or even to succeed within its own terms. Such is the experimental nature of modern art. In this respect, analytical, exclusive or strong Conceptualism displays the character of what Max Weber called a vanishing mediator: in Jameson's gloss: 'a catalytic agent that permits an exchange of energies between two otherwise mutually exclusive terms . . . [and] serves . . . as a kind of overall bracket or framework within which change takes place and which can be dismantled and removed when its usefulness is over.'[38] More specifically, one might say, philosophy was the vanishing mediator in the transition from LeWitt's ontologically ambiguous, weak or inclusive Conceptualism to the generic Conceptuality or post-Conceptual status of art since the mid-1970s. For in overreacting to the absolutization of the aesthetic in the Modernist ideology of pure visuality – by attempting the complete elimination of the aesthetic from the artistic field – theoretical or strong Conceptualism fulfilled the classically Hegelian function of exceeding a limit in such a way as to render it visible, thereby reinstituting it as a limit on new grounds. It is the ironic historical function of theoretical or strong Conceptualism, through its identification with philosophy, to have reasserted the inelim-inability of the aesthetic as a necessary element of the artwork, via a failed negation. At the same time, however, it also definitively demonstrated the radical insufficiency of this element to the meaning-producing capacity of the work. As such, it reaffirmed the constitutive ambiguity of philosophy's double-coding within the artistic field, as an enduring productive resource.

4

Still You Ask for More: Demand, Display and 'The New Art'

WILLIAM WOOD

Where the artist has a commodity – a thing in limited supply – to offer, his problems are merely those of demand, which, if he has a dealer, it becomes the dealer's duty to stimulate; but where his art by nature offers no transferable 'rare' 'physical' product, the artist attempting to work and earn as an artist within a system which . . . is geared to sale (and thus implicitly or explicitly the 'valuing') of rare objects, must either starve or fabricate (or allow his dealer to fabricate) criteria of rarity for what may, indeed, depend for its very identity as an endeavor within the domain of art upon the irrelevance of such criteria. In these circumstances distinctions between those artists who will permit their work to be 'dealt with' and those who will not become distinctions with potentially critical overtones.

Charles Harrison, 'Virgin Soils and Old Lands', 1971

Most of the familiar works associated with English Conceptual art date from the late 1960s and assumed forms that appeared to refuse the 'criteria of rarity' Charles Harrison describes. Copies of *Art-Language*, Victor Burgin's series of reflexive performative sentences, Gilbert and George's pathetically recurring *Singing Sculpture*, Richard Long's photographs of his walks – all were reproducible or repeatable and used relatively unconventional materials seemingly resistant to standard display and consumption. These were not works that seemed easy to assimilate to the workings of the art market and gallery system. Yet, by the mid-1970s at the latest, critics, curators, dealers and collectors had managed – often with the direct participation of the artists – to impart to them various qualities of specialness that massaged the works into the normal business of exhibitions and dealing. My aim here is to look at what can be regarded as a pivotal moment in this process. *The New Art* exhibition of August 1972 was when the ephemeral and the transient aspects of English Conceptual art, those aspects that had attached these English artists to an undeniably international movement that was mostly disregarded by the art world in

Great Britain, were officially recognized and arguably recuperated in the forms of stable, fixed and often nationalized artistic identities, and more or less permanent, rare art objects.

For *The New Art* exhibition at London's Hayward Gallery, Tate Gallery Assistant Keeper Anne Seymour brought together fourteen exhibitors and applied her decisive title to art where 'ideas and attitudes are equally if not more important than the media'.[1] The roster was a combination of artists associated with Conceptual art who had come to attention in the latter 1960s – Art & Language, Burgin, Gilbert and George, and Long most prominently – along with ten others who had lesser international profiles or a less clear identification with Conceptual art.[2] She described her aim to 'explore and collect together some of the criteria concerned' in work 'which does not presuppose the traditional categories of painting and sculpture' and ended up allowing that 'the artist can work in the areas he is interested in . . . without being tied to a number of aesthetic discomforts which he personally does not appreciate'.[3] Such art was both of Britain and concertedly global for Seymour, an aspect of a simultaneous 'world-wide upheaval', but also 'very specifically British'.[4] When it became necessary to list a common element joining the exhibitors, all Seymour came up with was the bland – and debatable – statement that their work involved 'a very straight use of materials, images and facts', attributes she saw as especially British in character.[5]

This tension between Britishness and international conditions proved crucial to the entire project of *The New Art*, for no matter what identified or animated this global vision and these national characteristics, the implication was that the British audience had lost out on something important. In their catalogue preface, Norbert Lynton and Robin Campbell stressed that the work 'had already won notice and acclaim abroad while meeting with no or little interest at home'.[6] In her 'Introduction', Seymour expanded on these concerns. Rather than discussing what distinguished her selection, she directed attention to the oversight she was rectifying:

The situation of a particular area of art crying out for attention is probably peculiar to the present time. But it is also justifiable to single it out for reasons of its international connections, the somewhat uneasy bed it has made for itself in art schools in this country, its lack of representation in its more radical forms in public museums and art galleries.[7]

Whatever Seymour meant by 'peculiar to the present time' was never clarified – just one example of the selector's uncertainty over what factors she

saw contributing to the art's misrepresented standing in Britain. The incongruence between success abroad and British neglect of the work structured her introductory remarks to the point where she tried to domesticate the art, since her professional goal was to gain the work's acceptance from the public and integrate it into the British scene, to at once bring the work into the fold and not disturb the environment in the process. Making a distinction which puts a premium on gallery display, she remarked, 'Although this kind of thing [work with conceptual predilections] has long been featured in art magazines and things have snowballed in the field of written and photographed information since 1969 . . . in Britain we have actually *seen* very little of it'.[8] This distinction, presenting art as being made for galleries, is difficult to reconcile with the intentions of some forms of Conceptual art. It also depended on the artists being perceived as producers of specific things made to be seen, exceptional and especially visible things worthy of a gallery setting, a dependence often at odds with certain concerns of Conceptual art. In the end, however, the ways in which artists adapted to conventional display, or attempted to dispute its conditions, proved to be the most contentious aspect of the exhibition and its reception.

In further justifying *The New Art*, Seymour did not discuss the art schools in any depth, nor did she go far into the exclusion of Conceptualism from the nation's galleries. The 'uneasy' embedding of Conceptualism in art education was a veiled allusion to the termination of the Art Theory course staffed mainly by Art & Language members at Lanchester Polytechnic in Coventry. The sacking of the artists, the fate of the students on the course and the state of art education had been discussed in *Studio International*, but the Coventry débâcle had not overly affected other art schools.[9] Regarding the public galleries, Seymour briefly recorded two London group exhibitions and the small number of solo exhibitions and commercial gallery affiliations her chosen artists had in London. She compared this with their higher profile abroad, using a curious standard: 'Many of the artists are in constant demand in other parts of the world,' she enthused, 'and some have become very selective about where they exhibit'.[10] Making a kind of homely virtue out of this, she continued, 'Britain is a quiet place to work, but New York, Düsseldorf, Paris and Turin are where they sell and display their ideas'. For Seymour, the 'demand' coming from abroad was for the artists to deliver their 'ideas' for sale and display, and her strategy highlighted this marketability. To enhance the prestige of her selection, and to pre-empt critics questioning art that was not painting and sculpture, she insisted on commercial

demand, even if such work seemed to embody ambivalent attitudes towards being 'dealt with' in the market. While Seymour was not alone among critics in mentioning Conceptualism's commercial connections, she was almost alone in ascribing a diminished criticality to the work as a result. Lucy Lippard noted that, while she had thought that the unusual methods and materials of Conceptual art would bypass 'the tyranny of commodity status and market-orientation', by 1973 she reported, 'the major conceptualists are selling work for substantial sums' through 'the most prestigious galleries'. She pointedly concluded, 'Art and artist in cap-italist societies remain luxuries'.[11] Seymour wanted those 'luxuries' to be proof of the British work's entitlement to be exhibited. She had doubts, 'in financial respects', about the 'political and social significance of work which may be made of ephemeral or unimportant materials'; but this was because 'instead of being unusable within the sinister structure of the art market an enormous amount of money has been made out of conceptual art'.[12] Even so, she added, 'the moral and physical results remain', her prose becoming hazy and her argument questionable.

There had indeed developed a network of dealers, galleries and collec-tors for Conceptual art, mainly in Western Europe, and Lippard was cor-rect that some prestigious galleries – Konrad Fischer in Düsseldorf or Ileana Sonnabend in New York – represented some of Seymour's artists. Yet the amount of money involved was small relative to the market for painting and sculpture. At the end of 1972, *Studio International* reported on Willi Bongard's 1972 ranking of the top 100 contemporary artists: of the artists in *The New Art*, only Long and Gilbert and George made the list, at 74 and 82 respectively, with the top ten all being neo-Dada and Pop painters and sculptors.[13] To give an idea of the amounts involved, here are some contem-porary prices. In the early 1970s, copies of *Art-Language* carried a cover price of 12s. 6d., or US$2.50, five shillings less than a single issue of *Studio International*.[14] Booklets by Terry Atkinson and Michael Baldwin of Art & Language were selling for US$65 (£25).[15] Burgin was selling text works in edition through his German dealer, Galerie Paul Maenz, for US$280 (£115) and had sold an installation of his *Photo Path* for US$5,000 (£2,000).[16] In May 1972, Long sold to the Italian collector, Giuseppe Panza di Biumo, a photograph of a 1968 outdoor sculpture for US$2,000 (£800); slightly later, a 1969 indoor sculpture made of pine needles went to the same collector for 3,300,000 lira (£1,300).[17] These are 'substantial sums' but not 'enormous' ones, compared to prices for post-war American painting: a New York auc-tion in November 1971 saw US$50,000 (£20,000) paid for Morris Louis's *Floral*, from 1959, and US$36,000 (£14,500) for a 1968 Frank Stella.[18] There

Cover of *Art-Language*, I:3 (June 1970).

Cover of *Art-Language*, I:1 (May 1969).

are, of course, important differences between large, singular canvases and typeset booklets, but the notion that dealing these works affects their meaning points to other factors.

Only by taking advantage of the implication that 'unimportant materials' – typesetting, photographs, pine needles – should not achieve prices comparable to works of art composed using traditional ones can the monetary component be used, first, to discount the potential 'social and political significance' of the art and, second, to permit that art 'aspects' which are somehow separate from commodity status. Seymour's was a dubious argument, for, if the 'moral and physical' base of conceptual art was separate from its resistance to being reduced to a marketable commodity, international 'demand' placed that value fundamentally within the market. To offset this, it is not the marketability of the work alone but its national representation of a global shift in aesthetic concerns which ultimately established the art's merit for Seymour. Yet this again is qualified by her understanding that what is precious about the work is responsible for the international desirability: nothing explicit about its materials either encouraged or operated against demand. For Seymour, the amorphous idea of an overall shift in priorities in art from media to ideas permitted a conflation such that what is most timely about the art, its global character and its national associations, was also most desirable and lucrative. Its value was not estimable but inchoate – much like the global consciousness she saw it as representing.

The allure of renown abroad and of money being made from Conceptualism demonstrates value in standard terms and also works to remove elements of a potentially unsettling character. When Burgin, for example, talked approvingly of the artist coming 'to see himself not as the creator of new materials but rather as the coordinator of existing materials', he opposed this to the 'conspicuous consumption' encouraged by the 'cybernated cornucopias of industry'[19] – but there was no direct criticism of the art market in the opposition. It was to maintain a comprehensive separation of art and its values from industry and its values that Burgin derided consumption. Like Lippard, Burgin may have assumed that the attraction to purchasers was slight because the art did not satisfy visual interest, but there was no sense that the critical elements of the art would be depleted by being dealt. Burgin came close to articulating this in *The New Art* catalogue: in order to aim towards a socially critical practice, he wrote of art which 'has more than just *Art* as its content and which carries the possibility of becoming more than just the rejectamenta of our economic surplus'.[20]

Burgin's 'becoming more' recognizes that art would probably remain part of the debris excreted through surplus. His view was generally in accord with Harrison's observation that market status was not so much a matter of inconsistency between the goals and effects of Conceptual art as a consequence of individual artist's decisions about being 'dealt with'. It was a matter of tractability not duplicity, related to life under capitalism.[21] For Harrison, the purpose of 'criteria of rarity' was falsely to ameliorate negativity and obscurity by normalizing the work as a stable entity and the artist as a supplier of such entities in spite of their potentially subversive implications. No such arguments can be located in Seymour's 'Introduction'. She did not seem to recognize the work as critical, but strove to represent the importance of the artists' 'ideas and attitudes' as they applied to their working methods and resources, leaving the tangible objects produced out of the picture.

Even so, Harrison's talk of fabricating 'criteria of rarity' points to factors operating in Seymour's 'collecting' and to the moral and ethical scales she used to determine the motives and intents of the artists. Seymour sought to present her criteria of celebrity and inchoate value in relation to art history and global consciousness. In order to advance her view of a peculiarly British 'very straight use of materials, images and facts', she attempted to establish an unspecified simultaneity to allow for global change to be instanced in the British work; next, she developed a specific contrast within her selection. This was done in a meandering sort of way, but one symptomatic of the problems Seymour faced in domesticating *The New Art*. Writing of 'transatlantic and continental influence', she offered examples of British work simultaneous with American and European work while asserting that, for some of these same artists, an understanding of their art as incorporating 'a way of life' resisted the processing of their work by the 'great art history machine'. Other artists are represented as deliberately tied to that machine. As she goes on, her contrast is between Long and Art & Language. Seymour summons up Carl Andre's view that Long was one of a number of artists who, independently, 'had reached the same objective state' but each had a 'subjective reaction' so that they 'worked in similar ways',[22] while Art & Language's ties to New York artists like Sol LeWitt and Dan Graham are 'a search for like-minded thinking'.[23] There is a split here: Long reaches an independent state of working 'similar' to others, while Art & Language sought out 'like-minded thinking' to reinforce their New York-influenced work. This is but one instance in her account where the 'intellectual context' is downplayed to favour 'a complete worldwide consciousness in time and space'.[24]

The comparison is further worked towards an ethical explanation. There are 'two poles of principle within the criteria which motivate' the artists.[25] Art & Language are said to be 'beyond the aestheticism of so-called "modernist" art', while Long's example 'repudiates not only aesthetic discussions of art but emphasizes that is it necessary to work according to no pre-conceived philosophies'. He works with 'things at their rawest, their simplest, their most pure'. Where Art & Language are magpies picking up on 'logic, mathematics, information theory, philosophy, history, cybernetics', Long's work is 'a quiet connection, private, a philosophical dialogue between the artist and the earth'. Opposing the chattering to the quiet, the group to the individual, purity versus complications and convolution, Seymour effectively characterized Art & Language as too complex and adulterated compared to Long. Art & Language may converse among themselves about concepts, yet Long is in direct dialogue with the earth, with space and time. Moreover, Long's approach had attracted other artists, Seymour avers – Hamish Fulton being the obvious one, Gilbert and George being less obvious others. Their work is held to represent an art 'extending in time and space to include a way of life'. The interest in displaying Long's and Fulton's pastoral, peripatetic work, and more urbane work by Gilbert and George, is

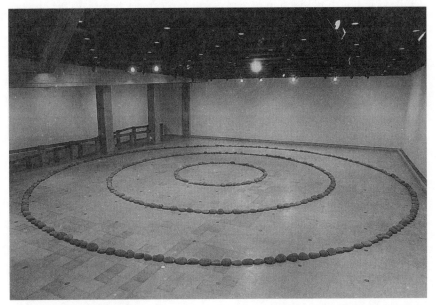

Richard Long, *Three Circles of Stones* (1972), as shown in the exhibition *The New Art* at the Hayward Gallery (August–September 1972).

said, in a very strange phrase, to be because it 'seems to counter the breathtaking freedom suggested by adopting moral obligations against which careless spectators can stub their toes'.[26] Although those 'moral obligations' could refer to a long history of moralizing in British art and culture that almost all the artists might want to evade, what is apparent is that Long and his followers are prized for their immediacy that escapes such concerns to the point where the mediations of representation and the burdens of art history appear to be inappropriate to their art.

This valuing of immediacy becomes clearer when Seymour observes that Long and Fulton refused to submit or have 'explanatory material' in the catalogue. The catalogue was separated into a selection of material chosen by the artists and an 'Information Section' providing background material. Instead of prose statements, interviews or expository writing, Long and Fulton simply presented photographs. Meanwhile, the other artists were represented through interviews with Seymour or had assisted with essays written by her. They also published artists' projects – eight pages of Art & Language writing and an essay by Burgin, for example. The published texts by these artists led Seymour to record:

The difficulty with the language-orientated work is the amount of pre-reading which is necessary, but other kinds of work also demand a much more detailed kind of thinking than perhaps seemed necessary before. In the absence of such miracles, Long and Fulton continue to work in peace – at their express request.[27]

The absent miracles would seem to describe, together with Seymour's depreciation of work against which 'careless spectators can stub their toes', the engaged and cognitively active spectatorship demanded by Art & Language and Burgin. 'Pre-reading' and 'detailed' thinking required by work that is not simple and direct is perceived as lacking something basic, needing not just some preparation or work by the spectator but retuning to the messages of the global consciousness.

However Seymour sought to cast it, the reluctance of Long to submit to summary was habitual and strategic. In lieu of statements or interviews, since 1969 he had published in magazines, catalogues and booklets different sorts of collections of photographs to represent his work.[28] Although these publications sometimes contained poetry or popular song lyrics, he avoided any commitment beyond these pithy lines.[29] His emphasis on illustration without substantial comment reinforced the pastoral tone of his imagery (the 'straight use' Seymour enjoyed) and linked his personality to such gentle themes. The avoidance of explanation complemented

the hushed actuality in the views of his outdoor scenes and the character imputed to his peregrinations. Many of these published displays featured a representation of the artist. The catalogue of 1971's *The British Avant Garde* included a full-page colour image of Long pictured on a rolling, verdant moor, dressed in hiking gear and unshaven beside a neatly tacked-down tent.[30] As the caption – 'Richard Long standing near his walk' – makes clear, this is not a specific work Long executed, or an image of him working. He is 'standing near' his walk, resting for a moment in perfect character to personify his pastoral work.

Such an image authorizes other images presented; Long established his credentials as an outdoorsman, underlined the simplicity of his demeanour, suggested bonds between the spareness of his document-ation and himself. He also assumed historical personae, as when he juxta-posed a photograph of himself 'Climbing Mt. Kilimanjaro Africa 1969' to the Long Man of Wilmington in *The New Art* catalogue.[31] Rucksack-carrying Long proposes a historical continuity between the seventh-cen-tury stick-carrying figure and himself, but the equation is not thought through; the correspondence is enough. Yet the associations he accumu-lated, to Neolithic earthworks, contemporary nomads and local legends, contrived to create an identity for Long as a solitary individual incarnat-ing past habits, working on variations on circles and lines. Enacting walks of severe discipline, he composed arrangements unidentifiable as art without a pictorial souvenir substituting for the remote, all but unlocat-able, makeshift effort imaged through photography. Not depicted is the artist sorting negatives and contact sheets, ordering prints or travelling to talk to dealers and collectors. These are historic roles unrelated to the folk memories and inviolable self-image that served as a phantom projection of the figure Long had become.

Long rooted himself historically prior to Modernism partly to insulate himself from aesthetic debate, and Seymour attached him to nostalgic associations with the simple past. By contrast, Art & Language had used their group exhibition opportunities to print essays, presenting difficult prose and recondite arguments, replacing the materials of art with lan-guage that debated as it conjured mental schemes, entwining itself in the trails of words and meanings rather than settling down. Burgin too typi-cally presented texts, both in catalogues and in magazines, as well as for gallery presentation, but his texts took two forms. Some were series of sentence-length statements meant to be 'performed' by the gallery-goer or page-reader, while others, such as the 'Margin Note' published in *The New Art* catalogue, were expository essays.[32] Where the former were con-

cerned with what Burgin called '*events* in the life of the observer',[33] the
latter were reasoned and accessible arguments concerning Modernism
and 'the question of art's *use*'[34] that tacitly acknowledged the 'performa-
tive' aspects of the series of sentences as exemplary of a textual challenge
to Modernist autonomy and formalist closure. This contrasted to Art &
Language's almost exclusive use of expository formats and their concern
less with accessibility or the performative than with an 'analysis of the
languge-use of the art society',[35] involving figuring out 'what it is pre-
cisely that the members [of Art & Language] are talking about'.[36] While
this appeared to be a recipe for a quasi-autonomous talking shop uncon-
cerned with engagement with a broader constituency, the works they
began in 1972 – collectively known as the *Indexes* – included couched calls
for participation in what they invariably described as the Art & Language
'conversation'.

 Both Long and text-centred artists like Burgin and Art & Language
steered away from implying that the products of their activities – as mat-
erially opposite as they were potentially antagonistic aesthetically – were
available as some form of commodity. Neither did they directly imply that
there were serious alternatives to the close-mouthed approach of the peri-
patetic or the overwhelmingly verbalized discourse of the problem-seeker.
While Terry Atkinson had written that 'most of the work classed within
the conceptual tag thinkworks, earthworks, waterworks, skyworks, etc.,
etc., is founded upon abortive and sloppy thinking',[37] and Charles
Harrison – named as *Art-Language* general editor in 1971 – had written
of Long's work as having an 'isolated or isolationist' relationship to ques-
tions of value'[38] based on the problematic of the placelessness of his pro-
duction with regard to the status of his documentation as art, these were
minor skirmishes that overrode any full-fledged sense that some kind of
product, market or viewer was prodded to reform itself in relation to the
words and images offered. To some degree, this aspect was addressed by
Gilbert and George in their works of the early 1970s.

 Whereas Long stressed the sincerity of art, Gilbert and George had
adjusted to the market without totally abandoning a pose between insin-
cerity and self-promotion. For Michel Claura's '18 Paris IV.70' exhibition
of 1970, they sent all the artists contributing a printed card inscribed, 'All
my life I give you nothing and still you ask for more'. The phrase was also
hand-printed above the heads of full-length drawn portraits of Gilbert
and George shown in the gallery. These separate panels were made of
creased and artificially distressed paper sheets secured to the wall with
ribbons. The drawings are not accomplished; incomplete, sketchy, they

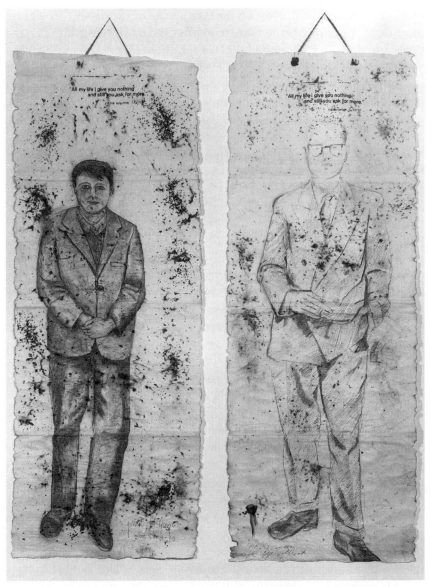

Gilbert and George, *All my life I give you nothing and still you ask for more*, 1970, charcoal on paper attached to mounts with ribbon.

nastily combine clumsiness with the fake ageing of the paper. The phrase plays on the notion of being asked to exhibit and one has to admit that the cards and drawings are something, tokens answering to a request with a slightly insolent but nicely phrased response. Reluctance is expressed, but the responding materials satisfy etiquette, meeting demand in a manner at once deferential and begrudging, retaining a simultaneous insincere and polite veneer.

These are but two of the drawings Gilbert and George produced between 1970 and 1972. Ranging from small panels to wall-sized, sometimes gallery-sized, presentations, the drawings engage demand by satisfying the requirement that Gilbert and George show something for galleries. As with the 'All my life I give you nothing . . .' panels, they attempted to recall the futility of their performances by being awkward pseudo-narcissists always portraying themselves. Yet, ingeniously, they managed also to recall something of the public aspect of their earlier work by becoming more capable of tactically playing the uselessness of their actions against the standards by which artists are commonly judged. When Seymour related them to Long and Fulton for *The New Art*, she also noted that Gilbert and George 'have taken their practice right out into the public domain and given it a deliberately ambivalent and precarious role in art between sophistication and naïveté'.[39] This was the reputation they had achieved since 1969 through public exposure as the *Singing Sculpture*, but some modifications had altered the character of this piece. First, they included metallic make-up and sang along to the record, then they lengthened the performance's duration: from the few minutes of their early performances, they later performed for hours at a time, then five to eight-hour periods over a number of days, and, for its longest duration, a ten-day, full opening-hours *Singing Sculpture* was held to inaugurate New York's Sonnabend Gallery. This lengthening of the event, the repetitive quality it acquired and the relocation of the 'feat of endurance' to galleries proper began to be not merely noted but admired and interpreted in journalistic profiles and reviews.[40] In effect, the connoisseurs in the audience came forth with allusions to canonical Modernist figures like Samuel Beckett and André Breton and the burlesque of the piece almost evaporated.

While performing at Sonnabend, Gilbert and George displayed a 23-part drawing suite entitled, *The General Jungle*, imaging Gilbert and George in parkland settings. Each work bears texts like, 'We step into the responsibility-suits of our art', 'As day breaks we rise into our vacuum' and 'Walking is an eternity of our living moment, it can never tell us of an end'. The images and texts seem mismatched, as the comforts of forest or

park bring up only the language of responsibility, vacuity and endlessness, and the figures are as much paralysed as walking. In company with Long's photographic self-representations, the vestments of Gilbert and George's artistic personae and the mysteries of walking are celebrated by still figures set amid greenery that gives a backdrop for their respective allusions to the efforts they make in order to make art. In Gilbert and George's case, minor dandies that they are, the walk is aimless, pointless, full of ennui. In a sly way, this is a Long work made in London: the images are of Regent's Park, Kew Gardens and Hyde Park, and were taken from photographs projected and then drawn.[41] The prose is in overall tension between representing the disordered joint psyche of the pair and their obligation to be malingerers and time-wasters now that they have made their reputation as such worthless types.

In this tension Gilbert and George sought, as in their previous work, to bracket the question of the attention they received with awareness that, since they were in demand, there must be some value to the endeavour, if only to maintain the imagery of idleness amid the evidence of busy work by others. Gilbert and George could exploit evidence of their endurance in trying to live up to that image. As noted earlier, these supposed idlers were ranked among the top 100 of contemporary artists; for better or worse, that entailed more than malingering and vacuity. By producing the drawings or drawing out the *Singing Sculpture* to mock-epic proportions, they parodied the idealism expected of producers like Long – whose busy itinerary contrasted with his persona as a rustic – and Art & Language – who insisted that their talk about art substituted for object-making. Gilbert and George offered work that took effort but was about sloth and impotence, provided clumsy objects with talk attached, objects that were made for something but conveyed a sense of having nothing at the core.

For *The New Art*, Gilbert and George were given pride of place, appearing on the announcement card and occupying the entrance gallery. They presented a massive floor-to-ceiling drawing titled *The Shrubberies*, with Gilbert and George appearing walking through their landscape. A band of text running along the bottom borrowed terms from cricket and racing ('WELL BOWLED', 'THEY'RE OFF'), and common expressions from pubs and clubs ('BAD BLOOD', 'SCRUFF OF HIS NECK'). For English critics, this was the most discussed piece. William Feaver claimed it was 'designed to save them having to hang around as art-works for a month',[42] and most commentary concerned Gilbert and George's promotional capabilities, with Feaver calling the pair 'colour supplement material . . . immediately recognizable to an up-market A–B class readership'.

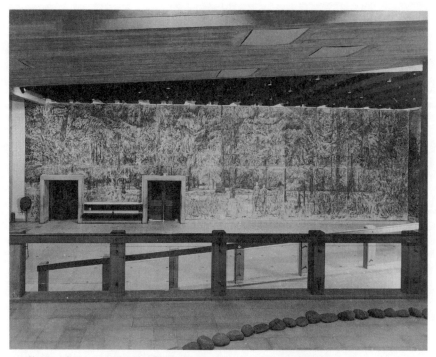

Gilbert and George, *The Shrubberies*, 1972, charcoal on paper, as shown at the Hayward
Gallery, London, exhibition *The New Art* (August–September 1972). Richard Long's
Three Circles of Stones (1972) is partly visible in the foreground.

Feaver's comments reflect the general tone of the reviews from London.
Critics took the prominence of Gilbert and George, rightly, as indicative
of Seymour's overall aims. Robert Melville held that she was deluded by
thinking:

that the things she exhibited – tokens of a self-indulgent life-style, or statements
of intent by non-practicing artists in which their intentions remain obscure . . .
must in some way be related to demands for a better society and ought to be unus-
able under capitalism . . . In fact their work faithfully reflects the capitalist sys-
tem, with its growing dependence on instant obsolescence and the production of
ephemera.[43]

Though a poor reading of Seymour's 'Introduction', Melville picked up
on the incongruity between lifestyle and commercial demand that struc-
tured Seymour's curation. As well, he, together with others, was sensitive
to the problems of exhibiting the art as something visible in the gallery,
suggesting that Seymour was right to appeal to the visual but had chosen
the wrong artists. No English reviewer seemed burdened by a new art

composed to fit 'a way of life', and where they did recognize the notion they ridiculed it. Feaver wrote of how Long had 'made his reputation outdoors [and] is being drawn back into the shop-window gallery . . . to install something of the effects he brings about in the open countryside'. Acknowledging that 'in its time, this was a breakthrough,' he went on to note the 'standard sculptural conventions' involved and enjoyed the irony that Long's pared-down work could be said to offer 'little to galleries'. This elegy for a 'breakthrough' lead him to a more incisive comment on Fulton and *The New Art* as a whole:

[S]ites which, a couple of generations of taste ago, would have been considered incomplete without a Moore on the skyline, can indeed serve as fit and proper ends in themselves. This, in its own semi-private way, is a valid enough point. Like so much of the selections of *The New Art*, Fulton's photographs and occasional laconic captions are meaningful . . . only in a highly sophisticated art context, as disclaimers of past taste, as declarations of independence from the various dummy tyrannies of the Object, the System, and indeed most past orders of priorities.

Feaver was not sympathetic to opposition to 'dummy tyrannies', but he did see behind the simplicities to the sophisticated contexts in which these artists operated. Similar reservations were concentrated on the display Art & Language presented for *The New Art*:

The outline scheme of Art-Language is a sort of conceptual art potholing, a prolonged wriggling into ideas of the theory, the nature and the purpose of art, through tortuous semantic and philosophical channels . . . The interested observer, in my experience, retires baffled, agreeing on the whole that this high-thinking, this probing analysis must in principle be a Good Thing if only by virtue of its suggestion in art schools circles and beyond that thought is a useful, probably vital prerequisite to artistic concerns.[44]

The Art & Language work for the Hayward was their most complex and collaborative work to date. Initially produced for installation for 'Documenta 5', the installation compiled writings associated with Art & Language using an indexing system to 'map' their idiomatic 'conversation'; *The New Art* version was almost identical to the Kassel version but with some changes in the indexing system. For both versions, over 100 texts by Art & Language and others – all those written since 1968 and most published in *Art-Language* – were collected into filing cabinets and placed in a separate gallery. Sheets of alphanumeric citations covered the walls listing interrelations of the texts according to compatibility, using

logical notation for compatible ideas, incompatible ideas or areas where insufficient grounds for determining compatibility were sensed. Where the initial installation, later called *Index 01*, simply read the texts one-to-one, the Hayward version, called *Index 02*, stretched the logical net further so that a one-to-one relation of compatibility was mapped against the sum of compatibility for each citation. The full array of relations could be determined by anyone who grasped the system, and texts in the catalogue offered instruction. Although it is fairly apparent that the components invited participation, few did more than simply glance at the massed detail and stroll away.

 This is not surprising, for the relentless bulk of text and the thick language used demand extraordinary time, patience and interest. Reviewers of 'Documenta' almost all mentioned *Index 01* but came up with quips on its visual look, saying it expressed 'an insane love of filing systems and office furniture',[45] and reviewers of *The New Art* followed suit, with only Feaver seeming to appreciate the density of the work and its underlying implications of endless discussion. These views foreground a problem Art & Language texts provoked for exhibition: how to present writing as theoretical discourse instead of text as novel artistic material; that is, how to work as artists with concepts having potential bearing on practice without appearing simply to annex those concepts as the content of a revamped art object. In part, the *Indexes* were designed to force a choice upon this confusion: if you just looked at the work it had nothing much to say that you had not already responded to by neglecting its materials and

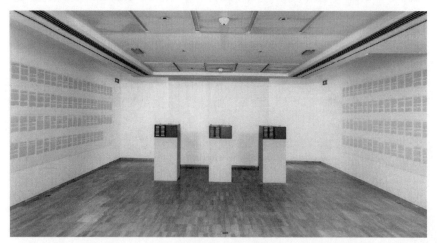

Art & Language, *Index 02*, 1972, filing cabinets and files, wall-mounted photostats on masonite, as installed at the Lisson Gallery, London, in 1978.

system, while a move to read and think about the contents would recognize Art & Language's viability and probably mean missing the rest of the exhibition.

Although there was significant identification among Art & Language associates, an Art & Language retrospective installation implied a cohesive product. The group called the work a 'programme/map' or its 'textbook/map', using Thomas Kuhn's paradigm shift to characterize the alliance's move from object-makers to conversational theorists. On this analogy, the *Indexes* represented 'sets of questions to be asked . . . rather than the projection of transcendental elements encapsulated as "results"',[46] meaning that their inquiry was into the conditions under which a shift away from object-making could take place rather than stating that they provided the evidence of a new conceptual framework:

The Art-Language association is characterised by the desire and ability of its members to talk to each other . . . We implicitly agree to admit (not encourage) our own and others' vulnerabilities . . . This may come out in public as a matter of permitting 'idiomatic talk' (internally, that is – we don't have to suffer other fools gladly).[47]

This approach, they claimed, 'replaced style (correct and proper procedures)' as found in 'the conventional "show-biz" aspects of many contemporary art practices'[48] with 'epistemology (reflection on the constitution of communicating knowledge)'.[49] Only open inquiry permitted such reflection: 'Once you stop trying to define the undefinable – "What is art?" – and start trying to answer the question, "What sort of a concept is 'art'?", there is no other way to avoid narrowmindedness and naivety.'[50] Consequently, they were setting out to search their peculiar interrelations, assuming their limited association to be a model for social exchange and their accumulated texts as a resource of typical and competent language-use. There was a role for interlocutors as well: 'The character of the work which falls under the aegis of the Institute *is* instructive,' they wrote, 'that is, it teaches to learn',[51] for 'anyone who asserts common ground with us . . . invokes a logically possible "conversational state of affairs"'.[52]

As a pliable net indicating agreement, disagreement or non-relation, the indexing system discriminated between texts without privileging terms or topics. It was presumed that the mapping exercise would permit significant correlations to appear and the objective was to indicate areas not yet considered and potential transformations of existing work into new modes of conversation. The outcome distinguished the association,

presenting Art & Language as a research group, as knowledge-producers, a status confounding others to approximate such post-artisanal identity. With this, the *Indexes* represented a means of consolidating Art & Language work through a fractionalization of contemporary art. The overwhelming level of detail and overbearing scrutiny of each contribution regulated its constituents to produce an appearance of unity, an effect turned on to the public through the frigid components, while Art & Language's assumed singularity derogated systematically the other exhibitors as examples of the conditions Art & Language were trying to figure out and question.

The choice presented by the *Indexes* is whether art could be a place for activities engaging knowledge beyond mere consumption or appreciation. They could be categorized as extending public access or as a radical decentring of professional and institutional protocols, but, in 1972, such aims were virtually ignored as a matter of participation. Indeed, whether there was the possibility of participation dominated the views of two informed continental reviewers of *The New Art*. Both R. H. Fuchs and Germano Celant took Seymour's contrast between Long and Art & Language as a serious proposition and used it to further her notion that certain artists represented 'a way of life' while equally considering what Celant called 'the progress of art thinking'[53] discernible in Art & Language's and Burgin's texts. Where Celant held forth on the cultural history of this split, seeing it instated in the antagonism between 'centres of philosophy like Oxford and Cambridge and . . . educational institutions like the schools and colleges of art', Fuchs claimed that 'each artist is quietly (or sometimes fanatically) following the lines of his own private orthodoxy'[54] and that this fit with 'the art situation now' across contemporary work. Although he based this assertion on an idea of the artist achieving 'a language completely his own', he saw no structure to communicate that language outside of what, apropos of Gilbert and George, he called 'discrete glimpses of a *private* life', or, for Art & Language the construction of 'the grand allegory of art's contemporary privateness' composed using 'technical procedures'. For Fuchs and Celant, Art & Language's project was non-participatory and did not oblige critics to do any thinking on their own. For Fuchs the idiosyncrasy of the discourse made it an allegory of privateness. Not surprisingly, for Celant, this was a virtue, as it propelled the question of 'analysis' and 'research' to new levels.[55] Celant regarded them as 'leaving the gallery world' to foment change in the art schools and colleges. The end of the course at Coventry actually had the opposite effect: within two years none of the remaining

Art & Language cohorts were in teaching positions and the need to generate funds to continue the operation meant dealing early works and other money-making schemes that fragmented the group. It is as if, following the search for problems, Art & Language became problems themselves, and finally to themselves.

Like Art & Language, Burgin presented a retrospective of six text-works from the previous three years in booklet form and on the wall. Although using similar display techniques, Burgin strongly attacked Art & Language for their detachment from the ideological ramifications of 'the social mediation of the physical world through the agency of *signs*'.[56] For Burgin, by using the philosophy of science, Art & Language recapitulated formalist approaches which separated the art object off from signification through generating specialist discourse. Submitting a semiotically flavoured sketch of historical development of such discourse, he called 'the structure of the art community' a 'miniature' of the 'Western capitalism which contains it'. To avoid this structure, he proposed 'a sort of secularised version of Pascal's wager', whereby artists 'act "as if" art may be socially effective'. Yet he faced the problem of his wager in terms of constituency as well as intent. Burgin's study of mediation and cultural coding through art has the promise of serving social effectiveness to recommend it, yet whether he saw his work as achieving such a goal is not distinct from the work's specialized qualities and demanding degrees of conceptual manipulation. In this regard, Burgin represented an intellectual fellow-traveller and, as Feaver noted with Art & Language, there is a connotation here of art and thought as inherently 'Good Things' without questioning the assumptions that sustain them.

Although they might appear to travesty the seriousness of art as a social instrument, Gilbert and George disclosed the latent snobbery and hypocrisy of an art world which shunned the most natural of its constituents in the middle class and still held that it was a form of 'social mediation'. The socially useful, preoccupied and responsible artist is the role Gilbert and George insisted they emulated in their writing, while their addled pictorial work undermined that role to set up competition between the two claims and manoeuvred between them to fashion a resonant commentary on the art world as at once miniature capitalism and mystic refuge, a place where 'valuing' depends upon demand and display. Unintentionally, Richard Long's *Three Circles of Stones* prompted such questions of value. Placed overlooking Gilbert and George's *The Shrubberies* were three consecutive rings of water-eroded stones; it was his largest indoor work to date, a type of monument. To Melville, it was

'the simplest and most impressive exhibit', expressing 'magical practices' and 'reverence for natural objects' evocative of 'ritual objects of pre-historic man'.[57] Feaver, aware of the excitement Long's work had elicited when he first began showing, regarded this as a decline into 'shop-window' display: 'Now . . . having been armed with a special Arts Council chit authorizing him to remove his lorryload of stones from a suitable beach, he has come full circle. His cycle of escape and discovery is so well-established as to be almost commonplace.'[58] This comment is based on Feaver's overall depreciation of attacks upon dummy targets, but he links Long's adoption of conventional forms of institutional display to an undermining of the basis of his work in the transient and impermanent. The talk of authorization and the 'commonplace' reduces the work to a routine outing lacking magic or intimacy. This tarnishes the myth of the solitary walker in tune with the land, suggesting licensed pilferage of beach stones with a waiting lorry to ease transport to the gallery, and calls for some value other than sanctioned reputation to justify display.

The interesting aspect of this is that Long no longer needed to document the placelessness of this work or even allude to the necessarily collective efforts required to make it. As Feaver showed, this was actually a detriment, since it contradicted privateness with logistics involving values other than Long's intimacy with nature. Yet the connection of Long's stones to his earlier remote work shadowed the piece to lend it magical qualities in its repetition of archaic practice. If Long had alluded to such practices before, now his work brought to the public palpable evidence of his regaining of the power of permanent materials to symbolize an artistic vocation that had begun in transience and dissidence. This links him to Gilbert and George and their massive drawing: both return to more or less conventional forms of materials and presentation while implying that this return captures the essence of their previous impermanent actions and documentation. In fact, the reputation for the unconventional sustains the return by reinstating notions of inspiration that has travelled from eccentric experiment to canonical status and market viability.

Such would be one version of what happened to *The New Art*. What had elicited 'little or no interest' in England became transformed into the 'discrete glimpses of a *private* life' now idiosyncratically public and based in altered forms of convention. With Art & Language and Burgin, their continued adherence to text and dialogue does not rely on a return like Gilbert and George and Long, but their progress came to represent the difficulty and perhaps unfeasible character of attempting what Harrison once called a 'rapprochement between art and philosophy'.[59] In *Index 02*,

those attempts were so strictly presented that the negative and inter-
minable come forth as forcing the confederates away from contact with
aesthetic matters; for the next few years, the clamour around Art &
Language was about 'going on' with an epistemological project bereft of
aesthetic merit. For Burgin, the need was for the artist to join in a social
pact, an imagined contract reminiscent of his early interest in sharing out
the labour of the artwork with the spectator who performed his sen-
tences. Now, though, the focus was not on generating situations for stim-
ulating experiences but on the play of cultural codes and on becoming an
intellectual figure unveiling ideology as an antidote to the narrow way art
had been represented. In this strategy, the cultural implications of art as
something mystified were to be undone not by looking towards thought
alone but by emphasizing that the social world was a network of institu-
tionalized contacts where art contested its legacy of ineffectiveness and
detachment. However, as Burgin noted, such contestings were 'marginal
activities', at best relegating art to the status of 'an agency of socialisa-
tion'[60] within institutional space. With such alternatives, between canon
and margins, *The New Art* exhibition showed that, in England at least,
Conceptual art had been something more than 'a way of life', but not an
activity where the working of 'criteria of rarity' were effectively disabled.
Rather, a certain shift took place wherein the variety and idiosyncracy of
the 'ideas and attitudes' attributable to the artists became controlling
mechanisms operating to contain most of the contestation over demand
and also capable of reducing their project to mere display.

Minding the Body:
Robert Morris's 1971 Tate Gallery Retrospective

JON BIRD

What is revealed is that art itself is an activity of change, of disorientation
and shift, of violent discontinuity and mutability, of the willingness for
confusion even in the service of discovering new perceptual modes.

Robert Morris[1]

Indeterminacy has an important social aspect; it requires the cooperation of
others.

Anton Ehrenzweig[2]

I believe [Morris] thought these works would create a ruminative atmosphere.
My evidence for this is the film he made . . . 48 hours before the exhibition . . . He
got hold of a girl and got her to take her clothes off, and she very much appeared
as a classic art-school nude . . . The point is that the atmosphere of that film is of
an incredible solemn calm . . . There is a kind of serenity about the whole thing
which is very beautiful. I take it from the film that Morris idealized his concept
into something where the interactions between the objects and the visitor would
happen in a state of contemplative calm.

David Sylvester[3]

The trouble with participation, it seems, is that apart from making us forget what
art's all about, and inducing the very restlessness of mind which it's supposed to
ease, it makes people behave like wild beasts . . .

Michael Shepherd[4]

*A grainy, black-and-white image of an almost perspectiveless space. A room, a
white wall whose nondescript surface is interrupted by the entry into the frame of
a large wooden cylinder, maybe six feet in diameter, rolling slowly, ponderously,
across the screen from left to right, then right to left. CUT. The same cylinder,
now frontally positioned in relation to the camera, rolls towards the viewer in a
straight line, halts up close to the camera filling the screen and revealing the pat-
terns in the surface structure, then gradually retreats towards the rear wall. CUT.*

Again the cylinder in side elevation but this time the movement is controlled by a figure, on the far side to the camera, promenading the object. The figure, a muscular nude woman, is slightly awkward in her actions, perhaps conscious of the camera, perhaps simply uncertain of her role in the performance. CUT. The action is repeated with the camera closer to the woman and the cylinder. CUT. The second sequence is repeated - but now the pace of the cylinder rolling towards the camera is determined by the woman as she retreats before its advance, hands up against its surface. Her awkwardness is exaggerated by the implied threat of the object, which rears above and bears down upon her as she bears down upon the viewer. She halts with her buttocks almost against the camera lens, pauses, then slowly pushes the cylinder back into the space towards the rear wall. This sequence is repeated. CUT. The cylinder, side elevation, its space filled by the woman kneeling and applying pressure to the interior surface, a gentle rocking motion. Her position emphasises the weight of her breasts, a dark profile outlined against the white rear wall. CUT. The woman moves across the screen rolling a large ball, maybe 24" diameter. The camera cuts her body so that her head is out of frame, which emphasises her weight and musculature. She returns pushing the cylinder with the ball inside. CUT. Two rails, frontally to the camera, bisect the screen, their perspectival foreshortening flattening the space even further. The ball runs unsteadily along the rails from the rear wall towards the camera, an unoriginated movement, which halts with a close-up of the objects surface: not wood, it could be concrete, or, perhaps, polystyrene. This 'to-and-fro' action is repeated several times. CUT. The cylinder rolls across the screen only this time its space is occupied by a revolving clothed male figure, arms and legs tensioned against the interior surface like the spokes of a wheel. Briefly, we recognise the figure as Morris. CUT. A thick hemp rope stretches across the screen, suspended above the ground. Panning along the rope, the camera encounters a naked foot balancing on the rope exerting a gentle pressure, up . . . down . . . up . . . down . . . CUT. A ramp with ropes snaking across it. A male figure holds the rope and gradually, hand-over-hand, ascends the ramp. CUT. A close-up of a (male?) hand moving, caressingly, over and around the surface and edge of a thick metal plate. CUT. Two hands holding a rectangular metal plate pendulum across the screen, a fast action which obscures the image. CUT. The ball rolls slowly down an angled plane, across the floor, coming to rest against another ramp. CUT. A prone nude figure, after a moment identifiable as the woman, on her back supporting and rotating above her, with some difficulty, a large sheet of plywood. Between the uneven rotation and the rise and fall of the sheet the viewer glimpses her body, the tufts of her pubic hair outlined against the wood, her breasts squashed up against its surface. We feel her discomfort. CUT. The ball nudges against a ramp. CUT. The woman rotates the sheet. CUT. The ball ambles to a halt against a ramp. END.

Neo Classic[5]

Can we say that a kind of grammatical chasm exists between the form of the proposition and that of the question? Is there a kind of world, as it were, of the question, whose difference, verging on the suspicion of a kind of lack, sets it in perpetual opposition to that other world, that of the statement? Some might read such differences as an allegory of gender – defined, admittedly, in a rather essentialist way. And when it comes to actions, are there those one could designate as interrogative? And what about objects? . . . I would like to float out the notion of an interrogative space . . . so that when the examples of the art appear they are coated or infected with a kind of questionlike aspect.

<div align="right">Robert Morris[6]</div>

The idea of a Robert Morris exhibition was first proposed to the Tate Gallery by the critic and Tate Trustee David Sylvester in October 1968. Sylvester had seen work by Morris in America at Leo Castelli's New York gallery and in other exhibitions and public and private collections, and had discussed the possibility with the artist earlier that year. Sylvester had interviewed Morris for his series of talks on contemporary artists for the BBC and it is evident from Morris's correspondence with the Tate that he had a great deal of respect for Sylvester's critical and curatorial abilities. ('I would certainly want to consult with David . . . about all aspects of the show').[7] Morris's work was little known in Britain at this time and what Sylvester had in mind was a conventional retrospective concentrating on the Minimalist works of the 1960s. In May 1970, Michael Compton, Keeper of Exhibitions and Education at the Tate Gallery, wrote to Morris proposing a retrospective exhibition and in his reply Morris recognized the necessity for showing past works in London, although from the outset he clearly intended to limit the retrospective element within an overall conception of a large-scale installation along the lines of his recent exhibitions at the Corcoran Gallery and the Whitney Museum.

Since 1967 Morris's work had shifted in its formal and conceptual properties from the closed Minimalist structures of monochrome plywood, steel mesh and various arrangements of metal girders to the hanging and piled *Felt Works* and assemblages of random materials and 'stuff' – the 'anti-form' and scatter pieces. Morris's critical writings, which always accompanied his sculptural works and provided the theoretical context, specifically 'Notes on Sculpture: Parts I–IV', 'Anti-Form' and 'Some Notes on the Phenomenology of Making: The Search for the Motivated', all appeared in *Artforum* between 1966 and 1970. A Duchampian concern with the visual and the verbal, with the semiotic play of meaning across the systems of word and image, is characteristic of this period in the visual arts and is the consistent factor in Morris's prac-

tice, which otherwise appears somewhat disconnected and arbitrary, shifting as it does between styles, techniques and forms of expression. (These include, besides the sculptural works, writings, reliefs, performance works, dance, choreography and public lectures.) Morris had absorbed the implications of the propositional aspect of Duchamp – of art as a form of language-game – in the early 1960s. 'My fascination with and respect for Duchamp was related to his linguistic fixation, to the idea that all of his operations were ultimately built on a sophisticated understanding of language itself'.[8] No pre-history of Conceptual art could exclude *Box with Sound of its Own Making* (1961), or *Card File Index* (1962). *Box with Sound* . . . clearly references Duchamp's assisted readymade *with Hidden Noise* and his *Green Box* containing the notes for the *Large Glass*, and introduces a theme which returns in the later installations, the crossing or mixing of generic styles to suggest an experiential relation between viewer and object. The simplicity of form – a wooden cube – is distorted by the looped tape playing back the sounds made during its three-hour construction, a mixing of visual and auditory sensations that also raises questions of reflexivity, authorship and intentionality (the box clearly didn't make itself) which were to become central to Conceptualism's critical development. *Card File Index*, an equally self-referential work, also sets up contrasting systems which contaminate any sense of unitary or fixed meaning. The system's instrumental logic is subverted by the idiosyncratic nature of some of the categories. Morris, apparently, conceived the work while having a coffee in the New York Public Library and finished it on 31 December 1962, at 5.10 p.m. – noted in the file under 'Decisions'. Another file is titled 'Category', which gives the total number of categories generated by the work as '44'. Another key and enigmatic work of this period, *I-Box* (1962), fuses the iconic, indexical and symbolic elements of language. A hinged, I-shaped door reveals an interior space exhibiting a nude, grinning photograph of the artist, a masquerading of masculinity revealed and situated by the performative act of opening or closing the 'I'. Meaning shifts through positionality and the action of revealing and concealing suggests Freud's famous observation of the child's repetitive action with a cotton reel – the 'Fort/Da' symbolization of presence and absence.

Although some of these themes persist in the work of the mid-1960s, Morris's focus moved to the unitary gestalt of the large minimal and serial sculptures produced between 1964 and 1967. The more complexly coded and phenomenological concerns encapsulated in these earlier constructions re-emerge in the late 1960s, possibly partly as a response to the

broader set of relations that constitute the field of cultural production that would have to include the political and social after-effects of the Cold War, the Civil Rights Movement, the Nixon government's escalating military involvement in South-East Asia and the beginnings of the Women's Movement. Morris's position within the American New Left and his ambivalence over the social role of the artist in a culture which increasingly alienated its intelligentsia emerged in his 1970 advertisement, placed in various art journals, for the Peripatetic Artists' Guild. In this Morris offered himself for hire by the hour as an 'art worker' available for a range of 'commissions anywhere in the world'. These might include such disparate and non-artistic events as 'Explosions, Chemical Swamps, Alternate Political Systems, Demonstrations, Ensembles of Curious Objects To Be Seen While Travelling At Great Speed . . .' etc. Inviting other artists to collaborate, the advertisement suggests a '$25.00 per working hour wage plus all travel, materials, construction and other costs to be paid by the owner-sponsor'.[9] Morris's parodic utilitarianism, equating the activities of the artist with calculable wage labour in projects which range from the practical to the phantasmagoric, is yet another implicit acknowledgement of his recurrent interest in Modernism's exemplary ironist, Duchamp.

The tensions between an internal language of Greenbergian formal aesthetics as a limitation on or prescription for practice, the commodification of the work of art and its institutionalization in public and private collections, and the increasing marginalization of the artist-subject in the social formation can all be evidenced in the various visual and textual strategies deployed by artists in the period from the mid-1960s to the mid-'70s. For Morris, critical writing, sculptural object and social role intersected in the texts and installations that staged the performative and disruptive possibilities of the work of art, or, perhaps more precisely, the *work* of the work of art. Always more drawn to art as a phenomenological rather than a philosophical investigation, Morris maintained a tangential relation to the primary concern of post-Duchampian Conceptualism, the attack upon the visual. It was in his Tate Gallery installation of 1971 that he pushed up against the hegemonic definitions of work, site, context and audience in ways that clearly revealed their regulatory boundaries and exclusions.

Throughout the correspondence between Compton and Morris during the exhibition's planning – a period lasting approximately eleven months, until the actual opening in April – the traces of Morris's shifting theoretical and political interests can be discerned in his reconceptualization of

Photograph of the *Robert Morris Retrospective* at the Tate Gallery, London (April–May 1971).

Photograph of the Morris retrospective at the Tate Gallery.

Photograph of the Morris retrospective at the Tate Gallery.

Photograph of the Morris retrospective at the Tate Gallery.

Photograph of the Morris retrospective at the Tate Gallery.

the structure and content of what would finally comprise the work on show. From the outset Morris was concerned to work with non-art materials which could be purchased locally and then recycled after the exhibition was dismantled. Michael Compton recalls three designs prior to the final structure. Initially Morris requested materials similar to his Whitney installation: nine granite blocks eight by four by three feet, 40 timbers twelve to fifteen feet long, twelve-inch-square steel pipes, rusted steel plates and truckloads of coarse gravel. (Morris's response to Marcia Tucker's invitation for a retrospective at the Whitney Museum of American Art in New York had been to agree on the condition that he made a site-specific installation with the active participation of building workers to shift and install the massive concrete blocks, pipes and timbers, and that the economic value of the work was, precisely, the material and labour costs of its production. Three weeks prior to opening, Morris reacted to the shooting of four anti-Vietnam student protesters at Kent State University by National Guardsmen by demanding that the exhibition be abandoned and museum staff reassigned to initiating meetings and discussions on institutional complicity in repressive policies against artists and audiences alike. Although the Whitney ignored this request, the exhibition did close three weeks early.)

Over Christmas 1970, Morris rethought his monumental schema and shifted to an environmental, audience-participatory construction of plywood based on a rough cardboard model he made in his studio. Writing to Compton, he described his intentions: 'Time to press up against things,

squeeze around, crawl over – not so much out of a childish naïveté to return to the playground, but more to acknowledge that the world begins to exist at the limits of our skin and what goes on at that interface between the physical self and external conditions doesn't detach us like the detached glance.'[10] Morris's essay 'Some Notes on the Phenomenology of Making: The Search for the Motivated' was published in the April issue of *Artforum,* and it seems reasonable to cross-reference between this essay and the development of his concept for the exhibition. Two themes characterize his thinking. First, a shift from a reflective spectator/object relation where meaning is determined by the optical exchange across the visual field to a haptic or tactile phenomenology of the body as it encounters the physical world – a felt and lived experience of corporeality. Secondly, a model of language based upon Wittgenstein's notion of 'language games' and including a systems theory and semiotic understanding of art's social function and the work as text.[11] With references to Morse Peckham, Ferdinand de Saussure and Anton Ehrenzweig's *The Hidden Order of Art*, and employing Pollock's gestural immersion in the process of art-making as an example of the interaction between chance and order, body and material, Morris positions art as an arena for performative play in which the active participation of the spectator completes the work. The emphasis upon 'disorientation' and the 'irrational' also opens both work and site to the unconscious, to desire and the body, a reinscription of Pollock's pictorial space as event, to an arena for the coming-into-being of work and spectator in an unstable and active field of participatory experiences: 'As ends and means are more unified, as process becomes part of the work instead of prior to it, one is enabled to engage more directly with the world in art making because forming is moved further into the presentation.'[12]

In relation to this we should also take account of Morris's choreographic work, which emphasized everyday actions and struggles as central to identity formation. Morris has recognized the influence of the dancer and choreographer Simone Forti, his first wife, on his activities in the late 1950s and early 1960s which resulted in his collaborations with the Judson Group (a name taken from the venue for performance work in New York in the 1960s – the Judson Memorial Chapel). Forti, Rainer and other choreographers and dancers also responded to Wittgenstein's emphasis upon meaning as a determinant of context in their deployment of the routine actions and gestures of everyday life in their performances. Morris's 1973 essay 'Some Splashes in the Ebb Tide' includes a photograph from a Simone Forti work, *See-Saw* (1961), which shows two fig-

ures balancing precariously on a pivoted wooden beam, a device which reappears as an element in the Tate installation. Morris ceased choreographic work in 1966 at the request of his then partner, Yvonne Rainer.[13]

If space as a performative field figures centrally in Morris's thinking at this time, he equally emphasizes the self as a temporal construct - that it is formed through real-time experience of the situated body as acting on, and acted upon by, the world:

From the body relating to the spaces of the Tate via my alterations of the architectural elements of passages and surfaces to the body relating to its own conditions . . . The progression is from the manipulation of objects, to constructions which adjust to the body's presence, to situations where the body itself is manipulated. I want to provide a situation where people can become more aware of themselves and their own experience rather than more aware of some version of my experience.[14]

A few weeks before the opening of the exhibition, Morris sent a rough drawing outlining the final design for three interactive spaces creating different physical relations between the spectators and the objects and structures which were to divide the central Duveen Galleries. In the first area were objects acted upon by the spectator – lumps of metal or stone to be heaved around or rolled over wood and metal ramps and inclined planes. In the second area it was an action or movement by the spectator that set the object in motion – timber logs or large cylinders that could be set rolling, plywood platforms balanced on large balls, or balls that could be propelled along tracks. Here the works were mutually interactive and imposed a certain choreographic pattern on the movement and gestures of the spectators. Finally, the largest space in the North Duveen Gallery was to be filled with fixed structures in which the component parts determined the actions of the participants – variations on the theme of a tightrope, double-tiered ramps which increased and decreased in height,

Robert Morris, Exhibition plan for the Tate Gallery, London, April 1971.

contorting the body as it moved up or down, and wooden crevices negoti-
ated by jamming the body, or part of the body against the structure and
using leverage to gain or lose height.

Morris intended to bricolage the installation on-site using cheap,
reusable materials and scrapyard metal.[15] In addition, he stipulated that
the only directions as to how the public should interact with the works
would come from a series of photographs placed on the gallery walls
adjacent to the relevant object or structure, demonstrating 'the possibili-
ties of each set of objects or devices'. These 10" x 14" black-and-white
images were produced prior to the public opening, using museum staff
somewhat self-consciously 'interacting' with the various assemblages. In
addition to the construction, Morris agreed to a slide show of past work,
the screening of some of his films, including *Neo Classic*, and the repro-
duction of a limited number of Minimal sculptures to be sited on the lawn
in front of the museum.

The work which most clearly prefigured Morris's final design was a
three-week installation at Leo Castelli's New York Warehouse Gallery in
March 1969 – *Continuous Project Altered Daily*. Each day Morris added
to, and acted upon, the materials, which, in their rough physicality and
random placement, resembled a building site: piles of 'matter' (dirt, clay,
sand, latex, gravel, grease, wood and cloth), moved around with a shovel,
heaped on to wooden platforms, the whole scene illuminated by hanging,
naked light bulbs. Besides the daily manipulating and redistributing of
the material, Morris photographically documented and displayed the
result of each day's labours and kept a notebook of his thoughts and
actions. This journal of the unfolding event combines a record of daily
materials and routines with an attempt to narrativize his sensory and psy-
chological reactions, which included disgust and revulsion, describing it
as 'a work of the bowels . . .' Given Morris's political and theoretical inter-
ests, this could be read as another ironic commentary upon use and
exchange value in the production of art as aesthetic object or commodity,
or a practical example of Peircian semiotics - the work functioning simul-
taneously as index, icon and symbol.[16]

Chaos is precariously near

 Anton Ehrenzweig[17]

In the fourth of his reflective essays on sculpture, the most critical of
the appropriative tendencies of the dominant culture, Morris attacks
both the commodity status of the art object and the immediate institu-
tionalization of the processes of cultural production: 'Under attack is the

Installation shot of Robert Morris's exhibition *Continuous Project Altered Daily*
at the Leo Castelli Warehouse Gallery, New York (March 1969).

rationalistic notion that art is a form of work that results in a finished product . . . The notion that work is an irreversible process ending in a static icon-object no longer has much relevance.'[18] In the same essay, Morris several times quotes Anton Ehrenzweig, and *The Hidden Order of Art* is a suggestive reference in Morris's re-evaluation of the formal and conceptual status of the sculptural object – in Lucy Lippard's memorable term, its 'dematerialization'.[19] 'The art under discussion relates to a mode of vision that Ehrenzweig terms variously as scanning, syncretistic and dedifferentiated – a purposeful detachment from holistic readings in terms of gestalt-bound forms.'[20] Published posthumously, Ehrenzweig's *The Hidden Order of Art* develops a theory of artistic creativity based upon 'depth psychology'. Taking the work of art itself as the manifest content of unconscious creative processes that avoid the formulas and restrictions of 'our normal logical habits of thinking', Ehrenzweig argues that all artistic structures are essentially 'polyphonic', and that the artistic imagination is characterized by 'unconscious scanning' – a critical form of scattered attention that selects significant elements from the unconscious psychic processes and finds resolution in their completed aesthetic form. Constantly threatened with psychosis, the artist succeeds in alternating between 'differentiated and dedifferentiated' conceptual modes.[21] The traces of chaotic fragmentation remain as a veiled presence in the work, evidence of the struggle to form and of the work of the unconscious – art's 'hidden order'.

In interviews, Morris has subsequently played down the influence of Ehrenzweig's theories on his own critical and sculptural output. However, some of the key concepts from *The Hidden Order of Art* would appear, at least partially, to contribute to the moves in theory and practice that he was making at this time. It wasn't only Morris who was interested in Ehrenzweig's writing. *The Hidden Order of Art* was an influential text for, among others, Robert Smithson, whose entropic *Non-Sites* reinterpreted Ehrenzweig's concept of 'dedifferentiation' as a relation of interior to exterior. In the British context, Richard Hamilton, Eduardo Paolozzi and the painter Bridget Riley were all closely associated with him in the 1950s and 60s.[22] Formally, the relations between figure and ground provide the conceptual basis for the redefining of the art objects' ontological status that Morris and other artists were pursuing through the late 1960s and early 1970s. Morris's Minimalist sculptures – particularly the simple grey and white polyhedrons – cast the phenomenological weight upon the slight shifts experienced by the viewer moving in relation to the object so that its primary property – shape – is constantly disturbed by a fluctuat-

ing pattern of visual moments: a restaging of the division between know-
ing and seeing, or mind and body. In a sense, these sculptures emphasized
the object as sign, the focus for a semiotic play of meanings between
sculpture, context and viewer, or, using Morris's own terms of reference
in the mid-1960s, works that claimed to be visual expressions in a
Wittgensteinian 'language game'.[23] However open the Minimalist sculp-
ture was to a textual reading – meaning produced through the visual
interaction between viewer and work – its status as physical object and
the institutional space of its reception, the museum or gallery, became for
Morris a repressive regime. Blurring the boundaries, opening the work to
the site either as the resultant effect of gravity – the *Felts*, or the random
distribution of 'stuff' – the creation of a 'visual field' as in *Continuous
Project Altered Daily* – effected a realignment in the relations between
work, viewer and space/context which introduced a more playfully libidi-
nous role for the viewer/spectator, further undermined the work's status
as the bearer of aesthetic meaning, and made explicit the legitimating
function of the institution. Morris, however, was prescient in recognizing
how rapidly any 'anti-aesthetic' became a signature style, revalidated by
the institutional framework.[24]

Controlling chaos might aptly describe Morris's performative actions
upon the brute material that he shovelled, spread, manipulated and
rearranged in the sparse warehouse environment of Castelli's gallery.
'Chance' and 'indeterminacy' define the sculptural priorities expressed in
the 'Anti-Form' essay and echo Ehrenzweig's introduction to the principle
of 'unconscious scanning': 'What is common to all examples of dediffer-
entiation is their freedom from having to make a choice.'[25] In
Ehrenzweig's argument, 'unconscious scanning' provides an explanation
– a way out – of Wittgenstein's language game paradox: how can we pos-
sess knowledge of the total system (language) when the individual ele-
ments are variable and interchangeable. We comprehend instantaneously,
yet meaning is determinable from future use. Unconscious scanning 'can
handle "open" structures with blurred frontiers which will be drawn with
proper precision only in the unknowable future.'[26] In another chapter –
'Enveloping Pictorial Space' – Ehrenzweig introduces the term 'oceanic
envelopment' to describe the viewer's experience of pictorial space and
all-over surface in American painting (he specifically mentions Pollock),
which he sees as a tension between 'oneness' and 'otherness'. In both, it is
the experience of separation essential for the forming of a coherent sub-
jectivity that inheres in all processes of representation – what is present
standing in for what is absent. In Morris's projects of the late 1960s and

early 70s, it is first the work as a coherent entity – its formal integrity – that is absented, and then, subsequently, the author/producer. (Roland Barthes's hugely influential essay 'Death of the Author' was published in 1968.) What is substituted is the notion of a 'visual field' as the site for a participatory exchange or 'process' which is determinedly fluid and non-end orientated: 'What is revealed is that art itself is an activity of change, of disorientation and shift, of violent discontinuity and mutability, of the willingness for confusion even in the service of discovering new perceptual modes.'[27]

And this is precisely what an exhibition is – a strategic system of representations.
Bruce W. Ferguson[28]

The Morris retrospective opened at the Tate Gallery on 28 April 1971. It remained open for five days and was then closed on the recommendation of Michael Compton and on the order of the Director, Norman Reid. Reid's statement, circulated to the Trustees on 7 May, listed five reasons for closure, including a number of 'minor accidents' to visitors and the possibility of a more serious incident, and the 'exuberant and excited behaviour' of some members of the public whose actions had significantly damaged a number of the installations. On 13 May, Michael Compton wrote at length to Morris, explaining in detail (he itemized nineteen separate incidents involving individual pieces and structures, and added a further five reflections upon the general public's response to the exhibition) the Tate's decision. He concluded:

In spite of all this I do not regard the show as having been a failure. I am convinced that, as well as providing the ground for a very special experience and being full of genuine invention, it posed in a particularly succinct and explicit manner some of the important issues of art. For example, the relationship of the way that groups or individuals use art to the way that it is conceived and made; the social role of the museum; the notions of freedom and responsibility in art; etc., as well as those that I expected.[29]

Six days after closure a substantially remade conventional retrospective reopened and ran until 6 June. The catalogue which accompanied the exhibition also served to supplement the historical gaps in the actual works exhibited through photographic documentation, with introductory notes written by Compton, of Morris's output during the preceding decade. The catalogue essays provided a biographical summary, also written by Compton, a description and commentary on Box *with Sound of Its Own Making* by Sylvester, a conversation between the artist and

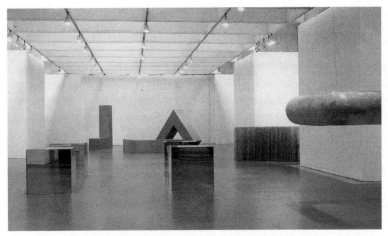

Installation shot of the reinstalled Morris retrospective
at the Tate Gallery (May–June 1971).

Sylvester recorded in 1967 and a short text by Morris, 'A Method for Sorting Cows', which had originally been a spoken element in an early choreographic work, *Arizona* (1963). One whole page of the catalogue was taken up with a reproduction of Morris's 1970 advertisement for the *Peripatetic Artists Guild*. A removable poster in the back of the catalogue illustrated Morris's final working drawing for the installation, along with photographs of museum staff interacting with the objects and structures, and a brief descriptive statement about the evolution of the design, concluding with a claim for the works as representing 'an art that goes beyond the making, selling, collecting and looking at kind of art, and proposes a new role for the artist in relation to society'.

Little serious critical attention has been paid to the Tate retrospective other than by Maurice Berger in his account of Morris's work of the 1960s,[30] and a brief reference, based on Berger, by David Antin in his essay for the catalogue for the 1994 Guggenheim retrospective.[31] For Berger, Morris's 'challenge to the repressive hierarchies of the museum'[32] was too threatening for the institution to accommodate or accept, a reaction reinforced by what Berger perceived as a uniformally negative critical response. However, reading the numerous comments and articles produced throughout the course of the exhibition and subsequently, from the art journals to the general press coverage, a more contradictory and nuanced discourse is revealed. Certainly accusations against the installation for resembling a 'gym', an 'assault course' or a 'children's playground' are repetitively narrated, but so also are issues of gender, the

body, the radical possibilities of the museum as a space of play, and the social aspects of a participatory relation between public and artwork. It is unlikely that the somewhat naively utopian claim expressed in the catalogue text anticipated the extent of anarchic engagement with the installation by many of the adult visitors (reports by museum staff suggested that the response by children, who had evidently been properly socialized into appropriate playground behaviour, more closely followed the illustrative photographs displayed in the galleries).

The most perceptive comments came from Guy Brett in *The Times* (11 May), Rayner Banham in *The New York Times* (23 May) and, much later and presumably with a specific political agenda, Edward Lucie-Smith in *Encounter* (August issue). Banham reads the audience participation against the grain of Morris's film, *Neo Classic*, whose slow rhythms of body/object interaction suggested 'a refined, gentlemanly and contemplative aestheticism'. Against this, Banham describes a carnivalesque inversion of social rules and conventions: 'by the end of the private viewing the place was a bedlam in which all rules of decorum had been abandoned as liberated aesthetes leaped and teetered and heaved and clambered and shouted and joined hands with total strangers'. For Guy Brett the exhibition represented a moment when the repressed within social life returned as a disruptive element, breaking against the public role of the museum as an authoritarian structure. Rather than catharsis, however, Brett suggests an excess of psychic release uncontainable by the regulatory regime of the institutional apparatus:

The invitation to 'participate' in a work of art is an invitation to explore sensory experiences, but the implications of participation, the relationships it creates, obviously spread out into life in general. It places art in a social context. And it makes what happens in an exhibition inevitably a part of the exhibition, even if it takes a wrong turning and becomes destructive.

Writing some two months after the final closure of the exhibition, Lucie-Smith challenged what he interpreted as the relationship of play to 'aesthetic experience'. Hanging his argument on a negative assessment of the recently published paean to a Marcusian-inspired celebration of revolutionary liberated practice, Richard Neville's book *Play Power*,[33] which, he implies, legitimated the aesthetic strategies of participatory artworks, Lucie-Smith argued that the notion of art as 'play' found its administrative equivalent in the then fashionable political discourse of 'leisure time'. 'For my own part, I am not certain that play-power in the visual arts isn't simply a new disguise for philistinism.' In this equation, 'art-as-play' is

appropriated into the hegemonic discourse around non-productive (unwaged) social activity – a reinscription of libidinal and disruptive energies into non-threatening cultural pursuits: rather the public break up the art in the museum than the museum itself. Earlier in the same article, Lucie-Smith takes a curious step into gender politics. Repeating the popular analogy of the installation as an 'assault course', he accuses Morris of a bias towards young, active males, thereby putting himself (Morris) 'at the service of physical aristocracy'.

Whether the museum and its displays are theorized as an apparatus for the ritualistic reproduction of the citizen-subject, as a disciplinary complex for the operation of power/knowledge, or as a psychic space for the dialectic of desire and the law, there is clearly a more complex economy at work than the restaging of familiar relations and oppositions between the institution, the artwork and the viewer.[34] And it is reasonable to suppose that Morris's intentions extended beyond the simple generation of dissent. Depending upon the centrality accorded to *Neo Classic* as an idealized depiction of a performative arena, and the critical texts and exhibited works that preceded this retrospective, something more oblique, reflective and ambivalent informed Morris's conception of the installation.[35] In fact, both Sylvester in his celebration of *Neo Classic* and Banham in his somewhat dismissive remarks seem to miss the complex gender politics that interweave throughout Morris's practice of the 1960s, including *I-Box*, *Site* (1964), a performance with Carolee Schneeman enacting the role of Manet's *Olympia*, and *Waterman Switch* (1965), Morris's final dance composition, performed with Lucinda Childs and Yvonne Rainer, which had Morris and Rainer covered only in mineral oil, shuffling in a close embrace along a wooden track accompanied by Childs dressed in an over-large man's suit and hat. If managing chaos is one possible definition for the work of this period, then the Tate retrospective added a heightened awareness of the instability of meaning, the exhibition complex offering Morris the possibility for resignification – for meaning otherwise. Morris's position in relation to Conceptual art remained (and remains) problematic, despite sharing many of the general concerns of the 'movement': the decentring of traditional artistic categories, a theoretically informed discourse, an emphasis upon documentation and forms of institutional critique. However, the complexly layered and varied nature of his practice, its cross-generic and inter-textual referentiality, and the recurrent theme of how the haptic signifies without being flattened in the letteral, make him a loose thread that threatens to unravel any homogenizing overview. The Tate exhibition, through its combination of

elements and interactive dimension, prefigured later examples of installation art that sit securely in the institutional spaces that they set out to deconstruct. As one branch of Conceptualism turned inward and discounted any possibility of external reference or effect, Morris's investment in the body as a site of turbulence and parody suggested a different way for art to figure the world.

A few months prior to the exhibition Morris published his most Duchampian text, 'The Art of Existence. Three Extra-Visual Artists: Works in Progress' (*Artforum*, January 1971). Superficially a description of a number of visits he made to three young West Coast 'environmental' artists, the narrative documents their work and Morris's perceptual and emotional response as he experiences various forms of sensory assault, from the 'dampness and . . . slight chill' of Marvin Blaine's underground passage, designed to maximize the visual effect of the summer solstice, to Jason Taub's sound transmissions, 'similar to what one experiences when one hears a ringing in one's ears', ending with a 'retrospective gassing' in the 'Gas Mixing and Compression Chamber' of the manically sinister Robert Dayton. Interweaving documentary and fictional narrative styles, Morris's spurious account has sufficient detail and proximity to existing artists and works to function as an ironic meta-text on the dominant themes and ideologies of post-Minimalist art. These include the status of the object *qua* object, the claims for art as a scientific-like inquiry, (there was much interest in Thomas Kuhn's book *The Structure of Scientific Revolutions*),[36] art as shamanistic ritual, or the experimental self as a body open to the physical world. That Morris himself touched upon all of these themes in his practice and theory was not an impediment to the process of critical reflection and ironic subversion. If in these fictional encounters he was projecting himself into a number of imaginary haptic situations, then the retrospective provided the context for their actual realization in the three sections of his installation. On reflection, the exhibition would appear to have allowed Morris the opportunity to combine a number of practical and theoretical interests: his commitment to the social and political character of art-making, a growing scepticism towards the museum or gallery as a neutral space for the encounter between spectator and work, an emphasis upon the semiological structure of the art system with the object functioning as a sign for value in the reception and circulation of meanings, and a shift from the making of art as a metaphor for other (alienated) forms of labour to art as play – a metonym for the embodied subject in a tactile and libidinal relation to the world.

Cleaning Up in the 1970s:
The Work of Judy Chicago, Mary Kelly and Mierle Laderman Ukeles

HELEN MOLESWORTH

Recently there has been a much-noted renewal of interest in art practices from the 1970s on the part of both artists and writers. This revival has witnessed, in the form of numerous exhibitions and publications, a considerable amount of attention paid to the feminist art of that period.[1] However, many of these retrospective stagings have continued, unfortunately, to consolidate a logic of us and them, a structure of bitter compare and contrast, an intellectual disjuncture between feminist work based in 'theory', post-structuralism or social constructionism, and work derived from the principles of 'essentialism'.

Briefly sketched, for the debate is well known, the feminism that emerged in the United States during the 1970s operated according to an empirical logic and, in a sociological tradition, was based on the daily lived experiences of women's lives and bodies. In the visual arts this translated into works that offered 'positive' images of women, explored female sexuality and focused on the biological processes of the female body such as menstruation and childbirth. There was a concentration on domesticity and women's handicrafts as historical forms of artistic expression; a reclamation of women's historical achievements; and explorations of non-patriarchal cultures and religions. American feminist theory was characterized by a presumption of equality to men under the law and geared itself towards the redress of medical and juridical inequities.[2]

Such work, however, was largely denigrated as 'essentialist' by feminists informed by post-structuralist theory, who argued that these practices presumed a cohesive identity – 'Woman' – one rooted in the facticity of the biological body. Furthermore, this work was critiqued by theorists informed by post-colonial theory and cultural critics interested in problems of race, sexuality and ethnicity for its presumption of a universaliz-

ing notion of Woman, invariably presumed to be white, which neglected or hierarchized other forms of difference.

In its stead feminists active during the 1980s offered a rather different field of inquiry for feminist practices.[3] Using linguistic-based theories, they argued against the idea that 'reality' exists *a priori* and is subsequently submitted to representation. They investigated, instead, the notion that reality is in and of itself a construction, that 'there can be no reality outside of representation'.[4] Hence woman was a social construction in need of *dis*articulation, not a solid ground on which to base an idea or a politics. These feminists investigated the ways in which representation constructed not only the idea 'Woman' but the very idea of sexual difference. Furthermore, the construction of sexual difference through representation was deemed to be instrumental in the formation of the subject, a subject posited to be structured by sexuality. The artwork produced under this rubric focused largely on how acts of representation – both linguistic and pictorial – construct meaning. They examined the production of sexual difference *through* representation as opposed to representations *of* sexual difference; they explored the role of vision, specifically access to the gaze in the creation of difference; and they explored the homologous relations between art and women as a form of the commodity fetish. And they often framed their work as an oppositional response to the work of artists in the 1970s, in that they were explicitly rejecting what they saw as works posited on an idea of an essential, biologically based, femininity.

Despite the breadth and complexity of the issues – the diversity of practices within each somewhat loosely defined 'group' – a certain reduction has taken place in the reception of 1970s feminist work, and different feminist practices have been hypostatized into an opposition, a compare and contrast often iconically represented by two seemingly antithetical artworks: Judy Chicago's *The Dinner Party* and Mary Kelly's *Post-Partum Document*, both completed in 1979. Each work is seen to be exemplary of the terms deployed by, in Chicago's case, essentialism and, in Kelly's case, a theory-based feminist practice.

How do these works exemplify the terms with which they are so often associated? Chicago's *The Dinner Party* is a triangular-shaped 'table' set atop a ceramic tiled floor on which are written in gold the names of 999 women. Each place mat bears an embroidered woman's name, a plate, silverware and a wine goblet. The plates, as is now well known, are largely vulvar in form, save the plate of Sojourner Truth, the only one to image a face. (The unrepresentability of a Black woman's sex is a frequent and

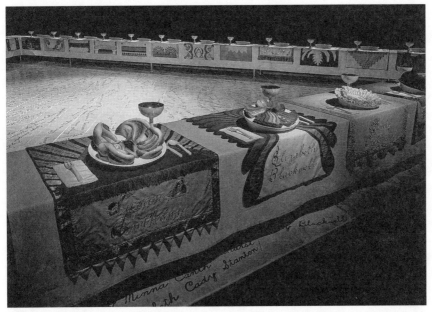

View from the Susan B. Anthony place-setting of Judy Chicago's *The Dinner Party*, 1979, mixed media. Collection of the Dinner Party Trust.

incisive criticism of *The Dinner Party*.[5]) Spectacular, oversized, abstracted and glorified cunts, the plates are in keeping with Chicago's notion of 'central core imagery'. Chicago argued that central core imagery was a specifically female form of expression – labial and circular in form – that traversed different cultures and historical periods. Hence the sensuous plates were to be a glorious celebration not only of the female body but of women's sexuality, and moreover their creative impulses, impulses traditionally channelled into women's handicrafts such as embroidery, plate painting and entertaining. The reclamation of women's history, so crucial to the second wave of American feminism, is here writ large as the plates act as commemorations of women whose historical achievements were notable. The embroidered settings and larger than life feel of the piece gave it a quasi-religious air, referencing as it does the Last Supper. The substitution of male apostles with women's highly abstracted genitalia suggests a logic of equal substitution of women for men. All of these attributes make *The Dinner Party* emblematic of 1970s feminist art.

So too Kelly's landmark *Post-Partum Document* functions as a simultaneous repository and generator of the terms largely associated with 1980s or theoretically based feminist practice. The *Document*, comprised of six

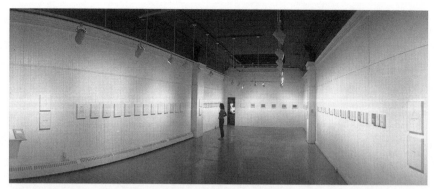

Mary Kelly, *Post-Partum Document*, 1973–9, installed at the Anna Leonowens Gallery,
Nova Scotia College of Art and Design, in 1981.

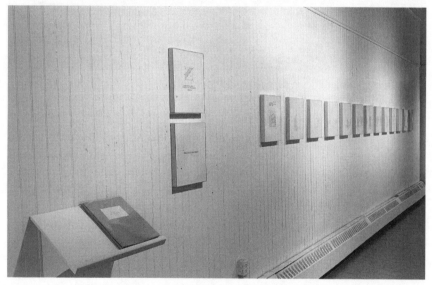

Mary Kelly, 'Footnotes and Bibliography, Diagrams and Documentation I'
from *Post-Partum Document*, installed at the Anna Leonowens Gallery.

sections, narrates the history of the artist's relationship with her son,
post-weaning until age five. The mother in *Post-Partum Document* is
never imaged pictorially only textually,[6] a strategy meant to mitigate
against the prevailing problematic of woman as object of the gaze (a gaze
presumed male). By refusing to spectacularize the female body, the
Document posited femininity as a position occupied within language,
and hence subject to the unfixed quality of signification. Using psychoan-

alytic theory as a structuring device, the *Document* sought to articulate the figure of the mother as one who possesses desire; the mother as a denaturalized and sexualized subject. In its emphasis on desire, the *Document* stages the production of sexual difference in representation, as opposed to a difference based on a biological body.

This comparison is well known to any art history student of post-1960s art, and particularly to students of feminism. It is a curious opposition as it is often asked to bear the weight of a generational split – from the 1970s to the 1980s – and a geographical split – from America to Britain – as well as presenting, equally self-evidently, the 'progression' in feminist art *from* essentialism *to* theory. The language of progress is used by members of both 'groups'. Lisa Tickner has argued that the 'adolescent vitality of 1970s feminism matured successfully into a body of rigorous 1980s art and criticism'.[7] Similarly, Griselda Pollock notes a shift from a politics of 'liberation' to a 'structural mode of analysis'.[8] And Faith Wilding, a member of Womanhouse, has described some of the early artistic experiments, particularly cunt imagery, as 'crude...precursors for a new vocabulary for representing female sexuality and the body in art'.[9]

I suppose it could be blamed on Heinrich Wölfflin. It was Wölfflin, after all, who suggested that we, as art historians, could define 'Dutch art [only] by contrasting it with Flemish art'[10] and hence initiated the discourse in the structural logic of compare and contrast. For Wölfflin, every era had its own historical style and each era subsequently built on the style that preceded it. The task of the art historian was to render these stylistic shifts into a narrative. This historical movement always took the form of progress, for while 'not everything is possible at all times',[11] styles, good ones that is, sublate the one previous to them. Certainly nothing can be known in and of itself, and Wölfflin's insightful introduction of the compare and contrast model helped to move the discipline away from the ontological logic of Kant. But the tenacity of Wölfflin's model may have more to do with contemporary art-historical debates than we acknowledge. For instance, might it be why every art-history lecture room in the country is outfitted with two slide projectors, as opposed to, say, three? And might this binarism – at the methodological, discursive and technological level – have quite a bit to do with how we think, the arguments we make, the lectures we prepare?

I am not the first to find the polarized discourse of essentialism versus theory unproductive. Many, on both sides of the debate, have questioned its premise. For instance, when the editors of *October* framed their feminist questionnaire in explicitly generational terms, and hence firmly held

the line between essentialism and theory in place, more writers than not
suggested that the framing of the debate in this manner was unproduc-
tive. Or at the least, they registered the anxiety that seemed to fuel the
desire to uphold the generational boundaries so strongly. Similarly,
among writers identified with the position deemed 'essentialist' by femi-
nists and theoreticians of the 1980s there is a fatigue with the current state
of the discourse. Mira Schor has repeatedly argued that the accusation of
essentialism is a misnomer, that artists of the 1970s were also examining
the constructed nature of their identities as women.[12] And Amelia Jones,
in her work on Chicago's *The Dinner Party*, has attempted to hold the two
seemingly untenable positions together.[13] Yet I confess I have experienced
these moments of resistance to the frame with a certain degree of dissat-
isfaction. In the attempt to broker a deal between the two, people have
often tried to read the concerns of one through the other (such is the case
with Schor and Jones); or they have seen instead a natural theoretical pro-
gression of one from the other (as both Tickner and Pollock have done).
In each argumentative strategy (in almost every instance), the terms them-
selves remain unchallenged. In fact, perversely, they remain all the more
secure.

Given the tenacity of this division and the bitterness it has engendered,
we have forgotten, perhaps, to ask the obvious question: Why is this split
a problem? For instance, why don't we simply say, 'Well, both "camps"
have stronger and weaker points,' and pluralistically be done with it? To
return to the questions of art history, raised by the spectre of Wölfflin, if
(and when) we simply roll it all into the survey under the rubric 'feminist
art', the problems of pluralism and the survey remain in place, marked as
they are by a lack of politics and assignations of value that are designed to
maintain the status quo.[14] And perhaps the most prevalent form of the
status quo is the very distinction 'feminist art'. As a separate category,
feminist art is stripped of its power. Rendered separate and distinct, and
hence easier to marginalize, it is unable to modify, and possibly trans-
form, our definitions of other artistic categories.[15] This bitter division has
disallowed articulations of the connective tissue between these works and
the putatively 'dominant' conversations being conducted simultaneously
in the art world. By continually rehearsing the theory/essentialism
debate, only to choose sides at the end, we have disallowed other form-
ations to arise. In other words, the division maintains, rather than
expands, the rather limited range of feminist theory that operates in the
art world. After all, there are feminist theories other than Anglo-
American empiricism and continental theory; and the chasm between

them has been navigated in other fields, most notably by theorists of political philosophy, and their arguments may be telling for us now.

Moira Gatens has staged the feminist debate in terms of those who privilege a model of equality and those who think in terms of difference. These terms are analogous – although in no way transparent – to the essentialism/theory split inasmuch as 'theory', in this context, has largely meant psychoanalytically based work on subjectivity, which has foregrounded the notions of sexual difference as opposed to biologically determined bodies. Those deemed 'essentialist' have foregrounded women's unique characteristics – often stemming from biology – but have largely insisted upon women's equality to men. Gatens astutely problematizes both positions.

In *Feminism and Philosophy* she begins by dismantling the idea of equality. She argues that the problem with the model of 'equality in the public sphere is that the public sphere is dependent upon and developed around a male subject who acts in the public sphere but is maintained in the private sphere, traditionally by women. This is to say that liberal society assumes that its citizens continue to be what they were historically, namely male heads of households who have at their disposal the services of an unpaid domestic worker/mother/wife.'[16]

In other words, she suggests that the political realm within which women struggle for equality must be disarticulated, not presumed *a priori* to be a 'neutral' system (for instance, democracy) except for *its inability to grant women equality*. Rather, she argues that the system itself is structured *on* the inequality, hence 'equality in this context can involve only the abstract opportunity to become men'.[17] This structural dependence upon inequality has been naturalized as the public and private spheres have been used to shore up distinctions and inequities between men and women, particularly in that the private sphere has been 'intricate[ly] and extensive[ly] cross-reference[d]with the body, passions, and nature'.[18] This critique of equality uncovers a structural problematic within liberal thought by exposing the very notion of equality and its symbolic representation in the public sphere as historically dependent upon the unacknowledged (and unequal) labour of the private sphere.[19]

Yet Gatens is also suspicious of the move from a naturalized discourse of equality to the discourse of difference. She argues that feminist writing and art practice, after freeing themselves from the tyranny of nature, took up explorations of female sexuality. She warns, however, that such a move runs the risk of reducing women's subjectivity to their sexuality. While her critique is sympathetic to the critical feminist exploration of psychoana-

lytic models of subjectivity that are fundamentally rooted in sexuality, she counters the structural and ahistorical logic of the discourse by submitting it to a Foucauldian analysis that permits us to see the body as 'an effect of socially and historically specific practices'.[20] She would rather entertain a 'multiplicity of differences', arguing that 'to insist on sexual difference as *the* fundamental and eternally immutable difference would be to take for granted the intricate and pervasive ways in which patriarchal culture has made that difference its insignia'.[21] She is wary, then, of feminists who place sexuality (as the extension or outcome of sexual difference) centre stage, both at the level of the discourse and with regards to a model of the subject. One thing Gatens's admonition might reveal is the extent to which *both* 1970s and 1980s feminist work explored issues of sexuality to the exclusion of other attributes of subjectivity and also to the exclusion of political philosophy's critique of the role of the private sphere in the democracy-capitalism nexus.

I want to try to rethink, or rather, think outside of, the seemingly uncrossable chasm of essentialism versus theory that plagues the art historical-discourse with regards to feminism, and I want to do this by undoing the iconic compare and contrast of *Post-Partum Document* and *The Dinner Party* with the work of Mierle Laderman Ukeles. If her work helps to triangulate the theory/essentialism binary, then it does so by shifting the terms of the discussion away from both the essentialist/juridical nature of the subject in Chicago's work and the psychoanalytic description of the subject in Kelly's work. The alteration of the field of discussion made possible by the inclusion of Ukeles's work means that theoretical questions of public and private come to the fore, specifically with regards to the problematic of labour. I am not suggesting that the problematic of the public and private sphere is not present in *The Dinner Party* and *Post-Partum Document*. Rather, I am suggesting that the essentialism/theory debate has occluded their importance and has disallowed the debate to be framed in terms of *political* economy as opposed to a bodily or psychic one.

So let's return to the problem of three slide projectors. In an imaginary classroom three images are projected: *The Dinner Party*, *Post-Partum Document* and *Maintenance Art Performances*, all offered as exemplary works produced in the 1970s under the general rubric of feminism. In her 1969 'Maintenance Art Manifesto', Ukeles divided human labour into two categories: development and maintenance. Development corresponds largely with Modernist notions of progress and individuality, while maintenance, on the other hand, is the realm of human activities

that keep things going – cooking, cleaning, shopping, child-rearing and so forth. In this manifesto she proposed living in the museum and performing her maintenance activities. While the gallery might look 'empty', she explained, her labour would in fact be the 'work'.[22] In 1973 the *Maintenance Art Performances* were conducted by Ukeles in the Wadsworth Athenaeum in Connecticut. In *Hartford Wash: Washing Tracks, Maintenance Inside*, Ukeles scrubbed and mopped the floor of the museum for four hours. In *Hartford Wash: Washing Tracks, Maintenance Outside*, she cleaned the exterior plaza and steps of the museum. She referred to these activities as 'floor paintings'. In *Transfer: The Maintenance of the Art Object*, she designated her cleaning of a protective display case as an artwork (a 'dust painting'). Normally this case was cleaned by the janitor, but once it was designated as 'art' the responsibility for the cleaning and maintenance of this case became the job of the registrar. The fourth performance, *The Keeping of the Keys*, consisted of Ukeles taking the museum guards' keys and locking and unlocking galleries and offices, which when locked were subsequently deemed to be a work of 'maintenance art'. In each performance Ukeles's role as 'artist' allowed her to reconfigure the value bestowed upon these otherwise unobtrusive maintenance operations, and explore the ramifications of making maintenance visible in public.

This triangulation of the field with a work that falls outside the terms of either 'camp'[23] pulls into focus different aspects of each of the other works. Instead of seeing the stark contrast between, let's say, Chicago's cunt-based central core imagery and Kelly's pointed refusal to represent the female body, we might see that all three deal in varying degrees with putatively 'private' aspects of women's lives and experience: motherhood, cleaning, cooking and entertaining. Similarly, instead of first seeing the strong contrast between the diagrammatic aspect of Kelly's work and the lush tactile quality of Chicago's, we might see instead the inclusion of text in all three pieces. The women's names which cover the floor and place settings make reading integral to viewing *The Dinner Party*. Likewise, Ukeles's works contain charts, posted announcements and the 'Maintenance Art' verification stamp. So too the performative nature of Ukeles's work helps to spatialize our understanding of all three works. Given that a wide variety of artistic practices of the 1970s were engaged in challenging the privileged role of vision in aesthetics and perception, especially as described by critics like Clement Greenberg and Michael Fried, when we look at these three works we can see that they were all directly engaged with the most 'advanced' artistic practices of the day:

Detail from Mierle Laderman Ukeles,
*Hartford Wash: Washing, Tracks,
Maintenance Inside*, performance at the
Wadsworth Athenaeum, Hartford,
Connecticut, 22 July 1993.

Detail from Mierle Laderman Ukeles,
*Hartford Wash: Washing, Tracks,
Maintenance Outside* at the
Wadsworth Athenaeum.

Detail from Mierle Laderman Ukeles,
*Transfer: The Maintenance of the Art
Object*, performance at the
Wadsworth Athenaeum, Hartford,
Connecticut, 20 July 1993.

that is, Minimalism and Conceptual art. They were in the process, as well, of forming the practice of Institutional Critique. If these three artistic movements took as part of their inquiry the institutions within which art is encountered, then Ukeles's explicit address of the museum, and the objects encountered within it, serves to highlight the shared concerns of *The Dinner Party* and *Post-Partum Document* as objects destined for the museum/gallery nexus.

It is precisely the public nature of these works to which I would now like to turn. Ukeles's performances articulate the tension between public and private realms of experience. Yet by renaming domestic labour (read private, read natural) 'maintenance', she elaborates upon the structural conditions of the relations between public and private spheres. It is the hidden nature of this labour that permits the myth that the public sphere can function as a site devoid of interest. However, by staging such labours in the museum, a traditional institution of the public sphere, Ukeles's work establishes maintenance labour as a subject for debate. For, as Rosalyn Deutsche has argued, 'What is recognized in public space is the legitimacy of debate about what is legitimate and what is illegitimate.'[24] (It is the very publicness of art, art's traditional reliance upon a public sphere for its legibility and value, that makes art such a rich terrain for feminist critique.) Hence Ukeles's performance of maintenance activities, in full view of the museum and its visitors, opens public space to the pressures of what it traditionally excludes. Kelly's and Chicago's work does this as well, at the level of explicit content. But when Ukeles's renames domestic labour 'maintenance' she underscores the public sphere's *structural* reliance upon private/domestic labour. This is to say, she uses ideas and processes usually deemed 'private' in order to open institutions and ideas usually deemed 'public'. This gesture is not only in obvious sympathy with the 'personal is political' but, more incisively, supports political philosopher Carole Pateman's contention that 'the public sphere is always assumed to throw light onto the private sphere, rather than vice versa. On the contrary, an understanding of modern patriarchy requires that the employment contract is illuminated by the structure of domestic relations.'[25] In other words, one legacy of feminist criticism is to establish that it is the private sphere (and the potential impossibility thereof) that can help us to rearticulate the public sphere, as opposed to the other way around. Ukeles's exposure of this structural problematic animates the content of labour in both *The Dinner Party* and *Post-Partum Document*, pulling these works away from their more traditionally ensconced interpretations.

Art historian Frazer Ward has argued that public/private negotiations are perhaps the structuring problematic of post-Second World War art.[26] That being said, to read this work in these terms is to establish its links to, as opposed to its separation from, other post-war art practices. If Minimalism can be seen to be the most elaborated investigation of the art object's dependence upon a traditionally defined public site, in that it asked viewers to articulate their bodies' relation not only to an object but to the room in which that object was encountered, then Chicago's repetitive formal structure, her use of the triangular-shaped table and her similar fetishism of surface and texture show her to be in dialogue with Minimalism.[27] However, Chicago obviously has imported content into these otherwise formal structures. Specifically sexed bodies are offered as opposed to the generic body posited by Minimalism's dependence upon phenomenology, and the supposedly private nature of genitalia, specifically the vagina, is rendered spectacularly public. So too historically under-recognized forms of domestic and decorative craft replace the lure (and perhaps just barely veiled decorative aspects) of industrial production. If Minimalism asked for a consideration of the logic of repetition in Donald Judd's oft-quoted 'one thing after another', then a reading of *The Dinner Party* through a hermeneutics of maintenance suggests that the logic of repetition may be equally dominant in the perpetual labours of cooking, eating and cleaning up: the women's work that is never done. (Work, it should be noted, that is conspicuously absent in *The Dinner Party*, suggesting that the problem with Chicago's work might not be essentialism as much as an underdeveloped relation between public and private.) And if Minimalism asked its viewers to distinguish what in the room was not sculpture, then *The Dinner Party* potentially asked viewers to articulate what in the room existed in the realm of the private and what belonged in the realm of the public?

If Chicago registered the porosity of the realms of public and private by turning Minimalism inside out then Kelly performed an homologous operation upon the terms of Conceptual art. Conceptual art followed upon Minimalism's investigation of the public quality of art in part by replacing spatial and visual experience with a linguistic one, what has been called 'the work as analytic proposition'.[28] This analytic proposition meant that the art object could be radically deskilled, potentially democratizing art's production. However, Frazer Ward has argued that while Conceptual art 'sought to demystify aesthetic experience and mastery ('Anybody can do that'), [it] maintained the abstraction of content crucial to the high Modernist art,' hence, 'if Modernist painting was just about

painting, Conceptual art was just about art'.[29] Like Chicago's exposure of Minimalism's abstract viewer, the explicit content of *Post-Partum Document* serves to bare the abstraction of Conceptual art. A large component of *Document*'s content comprises graphs and charts that serve to represent the labour of childcare, labour normally occluded in capitalist cultures. One effect of the category of the mother as essential, biological is to naturalize this labour, rendering it outside social conditions, such as a salary. (*Document* emerges around the time of the idea of the 'working mother', as if mothering weren't already a form of work.) In *Document* Kelly disallows the labour of motherhood to be naturalized and, in Gatens's words, 'cross referenced with the private'. Instead she submits this labour to the public and social languages of work and science. And in so doing *Document* countermands Conceptual art's maintenance of abstract relations between public and private realms which disallows its continuation of a Modernist paradigm of art for art's sake. (Indeed, if one of the primary responses to Modernist painting is, 'My kid could do that!' or, 'What is that crap on the walls?', then Kelly's inclusion of her son's soiled diapers offers a humorous meta-commentary on the possible relations between Conceptual art and Modernist painting.) Kelly's insistence upon the content of maintenance labour also allowed her to address the institutional site of the museum, in that it allowed her to represent two forms of labour – artistic and domestic – both of which debunk the myths of non-work that surround both forms of reproduction (artist as genius, mother as natural). *Post-Partum Document* stages the relations between artistic and human creation as analogous, and by doing so interrogates the boundaries between public and private realms of experience. And if Conceptual art has an 'Anyone can do it' premise, then Kelly's work suggests that the same is true of the labour of mothering.

As I have already suggested, it is Mierle Laderman Ukeles's *Maintenance Art Performances* that stage, most explicitly, the structural relations between the putatively private, unpaid or underpaid labour of maintenance and the supposedly disinterested space of the public sphere. If Chicago and Kelly can be seen to engage with the public discursive fields of Minimalism and Conceptual art, then Ukeles's direct address of the museum places her work as one of the early instances of Institutional Critique. Ukeles took the usually hidden labour of the private sphere and submitted it to public scrutiny in the institutions of art. But by doing so she exposed the muddiness of the waters that separate public and private, as her performances demonstrated that the work of maintenance is neither exclusively public nor private; *it is the realm of human activities that*

serves to bind the two. Yet when this bonding is exposed, it disallows the 'proper' functioning of the public institution. Ukeles's performances dramatize that when maintenance is put front and centre, made visible, given equal value with, say, art objects, the museum chokes and splutters. For instance, in *The Keeping of the Keys*, Ukeles wreaked havoc on the museum's normal workday. The piece so infuriated the curators, who felt that their offices and floors should be exempt, that when Ukeles announced that their office was to become a piece of 'Maintenance Art' all but one ran out of the office, fleeing both the artist and their own work. So too in *Transfer* Ukeles's exposure of maintenance added a cog to the wheel of the museum's normal procedures, creating extra work. The work stoppage or increase that resulted from the systematic privileging of maintenance work over other forms of work shows, as Carole Pateman has argued, how absolutely structural it is to patriarchy and capitalism that the labour of maintenance should remain *invisible.* When made visible, the maintenance work that makes other work possible arrests or stymies the very labour it is designed to maintain.[30]

I have been arguing that the aspect which binds these three works together is their address to the public institutions of art. By importing explicitly domestic or private content (like Chicago and Kelly) or by substituting the notion of domestic labour with maintenance labour – and, even further, maintenance labour with art – (like Ukeles) all three artists explore the interpenetration between public and private institutions. This is notable, for in each case the various institutions of art have wanted precisely to suppress the public address of the works. This is why, for instance, the attack of kitsch is launched against *The Dinner Party*, for Chicago has smuggled the decorative and the domestic into the Modernist museum. So too the familiar disparagement of *Post-Partum Document* that it should 'be a book' is a desire to deny its place in the public space of the museum, to disallow the non-naturalness of motherhood as a legitimate public discussion. Finally, and perhaps most telling of all, the Wadsworth Athenaeum kept no records of Ukeles's *Maintenance Art Performances*, perhaps proving Miwon Kwon's observation that when the work of maintenance is well accomplished it goes unseen.[31]

Another aspect that binds these works is that they all participate in what Fredric Jameson has called the 'laboratory situation' of art.[32] All three works submit various 'givens' about the way the world works to a type of laboratory experimentation. For instance, the body and perception are questioned by Minimalism; the status of the art object is queried by Conceptual art; and the regimes of power embedded in the museum

are articulated by Institutional Critique. Yet I would contend that these artists add yet another layer to these 'laboratory experiments', for embodied in each work is a proposition about how the world might be *differently* organized. Woven into the fabric of each work is the utopian question, 'What if the world worked like this?' Chicago offers us the old parlour game of the ideal dinner party, and suggests that the museum could be a site for conviviality, social exchange and the pleasures of the flesh. Kelly's work intimates the desire for a culture that would bestow equal value upon the work of mothering and the labour of the artist; so too the work's very existence points towards a different model of the 'working mother'. Ukeles's work, again, may be the most explicit in its utopian dimension, its literalness a demand beyond 'equal time equal pay' or the 'personal is political', for hers is a world where maintenance has value equal to art – a proposition which would require a radically different organization of the public and private spheres.

Feminism has long operated with the power (and limitations) of utopian thought. It is telling, then, that these artists have dovetailed the 'what if?' potential of both art and feminism. Yet in doing so they have not collapsed the distinction between art and life; rather, they have used art as a form of legitimated public discourse, a conduit through which to enter ideas into public discussion. So while all of the works expose the porosity between public and private spheres, none calls for the dismantling of these formations. Fictional as the division might be, the myth of a private sphere is too dear to relinquish[33] and the public sphere as a site of discourse and debate is too important a fiction for democracy to disavow. Instead what these artworks have articulated is something similar to the utopian thought of feminists like Moira Gatens and, more recently, Drucilla Cornell. Gatens argues:

To effect the total insertion of women into capitalist society would involve the acknowledgment of the 'blind spot' of traditional socio-political theorizing: that the reproduction of the species, sexual relations and domestic work are performed under *socially constructed* conditions, not natural ones, and that these tasks are socially and economically necessary.[34]

She suggests a new model of the body politic, one that would be able to account for the heterogeneity of its subjects and their asymmetrical relations to reproduction, sexuality and subjectivity.

Such utopian language is vague and for some time now, it seems, this vagueness has produced frustration or dismissal. However, this is a utopian language without the problematic proscriptive nature of prev-

ious utopian thought. Similarly, it is not a theoretical language that ceases and desists with a description of a system or an ideology. Instead, it offers *speculation*. At the end of *Feminism and Philosophy*, Gatens calls for representations, both symbolic and factual, of future conceptions of socio-political and ethical life. So too, in *At the Heart of Freedom*, Drucilla Cornell writes, 'There is a necessary aesthetic dimension to a feminist practice of freedom. Feminism is invariably a symbolic project.'[35] It is within the tradition of art as a laboratory experiment that Chicago, Kelly and Ukeles engage in a speculative form of feminist utopian thought, each attempting to rearticulate the terms of public and private in ways that might fashion new possibilities for both spheres and the labour they entail.

That this work has received the renewed attention I commented upon at the beginning of this essay is perhaps due to the problems of labour that shape our current public sphere: from the 'end' of the welfare mother to home officing; from the new threats to privacy made possible by the ever-expanding role of the Internet in the lives of people in developed nations to the multinational corporate reorganization of public space. These issues seem to run through the fabric of our daily lives with astounding thoroughness. If the politics of the 1970s were marked by various battles for equality, and the politics of the 1980s were shaped by struggles over the politics of representation under the Reagan/Thatcher nexus where the spectacle reigned supreme, then the core of contemporary politics may be shaped largely by the reciprocity and contested relations between the public and private spheres and the emerging forms of labour that support them. Ironically enough, dormant within the artwork of both sides, yet occluded by a logic of binary opposition, suggestions for the future abound.

Conceptual Art History or,
A Home for Homes for America

DAVID CAMPANY

The notion that photography has made art history possible is far from new. Indeed it is only slightly younger than art history itself, which grasped the structure of its reproductive condition almost from the outset. But it has never been a firm grasp. To ask of art history that it remain aware of its historical and contemporary dependence on photography is really too tall an order, too intrinsic a proposition. Photography remains something of a founding disavowal that lets art history function. Of course, the repression is never complete. Lodged in art history's preconscious, photography not only allows for the reproduction of art but by forming the field which will offer it an identity, also structures the conscious genesis of the artwork itself. The repression is never permanent either. Recognition of the dependence on photography will surface intermittently. We could see the writings of Walter Benjamin, André Malraux and even Jean Baudrillard as just such varied eruptions. Yet it is clear that they are only temporarily troublesome. Indeed they are an essential part of art history's delusion of self-knowledge. They are the essential moments when art history is forced to utter that 'it knows very well' and which then allows it to add 'but nevertheless'. It throws itself into crisis only to recover itself once more. But not forever.

As a consequence of this position as regards the foundation of art history, locating the moment of the *art photograph's* modern self-reflection within art history has never been a straightforward matter. Foregrounding a set of internal, formal criteria (the description of surfaces and volumes, the articulation of instants, the figuring of the quotidian), post-war art offered the photograph a place within the given configuration of high Modernism. But by the mid-1960s, different artists had become interested in different characteristics of the photograph. Or

rather, vanguardist criteria for art shifted to other potentials of the medium.[1] Unique capacities to inhabit the page alongside the word, to question objecthood and to form the very basis of the twentieth-century visual culture were thought to be at least equally characteristic. Two closely related ontologies, one stemming from high Modernism and the other from what has come to be known as Conceptual art, produced two closely related but fundamentally asymmetrical moments of photographic auto-critique.[2]

I want to suggest that a range of practices that might collectively be called photo-Conceptualism forced photography to confront its own constitutive heterogeneity, prompting an interrogation *within* art of a medium that wasn't really defined *by* art. Through an embrace of the photograph's broader social functions, Conceptualism revealed among other things the conventions by which modern art photography had been characterized. It edged towards an acknowledgement of the way in which photography performs two potentially incompatible functions within the discourse of art: it is at once an art form and the artless mass medium by which all other art forms are reproduced and disseminated.[3]

Prior to Conceptualism, modern art had affirmed the photograph's credentials almost in opposition to its ubiquity as a mass medium synonymous with the page. Yet its success depended in no small part on the book, in the form of catalogues and monographs. Modern art photography staked its claim as a valid and discrete form by positing the page as a neutral context, as a space simply to view its images. The art photograph could occupy the page but it would rarely address it directly as a site or connect its luxury with the printed page at large. While the photograph was the high art form, the book was usually but its forum. The consequences of this are significant and bear directly on the assumptions of both art photography and photo-Conceptualism, so elucidation is needed before I can consider in more depth some of the functions of photography in Conceptual art.

For structural reasons the photograph could not realistically hope to achieve the condition of the painting within Modernism. It was marked by an indexicality that was diametrically opposed to the modern desire for transcendence and autonomy. The notion that, as with the canvas, the camera could be a repository for the expression of instinctive ahistorical creativity with little cultural function outside itself was untenable from the outset. Even Clement Greenberg knew this well. In a review of a 1946 exhibition of photographs by Edward Weston, the rationale that each medium should do what it 'does best' was applied directly to the photo-

graph with an assertion that it concentrate its efforts on social representation. Appealing to the photograph's distinct and exemplary handling of the anecdotal, Greenberg declared, 'Let photography be "literary"', hinting as much at the cultural and historical connection with the page that the photograph shares with the word as at its indexicality.[4] Photography for Greenberg could never be disconnected or disinterested. Photographs and words are explicitly tethered to the world and implicitly tethered to each other. While the modern canvas aspired to express an autonomy identical with the space in which it hung, the transcendent gallery containing the transcendent work like a Russian doll inside its own image, the photograph couldn't hang there in anything like the same way. The brush-stroke or drip could be made to attempt an indexing of pure subjectivity, but the photograph could only begin to conceive of doing likewise by first indexing the world in which subjectivity is bound. (In truth this was much the same for painting, but the myth held out a little longer for that medium.) This goes some way towards accounting for why it was that the photographic works contemporary with high modern painting that were placed in the firmament of Modern Photography are either excessively descriptive or supremely anecdotal, yet borne of the development of signature styles within wider group styles that are comparable in some ways to movements in other art forms. The technically obsessive f64 group, which included Weston, and the art-photojournalism of the Magnum photo agency typified by Henri Cartier-Bresson represent modern photography's two possible poles. It is not that Greenberg's pronouncement on the medium had much bearing on the place and character of the photograph in modern art, but it illustrates how the extension of the ideology of North American Modernism to photography, with a so-called 'truth to materials' and an over-determined sense of artistic subjectivity, fosters particular kinds of imagery. After the imitation of the painterly image by photo-pictorialism, it was either technical preoccupation with detail, filtered through signature style and expressed in the laboured fine print, or vicarious geometries snatched from the everyday that were the calling cards of modern photography.

Opting for a formal definition of essence allowed art photography to busy itself with 'things themselves, details, frames, time and vantage points' to paraphrase John Szarkowski, one-time director of photography at New York's Museum of Modern Art.[5] It also allowed the medium to flourish by exploiting the coming era of mass consumption via the book. It almost goes without saying that many of the key moments in the history of photographic art are *publications* rather than exhibitions, and

that Szarkowski's years at MoMA mark an art photography publishing boom as much as a defining curatorial policy.[6] However, the separation of photography as a depictive high art from the grubby world in which it originated needed careful management. With a relentless avoidance of textual elaboration and a graphic isolation of each image in a buffer of whiteness on a single page, landmark books, from Walker Evan's *American Photographs* of 1938 to Robert Frank's *The Americans*, published twenty years later, offered beautifully alienated commentary on a continental slide towards spectacular consumer society without invoking their own medium as one of its prime agents.[7] This was so even when art photography embraced photojournalism directly. The art of the Magnum photographers, for example, incorporated an active notion of reproducibility into its conception by drawing on primary print sources to constitute exhibitable art, but the detextualized and decontextualized gallery and book presentation kept the commercial and artistic functions of the photographs well apart.

While the works produced by modern painting and modern photography had little in common outside of an assumed maximizing of the potential of their own substrate, the paths of each were inflected by similar cultural and economic changes in the post-war years. Just as vanguard fine art turned over the course of two decades from the subjective specifics of Abstract Expressionism to the purged, industrial anomie of Minimalism, so art photojournalism became more fixed and procedural in its own way. Street photography became a discrete genre with its own dynamics and rhythms, which were expressed both in art and in the ever-expanding field of editorial work. Through a hardening of idiomatic conventions, the styles of, for example, Gary Winogrand, William Klein and Danny Lyon, as well as many of the Magnum photographers, became almost indistinguishable. While sharing a particular aesthetic, each photographer came to be identified more by a signature content or subject matter than an individual style. So despite the almost total lack of dialogue, consumer society structured important parallels between the forms of modern art photojournalism and the minimal sculptural work of Carl Andre, Dan Flavin and Donald Judd. There were loosely shared approaches, individual uses of generic content and, most critically, a closer set of relations to mass production – of *objects* for Minimalism, of *imagery* for the concurrent photographic art. And it may be productive to see this similarity as the backdrop for art's more direct engagement of photography in the latter half of the 1960s. While photography had been spliced directly into contemporary art for the first time by Pop, it was

Conceptualism that subjected the industrially regularized photograph to the most sustained scrutiny.

The understanding of photography by art bifurcated quite clearly at the moment when its radical plurality began to insist. While Conceptualism is currently offered an increasingly significant (if neutered) place in new art histories, it is no surprise that it rarely registers in the mainstream histories of art photography that defend purity against an overwhelming tide of 'use'. This is a symptom of the slippery but obstinate distinction between 'art photographers' and 'artists using photography'. In the US and Europe the rift was as institutional as it was aesthetic or discursive. There were college art photography courses led by art photographers and there were much less well-equipped, and much less medium-specific, art courses led by artists. And each had its own network of display and dissemination. The thorough examination of the worldly photograph by Conceptualism was conducted in the main by artists who often didn't really give a fig for the medium as defined by Modernist criteria. For many, photography seemed the best means to several ends and the critique of specialized art photography occurred almost as a by-product. While getting on with the formulation of new questions and the eschewing of historically loaded media, Conceptualism cast its shadow over the small but well-guarded terrain of art photography, leaving it to become marginalized from vanguardist art practice at the turn of the 1970s.

It was for several reasons that photography became the medium of choice in the shift from high aestheticism to a concern with the status and social function of art. The medium was polymorphous, available, popular and easy. It also seemed to have a less qualified and less historically proscribed relation to the word than other media, so it could be harnessed in the challenge to the separation of image from language and the making plain of art's textual mediation. The argument that art was always learned could be made most readily – as theory and as art – through photographs and text. So it is with a degree of inevitability that the attempted break in the division of labour between art and art theory, if not in the distinction between the two, involved many figures pursuing both enterprises in the same photo-text substrate.

While some artists began to subsume all activity (from eating and talking to writing and exhibiting) under the umbrella term 'practice', others maintained a distinction between art and theory but opted for what Victor Burgin had called a 'complementary' rather than 'supplementary' relation between the two, even when both took the form of photographs and text contained within the covers of a single publication. Burgin's

Victor Burgin, 'Performative/Narrative', 1971,
photographs and printed text on paper, as reproduced in
Work and Commentary (London, 1973).

Work and Commentary (1973), for example, comprises a set of theoreti-
cal statements and a separate set of textual and photographic works.[8] The
theories would be digested and assimilated in order to then experience the
new complexities and concerns of the work. The inherently social charac-
ter of the word and photograph could be used to introduce audiences to
thinking about not just new meanings but the structures of meanings
both new and old. This is why so much work of the period looks disarm-
ingly simple. It plays down rarefied and exclusive aesthetics but often
attempts to discuss or invoke them on some level at the same time. Ideally
the audience would become and remain aware of the social and participa-
tory nature of the engagement with art. With the critique of Modernism's
assumption that interpretation occurs according to self-evident and uni-
versal criteria, the experience of art was 'denaturalized'. It became
expected that each artwork, artist's oeuvre or group practice would come
with an attendant theory or rationale (presented either on the wall, or
more commonly, as leaflets). In Conceptualism the act of learning within
art became much more explicit and demanding as artists and their audi-
ences became theorists too, not just of art but of communication in gen-
eral. One peculiar and not unamusing effect of this foregrounding of
textuality was the proliferation of desks in Conceptual art. As the desk
became a compound site for making, seeing, writing and reading about
art, it was perhaps inevitable that it would be actually included in art-
works as either photographs or installations. This prosaic and socially

hybrid item of furniture, belonging equally to home and office, public and private, studio and gallery, appears in a number of works by Burgin (*Performance/Narrative, Gradiva, Olympia, Hotel Latone* and *Office at Night*) and, among others, Joseph Beuys, Douglas Huebler, Mel Bochner, Robert Cumming, Robert Barry, On Kawara, Art & Language, Joseph Kosuth, David Lamelas, Dennis Oppenheim, Adrian Piper and William Wegman.[9] As an adaptable signifier of mental labour, the desk could highlight the solitary yet social work that had been performed by the artist and indicate the work that needed to be performed by the viewer. And as a theatre of interpretation it could set up the book as a mean term between the two.[10]

While some Conceptualists were unable to fully relinquish either the visual or the physical in the name of dematerialized 'ideas', other practitioners such as Ana Mendieta and Adrian Piper were unwilling to do so, embracing them as a focus for a politics of difference structured through the body. Either way, learning via the photograph's ambivalent status as both art object and teaching aid became a new mode of experiencing art, and the social acts of reading and cognition became aesthetic and sensual. A correspondence with Roland Barthes's programmatic 'corporealizing' of the reader seems clear from such a perspective. The European semiotics that was simultaneous with Conceptualism developed similar ideas around the linguistic legibility of the photograph and the body as text. Barthes's writings were prime among these. As with the printed coexistence of text and image on the page in photo-Conceptualism, so the two elements could also be found together in theoretical texts where again the argument for an implicit relation of the image to language was not just made but expressed in printed form. The texts actually contained, as well as referred to, the mass-produced photographic imagery under study. It is intriguing that the format of a set of essays like Barthes's *Image-Music-Text* and many others have so much of the flavour and aesthetic of much Conceptual art: low-quality, generic mass-media photographs discussed in catalogue-length essays, with text and image present both to the page and to each other.[11] Although Barthes's collection didn't appear until 1977, the comparison seems less forced given that his essay 'The Death of the Author' was been first published in English in *Aspen*, 5–6, in 1967.

Later, when Barthes moved to a Post-Structural discussion of the affective phenomena of specific photographs in *Camera Lucida* (1980), the print presentation of his texts also changed. As the writing became more literary and speculative, the type was set less densely with wider margins. And as the theoretical position shifted, so did the choice of

Double-page spread from Roland Barthes, *Image-Music-Text* (1977).

Double-page spread from Roland Barthes, *Camera Lucida* (1980).

imagery. Presented spaciously on single pages, *Camera Lucida*'s pho-
tographs came less from mass-media magazines and newspapers and
much more from the distant visual cultures of the nineteenth century as
well as from genres of portraiture. Barthes's disclosure in the book that
the choices were made by 'browsing' suggests an approach equally appro-
priate to the open-ended act of looking through books of pictures or

books of words. By the late 1970s art photography publishing had flour-
ished, but was still dominated by an older Modernist aesthetic and by the
trawling of photography's early decades. If he had been browsing in the
burgeoning field of the photographic art book, this is the kind of imagery
he would most readily have found. It can be made to suit solitary perusal
in book form, fostering an internalization of the privatized psyche in the
act of reading and looking alone. Over a desk. Barthes looks at the pic-
tures and writes, the viewer reads and looks. The public field of mass-
media imagery that had been subjected to structural and ideological
analysis rarely fosters this monadic intensity. The *Panzani* advertisement
for an 'Italianized' range of foodstuffs which had famously served an
account of the social structures of signification wasn't really going to pro-
voke the mournful reverie or the pricking of consciousness that Barthes
associated with the supremely isolated, book-based image.[12] Away from
the flux of commerce, *Camera Lucida* carves out a space of existential
abstraction (the debt to Sartre's *L'Imaginaire* was explicit). The discus-
sion is of imagery that seems to belong there on the page opposite the text
and only secondarily to the world. The page becomes the context of inter-
pretation as well as its site. Writing, reading, looking and interpretation
all fall into the same space, while Barthes's first-person narration is the
glue that seals the four to each other and to the paper. Appearing at the
emergence of photographic Post-Modernism, *Camera Lucida* somehow
assumes the task of a kind of overview of the dynamics not so much of the
classically modern photograph but of its mode of mediation.

Conceptualism was in many ways closer in spirit to Barthes's readings
of the socially imbricated rather than isolated image. The use of everyday
photography and text tended to connect the page to mass culture, rather
than rescue it. But this colonizing of the page was by no means straight-
forward. This is Victor Burgin in 1988, tracing his own post-Conceptual
trajectory with a remark that points to the complex position art public-
ation has occupied since the early 1970s:

When I was doing most of the work in *Between* [collected work and texts, 1987],
I was thinking, 'Well, I don't know who goes into the galleries anymore. All I do
know is that there are a lot of people who subscribe to the same magazines that I
subscribe to. So I'm going to make work for them'.[13]

Perhaps Burgin opted for the term 'subscribers' rather than the more
casual 'readers' to accommodate the way in which the consumption of
print was becoming much more integral to the experience of art culture.
As a specialist the subscriber misses nothing. Nevertheless, for many the

idea that print itself could be recognized as a principal forum for work never really appealed. The gallery was still regarded as the privileged space of art. Even the mass-produced artist's book, that mobile form and key legacy of Conceptual art, was perhaps destined to be reincorporated and accessed via art history, as well as exhibited.[14] In effect much art ended up being made *for* magazine and journal subscribers (in the visual languages of mass media) but *via* the gallery. Subscribers could read about work and even see it reproduced in print —quite comprehensively too, since so often it was photographic and textual – yet the gallery was still discursively located even within journals as the primary context.

The modern gallery has always depended on a notion of the primacy of vision, or more precisely of the primacy of visuality. As elaborated by keepers of the new histories of vision such as Norman Bryson, Jonathan Crary and Martin Jay, it is a primacy that is always in the end discursive and cultural in origin. Meaning does not spring miraculously from the gallery or the work within it. The edifice of modern purity needs constant support. Nevertheless, the episodic suspension of that knowledge is central to the experience of the modern gallery and it does produce particular physical and cognitive effects. In short, it makes pleasure (or displeasure) a considerable factor in experience, heightening and intensifying both the intellectual and the corporeal relation to work. The spatial particularity of the encounter is made analogous to the singular subjectivity of the maker. This is not always so and is not so for everyone. If the effect is fashioned discursively, then it is bound to be an acquired and complicit skill. There is nothing about a gallery as such that is pleasurable, or even comprehensible, as much Conceptual work was keen to point out. Such heightening or intensification doesn't manifest around a work reproduced in, or conceived for, mass print in the same way. But this is not just because of a lack of theatre or 'presence'. The page is the site of text, which in turn is the modern locus of language, interpretation, mediation and legitimation. It is the space in which the theatrical suspension that regulates the experience of a work as a work is underscored. The book can be modelled on the gallery or the gallery can be modelled on a book, but the difference remains.

The attempt by Conceptualism to make a shift in emphasis from aesthetic questions to ontological problems, as Marcel Duchamp had tried to do, was the source of art's linguistic turn. Both text and a 'deskilled' use of photography played essential roles here in the playing down of fetishized form and the insistence on subject matters previously outside the domain of art. The preoccupation with the notion of photography as

a medium that communicated ideas rather than producing objects often assumed a reduction of the status of the image from the primarily visual to the merely visible or informational. The particular visuality of certain strands of Conceptualism, what Benjamin Buchloh called, not without contention, the 'aesthetic of administration' and which really appears only in hindsight, seems to indicate how the denigration of the visual was by no means a negation.[15] While the photo-text was indeed a radical challenge to traditional notions of the aesthetic, it was neither an erasure nor a transformation into theory, whether it appeared on the wall or in print. But its easy way with reproduction meant that critique could soon take place outside the gallery; on the page. The necessary obverse of art's failure to dematerialize seems to have been the over-materialization of art theory that has in the end allowed for a return to the gallery as a space of textually regulated autonomy.[16]

Beginning as a largely unreproduceable material art object in photo-pictorialism and early Modernism, the art photograph also became a mass-reproduced image *and* an art object in art photojournalism. Later it also became a conveyor of concepts with a much downplayed sense of objecthood. It is crucial that this development is not conceived as a linear evolution. The crafted singular print is still with us, art photojournalists endlessly rework their illustrious past, while post-Conceptual practices continue to explore the breadth of the photograph's social functions. What seems to make all of this possible is the mutability of the photograph's relation to the page, particularly in the expanded field of art history. I want to look now at the art historical career of one particular work of Conceptualism to try and draw together the key strands of my discussion of the ontologies of the photograph in art and art history.

Through the actual experience of running a gallery, I learned that if a work of art wasn't written about and reproduced in a magazine it would have difficulty retaining the status of 'art'. It seemed that in order to be defined as having value, that is as 'art', a work had only to be exhibited in a gallery and then to be written about and reproduced as a photograph in an art magazine. Then this record of the no longer extant installation, along with more accretions of information after the fact, became the basis for its fame, and to a large extent its economic value.

Dan Graham[17]

There is nothing particularly unusual in the essence of Graham's remark. Similar sentiments can be found in many statements by artists associated with Conceptualism. And in the last quarter of the century the harnessing of art's spectacular mediation has become *de rigueur* for almost every

aspiring Post-Modernist. Photography was central to the attitudes of both Conceptualism and early Post-Modernism. It could aid the utopianism of an art distancing if not freeing itself from markets, while its reproductive possibilities could be made to reassert and advertise the art commodity in a culture ever more organized by mass print and money. While Graham's comment alludes to forms of cultural practice that assume fixed and self-serving relationships between artists, artworks, mediation and the market, it was actually made as part of a statement that accompanied an art historical publication of some works that were attempting something a little more disruptive. Graham's interventions known as the 'works for magazines' have not escaped art history or the market but they have caused the former some internal difficulties. Conceived for spaces traditionally associated with commentary and reproduction rather than with art 'itself', the magazine works of which the photo-text layout *Homes for America* (1966) has become the most visible (i.e. the most reproduced in books) occupy an ambivalent space in art culture. In a growing number of articles *Homes for America* is regularly lauded for a prototypically Conceptual transgression of the well patrolled borders between art and art history and between art and popular culture. With an implicit recognition of the pivotal positions of the magazine and the photograph within mass culture and high art, the piece has come to be formulated as an early challenge to the distinction between the artist as maker and the theorist as mediator.

Graham's interest in fusing Minimalist strategies with explicitly sociopolitical content led first of all to a set of serial colour photographs of North American tract housing which he hoped to publish in the mainstream press outside the realm of art in 'a magazine like *Esquire*'.[18] This never happened, but an invitation to publish in *Arts* magazine led to a reconfiguration of the images within a short article which is usually read by commentators as intending to make a radical and parodic juxtaposition of the socialized forms of domestic architecture with reductive forms then emerging in the field of sculpture. While the photographs never did appear in a non-art publication, *Arts* magazine eventually published *Homes for America* in December 1966 as an article typeset in the magazine's own house style with just one photograph (by Walker Evans rather than Dan Graham as it turned out).[19] There is nothing in the piece *per se* that juxtaposes tract housing with minimalism. *Homes for America* is a rather dry and systematic account of mass-produced suburban architecture, with no mention of art or of itself being art. If there is any juxtaposition, it is between the relentlessly deadpan description of modular

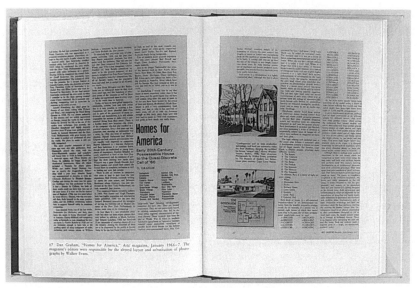

Dan Graham, *Homes for America*, as reproduced in *Arts* (December 1966) and, later, in Thomas Crow, *Modern Art in the Common Culture* (1996).

Photographs from Dan Graham, *Homes for America*, as reproduced in the catalogue *Walker Evans and Dan Graham* (1992).

housing and the article's appearances in the kinds of art context in which
Minimalism has a key standing. (It is doubtful whether the readers of
Esquire could have made the esoteric connection.) Still, such a stumbling
genesis hasn't prevented variations of *Homes for America* surfacing with
increasing frequency in anthologies, art magazines, essays and mono-
graphs. Indeed, as art publishing continues apace the piece manages over
30 years on to reinvent itself at each new moment of publication, while its
increasingly dated subject matter (1960s suburban housing) locates it for
art history somewhere in the past. But given that the piece has never
appeared outside art (although as Thomas Crow has pointed out, its
rhetoric suggests at least a popular appeal beyond art's specialized dis-
course), *Homes for America* needs consideration not least for its complex
relation to context.[20]

Graham himself has suggested that 'the fact that *Homes for America*
was in the end only a magazine article, and made no claims for itself as a
work of art [. . .] is its most important feature'.[21] Nevertheless, the piece
has manifested itself as, among other things, a quite traditional
exhibitable object. Entitled *Homes for America* (1965–70, two panels in
mixed media, each 102 x 77 cm) and comprising cut-and-pasted text and
imagery mounted on illustration board, it is framed and glazed like the
most conventional of art objects. While in theory it exists in potential as a
piece to be shifted in typographic mutation from context to context, from
publication to publication, what seems to happen is that the *Homes for
America* known to art history appears in one of two visually stable forms.
What is usually reproduced in articles is either a photographic trans-
parency of the pages of *Arts* magazine or a transparency of the original
paste-up.[22] So rather than adopting the graphic conventions of whichever
organ opts to publish it – allowing it to fully inhabit the page of its repro-
duction – it appears in the form of an artwork that is on some level 'else-
where'. The publications that carry it depict its pages in a manner that
highlights the graphic and institutional conventions of both the host pages
and the supposedly 'prior' context of the work. A distance is thus intro-
duced between Graham's pages and the pages on which they find them-
selves. Yet at the same time the work's configuration as pages precludes
that distance from remaining stable. The piece is flat to two coincident sur-
faces: the surface of its own layout and the surface of the host pages. The
meaning of the piece is subject to permanent movement between first- and
second-order knowledge. The work can be read 'directly', since it consists
of photographs and printed text (forms synonymous with the page), but it
appears framed by two contexts – Graham's pages and the pages of art his-

torical reproduction. *Homes for America* won't settle as either artwork or art history. While no work can be said to exist outside a discourse, at least not as a 'work', what is peculiar about *Homes for America* is that it has ever functioned within the material space of art history while not being wholly subject to it. If what could be said to characterize an artwork is, to invoke Walter Benjamin, 'a distance, however close it may be', then it follows that art history is a discourse that demands that artworks be distant things. In order to apprehend and comprehend *Homes for America*, art history insists that Graham's chameleonism show its colours rather than hide, that it distinguish itself from its background and offer itself up for interpretation as an absent artwork, despite the page of art history being its sole context. So the canonical place of the piece seems to be based on valorizing some inaugural unfulfilled intention to publish and remain outside the grasp of art: that is, to register for an audience without the regulatory presence of commentary and authored intention. This is a predicament common to much interventionist work that opts for the Situationist procedure of the détournement. Once the détournement is pointed out, the effect becomes as much learned as involuntarily experienced.[23] Work made outside the discursive framework that offers its makers affirmation will inevitably be transformed by that framework. Yet while Graham's piece first appeared within an art magazine, I would suggest that it was in some ways outside it too, since it didn't announce itself as a 'piece'. That task, of both transformation and affirmation, is performed by art history.

From this perspective we can return to the question of photographic ontology with which I began to look at the imagery of *Homes for America* in more detail. It seems clear from Graham's own accounts that his aesthetic was informed both by Minimal sculpture and by the institutional need to mimic the technically competent artlessness of real-estate photography.[24] Despite Graham's insistence that 'it is important that the photographs are not seen alone but as part of the over-all magazine article layout', and that 'they are illustrations of the text', they have been given life as separate artworks, allowing them to perform different but related functions.[25] As photographic art they could occupy a space somewhere between the earlier journalistic reserve of Walker Evans, the detached surveys of the New Topographers such as Robert Adams, Joe Deal and Lewis Baltz, and the studied wit of New Colorists like William Eggleston.[26] Tellingly, Graham once referred playfully to his work as 'photojournalism'.[27] It is the photojournalistic image that perhaps best epitomizes the contextual oscillation between authorless utilitarianism

and artistic statement to which, as Barthes had once indicated, any image is potentially prone. (That a photograph by Walker Evans could be made to illustrate the text of *Homes for America* on its first publication seems an ironic instance of this.[28]) Photojournalism is a polysemic practice that produces images that can move through overlapping discourses to stand as knowledge of the depicted world, serve a textual argument or index the subjectivity of the maker.[29] As elements of a layout and as separate photographs, Graham's images occupy all three positions. The oscillation of *Homes for America* between art and art history is redoubled through a photographic genre that itself hovers between archive and art. As a layout, the piece has become a canonical Conceptual work. And indeed its images could have become canonical photographs within a distinct history of art photography – within a history that would find the photo-text layout an intolerable threat to its identity.

What I think makes the piece so complex is the way in which it depends solely on art history to manifest itself but then exceeds it at the same time. It never allows the art historical page it colonizes to achieve the kind of neutrality required by commentary or critical distance. It reveals the page of art history as a place of construction rather than detached commentary; of promotion as much as description. In attempting to present commentaries on *Homes for America*, art history is forced to distance itself from it, approaching it as an 'artwork' and electing to reproduce some prior manifestation of it. This is why each commentary attempts to separate itself from others. Most articles on *Homes for America* opt to begin as meta-commentary: 'Graham's *Homes for America* has taken on canonical status . . .' [Thomas Crow] or 'The tendency of critics to assert their prerogatives by cultivating a forbiddingly difficult language has, of course, only increased since the time of Graham's quiet intervention . . .' [Jeff Wall].[30] In implying that the status of the work has been acquired elsewhere, it is as if art history is uneasy with its own promotional function. Compelled to situate the piece outside itself, it tries to preserve the critical distance that is its condition of possibility. In its contiguity with the page and its manifestation as informational substrate, *Homes for America* retains the capacity to both echo and remove itself from its sites of reproduction. As art history it is visible, as an artwork it is visual. It is a kind of Necker Cube of art and art history.

What ultimately distinguishes *Homes for America* from other art photography and from Graham's own photographs from the piece reproduced as distinct works is its denial of a stable position to itself and to art history. It foregrounds the nexus of contexts and the layering of meanings

that is the printed condition of post-Conceptual art historical knowledge as such. I use the word 'ultimate' not to mean 'best' or 'most accurate' but in its relation to destiny: Graham's piece moves through so many forms and manifestations in order to end up meaning this. With its initial promise as non-art now long gone, but with the kernel of that potential remaining in its structure as a page layout, it now becomes a singular 'work of art history' so to speak. It collapses the contexts of, and distances between, work and commentary but somehow recognizes they can never be the same. At the same time, its insistence on a popular subject matter highlights the disavowal that so often elevates and separates art publication from consumer culture in general (it is interesting that art history has little to say on the actual content of *Homes for America* beyond pointing out that it has one). Yet it is not the less than two-page article from 1966 that does this; rather, it is the potential of the piece to reactivate itself in reproduction (including here).

While Graham opted for such a mobile genre of photography, seeing the images both present to the page and placed at a distance within a paste-up artwork, one senses that perhaps the most apparently neutral photography is not photojournalism or any other kind of documentary, but the photography of artworks for reproduction. This rigorously systematic, descriptive and self-effacing practice is the aperture through which all artworks pass into contemporary systems of knowledge. *Homes for America* refuses to give up its subject matter of mass production, despite art history showing it little more than token interest, so it seems that the modularity described by the piece might now be read more productively as an allegory of the modularity of art history itself.

8

A Media Art:
Conceptualism in Latin America in the 1960s

ALEX ALBERRO

A number of art movements emerged in the late 1960s in the southern cone of Latin America, especially in Argentina and Brazil, that paralleled, and at times preceded, many of the better-known claims of Conceptual art in Europe and North America. From the beginning, however, there was a significant divergence between Latin American Conceptualists and their more post-structural counterparts in North America and Europe. Whereas the latter posited that language performed the fundamental role in the construction of the artwork (and, more generally, the subject, as in the notion that 'the subject is spoken through language'), Latin American Conceptualism, by contrast, predicated that extra-linguistic, all-encompassing mythical structures of ideology played that role.[1] Underpinning this view was a social and political movement that sought to counter the dominant hegemonic practices by appealing to anti-colonial and anti-imperialist feelings. It advocated a unique Latin American cultural perspective that would break with the bourgeois humanism that characterized post-war European and North American Modernism. This radical discourse coincided with an increasingly optimistic view of the social future. Inspired by an economic boom, a growing middle class and past development of consumer markets, that optimism – though naïve in retrospect – generated an unprecedented urban expansion, creating some of the largest megalopolises in the world.[2]

It is in this context that an art practice emerged in Latin America that not only discarded the old model of a concrete artistic work as the object of interaction between the artist and the public, but also dissolved the privileged function of the mediatory object and replaced it by the disembodied forces of mass-media communications. In other words, a basic shift took place as the central position of a material work of art was dis-

placed by an abstract system of information, circulation and distribution produced by different media. This was, of course, a rather paradoxical outcome for an artistic avant-garde that, in the very process of revealing and exposing the limiting institutional parameters of art, suddenly found itself turning to the institutional media as the source and manifestation of art.

Misleading as that notion may have been in view of the much more complex workings of art as an institution, it did provide an immediate alternative to the endemically genteel, snobbish, and unadventurous artistic culture dominant in the 1940s, 1950s and early 1960s throughout Latin America. Protest against that official 'academic' culture gave rise to the first recorded uses of the term 'media art' to qualify the aesthetic challenge posed by the new art. This movement united a growing number of young artists opposed to the various types of Lyrical Abstraction promoted by an elite educated in European or US universities. At the same time, many young artists felt equally distanced from the Expressionistic model promoted by the expansively gestural paintings of the increasingly prominent New York School. For the former, Expressionists indeed perpetuated an obsolete art of agonized private experience, still tied to the antiquated regimes of European powers. What eventually emerged was an artistic response intent on dislodging both dominant traditions in Latin America: European and North American.

We get an early glimpse of this new viewpoint in May 1966, when the Argentinian artist Roberto Jacoby proposed an exhibition that would consist entirely of information – a self-reflexive gesture in which the only object displayed within the framework of the exhibition would be its catalogue. Similar to typical exhibition catalogues, the one proposed by Jacoby featured descriptions of the works in the show, accompanied by critical essays, preparatory drawings and other relevant documentation. All of these elements were to serve concomitantly to complete the illusion that an exhibition was presented by the catalogue, and through their combined discourse to affirm the conceptual presence of that exhibition, despite its material absence.

This strategy of artistic production was then articulated in the manifesto 'A Media Art', published in Buenos Aires two months later (July 1966) by Jacoby and two of his compatriots, Eduardo Costa and Raúl Escari.[3] Prompted by their sensitivity to the profound impact of information media in late-twentieth-century society, these artists proposed to seize these media for the sake of art:

In a mass society, the public is not in direct contact with cultural activities but is informed of them through the media. For example, the mass audience does not see an exhibition at first hand, but, instead, sees its projection in the news. Ultimately, information consumers are not interested in whether or not an exhibition occurs; it is only the image the media constructs of the artistic event that matters.[4]

Logically, the stated aim of the authors of the 'Media Art' manifesto was to locate the artwork at its interface with the media: that is, ideally the moment of its transmission by the means of communication. As they put it in a lengthy passage that sums up their objectives:

We undertake to give to the press the written and photographic report of a happening that has not occurred. This false report would include the names of the participants, an indication of the time and location in which it took place and a description of the spectacle that is supposed to have happened, with pictures taken of the supposed participants in other circumstances. The work would begin to exist in the same moment that the consciousness of the spectator constitutes it as having been accomplished. Therefore there is a triple creation: 1) the formation of the false report; 2) the transmission of the report through existing channels of information; 3) the reception by the spectator who constructs – based on the information received and depending on the manner that information signifies for him – the substance of a nonexistent reality which he would imagine as truthful.[5]

Here they turn to a formula proposed ten years earlier by Roland Barthes in his seminal essay 'Myth Today' (1957). 'Truth to tell,' writes Barthes in a passage quoted by Jacoby in a 1966 article entitled 'Contra El Happening' ('Against Happenings'):

The best weapon against myth is perhaps to mythify it in its turn, and to produce an artificial myth: and this reconstituted myth will in fact be a mythology. Since myth robs language of something, why not rob myth? All that is needed is to use it as the departure point for a third semiological chain, to take its signification as the first term of a second myth. It is what could be called an experimental myth, a second-order myth.[6]

Such a secondary mythification was to become the political objective of the work of many artists in Latin America in the late 1960s. For them, to counter myth with counter-myths led not only to their appropriating the mythical and mythifying process by which artworks were brought into being by the mass media but also served to compound that process and redirect it. Targeting and, in theory, saturating the mass media with news-

paper and magazine accounts of artistic exhibitions and/or events that did not in fact take place, the Latin American Conceptualists hoped to carry out an effective *détournement* of the media, to employ the terminology of another group of radical theorists of the era, the European Situationists. Such a *détournement* was conceived of as being capable of simultaneously de-aestheticizing the art medium and empowering the spectator to construct the substance of the non-existent work by combining the (false) information received and the particular way in which that information would signify for them. In that way, in a completely different geographical context, a media art was unfolding parallel to ambitious artistic practices that in North America came to be defined as nascent Conceptual art. One is reminded in particular of the early Conceptualist work of the US artist Dan Graham, whose works for magazine pages of 1965–6 took place entirely within a specific structure of communication: the commercial magazine system.[7]

Yet in Argentina the idea of actual appropriation and manipulation of ready-made media forms and structures did not survive long, even in abstract form. The increasingly repressive social and political reality that followed the June 1966 military coup soon made such minor subversion of the prevailing system seem woefully inadequate. In response, there was an increase in the number of politically aggressive art interventions that, while still inspired by Conceptualism, bordered on direct action.[8] One of the most explosive of these, announced as '*En el mundo hay salida para todos*' ('In the World There is an Escape for Everyone'), consisted of an action performed by a group of artists from the industrial city of Rosario who, in collaboration with artists from Buenos Aires similarly close to Conceptual theories, locked for an hour the doors of the official 1966 Biennale of Córdoba exhibition. To the continued alarm of exhibition officials, when they finally managed to open the doors to the galleries, the artists accompanied by a group of students occupied the space and used the ensuing media attention to protest against the repressive political regime and its cultural apparatuses, such as the Biennale of Córdoba.[9]

The increased political activism in the Argentinean art world reached another plateau two years later at the exhibition *Ver y Estimar* in May 1968. The day of the opening one of the participating artists, Eduardo Ruano, entered the gallery with a group of friends chanting, 'Yankees out of Vietnam.' When the group passed by the showcase containing a photo of John F. Kennedy that Ruano had installed in the show, the artist 'completed' his work by smashing the case and crossing out the portrait.[10] Not surprisingly, the police immediately removed Ruano's work and expelled

him from the exhibition.[11] Also in May 1968, this time at the *Experiencias* exhibition in Buenos Aires, the artist Roberto Plate exhibited *Baûo*, an installation of simulated public lavatories upon which he encouraged the spectators to add graffiti. When the piece was dismantled by the police because of the inevitable insults inscribed on the walls of the *Baûo* directed at the military government of Juan Carlos Onganía, the remaining artists, in solidarity with Plate, withdrew their works from the show. The action was accompanied by a formal statement signed by 64 of the artists. It stated that such overt acts of repression by the military police were not limited to the art world, but were 'also directed against the student and the workers' movement. Once this repression has succeeded,' the artists' statement warned, 'it will try to silence all free conscience in our country.'[12]

The swift shift in focus from a Conceptualism that questioned the ideological bases of bourgeois art to an artistic movement that questioned all of the institutions of bourgeois culture is perhaps best exemplified by the 'Tucumán Arde' ('Tucuman Burns') project of 1968. In Tucumán, a small province in north-western Argentina, Onganía's harsh plan of economic rationalization had led to the closure of the majority of local sugar refineries. As these formed the province's principal means of income, their demise resulted in a depopulation of the area, leaving it poverty-stricken and without a strong labour force to protest against the disastrous conditions. The government, with the cooperation of the press, promoted then an 'Operativo Tucumán' in an attempt to conceal the dire situation of extreme poverty rampant in the province. A massive publicity campaign was launched that announced a largely mythical industrialization project financed by new capital industries throughout Tucumán. It was 'soon' to lead to prosperity, but in the meantime the pressing reality of the social catastrophe in Tucumán was downplayed and any remedy deferred.

In response, a group of artists from Rosario, Santa Fe and Buenos Aires formed the Grupo de Artistas de Vanguardia (Group of Avant-Garde Artists) and affiliated themselves with the Argentinian General Confederation of Labour (Confederación General del Trabajo, or CGT) in order to create a work that would 'come out of a consciousness of the current reality of the artist as an individual within the political and social context which surrounds him'.[13] This programme culminated in a 1968 action known as 'Tucumán Arde' that sought to expose the catastrophic policy in Tucumán by disseminating counter-information designed to subvert the mythical nature of official media information. Not only the

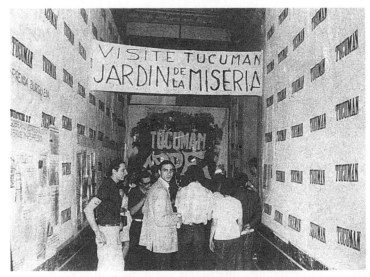

Grupo de Artistas de Vangardia, *Tucumán Arde* ('Tucumán Burns'), 1968.
Entrance to the Argentinian Confederación General del Trabajo de los Argentinos,
Rosario, November 1968.

existing situation but, more significantly, the factors that led up to it were
mercilessly publicized following an intense period of research systemati-
cally carried out by the Group. Posters and fliers of Tucumán were dis-
tributed throughout Rosario and Santa Fe. Next the Group decided to
escalate its action by mounting large multi-media exhibitions within
meeting locals of the CGT in Rosario and Buenos Aires. The installation
of the work in union halls, which drew a significantly different and larger
public than was usual for more conventional art exhibitions, facilitated
the political praxis of the work. The same circumstances also led to the
adoption of a larger design format for the work.

Viewers of the installation were treated to an all-encompassing interior
environment made of posters, placards, photo-murals, newspaper mon-
tages, tape recordings and an array of statistical graphs indicating rates of
infant mortality, tuberculosis and illiteracy in the region of Tucumán.
Juxtaposed to this information was the full range of government-
sponsored misinformation. The dramatic discrepancy between official
and factual information was theorized by the group as having the poten-
tial not only to educate but also to heighten the political consciousness of
the spectators. The group also expected that the media attention occa-
sioned by the shows would create an important vehicle for the spreading
of information. The progress from handbills to exhibition displays to

media stratagems underscores the growing awareness of these artists as they assessed the increased role of the media in production, transmission and, ultimately, control of information about art and politics alike.[14]

Particularly relevant in the context of the development (and diversification) of Conceptual art is that, like other strands of Conceptualism that dissolved the work of art into a means of communication, integrating it with publicity, the Grupo de Artistas de Vanguardia also called for the establishment of close connections between the work of art and the mass media. For this Group, revolutionary art consisted of creating 'informational circuits' about particular features of reality (such as the appalling conditions of the working population of Tucumán) capable of demythifying the dominant (i.e. bourgeois) mass-media image of that reality.[15] Such an awareness or consciousness, the Group's manifesto insisted, would inevitably galvanize other avant-garde artists to destroy bourgeois forms of art that 'reinforce the institution of individual property and the personal pleasure of the unique art object'.[16] However, the Grupo de Artistas de Vanguardia were clearly aware not only of the power of the media but also of its 'susceptibility to being charged with different kinds of content'.[17] Thus their assault on the images popularized by the media was only part of their strategy; equally important was the appropriation of the same media's structures in order to produce modifications in society in a way as efficacious as political action.

But as the exhibition was shut down under police pressure shortly after its opening in Buenos Aires, the dissemination of subversion by the Tucumán Arde through grass-roots, word-of-mouth communication and continued media attention – goals that were to be met during the project's final phase – was brought to an abrupt halt. In fact, this and other manifestations of censorship prevented many artists of the Grupo de Artistas de Vanguardia from practicing their art for years, and some of them for ever. Others gave up on the possibilities of Conceptual art to raise consciousness, turning instead to more direct forms of propaganda such as posters and comic-strips.[18] They thought – and some still do – that, in the contemporary context, popular culture was the only place where art was still capable of creating conditions of self-representation which could, in turn, raise political consciousness and resistance to oppression.

A similar interest in the semiotic potential of systems of distribution pervaded Brazilian artists' moves towards Conceptual art in the 1960s. The theoretical basis for one such move was articulated in the manifesto 'General Scheme of the New Objectivity', printed in the catalogue of the

1967 exhibition *Brazilian New Objectivity* in Rio de Janeiro. Written by Hélio Oiticica, the manifesto charts the principal characteristics of the new art, including 'the participation of the spectator (bodily, tactile, visual, semantic, etc.)', 'an engagement and a position on political, social and ethical problems', a 'tendency towards collective propositions' and 'a revival of, and new formulations in, the concept of anti-art'.[19] The impact that the theses of this manifesto were to have on a new generation of artists in Brazil and elsewhere on the continent may have been underestimated because of the extremely volatile and dangerous circumstances surrounding artistic production under military dictatorship. In Brazil, the army coup that toppled the constitutional regime in 1964 was followed by a reinforcement of the oppressive regime in 1968. The government, supported by Brazilian censors, immediately imposed an effective and dramatic crackdown on the arts. Within a year, the director of the Museu de Arte Moderna in Rio de Janeiro, Mauricio Roberto, was forced by the political police to take down a large exhibition of new art a few hours before the opening ceremony; a widespread international boycott of the São Paulo Biennial followed and persisted for over a decade but without tangible effects. In fact, many young artists, even those who did not produce work that addressed politics in any way, were taken to court or otherwise persecuted by the authorities.[20]

One of the artists upon whom Oiticica's manifesto had an obvious and profound impact, despite – or perhaps because of – the heightened level of artistic repression, was Cildo Meireles, whose work of the late 1960s fused Conceptual art with political activism. His series of *Insertions into Ideological Circuits* (*Inserções em circuitos ideológicos*) is a case in point. In 1969, responding to what he retrospectively described as the need 'to create a system for the circulation and exchange of information that did not depend on any kind of centralized control', Meireles launched his *Insertions* series, designed to transmit information through a variety of what he called 'ideological circuits'.[21] Alternately involving mass-produced paper currency – that is, banknotes on which the artist rubber-stamped messages before putting them back into circulation – and Coca-Cola bottles on which he inscribed critical notes about Brazilian and imperialistic politics prior to recycling them, these ready-made 'ideological circuits' were intended to subvert from the inside the common systems of communication and distribution that over-determined the human subject as a consumer in a culture driven by the market – in particular, the ideologically and politically colonized subject living on the periphery of Western imperialism.[22] More specifically, the 1970 *Coca-Cola Project*

Cildo Meireles, *Inserções em circuitos ideológicos: Projeto Coca-Cola*,
1970, silk-screen on bottles.

(*Projeto Coca-Cola*), one part of the *Insertions* series, consisted of silk-screening messages on to the sides of empty Coca-Cola bottles in vitreous white ink to match the bottles' logo and then reintroducing the 'empties' into circulation. The messages were virtually invisible when the bottles were empty, but as they were filled in the factory the information became legible. In this manner, the *Insertion* works inverted the fetishism of the ready-made that had characterized various Pop art strategies in the USA and Britain, as well as undermined much of what was grouped at that time under the rubric of Minimal art. Instead of placing the commodity-art object (or image) into the aesthetic space of a gallery, as artists as diverse as Eduardo Paolozzi, Robert Rauschenberg and Dan Flavin had done in the 1950s and early 1960s, Meireles's *Coca-Cola Project* returned the bottles to their original system of commercial circulation – albeit in a radically altered form. That such a strategy would emerge in Latin America in the 1960s rather than in North America should not be surprising, since, in contrast to the de-Marxification of the US intelligentsia that took place during the late 1940s and 1950s, powerful Marxist traditions persisted in Latin America and kept alive uncompromising suspicion of the brash promises of the capitalist system of commodities.[23]

Several characteristics of the *Insertions into Ideological Circuits* series had a close relation to key strategies of Conceptual art. For one thing, the altered bottles or banknotes that constituted the material element of the *Insertions* series clearly reached, because of their use value, many more people than more conventional artwork. Indeed, rather than requiring a

deliberate visit to a gallery or museum for the purpose of experiencing the work of art, the inserted objects were conveyed directly to their intended public. Also, paralleling the trend towards the dematerialization of the artwork that marked most forms of Conceptualism, the *Insertions* series in large part dissolved the discreet art objects, replacing them by an exchange practice. In addition, the same 'Death of the Author' that Roland Barthes observed in 1967 writing in the context of US Conceptualism, was obviously taking place in the context of the *Insertions* series, where the artist was becoming anonymous and relinquished control of the work once it left his hands.[24] The type of problematization of questions of ownership that is symptomatic of most Conceptual art was actually taken to a radical extreme as the work of art was decentred and virtually impossible to circumscribe or control, let alone buy or sell (other than, of course, for the price of a bottle of Coca-Cola).

But perhaps most significant was not resemblance but divergence: that is, the manner in which *Insertions into Ideological Circuits* was turning Conceptualism in the direction of explicit political content – an evolution not readily accepted by Conceptual art in general. In the 1960s, Coca-Cola represented, more than any other company, the aggressive, imperialist expansion of capitalism through the spread of US multinational corporations in Latin American countries.[25] Seen from this perspective, the radically transformed bottles in the *Coca-Cola Project* operated as at once a direct intervention in and an obstinate critique of the globalism of victorious US capitalism. The *détournement* of the mechanism of recirculation (already set up by the soft-drink industry) provided Meireles with a way of communicating a revolutionary message to an enormous public at a time when the Brazilian dictatorial regime was vigilantly monitoring all the conventional channels of communication.[26]

One must also single out the emphasis that *Insertions* placed not on the content but on the medium. For with this series, the relatively highbrow and esoteric traditional art media (painting, sculpture and the like) give way to the mass-communications media as the true bearers of aesthetic dimension. This end of artistic autonomy, of what used to be the closed space of the Modernist aesthetic, rendered anachronistic the avant-garde's attacks on the self-sufficiency of art that persisted through the Modernist period. Indeed, in a strict philosophical sense, the end of modernity also spells the end of aesthetics in general. This is not surprising in the context of Meireles's production. Here a comparison is quite revealing between Andy Warhol's silk-screen paintings of 1962, in particular *Green Coca-Cola Bottles* or *210 Coca-Cola Bottles*, obvious strong

precursors for Meireles, and the latter's *Project Coca-Cola* series. For one of the most striking aspects of Warhol's photographic appropriation is its denial of self-expression and the authorial self. And yet, in Warhol's case, the promise of anonymity and self-effacement is negated by the publicity and critical attention that the artist managed to garner through a systematic programme of self-promotion. Although Warhol's interventions in the art production process were minimal, his extraordinary public visibility, his 'superstardom', ensured that the self of the artist and his unique creative personality always loomed over his work. In contrast, Meireles literally disappears behind the work. There is virtually no connection back to the artist in his art, which is no doubt fortunate since such a connection, in late 1960s or early 1970s Brazil, would have certainly meant prosecution, a jail sentence or worse.

On a higher level of theoretical generalization, it is quite evident that, whatever their topical sources, Warhol's silk-screens transform through various institutional and, more importantly, ideological mechanisms the singularity of the Coca-Cola pattern into a universal sign of high art. Such a transformation occurs as a manifestation of a socio-cultural process that has been ruling the identification of works of art in modern Europe since at least the Renaissance, eventually affecting North America as well – a vision of the nature of art that appears spontaneously at one with the very self-determining belief in the autonomy of the individual in society. Behind the new aesthetic model stands a new kind of bourgeois imperative that individuals must somehow themselves become responsible for art, drawing their inspiration from their personal judgements and sensations. This belief in individual creation and judgement achieved, with Modernism, the authority and power of what Antonio Gramsci has termed 'hegemony': a social condition under which any particular subject introjects universal models, aesthetic as well as ethical or political, and acquiesces to their imperatives in his or her own deepest being. Hence the profound conviction of European and North American artists that, even when their ideologies were influenced by leftist ideas, their confidence in their role as authors of their artwork remained solidly anchored in capitalist entrepreneurship.

Such a hegemonic view of art and artists, however, had to encounter a resistance in cultures with a strong colonial past. For colonialism was clearly alien, or heteronomous, to the individual structuring of identity based on traditions and rigid roles. By the same token, a mass-marketed Coca-Cola bottle will not be easily transformed, through a totalizing confluence of universal art and particular interests, into an aesthetic icon.

Instead, even filtered through dominant institutions, such mass objects will remain perceptibly 'other' and hence potentially much more explosive than their aestheticized replicas. In short, they would become objects of contestation rather than marketing. It is therefore not surprising that, in the Latin American context, Meireles's insertions in the circuits of communication and distribution would interrupt the loop of ideological and commercial valuation of objects such as Coca-Cola bottles. As Meireles himself noted retrospectively about the *Insertions into Ideological Circuits*, 'the important thing in the project was the introduction of the concept of "circuit", isolating it and fixing it', for, as he continues:

the container always carries with it an ideology. So, the initial idea was the recognition of a (natural) 'circuit' that exists and on which it is possible to do real work. Actually, an 'insertion' into this circuit is always a kind of counter-information. It capitalizes on the sophistication of the medium in order to achieve an increase in equality of access to mass communication and also, one must add, to bring about a neutralization of the original ideological propaganda (whether produced by industry or by the state), which always has an anaesthetic effect.[27]

In short, what we have with Meireles's *Insertions into Ideological Circuits* is an artistic practice of direct intervention into the dominant system, where, to borrow a cliché from Marshall McLuhan, the medium literally becomes the message.[28]

Two dominant strategies underlie modes of Latin American Conceptualism in the 1960s, neither of which relies on dominant artistic traditions or national or regional heritage. One appropriates and manipulates ready-made media forms and structures, or, in Barthes's terms, 'myths', and highlights their ideological commitment behind their fake neutrality. The other builds upon the appropriations of the first, compounding the myths and recharging them with a radical and often political content that aims to transform the viewers' habitual perception of both artworks and artefacts of everyday life as well. It is this subversion of the mythical operation of the mass media and parallel ideological circuits – a subversion that in some cases resorts to what could properly be termed 'guerrilla' tactics – that in the context of the 1960s forms the particular character of Latin American Conceptual art. And it is this same strategy that ultimately makes Latin American Conceptualism uniquely relevant to the subsequent history of Conceptual and Post-Conceptual art practices everywhere, and, in more general terms, to the history of the avantgarde in the twentieth century.

Matter of Words:
Translations in East European Conceptualism

DESA PHILIPPI

'We reach the threshold of a new and very different Don Quixote and a new Quixotism,' Václav Černý told his audience in a public lecture which marked the three hundred and fiftieth anniversary of the death of Miguel de Cervantes.[1] This new Quixotism, with its emphasis on the transhistoric and living, is a metaphor for the situation of Czech intellectuals, writers and artists in the 1960s, it soon becomes clear. It is also meant as an appeal.

For the artist there are two possible perceptions of reality: Don Quixote's giants versus Sancho Panza's windmills, madness versus reason, or the unreasonable hero versus the reasonable coward. In a nice twist of the argument, Černý asks who all those characters are in the novel who agree with 'windmills' as opposed to 'giants', and answers, 'Practically everybody', following up on this claim with a long list of criminals, profiteers, frauds and swindlers, people in short who, if measured by the standards of human decency and honesty, are themselves found wanting, deviant in fact. Seen from this angle, Don Quixote's sublime madness no longer confronts reason but rather another sort of craziness which more often than not turns out to be mean and self-serving.

Truth does not abide by the reality principle. In subscribing to the new Quixotism, the writer or artist puts him/herself on the side of truth against lies, excuses, circumstance and compromise. It is his or her job to wilfully ignore the self-evident and the officially sanctioned. Černý presents 'the new Don Quixote' not as a tragic hero but as the unfaltering optimist whose happiness lies in his embodying truth. Being true (to oneself) is contrasted with the knowledge of truth as in 'knowing the facts', and art, Černý suggests, has to be true in the former sense. How is this to be achieved? With irony, with humour, with humility, 'Forgive us our madmen and we forgive you your idiots.'

What can work from Eastern Europe contribute to a contemporary discussion of Conceptual art?[2] There are two approaches. One is to document conceptual work in Eastern Europe in order to achieve a more complete picture of one of the last movements of the artistic neo-avant-garde. Given the lack of consensus about what constitutes Conceptual art, whether or not it is ongoing, and who should be included among the ranks of conceptual artists, this seems a difficult task even before one comes up against practical problems such as the frequent lack of documentation of 'unofficial' art activity right up to 1989. Personally, I am less and less sure what, precisely, Conceptual art is or was in either East or West. Judging by the recent literature, it seems as if the longer the debate continues, the larger the category becomes.

Another approach selectively uses certain works in order to draw attention to a particular problem; it emphasizes a specific aspect within a plethora of supposedly conceptual practices. This is the path I follow here. My thesis is simple. Even at its most theoretical, non-official art behind the Iron Curtain maintained an important existential dimension. Unlike Socialist Realism and the various forms of neo-Constructivism and Lyrical Abstraction which were eventually sanctioned by the state, and also unlike much post-Duchampian work in the West, 'actions' in East European countries remained largely experiential.[3] This is why they were perceived as threatening by the authorities and frequently censored. (In general, I believe this to be the main difference between academic or 'official' art and art that remains contemporary and speaks to us across geographical and cultural borders.)

In what follows, I look at different ways in which experience figures in certain works which originated even if they did not always continue on the Eastern side of the Iron Curtain, and are situated under today's golf-size umbrella of Conceptual art.

In 1965 the Polish artist Roman Opalka embarked on what he had decided would be his life project, *OPALKA 1965/1-∞*.

... enfin, après tout ce temps, cette préparation mentale et structurelle de mon projet, j'ai commencé mon premier 'Détail' . . . ma main tremblait devant l'immensité de mon entreprise, ce minuscule un, décision radicale du premier instant du temps irréversible.[4] [. . . finally, after all this time spent in mental and structural preparation of my project, I started on my first 'Détail' . . . my hand trembled before the hugeness of the task, this little 1, this radical commitment to the first instant of irreversible time.]

After a short period of experimenting with different colours and formats, Opalka settled on what was to become the standard format of the paintings he refers to as *Détails*.[5] Starting with 1, the progression of numbers is inscribed in white acrylic paint on a grey background. The *Détails* measure 196 x 135 cm, a size determined by practical rather than aesthetic considerations, and the numbers are painted with the smallest standard paintbrush. They are 13 mm high, just large enough to allow the artist to work on the painting for hours at a stretch, while clearly registering the self-imposed discipline by emphasizing the slowness of the process.[6] To the extent that the *Détails* are a record, they record the process of their making, the inscription of irreversible time. The repetition which underlies this counting figures in two ways: in the $n + 1$ gesture of counting itself and in the visual rhythm created by using the paintbrush like a fountain pen which is refilled only when the ink, or in this instance the paint, has been used up. This way of working emphasizes the manual and physical aspect of the activity. When Opalka had passed 1 million in 1972, he extended and modified the project: henceforth, the grey background of every new *Détail* would be a degree lighter than the previous one. At the same time, he began to record the counting on tape and after each session he now takes a photograph of himself, always a frontal head-and-shoulder portrait in black and white. These days, an installation of his work typically includes all three components of the project. The photographs are placed alongside the paintings and the spectator hears a quiet but insistent voice counting in Polish. The recording of his voice will also serve a practical purpose once the written numbers can no longer be read on the canvas. As the background of the paintings becomes lighter, the moment will be reached when the artist paints white on white and has to rely on his recorded voice to guarantee the accuracy of the inscription. *OPALKA 1965/1-∞* ends with the artist's death. The last *Détail* will remain unfinished and, by virtue of its incompleteness, render complete all the others.

Where Jasper Johns used numbers as a visual repertoire of shapes to stage an irreconcilable tension between cliché – the identical and reproducible – and expressive gesture in the number paintings of the late 1950s, Opalka turned painting into a process of counting. And where in the 1970s his compatriot Zbigniew Gostomski used counting to determine the distribution of colours on the canvas, with each number representing a different colour, Opalka's counting began to move towards invisibility. Ultimately independent of visibility, this process derives its significance and signification from its ceaseless realization. The numbers appear in

Roman Opalka at work in his studio in Mansuria,
where he passed the first million in 1972.

sequence, and their meaning is determined in that sequence without external referent. To the extent that the process of counting is considered to be objective and independent of history, culture and agency, it can be thought to go on for ever. In mathematics the unimaginable – infinity – is easily and unproblematically representable because recursion allows us to understand numbers as objects prior to their enumeration. Yet the whole point of Opalka's project is to create a material trace of finite, lived time. In that sense, the work is the opposite of an abstract proposition. Determined, literally down to the last *Détail* by its concept, the concept also demands its continuous materialization.

Opalka's work transforms mathematical infinity from an ideal object into a potentiality, into something that is never reached but always moved towards, an irreducible and mobile limit, like a horizon, that can only be approached but not attained or transgressed. As evidence of the duration of the artist's labours, the *Détails* draw attention to human finitude as that which gives meaning to the infinite and ideal. In order for this to hap-

pen, representation has to be evoked although, strictly speaking, the paintings do not represent anything. In the instance of Opalka's project, the representational gesture is narrative. All the narrative trappings are present: the overdetermined beginning and conclusion, and important moments along the way. The right format is found, the project is extended, another million is reached, the numbers become invisible . . .

While the paintings cannot tell us anything about any particular life, they provide a model of how a set of unique moments becomes a project; more precisely, how an abstract sequence becomes a form we recognize – a biography. This form is both the possibility and the tyranny of *OPALKA 1965/1-∞*.

While his preoccupation with the formalization of time has much in common with the work of artists such as Hanne Darboven and On Kawara, Opalka's project emerged from a different context. In 1960s Poland, opposition to Socialist Realism usually meant enthusiastic support for anything associated with artistic modernism. The latter was available either as a neo-Constructivism developed from the work of artists associated with the group Blok and the Unism of Władysław Strzemiński in particular, or as performance-oriented art often influenced by the work of Tadeusz Kantor, who staged the first happenings anywhere in Eastern Europe in Poland in 1965. These tendencies continued the parallel importance of the Constructivist and Surrealist heritage in Poland and other East European countries. As Mariusz Hermansdorfer put it in a catalogue introduction to an exhibition of contemporary Polish art in 1975, on the one hand, 'art as order, as simple construction calculated with mathematical exactitude', and on the other, 'art as expression, disquiet and posing the question of existence [*Existenzialfrage*]'.[7] Wary of uncritically embracing either of these tendencies, Opalka none the less formulated and formalized the '*Existenzialfrage*' with all the seriousness and pathos of high Modernism. The limit of the work here becomes the limit of the artist's life.

Other artists and writers who grappled with a similar historical and artistic predicament chose parody to negotiate individual voices in an environment which systematically denied the importance of individual expression, experience and memory. Bureaucratic and administrative categories were translated into art and literature. In Eastern Europe there is a predominantly literary tradition which predates Communism and addresses the unequal and arbitrary relationship between individuals and institutions of the state. Rarely transparent and never straightforward, in the twentieth century this relationship became a recurrent preoccupation

in the otherwise completely different works of writers such as Franz Kafka and his exact contemporary Jaroslav Hašek. Closer to us in time is the well-known playwright and novelist Pavel Kohout, author of, among many other things, *Bílá kniha o kauze Adam Juráček* (1970) [*White Book Adam Juráček*], which was finally published in Czech in 1991.[8] This hilariously surreal novel takes its readers through records and documents which detail the tribulations of Adam Juráček, Professor of Drawing and Physical Education at the educational institute in K., who managed to overcome the law of gravity and walk on walls and ceilings. A series of reconstructions, protocols, speeches, testimonies, photographs, letters, and transcripts of party meetings reveals not only the impact of this extraordinary and absurd event but also the almost equally bizarre logic by which an individual's destiny is negotiated through a network of institutional relationships. Yet, unlike the event which triggered the paper flood, the bureaucratic logic *qua* logic is entirely believable, despite its ever more convoluted and grotesque effects. One of the reasons why this fantastic story is both hugely entertaining and strangely convincing has to do with the way it inhabits the mechanisms of official speech, especially the use of a particular sort of naïve speech which suggests a society where everything is entirely transparent, normal and normalized to the enjoyment of every good citizen.

The same kind of naïve speech figures prominently in the artist's book *Il'ja Kabakov, V našem ŽĚKe* [*Ilya Kabakov in our Zhek*].[9] This work presents the artist as writer, painter and collector. In the Soviet Union, a Zhek (*zhilischtschno-eskpluatazionnaja kontora*) was an office for the administration of apartments in urban neighbourhoods. It usually looked after several buildings and was responsible for repairs and for issuing various kinds of documents to the inhabitants. For Kabakov, the Zhek becomes a micro-environment whose structures the artist both inhabits and uses to reflect on his art. While other artists from the group that became known in the late 1970s as the Moscow Conceptualists, such as Bulatov and Kolmar and Melamid, worked with the emblems of Soviet power, Kabakov's interest lay in the intrusive but banal routines of daily life. The structures of the quotidian form inescapable mentalities, such as the Zhek mentality, 'a consciousness which all members of the Zhek share', parodies fictional Zhek theorist W. Fjodorov.[10]

This work by Ilya Kabakov mimics the language and mythology of Soviet life at its most intimate and pervasive. Unlike much dissident art which kept a satirical distance from lived reality in its attempts to connect to an authentic avant-garde of the past, Kabakov confronts the situation

Ilya Kabakov, *Book*, 1980, postcards pasted in an English textbook.

of the artist who is excluded from the official art institutions from within another kind of institutional set-up. As he cannot be an officially recognized artist, he carves out an identity for himself as a hobby artist and Sunday painter of ornaments within the leisure activities of the Zhek. In this context, Kabakov invents all types of categories and activities, for instance the 'Zhek No. 8 section for cultural mass activity, subsection creative art', which allows him to present and describe different series of drawings, just as the 'Circle of Collectors' provides the opportunity to introduce and comment on various collections of postcards glued into old textbooks which are thus turned into albums. The second half of the book consists of texts which complement and theorize the collections. One of the most interesting of these is a short text entitled 'Trash' and signed by Kabakov. The trash in question is the steady flow of paper which accumulates next to the telephone, on one's desk, at work – everywhere. In order to keep this paper flow from turning into an avalanche, it needs to be sorted into useful and garbage. Now what happens, Kabakov asks, when we can no longer distinguish between important and unimportant, between useful and garbage? What happens when we can no longer tell whether one ordering system is better than another, and whether we should keep everything or throw everything away. Kabakov does not transform yesterday's newspapers or old cinema tickets into an aesthetic assemblage à la Schwitters. Piled into boxes and folders instead, scraps of paper supposedly turn into supports of the mind. Personal memories are attached to these items which affirm the unique past of every individual. The bus tickets, paid bills, old letters, invitations and reminders, all those bits and pieces, 'represent the only and real stuff of my life, even if from the outside they appear as trash and nonsense'.[11]

In order to be recognized as valuable by the collective, papers and objects have to be collected, that is, shown to belong to a coherent category. In this way collecting confers value and meaning on things that would otherwise be regarded as trash – matchboxes, beer mats, old stamps, postcards, Metro tickets, the arbitrary accumulations in one's coat pocket. In a highly regulated society, Kabakov seems to suggest, what accumulates willy-nilly becomes by that very fact a collectable, meaningful and worth preserving, because it testifies to oneself as a person and an individual, even if it does so in the most rudimentary sense: as someone who reads letters, buys tickets to the movies, etc. And each of these experiences, even if they are shared by thousands of others with the same Zhek mentality, in the same cinema, surrounded by the same garbage and listening to the same tired political slogans, will create a unique memory in a unique life.

Except that all these collections, classifications, folders, containers, categories and catalogues suggest that the individual's memory itself has become entirely bureaucratized. A telling gap opens between the detailed attention paid to the classificatory process and the intellectual and material poverty that results from it. Where everything can be turned into a collectable and equally becomes a repository of memory, memory itself turns into trash – arbitrary, unreliable, formless.

Kabakov's acute insight in the Zhek piece is the equation of too much = too little, a paradox which may be understood in a number of ways: as a symptom of totalitarianism (any kind of totalitarian tendency – political, economic, technological), leading to forms of more or less compulsive compensation. Collecting rubbish would be one of those compensatory activities, whether the debris is quotidian socialist garbage (Kabakov) or Western consumer trash (Arman). A more metaphysical way of looking at trash (or the discarded, if you prefer) focuses on the relationship between remembering and forgetting. Here the artist's collections turn into archives where memories are as much buried as they are unearthed, and Kabakov joins Boltanski in an artistic arena where the line between retrieval and invention has become blurred.

The particular kind of loss (and waste) that has shaped so much of unofficial art in the East found one of its most intelligent and funny expressions in Bohumil Hrabal's 1976 novel *Prilis hlucná samota* (*Too Loud a Solitude*).[12] Hant'a, the hero of that tale, has been compacting waste paper and censored books in a hydraulic press for 35 years. His thoughts are fuelled by the books he rescues and the enormous quantities of beer he consumes. Hant'a considers himself an artist, and the artwork he produces in the form of compacted waste paper is the art made when

the foundations of a culture, its continuity and artistic aspirations, have been relegated to the pulping and recycling plant. Illustrations of Old Master paintings, poetry, philosophy books and the classics tumble into his cellar through a chute in the ceiling, forming huge heaps of paper for mice to temporarily build their nests in, until the paper mountain – reproductions of paintings by Van Gogh, rodents, Immanuel Kant and all – end up as yet another bale of waste paper.

Last month they delivered nearly fifteen hundred pounds of 'Old Masters' reproductions, dropped nearly fifteen hundred pounds of sopping-wet Rembrandts, Halses, Monets, Manets, Klimts, Cézannes, and other big guns of European art into my cellar, so now I frame each of my bales with reproductions, and when evening comes and the bales stand one next to the other waiting in all their splendor for the service elevator, I can't take my eyes off them: now the *Night Watch*, now *Saskia*, here the *Déjeuner sur l'herbe* . . . Besides, I'm the only one on earth who knows that deep in the heart of each bale there's a wide open *Faust* or *Don Carlos* . . . I am the only one on earth who knows which bale has Goethe, which Schiller, which Hölderlin, which Nietzsche. In a sense, I am both artist and audience, but the daily pressure does me in, tires me out . . .

Another situation of too much = too little: endless reading material persisting in the mind with only the most tenuous connections to the outside world is both a blessing and a curse. Again the question of value and re-evaluation arises, but in this instance the paper flood seems to encompass all of culture. Whole libraries fall victim to recycling, the transformation of the written page into matter (pulp). Except that this destruction of art and writing cannot but produce more art, not only because 'inquisitors burn books in vain' but because a certain madness becomes a form of survival and vice versa.

Like Kabakov, Hrabal suggests that there is no escaping the totalitarian mentality. The recycling does not stop at books. Instead, 'I look on my brain as a mass of hydraulically compacted thoughts, a bale of ideas' and 'I have a physical sense of myself as a bale of compacted books,' his hero tells us. Neither will the recycling end with the retirement of Hant'a, because his plan is to buy the press and continue with the books he has rescued over the years: 'I'll make only one bale a day, but what a bale, a bale to end all bales, a statue, an artifact and when a year is up – an exhibition, I'll hold an exhibition in the garden' But this is not to be, because, after 35 years, the hero gets booted out from his cellar, which leaves him only one option: 'I will follow Seneca, I will follow Socrates, and here, in my press, in my cellar, choose my own fall, which is ascension'.

With tragicomic hyperbole, we are presented with a parody of the artist as romantic hero – the mad outsider, indubitably male, ravaged by alcohol, who ends up killing himself. Yet this character is portrayed as the very product of totalitarian re-evaluation, the process whereby the boundaries between what's considered valuable and what trash are arbitrarily redrawn.

The work of Opalka, Kabakov, Hrabal and others shows us in a number of different ways that this process cannot simply be reversed. It is not merely a symbolic operation that can be undone in private if not in public. Something remains, something that disturbs the most basic distinctions between inside and outside, between self and other. Right at the beginning of the tale, the protagonist tells us:

> My education has been so unwitting I can't quite tell which of my thoughts come from me and which from my books ... Because when I read, I don't really read; I pop a beautiful sentence into my mouth and suck it like a fruit drop, or sip it like a liqueur until the thought dissolves in me like alcohol, infusing brain and heart and coursing on through the veins to the root of each blood vessel.

Thoughts become liquid, words are like things. Texts get broken down into sentences, or even words or letters, floating in a sea of repetition. Symbols turn into stuff, signification into matter – too much becomes too little as one of the ways things 'speak to us'. Pulped paper manifests a stage in a process of destruction and transformation – same but different – of old texts and reproductions into new ones.

This is the principle also of the later work of Jiří Kolář and J. H. Kocman. Both artists work with mass-produced images and texts which they transform into originals. The historical development from the unique, handmade object to its industrially produced copy is thereby reversed, except that mass-produced representations are now the very material from which the unique object is fashioned.

No artist has invented and used more collage techniques than Jiří Kolář. His repertoire includes over 50 techniques.[13] Most of these share an initial act of destruction (cutting, tearing, creasing, crumpling), which is followed by a recombination of the fragments. The signature of his work from the mid-1960s on is the Chiasmage, torn-up print rearranged as a fragmented, faceted, textual surface which still discloses its generic origin – a map, musical notations, text from a book – but withholds any specific semantic coherence. Kolář mistrusts Realism – that convention which tries to hide its conventionality – the prose text that explains how things really are or the photographic reproduction which habitually takes

the place of the original artwork. In his art, representations of the world in the form of mechanical reproductions are treated as another raw material of the world itself. This suggests that in its very materiality, the world is now made up of the traces of the historical and technological transformations of its representations. For Kolář collage is a form of concrete poetry where meaning is anchored in the materiality and form of whatever he chooses to combine and juxtapose. In the words of fellow poets Josef Hiršal and Bohumila Grögerová, the aim is to show 'not only the image of the world but its schemes'.[14] Despite his belief in what he called the 'immeasurable unity of reality', Kolář does not trust the supposed immediacy of symbolic equivalence.[15] Unlike the hero of Hrabal's novel, who was seduced by isolated beautiful sentences which ended up as a pile of words he could no longer remember or relate to anything else, perhaps because of that danger, Kolář insists on creating extended allegories, often in homage to a previous artist or poet. The images and objects made in this way, usually on a relatively small scale, are visually exquisite. They are not meant to shock. They certainly do not issue statements. Kolář's work insists on creativity as the invention of a level of continuity and coherence in the arts across time and space, a continuity which is under the technical and technological imperative of reproduction, yet does not simply reproduce.

On this territory he is joined by J. H. Kocman, whose work, particularly from the late 1970s on, evolves around the physical and conceptual remaking of printed books.[16] Kocman was one of the 'classic' conceptual artists in the former Czechoslovakia. In the late 1960s and early 1970s, his investigations into an extended notion of art included mail art, 'actions' such as *Touch Activity* (1971), which explored the relationship between touch and vision, and collaborations with other artists who worked in the interdisciplinary arena of land art, Conceptual art and body art. Early on, Kocman started making artist's books. Initially, there were the *Prepared Books* of the early 1970s, found books modified by cutting. At the same time, he produced simple paperbacks in the horizontal format of sketchbooks, the *Chromatographic Books*. In these he experimented with the absorption of colour pigments and the change of colour patterns as the paint soaked through the pages. Throughout the 1970s he systematically investigated the different formal and conceptual aspects of books and, in the process, learned to make paper and the skills of bookbinding. In 1979, in the series *Paper as Poetry*, he mixed fragments of maps and texts with pulp to make his own sheets of paper. As in the Chiasmages by Kolár, the source text can no longer be read but there remains enough

J. H. Kocman, from the series *Paper as Poetry*, 1979.

J. H. Kocman, *Paper Re-Making Book No. 72*, 1983.

detail to recognize something textural, the particular language of the source text, say, individual letters or the typeface. Emphasis is now placed on the texture of the textual, the handmade quality of paper with its rough, uneven surface that seems to absorb print as something primarily liquid like watercolour, or a cup of tea in *The Book of One Cup of Tea* (1980). The *Paper-Re-Making Books* of the 1980s both incorporate and 'reissue' books. Again there are different series, and because the work is so directly and materially indexed to pre-existing publications, it pays homage not only thematically in the books of/about Josef Váchal, a curious figure in the history of Czech printing, as well as various poets and artists, but also generically as books (as art objects). One of the remarkable things about Kocman's books is the understanding of the book as indebted, as paying homage *qua* art-object book. Many of his books are bound in leather and sport embossed titles as no modern publication would. Here restoration is displayed as a repertoire of techniques which is mastered in order to make something quite different, books which acknowledge history literally as the fabric from which the new is made. At the same time the making of the new is itself always a remaking. In its incorporation of tradition, it is rendered less rather than more intelligible, less rather than more legible. Yet what was pulped was mass-produced in the first place, which means that there is, at least in theory if not always in practice, another copy we can look at in order to think about the difference between, for instance, Edgar Allan Poe's *The Raven* and *E. A. Poe's The Raven Reduced by JHK* (1982).

The work discussed so far interests me because of what I call, for want of a better term, its embeddedness in the world, its existential dimension. This embeddedness produces obscurity, a particular kind of illegibility, a reduction. Lived time, instead of allowing us to gain experience, leads inexorably to a state of blindness. Yet in the process Opalka produces paintings of great intensity and beauty. Collections of objects and papers no longer guarantee order and coherent categories. Kabakov's work suggests that instead of making reality intelligible, the obsessive preoccupation with definitions and types keeps referring us back to our difficulties of understanding or accepting reality in the first place. Finally, the reproductions of artworks and printed matter of all sorts has been art's 'raw material' for some time, but not only in the ready-made way we tend to think about it. The work of Kolář and Kocman shows us how to pay homage without imitating or otherwise reproducing. Instead, its relationship to history in its various technologies of inscription and reduplication implies that indebtedness is intrinsic to creative freedom. The defining

condition of today's original is that it consciously pays homage, their work suggests. Paying homage here means intimacy with rather than distance from the past; however, this does not mean, as all forms of academic art would have us believe, that the past is thereby fully recoverable. On the contrary, intimacy suggests an inevitable partiality and blindness, a single-mindedness and insistence at times bordering on stupidity or madness, as in love, as in passion.

In the early 1970s, the Czech artist Ladislav Novák produced a number of actions in the countryside which involved the 'drawing' and 'erasure' of basic geometric or organic shapes. In one of these pieces, Novák drew a large circle with chicken feed. A series of photographs shows him making the circle, the chickens occupying it and picking until nothing remains of the shape. In another piece, *Pouring and Destroying the Line* (January 1971), near Třebič, Novák poured the outline of a figure in the snow and invited a group of boys who happened to play nearby to run across the finished drawing and obliterate it. Other artists collaborated on actions in a similar vein, such as Jirí Valoch's *Paper Cross* (1970) or Pavel Büchler's *Landscape Action* (1975). The latter involved six people forming a large circle in a snow-covered field in Konojedy, near Prague. Each started digging a shallow trench towards the approximate centre of the circle. Several hours later, *Landscape Action* was complete. The photographic documentation shows a black star on a white field.

Using the universal language of geometry to stage the desire for expression as itself expressive, these works make speechlessness eloquent by evoking ritual and by falling back on a universal and archaic repertory of forms – the cross, the circle, the star, the human form. But unlike their Western counterparts, emphasis in these instances is on a shared activity and a concrete situation. Where officially there was no audience and no institutional place for symbolic forms to exist in and for themselves – no stone circles were brought back to museums from these excursions – the marks in their abstract autonomy keep referring back to the symbolizing process itself as a fundamental and defining human activity. This situation is made explicit in another piece by Büchler, the photowork *Material Facts* (1979), in which the photograph of the star of *Landscape Action* is combined with a found aerial view of Bory Prison, where Büchler spent the entire year of 1979. The prison also forms a star with a domed building at its centre. The juxtaposition of these two star shapes focuses the stakes in the conflicting claims to universality. In the first instance a symbol is created which is easily recognized, yet it is impossible to attribute any particular meaning to it. In the second instance, geometry is

Ladislav Novák, *Circle*, 1971.

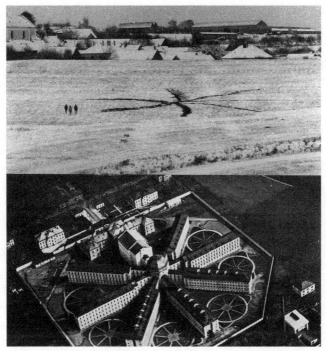

Pavel Büchler, *Material Facts*, 1975–9.

employed to give a particular institutional building type the appearance of a natural and immutable order.

Landscape Action was followed in the late 1970s by a number of solo actions performed for the camera. Collectively titled *Blind Circles (Under Surveillance)*, these pieces involved the artist blindly drawing a circle directly on to the wall for the estimated duration of one hour. The size of the circle was determined by the reach of his arm and the activity of drawing was recorded in a single image with the exposure time fixed at 60 minutes. Once the camera was set up, Büchler had to perform for and conform with its coordinates. If he underestimated the drawing time, as happened on occasion, the negative would be empty. When the experiment was successful, the image recorded the 'progress' of the drawing. The hand which held the chalk or charcoal and any part of the body which moved would be invisible or blurred, while the line of the circle (drawn clockwise) grows increasingly blurred towards the end. In some photographs, the silhouette of the artist is clearly visible, indicating that he hardly moved while drawing; in another image only the left hand appears pressed against the wall; in a third, the centre is simply blurred,

suggesting an unidentified human presence. Each photograph allows us to reconstruct in some detail how a particular circle was executed in real time. It does not, however, yield the information we habitually expect from a documentary photograph, namely the identity of the subject thus recorded. The conception of *Blind Circles* and the nature of its documentation suggest that the performer is interchangeable. The circle is understood as an elementary figure in relation to the human body, which could be drawn by anybody – blindly. Emphasis is placed on duration and endurance. The longer one takes to execute the drawing, the harder it gets. In this sense, *Blind Circles* emphasizes perseverance and endurance, less as an identifiable and individual artistic expression than as a generalizable response to a situation where individual and artistic autonomy was often reduced to basic forms of carrying on.

Paradoxically, there was a certain freedom in a situation where a whole range of art practices simply did not officially exist. Artists were left to their own devices, the only audience being other artists and, perhaps, a small group of like-minded friends. An ideal audience, except that it was the result of necessity rather than choice and in that sense could not help but emphasize the cultural void it tried to displace – another closed circle more or less sealed to the outside. It is interesting how much this situation mimicked the romantic notion of the artist who creates in isolation, ignored or confronted by suspicion if not outright hostility, all the while he is waiting for his genius to be discovered. Except that in post-Stalinist Eastern Europe, this wasn't going to happen, which is one of the reasons why artists found themselves at the threshold of a new Quixotism, with little or no support in the form of an art market, a public and art institutions.

This, of course, has changed now, and for some time. The work which speaks to us today does so because it transcends the conditions under which it was first imagined and made, but also, I want to suggest, because the vicissitudes of the 'new Quixotism' strike a chord in our own present. They do so every time we recognize the totalitarian equation of too much = too little in our own culture, whether it comes in the form of good old propaganda, consumerism, media hype or the compulsion to conform. And I find it significant that artists involved in otherwise very different projects insist on addressing this equation in terms of the ways it limits the representation and knowledge of one's own experiences.

Giulio Paolini

STEPHEN BANN

I

Visiting the Italian pavilion at the 1997 Venice Biennale, I searched high and low for the work of Giulio Paolini that I knew, from the published list of artists, to be there. Repeated circuits of the labyrinthine spaces of the building refreshed my awareness of an impressive roll call of contemporary painters and sculptors. But it was only when I was retreating, mystified, from the pavilion that I turned back and saw that Paolini's *Crystal Palace* occupied the whole of the façade. I write 'occupied'. This is, however, a term that I have to correct straight away in the interests of perceptual accuracy, for the very reason why I had not taken note of the presence of the work on my entry was its delicate adjustment to the slightly curved elevation of the front entrance. Paolini had, as it were, inscribed this façade with a scattered company of small frames, mostly at an angle to the horizontal and vertical emphases of the architectural bays, and presenting more or less complex effects of overlap. In the centre he had placed a falling figure, upside down, in evening dress and a top hat.

To comment further on this work, as on any of Paolini's works, it is necessary to enter another labyrinth, which is the sedulously cross-referenced system of his total oeuvre.[1] I note that a gallery installation, *Tutto qui* (1985–6), offers many of the same features that he has transposed, in *Crystal Palace*, onto an outside wall. *Tutto qui*, however, covers the white-painted surface with a regular distribution of frames and then adds a plethora of smaller rectangles – set at odd angles, tucked in behind and superimposed on the original frames – which turn out to be photographic images of the gallery space, recognizable because of its high-placed oculus. *Tutto qui* energizes an internal space through multiple transformations. *Crystal Palace*, on the other hand, initiates a subtle reframing of the

architectural members, as if to recall that any building – and perhaps especially a place of exhibition – is a projection of ideas before it is a solid structure: a vision of Utopia as well as a product of history, in the way that Paolini's title inevitably suggests. *Tutto qui* includes at its centre a top-hatted figure in evening dress whose face is obscured by the superimposed white squares that he proffers in our direction, like a conjurer displaying his tricks. In *Crystal Palace*, the figure plummets downwards, like Icarus, or like the various surrogates for Icarus that Paolini has distributed in his installations of the 1980s.[2]

Who, then, is Giulio Paolini? Even a very brief sortie into the world of his works (such as this has been) immediately raises a series of questions that are not simply biographical but, as it were, mythological. In biographical terms, as will be suggested later, Paolini's career as an artist offers few features of special interest that need to be taken into account as determining factors in his work. He has not taken a conspicuous public role and, indeed, one might be excused for thinking that he has succeeded all too well, in the past few years, in a strategy of effective self-effacement. But this strategy has been compensated for by (and perhaps, indeed, logically entailed) the ingenious way in which Paolini has constructed a myth of the artist to take his place. Who is the figure in the top hat, in *Tutto qui* or *Crystal Palace*? Without much ado, one can say that he is one of the contemporary avatars of the Artist as Dandy, according to a genealogy which Carter Ratcliff has traced in an absorbing essay.[3] He is inscribed in the lineage which passes from Baudelaire, through Marcel Duchamp, and no doubt as far as Andy Warhol. But the very mention of this high road of the avant-garde, at the end of which a greatly publicized life can hardly be dissociated from the body of work produced in the course of it, causes us to reflect on Paolini's very different posture. In one of two epigrams to a catalogue published in 1978, Paolini quoted from George Brummel, alias Beau Brummel and the veritable prototype of the English dandy, who was reported to have asked his valet the question, 'Robinson, which of the lakes do I prefer?'[4] The true dandy, in Brummel's mould, was not a strutting, egregious popinjay but, on the contrary, the leader of fashion whose achievement was to persuade the Regency bucks that a sober black was the most becoming costume; and, moreover, the man of taste who delegated his judgements to his valet.

Paolini's telling quote points to the centrality of the image of the dandy in the mythology of Modernism, and his invocation of the prototype of Beau Brummel seems no less relevant, in some respects, to the enigmatic persona of Marcel Duchamp than it is to his own practice. But again the

obligatory point of reference for all varieties of Conceptualism should be placed in a wider context if we are to appreciate Paolini's unique historicized vision of contemporary art. Valets are on hand, in line with Beau Brummel's prescription, to set up what could be regarded as a central work of Paolini's career, *The Triumph of Representation* (1983). It is central in the sense that (as Paolini himself has indicated) it refers back to the past and forward to the future. The work that he chooses to embody its past may indeed be one of the very first that he produced and exhibited, since it dates from as early as 1960, when he was twenty years old. Paolini glosses this piece, *Geometrical Drawing*, more than two decades later, by explaining that its simple structure, which we might describe as a rectangle with the cross of St George and the cross of St Andrew drawn upon it (the structure of the Union Jack), produces nine points of intersection: the four corners, the four median points on the bounding lines and the centric point where the two crosses coincide.[5] In *The Triumph of Representation*, collage images of the valets are on hand to support and, in the strict sense, render perceptible the perspectival recession implied by linear structures arranged according to an absent vanishing point. Paolini interprets their role, with regard to both artist and spectator, in the following way:

The work, in itself, imagines the author. Thus what reveals itself to the look is a moment prior to any possible definition, beyond which all definitions will, conversely, be possible. The interval which separates us from the image is the eternity which is consumed in waiting for the beginning.

The vision is confided to nine male figures: the *not yet*, or the *already no more*, that they celebrate is the quintessence of the absence of expressivity and distance. They put on the uniform of *valets de chambre*, and their presence is all the more anonymous and discreet. The artist is far away, admiring the silence of the constellations.[6]

Paolini's valets, therefore, serve a higher law which the artist has not brought into being and has no wish to imbue with his own subjective intentions. They stand obsequiously by the walls, as valets are prone to do. But in their relative diminishment of size according to the law of perspective, they assist in the definition of an illusionary space that is, after all, only tentatively indicated. Or, as in the third panel of the work, they bear the burden of the linear structure as if they were carrying a picture in the space within the frame. In *Geometrical Drawing*, the law revealed is of an axiomatic order. Those nine points of intersection infallibly occur when the lines are drawn. With the law of perspective, however, there are

perceptual consequences which bear on the position of the spectator and on that of the artist, in so far as he may be a spectator of his own work. Paolini delegates to his valets – and metonymically we might say he delegates to the properties of line – the moment of creation, which is replaced by a theoretical moment 'prior to any possible definition'.

No one has written with more insight about this defining aspect of Paolini's work than his compatriot, the Italian writer Italo Calvino. In an introduction to a book by Paolini dating from 1975 (the year of some of the first of his important *Mimesi* series), Calvino conducts a fascinating *paragone* between the effects available to the visual artist and to the writer in which his admiration for Modernist art becomes amply clear. The artist's advantage lies in the fact that the artwork is both conceptual and material at the same time. Visual works are 'moments in the relationship between the person who made the picture, the person who looks at it and the material object that constitutes the picture'.[7] In the achievement of this relationship, the search for individual expression is minimized: 'It is

Giulio Paolini, *Mimesi*, 1975, installation shot from
Galerie Yvon Lambert, Paris, 1976.

not the relationship of the I to the world that these works seek to fix; it is a relationship which becomes stabilized independently of the I and independently of the world.' If the artist, for Paolini, stands back to admire the representation inaugurated by his valets, there is also Calvino the writer taking up a further position in the chain, and his comments stand as a definitive judgement on Paolini's work – achieved in 1975 and still to come:

From one work to another the artist continues a single discourse, neither communicative nor expressive, since it does not claim to communicate anything that is outside or to express anything that he has inside, but all the same a discourse that is coherent and in continuous development. The writer looks at the world of the artist, pared down and shadeless, made up solely of affirmative statements, and asks himself how he might ever achieve such inner calm.[8]

II

Paolini's work thus both demonstrates and questions at the same time the point made by Michael Newman about the possibility of compiling a history of Conceptual art. Newman writes that since the initial drive of the movement was to resist the fate of being recuperated by historicism, the assimilation of these artists to a traditional art-historical narrative would signify the failure of their aims.[9] Leaving aside for the moment the question of whether Paolini was ever appropriately classed as a participant in the movement of Conceptualism, we might well acknowledge that his work has developed and intensified over the years since Calvino wrote his comments those qualities of internal coherence and, as it were, axiomatic clarity that threaten to make a nonsense of blunt historical enumeration. Having used the labyrinth earlier as a metaphor for finding one's way around Paolini's work, I have to admit that it is quite inappropriate, at least in so far as it conveys the idea of a single, obligatory track and the impossibility of taking an overview. Much more accurate is the image which Paolini himself used, in the passage previously quoted: 'The artist is far away, admiring the silence of the constellations.' The metaphor of interstellar space sits uncomfortably with any noisy narratives that we might devise for Paolini's career.

Yet of course it is precisely in Paolini's ahistoricism that a historical estimate of his significance can be found, however much it may fail to accord with the narratives of Conceptualism.[10] For Paolini to use the term 'constellation' in the way that he does, it may safely be assumed that he implicitly evoked the pivotal role of the word in the poetics of the paragon

of high Modernism, Stéphane Mallarmé, and that his choice of that image is contextually related to the revival of Mallarmé in diverse artistic and critical statements throughout the third quarter of the century. The Swiss poet Eugen Gomringer explicitly used Mallarmé's term in his founding manifesto of concrete poetry, 'From Line to Constellation', published for the first time in 1954. By the time that Jacques Derrida devoted the last section of *La dissémination* (1972) to a critique of Philippe Sollers's *Nombres* in the light of *Un coup de dés*, the link between Mallarmé's astronomical language and contemporary avant-garde poetics was well established.[11]

In effect, it may be more rewarding to pursue the hypothesis that Paolini can be approached through the general cultural matrix of European Modernism than through the specific history of Conceptual art, or indeed the history of Italian art in the post-war period. The history of Conceptualism in Italy, in so far as it has one, cannot easily be divorced from the critical and organizational activity of Germano Celant, who coined the term 'Arte Povera' in 1967, and later glossed it in the title of his important exhibition *Arte Povera: Earthworks, Impossible Art, Actual Art, Conceptual Art*. But although Paolini has been loosely associated with the Arte Povera group, and key works like his *A Young Man Looking at Lorenzo Lotto* (1967) were indeed first exhibited under their aegis, his reputation had already been established in 1964 by a one-man exhibition at the Galleria La Sallita in Rome. While at this stage his work was certainly conceptual in character – being concerned with 'the fundamental relationships involved in the conception of an exhibition' – it would be a mistake to assimilate it to any group or movement.

Paolini himself has commented usefully on the lack of communcation which existed at the period, compared with the 'crazy platform' offered by art magazines and other forms of activity just two decades later.[12] According to his testimony, there were few links, in the early 1960s, between young Italian artists, and it was only a matter of chance that he was able to see the odd work by Manzoni, together with work by Mario Schifano, Enrico Castellani and, at a later stage, Michelangelo Pistoletto. Manzoni, who died in 1963, can justly be seen as the main stimulus common to the heterogeneous group of artists, partly based in Turin, whose work became internationally known under the title of Arte Povera. However, each of the other artists whom Paolini mentions on this occasion is also significant, precisely because their effect on him must have seemed to come from several different directions. Pistoletto, born in 1933, was in essence a figurative painter, deeply influenced by Abstract

Giulio Paolini, *The Invention of Ingres*, 1968,
proof on photographic paper.

Expressionism, who made his international reputation in the mid-1960s
with his 'mirror paintings', involving realistic figures attached to polished
steel plates. Castellani, co-founder with Manzoni of the 'New Artistic
Conception' in 1960, was a Milan-based geometrical abstract artist who
created gallery installations of extreme purity and simplicity.[13] Schifano,
born in 1934, worked in Rome and developed a style of brushwork related
to Johns and Rauschenberg; his deliberate references to street imagery
and other Pop themes earned him the reputation as a politically commit-
ted artist who presented an alternative strategy to the canonical realist
paintings of Renato Guttuso.

Though there is no reason to doubt Paolini's implication that these artists
only lightly grazed his consciousness, it is clear that he shared with them the
general predicament of the Italian intelligentsia during this period. On the
one hand, Italy had been opened up to the diverse productions of internat-
ional, and especially American, Modernism by the successful development
of the Venice Biennale. On the other hand, Italian intellectual life was dom-
inated by the need to come to terms with the changing European perceptions
of the role of the Communist Party in national and cultural life. In the five

years 1957–62, as Franco Fortini had explained, the ideological dominance of the Communist party in Italy was shaken simultaneously by the repercussions of the revolts in Russia's East European satellites, Poland and Hungary, and by the unfolding of Italy's own 'economic miracle', which appeared to promise a glowing future within the capitalist world.[14] Umberto Eco has written incisively of the strategy which the literary avant-garde pursued in these circumstances, where the domestic political impasse developing from the decline of the Communist Party was doubled by a 'frozen' international situation, expressed by the concept of 'peaceful coexistence'. For Eco, and his colleagues who formed the 'Gruppo 63' at Palermo in 1963, the answer lay not in the forms of activism which characterized earlier phases of the avant-garde, but in a comprehensive debate about the 'super-structural' dimension of culture:

... we had to call into question the grand system by means of a critique of the super-structural dimension which directly concerned us and could easily be administered by our group. Hence we decided to set up a debate about language. We became convinced ... that to renew forms of communication and destroy established methods would be an effective and far-reaching platform for criticising, i.e. overturning, everything that those cultural forms expressed.[15]

It is no more convincing to represent Paolini as a conscious adherent of the avant-garde formation which included Eco than it is to class him with the artists in the Arte Povera, or the emerging movement of international Conceptual art. At the same time, it is clear that Paolini shared in many important respects the perspicacity and the breadth of vision which led Eco and his fellow writers to single out a particular strategy for the Italian avant-garde: not the 'Demagogism', 'Self-propagandizing' and 'Cult of modernity' associated with their Futurist predecessors, but what Renato Poggioli had termed the 'Domination of the opus by its poetics'.[16] One may draw an analogy with the way in which the French Supports-Surfaces group cooperated with and drew theoretical sustenance from the *Tel Quel* writers after 1968. The difference, however, is that Paolini was in no way a follower and his independence as an artist was already well established by 1964.

Indeed, Paolini's close affiliations, and the vehicles for his own 'debate about language', turn out at a very early stage to be those of the Western artist of what could broadly be called the classical tradition. In *Idem*, the book from 1975 whose introduction by Calvino has already been quoted here, he shifts rapidly from 'the Muse up-ended, the ruin of the picture' to his own statement of purpose: 'I invoke, in my work, the etymological

transparency of the works of Fra Angelico, Johannes Vermeer, Nicolas Poussin, Lorenzo Lotto, Jacques-Louis David.'[17] Invocation is, indeed, the oldest trope in Western poetics. The *Iliad* itself begins with an invocation to the Muse. Paolini justifies himself as a Conceptual artist by his insistence that Western art displays an *etymology*: that is, it is like a dictionary in which we can trace the historic usage and signifying roots of terms that are still in current use. But he also singles himself out as an unusual, if not unique, Conceptualist in his use of the word 'transparency'. It is a question of *seeing through*, of the history of the image being manifested through the actual (and eternal) conditions of sight.

Two works from the 1960s are enough to demonstrate immediately what might be called the visual economy of Paolini's approach and, at the same time, the historical dimension which he brings to the fore. *A Young Man Looking at Lorenzo Lotto* (1967) consists of a photograph of the portrait by Lotto mounted on canvas. It is, in the words of Paolini himself, 'A reconstruction of the time and place occupied by the author (1505) and spectator (now) of his painting.'[18] But this terse definition of course gives rise to certain ambiguities and even paradoxes. The 'author' – that is, Lorenzo Lotto – was also the first spectator of the painting that has been photographed. The 'spectator' – that is, Paolini himself in 1967 – is also the author who has relayed the image to another, potentially infinite, series of spectators. The 'young man' is Paolini looking at the Renaissance painting by Lorenzo Lotto, but also the object of Lotto's portraiture who stares back at the artist, the artist as spectator and the spectator who is not an artist. One could go on. But the essential point is that Paolini has used the unique indexical quality of the photographic image to demonstrate that the visual never consists of a simple relationship between subject and object. The gaze is reversible. What we see sees us.[19]

Dating from the year after *Young Man*, another work by Paolini involving the photographic image is *The Invention of Ingres* (1968). Here the strategy is to impose upon the image of Raphael's *Self-portrait* of 1506 the version of the painting as 'repeated and reinvented' by Ingres in 1824. An extraordinary epistemological density is created in this work as we observe the shifting grey tones of the minutely overlapping outlines and reflect on the different visual scenarios there are, so to speak, collapsed into one. Raphael's self-image, originally imbued with a narcissistic tenderness, undergoes the subtle but evidently consistent alterations of the nineteenth-century painter who worshipped him so devoutly as to collect and treasure his bodily relics – and yet insists on this inexorable transformation. What is the stake of Paolini in this process? One possibility is

Giulio Paolini, *A Young Man Looking at
Lorenzo Lotto*, 1967, proof on
photographic paper.

that he will take Ingres's licence for a further stage of 'reinvention' that
departs completely from the figurative tradition of Western art, yet
retains the fundamental structure of visuality. Thus Ingres becomes the
harbinger of abstraction. Paolini records this possiblity, presumably after
a visit to the Ingres Museum in Montauban, only to confess at the same
time that 'seeing' demands a historical perspective much broader than the
recent passage from neo-Classicism to Modernism:

I cannot affirm that my research is dedicated to the true (to the visible) in just the
same way as I cannot, perhaps, affirm that abstract art was born, in 1810, with
the 'errors' of Ingres. Two days at Montauban invite you to take possession of
this discovery; one minute, afterwards, is enough to extend it (or reduce it) to the
inexhaustible flux of the emotions. The only story told by these works is one of
absolute dedication to the – antique – phenomenon of seeing.[20]

III

I hope to have shown in the previous two sections how Paolini's place as a
Conceptualist artist is extremely difficult to assess. If it is a precondition
of being labelled in this way that an artist should have subscribed to a

common programme and participated in a shared history of exhibitions, manifestos and other public expressions of solidarity, then Paolini hardly fits the bill. This is not to say that he comes across as a unique, inexplicable creative phenomenon, as surprising in the Italian context as he seems to be when juxtaposed with his Anglo-American contemporaries. On the contrary, as I have tried to show, his distinctive avant-garde position has much in common with the precocious and sophisticated stance of the Italian intellectuals of the Gruppo 63, for whom Umberto Eco acted as spokesman. This can be said without impugning in any way his own deep commitment to 'the – antique – phenomenon of seeing' which (as Calvino's tribute acknowledges) implies attitudes and procedures quite different from those of the artist with words.

I am tempted to say, indeed, that Paolini's very distance from the competitive reductionism of early Anglo-American Conceptualism gives his work a special value in the general assessment of the significance of Conceptual art. It is not that he has a programme of his own, but precisely that his way of tackling the programme endows it with a historical and cultural resonance that is rarely present in the work of his contemporaries. Few people would disagree with the following statement, made by Michael Newman, about the fundamental aims of Conceptualism:

The aim of most Conceptual Art is for the conditions and limits of spectatorship to become a reflexive part of the work. Of course, everything depends on how those 'conditions and limits' are interpreted. Are they primarily perceptual, as was the case with Minimalism. Or do they extend to architectural, institutional and social conditions? Are they the conditions of knowledge or of being?[21]

In Paolini's case, the different steps of this definition can be read off without much ambiguity. Certainly his art is about the reflexive inclusion of the conditions and limits of spectatorship. As early as 1965, the photographic work whose title is its own date, *1421965*, encapsulates this message: we see in the photograph the photographer in the process of photographing the painter (Paolini) in the process of stretching his canvas.[22] But, however much Paolini employs an abstract vocabulary at this early stage – and however much he investigates the material properties of the artwork in ways which parallel the approach of the Supports/Surfaces group in France – his fascination with 'the – antique – phenomenon of seeing' is constantly infringing upon the sobriety of his approach. Even when he is most 'minimal' there is a preoccupation with the dividing line between the real and the illusionary, and a consequent repudiation of any 'literal' reading of space, that singles him out.

This can be shown in particular if we follow up further Newman's point about the 'conditions and limits of spectatorship' and their extending into 'architectural, institutional and social conditions'. Certainly few Conceptual artists can have expressed themselves as categorically about architecture as Paolini has. He has written, in a statement of 'Homage to the architect' that 'Architecture is all'.[23] But this does not imply, on the banal level, that he aspires to the goal so cherished by the generation of Modernist sculptors immediately before him: accessibility and immortality in the form of publicly sited works in the vicinity of new building schemes. On the contrary, as Paolini makes clear, architecture is important to him in so far it is the paradigm for progression 'from the idea to the realization of the work'.[24] As the history of the development of linear perspective with Brunelleschi demonstrates, the roles of the architect and the painter were inextricably connected at the time of the early Renaissance. Paolini's work recalls this historical moment, not because it aims to acquire semi-permanent status by association with architecture, but, on the contrary, because it implies the fusion of painterly and architectural intentions in the self-generating spatial project.

This can be seen clearly in the case of a recent and spectacular architectural work, in the strict sense of the term: Paolini's design of the entry to the Capitole Metro Station in Toulouse. It is evident that the basic principles of the scheme were anticipated in *Early Dynastic* (1971), a gallery installation which involved the distribution of regularly spaced double columns across a grid. However, the Toulouse work presents significant differences. The height of the ceiling is much lower and hence the non-structural role of the column is stressed. The columns themselves, of granite rather than a more temporary material, vary between the distinctive double structure (a smaller base and column mounted on a larger) and a simpler design. Judicious use of lighting, which also has to serve the functional purposes of this entry into the station allows the columns to cast shadows on the floor and to be reflected in the ceiling, while the wall shadows intersect with finely drawn lines repeating their profile. Consistent with his ideas at the period when *Early Dynastic* was first exhibited, Paolini has set up a system which seems capable of infinite extension. Indeed, it is the interplay between the non-functional architecture of the columns and their reduplication in the form of linear traces and multifarious shadows that makes the work at least as much a conceptual as a perceptual experience. Just as the title connotes Egyptian art (and refers to a pyramidal structure which completed the original installation of 1971), so the granite columns of new work generate a sense of

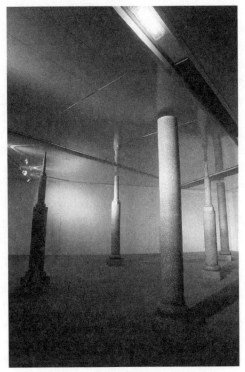

Giulio Paolini, *Entry to the Capitole Metro station*, Toulouse, 1994.

specifically historical complexity. They do not arrive at their capitals and so the canonical differentiation of the orders which was the legacy of Greek temple architecture is not yet in force. In the centre of Toulouse, a city notable in particular for its magnificent Romanesque and Gothic architecture, Paolini's columns intimate an archaeology of structure, a symbolic rendering of architectural morphology, prior to any actual realization in space.

In *Early Dynastic*, and its Toulouse avatar, the historical reference is muted. Yet in the works by which Paolini is best known, there is a much more explicit invocation of classical, mainly Greek, iconography. This alone would serve to distinguish his work, on a basic level, from that of virtually all other Conceptual artists. As David Elliott has pointed out, Paolini strictly subordinates his iconographic references to 'his research into the function of art'.[25] Where he uses 'well-known paintings', such as those by Lotto and Ingres, or plaster casts of classical Greek sculptures, they are part of his overall argument: 'not so much works in themselves but a critique of

the social, economic and cultural accretions which have become associated with the history of art.'[26] This is certainly true. But care must be taken to distinguish Paolini's approach from the 'critique' of pre-modern art embodied in the work of the majority of Conceptual artists, which may be ironic – in the tradition of Duchamp's altered *Mona Lisa* – or downright condemnatory when the familiar cultural icons are viewed simply in terms of their fetishized commodity status. Nothing could be further from Paolini's intentions. Indeed, this is the context in which he can be seen, perhaps more convincingly than any of his contemporaries, to pose the question specified by Michael Newman. Are 'the conditions and limits of spectatorship . . . the conditions of knowledge or of being'?

Around 1975, Paolini began a series of related works in which casts of classical sculpture were placed opposite each other, as if one cast was gazing at its exact replica. The general title for the series was derived from the Greek term for imitation, itself retained as a crucial marker for realistic representation throughout the Western tradition: *mimesis*. In one sense, there is an implicit irony in the very confrontation of such copies with their identical counterparts, but this is an irony which is historically based, rather than being a gesture of contemporary iconoclasm. The Graeco-Roman sculptural tradition was, indeed, a history of copies and copies of copies, to the extent that, during the Renaissance and for centuries afterwards, discrimination between originals and later versions was impossible to achieve. In the mid-eighteenth century Winckelmann began to construct the foundations for a genuinely historical estimate of the different periods and phases of ancient sculpture. In the same period, however, William Blake magnificently undermined the whole basis of historical connoisseurship by asserting that such archetypal works as the Venus de'Medici and the Apollo Belvedere were themselves simply copies of the original images of the Cherubim, which he himself had seen, 'having been taken in vision' to their original Asian location.[27]

Where Blake repudiates the condition of belatedness by asserting the visionary primacy of the artist's imagination, Paolini bases his strategy on the very structure of vision, creatively interpreted. What the self-regarding busts of *Mimesi* (1975) disclose is not the sovereign power of the Romantic imagination, but the essential reciprocity of the gaze. In this sense, the work does indeed become the artist's own portrait, as he has persuasively argued:

The illusion that has dogged the artist since time immemorial, namely that of translating his own image into another that has more significance and is thus less

precarious, is not at all inconceivable. The gaze, fixed on a picture or a sculpture, is directed neither at the maker nor at others, nor does it allow of one or many viewpoints, but it reflects in itself the demand in its own presence.[28]

It is important to be precise about what is being claimed here, and what is epitomized by Paolini's *Mimesi* series. The effect that he so compellingly obtains could be described as a *mise-en-abîme* of the gaze, in the way that contemporary theorists have analysed it. Norman Bryson rightly associates this concept with the Renaissance (re)invention of perspective, and the Albertian construct of a single vanishing point that is 'anchor of a system which *incarnates* the viewer'.[29] It is in relation to the hegemony of the Albertian system in academic painting, from the Renaissance onwards, that we can postulate 'the dyadic reversibility of the two gazes' – 'something is looking at my looking: a gaze whose position I can never occupy, and whose vista I can imagine only by reversing my own, by inverting the perspective before me . . .'[30]

This does not mean, however, that Paolini's artistic practice is fixated on the historical development of perspective theory, let alone that he is merely reacting to current ideas in art-historical methodology. Quite the opposite, Paolini's work with perspective (which I discussed at the beginning of this essay) and his *Mimesi* series both belong, together with the many facets of his mode of working, to a practice which reflects on the whole history of Western representation. When he writes of 'the – antique – phenomenon of seeing', he evokes a tradition which indeed crystallized in the Albertian system, but can be imagined as having operated from the very stage when the art of the ancient Greeks became something to be seen, rather than something to be worshipped: in other words, since the cultic value of Greek sculpture was supplanted by an aesthetic value, rooted in visibility.

This is a transformation which still resonates through the field of contemporary art. What was Duchamp's ready-made if not a parallel move which wrested the object from its function in the practical domain and invited our consideration of its pure visibility? Indeed, Duchamp's explicit concern with what he called the 'rehabilitation' of perspective, and his optical experiments culminating in the *Anemic cinema*, contribute to a totality of artistic response to the conditions of seeing that anticipates the work of Paolini. What is excluded in this transition from the Modern movement to the period of Conceptualism is, as Eco emphasized in relation to Gruppo 63, the avant-garde activism of the earlier period: 'Futurism; No more Latin in class . . . Dada; let the children have their fun.'[31] There are no moustaches on the plaster upper lips of Paolini's

classical casts, though it is obvious enough that they, like so many of the objects utilized by Paolini, can be allotted quite legitimately to the category of the ready-made.

It might indeed be thought that Paolini, in contrast to Duchamp, works exclusively within the registers of the iconic and the symbolic, without dirtying his hands with the indexical. But this would be to overlook the crucial role which the photographic image plays in his artistic practice. Reference has already been made to the photographic portrait of *1421965*, and to *Lorenzo Lotto*. In mature installation works like *The Three Graces* (1978), Paolini justifies his assertion, 'Photography is more than a technique, it is genuinely the revelation of the language'.[32] Although the use of the photographic image in Conceptualism is too widespread to merit attention in general terms, it is Paolini's special achievement to have realized that photography implied a comprehensive revaluation of the different signifying properties of the western artist's traditional techniques. Above all, it implied a reappraisal of the role of line, within the new conditions of temporality inaugurated by the instantaneity of the image. The following passage, written in 1986, helps to explicate the dynamic movement of *The Three Graces*, in which the circulation between three basic elements (the sculptural cast, the large photograph and the smaller variant imprinted with a drawing) is doubled by the circulation of three techniques: casting, drawing and photography:

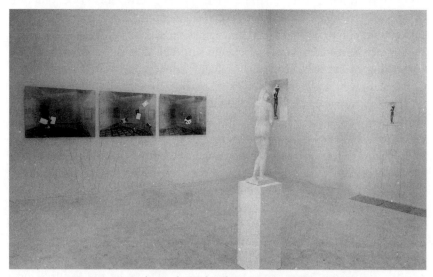

Giulio Paolini, *The Three Graces*, 1978,
installation shot from Galerie Yvon Lambert, Paris, 1978.

By extension each one of my works is a photograph: it implies a photographic way of seeing, even if in material terms it is not one – in the sense that it photographs a gesture, a distance, even an absence – that is to say, it tends to illustrate the instant of the eternity of the image. It is the experience of photography that has allowed me to comprehend the meaning of drawing, that which is designed as true, and this as intact, for all time.

If there exists no drawing without line, line nonetheless *advances*, as in a chess game, with no object to meet it (and so without entering into time), appearing in the place where it ought to appear . . . So many precarious and precious motifs, like those that the hand of the archaeologist brings back to the light of day, surrounding with diligent care these traces laid down by time.[33]

Paolini deserves to have this last word of his work. His final remarks do indeed epitomize its special character.

Marcel Broodthaers: The Place of the Subject

BIRGIT PELZER

PREFACE: PROJECT FOR A TEXT

Exploiting the tension between poetry and the plastic arts, the work of Marcel Broodthaers raises the question of the subject in a paradigmatic way. This work could be said to come under a pragmatics of discursive acts that itself proceeds from a particular link to fiction. In effect, with continual recourse to illusion or deception, Broodthaers's practice is supported by the constitutive feint of language, in order to define the nature of a division, of a basic alienation. His approach to the study of what constitutes the symbolic act and its effects involves a characteristic practice of elision. And so in a three-minute 1969 film entitled *The Rain: Project for a Text*, under 'rain' sprinkled from a watering can, Broodthaers presents himself to us while attempting to write. Damp, he manages to write; soaked, he persists even though the task is impossible. In this preliminary question, 'what is inscribable?', a characteristic game of appearance and disappearance is already manifest. The scene plays itself out in the difference between the impotent and the impossible. There, where the subject tries to centre itself, it experiences that which interrupts it.

In studying the place of the subject in Marcel Broodthaers, I have chosen to start with his relation to Mallarmé: that is, with the relation between an artist of the 1960s and an inaugural text of modernity, *Un Coup de dés*. I will consider Broodthaers's 1969 installation *Exposition littéraire autour de Mallarmé*, together with the book he conceived for this occasion, *Un Coup de dés jamais n'abolira le hasard (Image)*, but also, in order to clarify this relation, the *Pense-Bête*, [a collection of poetry] that marks the beginning of the artistic process for Broodthaers in 1964.

My account is based on Lacan's *Ecrits*, published in 1966 (Broodthaers expressly evoked Lacan in an open letter concerning this installation ded-

Marcel Broodthaers, Installation shot of *Exposition littéraire autour de Mallarmé*,
Wide White Space Gallery, Anvers, 1969.

Marcel Broodthaers,
Title page of *Un Coup jamais de dés
n'abolira le hasard (Image)* (1969).

Marcel Broodthaers, Double-page spread
from *Un Coup jamais de dés n'abolira
le hasard* (Image).

icated to Mallarmé).[1] A slightly different version of this essay was first presented in 1990 at a conference entitled 'Langage et modernité' at the Nouveau Musée, Villeurbanne, and appeared the following year in French in a volume published by the Nouveau Musée. As for Broodthaers's own texts, I will focus mainly on the interview 'Ten Thousand Francs Reward' and the manuscript MTL.[2]

MY RHETORIC

Before outlining the problem that Broodthaers constantly worked on, it is important to restate that the subject, inserted in language, issues from a symbolic order ruled by the laws of the signifier.

As Broodthaers never stopped pointing out, the subject is a point of structural incorporation in language, inserted in language to such an extent that language folds back on it. As a result, in order to say itself or to be said, the subject must pass through words. Yet the fact that the subject is taken up in language implies its division – the subject that speaks does not coincide with itself. It is represented by words, or, more exactly, by the signifier. One of Broodthaers's texts, *Ma rhétorique*, reflects on this, announcing, '*Moi je dis Je Moi Je dis Je le Rois des Moules*'.[3]

Through the play of signifiers, paradigms of power are established. These powers are founded on a certain articulation of words, on a discourse. In 'Recourse to the letter', by taking up the analyses of the four discourses in Lacan's work, I have shown that Broodthaers's position, stated in his open letters, proceeds from each of these discourses.[4] In effect, there is a logic of exchange defined as such by discourse as 'social bond'. This bond must be specified. The function of place is created only by discourse itself. The phrase 'each one has its place' functions only in discourse. All discourse thus implies a system of circulation, according to a given order, composed of four fixed places and four mobile terms.

To recap, the four fixed places are the place of the discursive agent in relation to the other, and the place that the truth occupies in relation to production. The four mobile terms are the divided subject, that in the name of which it speaks, the articulation of knowledge subsequently put into motion, and the real, presented every time by its substitutes, the objects.

I would like now to attempt to specify one of the terms of discourse, the divided subject. Broodthaers claims that his work aims at 'a contraction of the notion of the subject'.[5] The subject's place issues from an order of language which exists before the subject. In effect, before every formulation of a subject, this order counts, is already accounted. Pacts

have been established and engagements fixed long before the subject appears. These are the laws of alliance, of exchange, of the universe of discourse, and they assign to the subject its name and its place. Broodthaers indicates that the subject is subjected to this order of discourse. His work marks how much the subject incorporates a lack or a blank, starting from the side of language. His work shows (and in this way it distinguishes itself from most of the approaches of so-called Conceptual art practising a recourse to language, as well as from the variations of this recourse in the 1980s) that the insertion in language opposes itself fundamentally to the use of language. This in turn emphasizes that the relation of the subject to language is not a relation of mastery, that a language is not learned but rather we are taken up by it. In other words, Broodthaers interrogates the order of language which precedes every subjective position, every taking up of speech. Following the lead of Mallarmé, he poses the question of codification as that of a language.

This symbolic order, which is at the foundation of the subject's existence, is ruled by a logic, a determination of signifiers. We know that the signifier is a differential value, that it is structured only by opposing itself to other signifiers, that it exists only in the play of presence and absence. From this structure of reference, signifiers group themselves together. The fact that they repeat themselves means that there is a network. An implacable law rules the formation, circulation and grouping of the signifiers, making such trajectories possible or impossible. There is a forced circuit. These networks highlight the laws of filiation and succession, laws that prescribe or forbid certain groupings. As the two principal groupings of signifiers are metaphor (one word for another) and metonymy (word to word), Broodthaers's work will put the laws of condensation and displacement to work. And so, across the construction of these networks, he highlights the symbolic order as an ensemble of trajectories submitted to an imperative of coherence. Just as he makes us see that it is in these trajectories where the symbolic is developed, so too does he throw himself against an impossibility. This impossible attests to the real, which is outside meaning, disconnected from meaning, is always already there and has always already accomplished its effects as they appear.

How is it, then, that the symbolic can be in the real?

The impossible, flush with language, implies that it is not in the power of any other signifier to signify by itself, to say both what it means and what it says at once, without recourse to another signifier. A signifier does not say its truth at the very moment when it introduces its dimension.

During his first exhibition in 1964, Broodthaers said, 'The idea of invent-ing something insincere crossed my mind and I quickly got to work on it'.[6] Consequently, he manipulates this non-identity of the thing with its inscription. He never stops bringing to light the function of the signifier in the principle of non-correspondence and in the network that it obeys. His work, which is built on an order of absent unities and of empty forms of spatial language, attests precisely to the rules according to which the sig-nifier displaces itself, carrying the subject along into a combination of places.

As we know, Lacan borrows the definition of the sign from the American logician C. S. Peirce: 'According to Peirce, the sign represents something for someone.'[7] Precisely in opposition to this definition of the sign, Lacan introduces his definition of the signifier as that which repre-sents the subject for another signifier. This conserves, certainly, the struc-ture of representation, but now, the 'someone' is not the recipient of this representation, is not at the end and does not make the link between the sign and what it represents. Here, the 'someone' is only a poor subject bound up in a chain.

Lacan's definition of the signifier must let the subject in as that of which it is spoken, as deriving from a signifier, as ordered by it, reduced to being its 'serf'. In other words, the signifier plays and wins the game before the subject even thinks about it. The subject is a variable which takes its values from its disposition relative to the signifying articulation.

If the system of signifier and signified thus cancels out the subject, then the work of Broodthaers implies an explicit placement of this excision according to which signifier and signified, far from being in a continuity, are separated by a discontinuity. This essential discontinuity, which is also that of the subject of the statement and that of the subject of the act of stating, this antinomy of cause and effect, consequently means that the subject submits to an unravelling which necessarily undoes whatever it has to say. We cannot think of the subject as an internal unity of tempor-alization, but rather as submitting to and recuperating its own discont-inuity. Which means that what constitutes the singularity of the subject is made up of a lack of the signifier. The signifier cannot define it. By lacking a signifier in order to be able to be said, the subject is this unabsorbable discontinuity in the signifying chain.

The operation undertaken by Broodthaers is to attempt to materialize the signifying cut such as it is. Multiple interventions present in this way the production of the subject in its statement, a *mise-en-scène* proper to figuring its deviation from the stating itself. Beyond what is said, there is

the fact that one says. But the statement cannot state its own stating. As soon as the subject appears in the intervals of the signifier, it disappears. There is a fall from meaning, a lack. As Lacan points out in *L'Etourdit*, 'That which one says remains forgotten behind what is said in what is understood'.[8] As every time the subject vanishes while trying to be said, Broodthaers will materialize this very elision of the act of stating. He will try to operate starting from the gap as such. Of course, this empty space is valuable only in the way we furl and tighten it.

EXPOSITION LITTÉRAIRE AUTOUR DE MALLARMÉ

It is now time to look at the contents of Broodthaers's installation and his *Un Coup de dés jamais n'abolira le hasard (Image)*, and to consider what is at stake for Mallarmé himself. In effect, at various points, Mallarmé and Broodthaers join up on the question of modernity and the place of the subject.

The intervention called for by Broodthaers's *Exposition littéraire autour de Mallarmé* in December 1969 at the Wide White Space Gallery in Antwerp was accompanied by a stencilled open letter, signed by the artist. This open letter contains first a description of his work, then an evocation of its genesis and his motivations. 'Why? Magritte no doubt, whom I met long ago, invited me to meditate on this poem. So, I forgot, I meditated . . . today I make this image – I said Adieu – Long time lived – Adieu to all you dead men of letters. Dead artists.'

He continues, taking up in another order certain terms of *Coup de dés* so as to indicate his target: 'New! New? Maybe. Excepted. A constellation.'

Next comes a reference to the last line of Lacan's *Ecrits*, qualified by Broodthaers as a Mallarméan summation. In 'The Metaphor of the Subject', Lacan writes:

The only absolute statement has been said by whomever it concerns [*qui de droit*]: that is, no throw of the dice in the signifier will ever abolish chance – for the reason, we add, that no chance exists only in a determination of language, and that under some aspect that one conjugates, of automatism or of meeting.[9]

Broodthaers follows this up, writing: 'To whom it may concern. Letters stolen from the alphabet.'

As for the installation itself, it is presented as a suite, according to a photo of the piece at the time.[10] In the foreground, to the left, three shirts are hanging. On the small table to the left is a copy of *Coup de dés. Image*.

on transparent paper. On the wall at the rear hang four plaques made of plastic. The shelf on the right-hand wall displays the version of *Coup de dés. Image.* engraved on twelve aluminium plaques. Along the same axis as the shelf with the engraved version, one sees a tape recorder gently placed on a black pedestal. Moreover, the first edition of Mallarmé's *Coup de dés* was displayed on a table at the entrance to the room. The source is thus not only cited but also presented, and one can consult it.

On black shirts, Mallarmé's poem was written in chalk. At the beginning, there had also been the suit that Broodthaers had called 'Igitur'. Shirts and suits seem to figure just as much for the attributes of the poet as for those of the hero and the phantom. The scene evokes the theatrical abstraction towards which Mallarmé tended. The exergue from *Igitur ou la folie d'Elbehnon* announces, 'This tale is addressed to the Intelligence of the reader which stages things itself'.[11] In this tale, where Mallarmé looks for words in an echo, Igitur is 'a sort of impersonal Hamlet stripped of every anecdote'.[12] Broodthaers once again echoes this staging of the absent poet, who is himself concerned with the absence of the poet. In effect, in *Coup de dés* the attempt at abstraction, at the elimination of every personal attribute, is to be found again even more strongly reaffirmed.

Each of the four plaques made of plastic present – as a homage to the insistent absence of Magritte's images – a pipe furnished with a letter. Across the upper two plaques, an alphabet unfolds.

What support can be found to read only the letters? In what way can a letter serve to designate a place? In the letter, logical signs are brought into play, and consequently it is underwritten by the idea of position and circulation. The letter circulates, it is a brand name: that is, it is what indicates the origin of a place that one can find in another place. Whence its link to the market. It is the existence of these places that permits the abstraction of exchanges by which the market is defined.

In the interview with Irmeline Lebeer, 'Ten Thousand Francs Reward', Broodthaers mentions that the language of these plaques is that of the rebus, and their subject is a speculation on a difficulty of reading. Explicitly recalling here the relation of signifier/signified, and the bar that separates them, Broodthaers situates what is proper to the artistic attitude in the refusal to deliver a clear message: 'The way I see it, there can be no direct connection between art and message, especially if the message is political, without running the risk of being burned by the artifice.'[13] This poses, on the one hand, the question of metaphor, of the condensation of meaning which is not the abolition of it but elaborates it, and on the other

hand, the question of interpretation – notably of political interpretation – and its abuses.

Broodthaers goes further: 'Once I'd begun to make art, my own, the art I copied, the exploitation of the political consequences of that activity (whose theory can be defined only outside the domain where it operates) appeared ambiguous to me, suspect, too angelical.'[14] His interventions, in fact, always tend to produce a dissociation of the flux of meaning, to undo continuity of signification. In effect there is a diachronic movement linked to the system of reference of the signifiers, constituted knowledge, history, which at best can function all alone; but on the other hand, at the same time, there is a synchronic movement, a divided subject which tries to inscribe itself, tries to jump over the bar.

Elsewhere, in 1968,[15] Broodthaers had used plastic plaques entitled 'Industrial Poems' that, he said, occupy the limit between object and image. Certain of them appear close to the spirit of the installation of *Coup de dés*, notably by isolating the signs of punctuation. Broodthaers says, 'According to their mechanical production they seem to deny their status as art objects, or rather I should say, they tend to prove art and its reality by means of "negativity"'.[16]

The version of *Coup de dés. Image.* engraved on the twelve anodized aluminium plaques introduces yet another system of reading and reproduction. By association, the style of imprint of the engraved plaques – a line etched into a hard metallic material – is opposed to the erasable writing of chalk or of printing on paper. The furrow of the engraved bars is linked to music, to the recording of sounds and voices.

Just as the original of Mallarmé's *Coup de dés* is presented, Broodthaers exposes the matrix of *Coup de dés. Image.* We find once again the tactic that will be used for *Pense-Bête*: to make, according to Jakobsen's expression, 'a purely linguistic violence happen in the things'.[17]

The tape recorder, after three nearly theatrical claps, diffuses Broodthaers's voice, reading Mallarmé's poem six or seven times, with variations in the reading. In the manuscript MTL,[18] which constitutes in part a sketch of *Coup de dés. Image.*, Broodthaers writes at point 4: 'Sound, height and duration in function of the volume of typography – < essential (comprehensible) music.'[19] The recording ends with a sound effect of the interval and the amplitude of words. In this way, after having withdrawn the voice from the look in his *Coup de dés*, Broodthaers restores it to hearing. It responds to the gradual visuality of the poem by a multiplied, sonorous reading. He lends his voice to it.

UN COUP DE DÉS JAMAIS N'ABOLIRA LE HASARD (IMAGE).

Broodthaers's *Un Coup de dés jamais n'abolira le hasard (Image)* thus exists in three forms:

ten copies on aluminium plaques;
90 copies on transparent mechanographic paper, constituting the original edition;
300 copies on opaque paper, constituting the 'catalogue' edition.

I intend to focus on the transparent copies. These copies, each of 32 pages, were contained in two portfolios, each cut to the dimension of the page, allowing the reader to isolate one or two pages according to their taste. We see here again a characteristic practice of Broodthaers, already at work in *Pense-Bête*: he gives the spectator/reader the choice of appearance and disappearance, readability and unreadability, at the level of reading, of a vision.

I will start with a comparative description. On the cover, at first glance everything seems the same, apart from the fact that the small bar under the name of the author is absent in Broodthaers's work; in place of the subtitle *'Poème'* in Mallarmé, we see the subtitle 'image'; the indication 'NRF' is absent and, in place of the name of the editor in the Mallarmé text, we have the name of the two galleries in Broodthaers's (Michel Werner and Wide White Space). The first page reverses this arrangement. *'Image'* is now the principal title and *'un coup de dés jamais n'abolira le hasard'* becomes the subtitle. Even though Mallarmé's name is absent, Broodthaers's is there.

These interventions radicalize a logic already contained in Mallarmé. The suppression of the preface goes in the direction of this logic, since the preface begins in Mallarmé with the phrase 'I would rather that this note not be read, or, if glanced at, that it be forgotten'.[20] Broodthaers performs the act that Mallarmé indicates. In reality he cancels the preface of Mallarmé, but he inscribes under the title of the 'preface' the poem *'Coup de dés'*. In the transcription of the text, Broodthaers respects the capitals and marks the fact of linearity by bars, always without any distinction of the size of the characters. He suppresses the effect of dispersion and the variable scale of words by the homogenization of caesurae. On the other hand, in the place of the poem, the effect of dispersion and variable scale are reduced to pure and simple spatiality.

We are in the presence of a disjunction. Broodthaers disjoins the meaning of words, on the one hand, from a formalization of the page-setting and, on the other, from typographical variations. The gradual dismem-

berment of Mallarmé's phrase is brought back to a uniform continuity by linear rectangles. Broodthaers thus devisualizes the reading of the text in its semantic effect, and, on the contrary, he visualizes the system of position as taking place in the words, the articulation of places, their scale and punctuation as such. Quieting every voice, he encodes like Morse code – a dash, a dot. Do we have here a structure of a more general substitution that would be valid for language as such?

However, I have said that the preface allows him to cite in full the poem to which he made a reference. He thus follows step by step Mallarmé's procedures of placing a preamble in the address to the reader. What figures here as an *avant-propos* is Mallarmé's very intention: Broodthaers's thesis will no longer be of the order of words.

By threading the words of this poem simply into this preface, he echoes Mallarmé's voice. In effect, during the first reading of *Coup de dés* made to Valéry in 1897, Mallarmé read the poem 'in a low, even voice, without the least straining for effect, as if to himself'.[21] This uniform reading prepared, in contrast, the surprise of seeing the textual arrangement. Valéry writes: 'It seemed to me that I was looking at the form and pattern of a thought, placed for the first time in finite space. Here space itself truly spoke, dreamed, and gave birth to temporal forms.'[22] Playing on a similar contrast, Broodthaers transforms, on two levels, the preliminary reading that the reader may have of *Coup de dés*. Obversely, after the vision of *Coup de dés. Image.*, it is the return to the reading of Mallarmé's text that measures the exact intervention of Broodthaers: for example, where words are inclined in Mallarmé, we see an inclination of the beginning and of the end of the black bars. In this way the readings are not simply reciprocal but transitive. Here, we are not exactly in a ready-made, or in a citation; we are in a dialogue between the voice and the look. Even though we apparently find ourselves in front of a cancelling operation, it is the contrary, flush with the very synthesis undertaken there, a study of details, of those details which recall the order of things. In this way we do not get lost in the details, even though we are lost most often in views of the whole. It is the concentration on the detail of the text here – the placement, the scale – which, constituting a series, allows for the apprehension of a whole.[23]

Given this transparent version of the book, not only the whole of the page but also the whole of the volume is given directly. From the line to the outline, from the outline to the volume, one operation alone undertakes the sum of the three dimensions of space, maintained each time in their proper entity, as engendered by their reciprocal and progressive cuts.[24]

From the fact of this perception by transparence, the first bar, which obliterates the title *Un Coup de dés*, underlines when we turn the page, in the preface, one of the passages of the poem where Mallarmé evokes number. The second bar, which obliterates the first word of the poem – that is, the word 'never' – underlines in the preface the name of Stéphane Mallarmé. In a general way, the rectangular unities mark the coincidences of size, of the scale of words and the relations of them to the page. This 'image' that Broodthaers calls approximative, image of a text, marks the characteristic of the visual of being synthetic and simultaneous, where reading is discursive and diachronic. Broodthaers, while not suppressing the unfurling of successive time, oriented by the chain of words, gives to it at the same time a vision in the instant, which was already Mallarmé's aim.

The bars maintain the idea of the horizontality of a reading, thus respecting Mallarmé's recommendations in the preface concerning the double measure given by the simultaneous vision of the page and the verse as a perfect line. In Broodthaers, the linear black rectangles radicalize the black and white contrasts. They stabilize the mobility engendered by the cut-up disposition of the text, the spacing and dispersion of the reading proposed by Mallarmé. The bars are horizontal. As an editor's note concerning the innovation of *Coup de dés* emphasizes, 'There is not recto–verso, but the reading is done on the two pages at once, taking account simply of the ordinary descent of lines'.[25]

In this way the regularity inscribed in Broodthaers engenders, from the fact of the repetition of the horizontal rectangles, a structure linked to a coexistence. These rectangles function in relation to one another as implications. The impression of movement results from a succession of positions. Broodthaers balances many simultaneous trajectories like so many inscriptions in different times. This once again rejoins the aim of Mallarmé, who in *Coup de dés*, for a short moment, flies over time and renders it reversible.

THE INVENTION OF SPACE

A series of declarations by Broodthaers in the manuscript MTL-DTH indicates the thread which leads to *Coup de dés. Image*. Broodthaers writes, '*Un coup de dés*. This would be a treatise on art. The last one, that of Leonardo da Vinci, lost its importance, because it gave too great a place to the plastic arts, and we guess now, to his masters, the Médicis'.[26] On the first page of the same catalogue, he announces, 'Mallarmé is the source of contemporary art . . . he unconsciously invented modern space'.[27]

What is the relation between Broodthaers and Mallarmé with regard to the book, writing, reading and the voice? With regard to modernity? The place of the subject? Is it possible only to schematize here some traits of the Mallarméan enterprise by referring mainly to the books of Jacques Scherer, which Broodthaers very likely knew.[28]

Mallarmé's strategies all converge on an attempt to eliminate chance. Writing, according to the famous assertion, is 'Lines of chance vanquished word by word'.[29] To this end, he must suggest it and not name it, he must eliminate the author, the circumstance, the chance of writing in a particular language, as 'Languages are imperfect in that there are many'.[30] Consequently, how to act on the word without changing it? By making it play a new role in the whole by inclusion or exclusion. Mallarmé will thus attempt to vanquish chance by establishing a global system, the constraints of a structure, where the page, phrase, letter and word are rectified in succession. In order to vanquish chance, he attempts to create, following Poe's example, a system of expression that precedes every project of execution.

Mallarmé considered the functions of writing, of reading and of the book. To the question, 'Do we know what writing is?' he responded, among other things, by reflecting on the very materiality of the act of writing and by looking to disengage meaning from it. And so he will use the elements proper to edition – such as printed characters, measured white space, disposition and page-formatting – systematically and with an innovative density of application. It is italics, capitals and their difference that are the wellspring of the produced effect. According to Mallarmé, this use of typographical technique should materialize the complexity of movement of thought and support its tension: 'With one gradually descending line to a page, should keep the reader breathless throughout the book.'[31] The phrase is constructed by a series of enclaves in the intervals of which are born other enclaves as incidents of the spoken phrase. These incidents are linked to phenomena of disjunction and suspension. In this way the construction is subtended by syntax: that is, by the analysis of all relations that define the position of words in the more complex wholes where they are inserted.[32]

What is the function of reading as a result? The written marks the inflections of the voice. Mallarmé had the conviction that the written is issued from speech, that all literary texts must be able to be read aloud. Valéry qualified *Coup de dés* as the poem where ' the word coexisted'.'[33] This predominance of speech has consequences for his whole system, concerning punctuation and typography. Mallarmé announced in his

preface, 'The poem [is] without novelty except for the way the reading process is spaced out'.[34] However, while radicalizing typography, he remains faithful to traditional versification. It's the verse, and not the spoken language, that seems to him to be the source of all new typography. Scherer writes, 'He thought the verse to be the dispenser, the arranger of the play of the pages, the master of the book. This is the reason why the subtitle is "poem"'.[35] This is also why Mallarmé distanced himself from all graphic reductionism. If poetry is of the order of visuality, it does not submit to it.

Reading is thus linked to the marks of punctuation. In general, punctuation attributes exclusively logical, conventional values. Its functions are to mark silences, intonations, changes of register, shifts in meaning, allusions to non-expressed words. Mallarmé speaks of 'a punctuation, which, displayed on white paper, already signifies'.[36] In front of a journalist, he develops this paradox: 'I prefer a spaced design on white paper, as is my taste, commas and periods and their secondary combinations, naked, imitating the melody – to the text, suggested advantageously if, even sublime, it was not punctuated'.[37] Yet in *Coup de dés*, there is no punctuation. Its functions are filled by other means: the spacing of blank space, typography, etc. Mallarmé's analysis is founded on the page as visual unity. According to Valéry, 'Mallarmé had very carefully studied, even on posters and in the newspaper, the efficacity of the distribution of black and white, and the comparative intensity of typeface'.[38]

Mallarmé considers that the whole has a distinct value other than as an arithmetic sum of its elements. His conviction that the apprehension of the whole must precede that of the element led to speculations on the Book. He sees it as a volume in space the geometry and properties of which he studies by means of three images: the tomb, the trunk, the block – the block, a rectangular parallelepiped being linked to whole numbers.[39] In this way the book must be constructed as a monument, but moreover must not be immobile like a monument.[40] How does he reconcile these two contradictory demands? According to Mallarmé, the usual way to introduce movement in a book is to use a paper-knife, this is a brutal means. The true literary way is to make the very elements of the book move: the page, phrase, word and letter. Mallarmé says, 'The book, which is a total expansion of the letter, must find its mobility in the letter'.[41] Recall that Broodthaers, in the book *Un voyage en Mer du Nord* (1973), recommends to the reader to not cut the pages. According to Scherer, student of the Mallarméan plans for the Book, it is indispensable for Mallarmé that the book manifest 'an identity of itself to itself': that is, by

considering it under at least two aspects, it is possible to reconstitute the structure of the whole from it and then to 'prove that it is'.[42]

Resulting from this, in the project for the Book, the absence of message is highlighted. Mallarmé found that it was necessary to work with an idea. According to his relative, Bonniot:

he had given to us the taste of a projected book, in which – starting from this principle that we do not receive the idea as a fatality, and that it does not impose itself on us, but rather that we create it and are the master of its destiny – he constructs his idea in front of him, submits it to whatever detours he likes, institutes, each in its turn, his hairdresser, his architect, etc., then at the end becomes a surgeon and all of a sudden suppresses its existence for him by what he calls the operation.[43]

In this way the Book is the abolition of chance by its very own project: Mallarmé does not declare himself the author of it, only the operator.[44] At first the personality of the author is an obstacle on the path to the literature Mallarmé dreams of: 'The pure work implies the disappearance of the poet as speaker.'[45] And again, the operator is not 'the same intermediary as the actor who stops the thought at his cumbersome personage'.[46] The instance of the subject is an empty instance. The function of the operator is not necessarily to construct, but rather to make a machine function: that is, to make it produce the results that it is capable of giving.[47] And so, one can say 'I give myself' such a sheet of paper, 'I allocate myself' such a volume. In the same way, Mallarmé will state, 'All chance must be banished from the modern work and can only be feigned there'.[48]

I HATE MOVEMENT THAT DISPLACES LINES

Broodthaers's actions with regard to Mallarmé's *Coup de dés* reverberate in other books, notably Alexandre Dumas's *Vingt ans après* (1969), and two others relating to Baudelaire, *Je hais le mouvement qui déplace les lignes* (1973) and *Pauvre Belgique* (1974). In the paperback edition of Alexander Dumas, Broodthaers intervenes at the level of the cover, placing over a fluorescent strip the name of the author on which his name and the name of the gallery owner, R. Lucas, as the editor, both figure. The title remains visible, as long as one does not move the strip.

In *Je hais le mouvement qui déplace les lignes*, Broodthaers underlines the seventh verse of Baudelaire's sonnet 'La Beauté'. This line, isolated from the sonnet, printed in red, becomes the title of the book. Broodthaers's name is absent; only Baudelaire's name figures as the name of the author, along with the place and date of the edition, Hossman,

Hamburg, 1973. The entirety of the poem figures on a page marked 'Fig. 1'.

In *Pauvre Belgique*, the name of the author remains Charles Baudelaire, and the title is the same. But the cover is re-covered by a transparent jacket on which the first three letters of the alphabet are repeated, covering the title line and printed in the same type as the title, which renders it unreadable. Inside the book, Baudelaire's text is absent. Concerning the date and place of publication, we find '1974 Paris' on one side and '1974 New York' on the other. In the first case, it is a question of an intervention on two volumes in paperback, even though in the two books concerning Baudelaire, the book is conceived by Broodthaers.

These operations raise questions about metaphor and metonymy, or rather, points of fusion between metonymy and metaphor. Starting from the idea that a signifier is always elided, Broodthaers plays either with the placement or displacement of words, or with the readability and recovery, or with nomination and filiation of proper names. He carries out his acts in relation to the book-object, object *par excellence* linked to the ordering of the symbolic. It is, for example, this object which arranges a library where, two aisles further along, one no longer finds it, because it has been displaced.[49]

To place a tape-recorded message on a title or to isolate a verse which becomes a title, to cover a title with a superimposition which renders it unreadable, to keep text or to subtract it, to swap his name and the name of the author – each time Broodthaers plays with the conventions of editing, which are part of the definition of the book: that is, each time he plays with the common denominations like the name of the author, the title, the place and date of publication, always with the same strategy of an occultation that affirms, validates and makes present what is absent.

PENSE-BÊTE

Broodthaers inaugurated this very procedure of elision in a collection of his poems called *Pense-Bête* in 1964. Here he tells us, 'The book is the object that fascinates me, since for me it is the object of a prohibition. My very first artistic proposition bears the trace of this curse'.[50] We find the attempt to situate the coordinates of impotence, the impossible, and the forbidden. In the game of the said and the saying, the forbidden stands out. This forbidden is structure: it delineates the traits of the question that the subject poses[51] – an embarrassed subject, linked to the laws of alliance, exchange, the market, the letter. Broodthaers hoped in Pense-Bête to return the interdiction to the spectator, but 'no one had any curiosity about the text . . . No one was moved by the forbidden'.[52]

Marcel Broodthaers, *Le Pense-Bête*, 1964, books, plaster and rubber ball.

Marcel Broodthaers, *Le Pense-Bête*, obliterated pages from the books, as exhibited at
Galerie St-Laurent, Brussels, in 1964.

In this collection, he introduced difficulties of reading: paper glazed with colour in the forms of squares, rectangles, circles, printed in such a way as to mask in whole or in part his poems. At the time, the way the paper was arranged meant that one could lift it in order to read the text. And so his first proposition in the field of plastic arts is affirmed in relation to books and to his own poetic condition.

Some months later, he planted the two last bundles of the copies of *Pense-Bête* in plaster.[53] Broodthaers describes this passage of the surface of the volume in 'Ten Thousand Francs Reward':

The remaining copies of an edition of poems written by me served me as raw material for a sculpture . . . I took a bundle of fifty copies of a book called *Pense-Bête* and half-embedded them in plaster. The wrapping paper is torn off at the top of the 'sculpture', so you can see the stack of books (the bottom part is hidden by the plaster). Here you cannot read the book without destroying its sculptural aspect.[54]

The word 'sale' already points out the terms of remuneration, to the closing of an account, but also to the unsold remainders and to merchandise sold at a discount. It's this sale that Broodthaers materializes as a 'sculpture', and so establishes a relation between debt, the forbidden and the evil spell – this latter being taken, as in language, between credit and debit, and so in a debt that obliges, and an economy that forces engagement.

But what happened to the poet?

Broodthaers qualifies his poems as 'concrete signs of engagement since without reward'.[55] A difference is inscribed between 'engaging oneself' and 'being engaged'. This elicits the question of retribution and recompense, or, as Broodthaers says, the question of engagement for the enemy. In Edgar Allan Poe's tale 'The Purloined Letter', the prefect lets it slip to Dupin that the reward offered is enormous.[56] Poe makes us reflect on the contract concerning this sale of the letter that Dupin carries. Similarly for Broodthaers in the invitation to his first exhibition in 1964, he evoked the terms of the contract with the gallery owner.[57] Elsewhere in the interview 'Ten Thousand Francs Reward' he offers a prize to whomever would find the singular answer to the question of knowing how, opposed to the circulation of art that Broodthaers puts into question by the bias of his production, knowing how to indicate in this very production a risk larger than that of saving the bid.[58] We are in the symbolic circuit and in its supposed efficacy. Broodthaers is delivered from this forced circuit of the symbolic, by 'proposing little, all of it indifferent', as he says.[59] Again he

recognizes, 'My exhibitions depended and still depend on memories of a period when I assumed the creative situation in a heroic and solitary manner'.[60]

And so *Pense-Bête* materializes the fiction of passage from one status to another. This sculpture which the Book reveals to the look, while at the same time exhibiting it, maintains, like the signifier, singular relations with the place. The Book will be and will not be there where it is. In a seminar on 'The Purloined Letter', Lacan tells us, 'What is hidden is never but what is *missing from its place*'.[61] We are in the register of the symbolic, which allows us to name absence. This act of naming absence is founded on negativity. Recall that the function of the signifier is to introduce a lack, to evoke an absence. Differential value, marking an opposition between something which is inscribed and something which is lost, is that which suffers the cancellation of self. The subject receives its place from the travels of the signifier. In this way, in 'The Purloined Letter', the letter did not fulfil its destiny when it filled its function of carrying a message to the queen. Lacan will say that 'the signifier is not functional'.[62] Once consumed in its effect on the signified, the signifier is conserved in the letter, which returns to the subject.

In making a series of volumes into a sculpture, Broodthaers emphasizes that there is not a fixed attachment between signifier and signified, and so no univocal message. It is into this disjunction that the subject can attempt to insert itself. The position of Broodthaers in *Pense-Bête* is qualified as a recoil, where he seems to aim at the margin. We are in a metaphor. Starting from an elided element, there is production of a new meaning which is not confinable as such. This substitution is supported by what? In *Pense-Bête*, the effect is to place a subject on the scene, to represent it. Broodthaers, all in all, indicates to what point the subject is represented by a signifier for another within a chain that in part repeats itself.

Pense-Bête amounts to confirming a voice. The fact of planting books in plaster pretends to steal a chapter away from history. We return it missing to the edition. But at the same time, Broodthaers inscribes an object in the field of plastic arts. There is a designation of place. He says, 'Until that moment I lived practically isolated from all communication, since I had a fictitious audience. Suddenly I had a real audience, on that level where it is a question of space and conquest'.[63] In this crossing of spaces, to whom does Broodthaers address himself? From what place to which other? He plays with a symbolic partnership. In effect, the subject here is not uniquely taken up in a specular relation, but also in the fiction of spoken exchange. These closed books attest to an ambiguous solidarity

between the status of the subject and the status of the Other, the treasure of signifiers. They attest above all that the definition of the subject as discontinuity implies that speech has an impossibility to it, impossible speech being that which would erase the subject, that which would erase this discontinuity that the subject operates. If the subject 'isn't, if he isn't some thing, he obviously bears witness to some kind of absence, but he will always remain purveyor of this absence, I mean that he will bear the burden of its proof for lack of being capable of proving the presence'.[64] *Pense-Bête* figures, at the foot of the letter, that the subject as lack of a signifier obligates conceptualizing the materiality of the lack as such.

MAGIC – ART – POLITICS

Recall that Broodthaers intervened in a precise context: New Realism, Pop art, Minimal art, Conceptual art. He intervened there starting from a historical filiation, marking clearly his affiliations: Magritte, Schwitters, for example, and above all Baudelaire, Poe, Mallarmé.

Thereby he declares a heritage that he will seek not to falsify. Contrary to all supposed demystification, he will seek – especially in *Un Coup de dés jamais n'abolira le hasard (Image)* – to produce from it the most naked paradigm of what founds it. In the guise of a borrowing, this heritage serves as reference point for both a dialogue and a test for what he calls the 'falsity inherent to culture'.[65] He seems to indicate that the fact of evading all reflection on the subject of the enunciation contributes in large part to this falsifaction.

In any case, it is on the basis of a certain starting point that Broodthaers will seek to advance in the field of the plastic arts. Aiming at the margin that he has at his disposal, he questions the place that he occupies and the place from which he speaks, addresses it, and a production always out of sync with the truth. He will spell out his parameters in the course of the functions that he will adopt as poet, plastic artist, filmmaker, collector, historian, director of a fictive museum and finally organizer of exhibitions of his own work. Here a choice emerges, but an oriented one, since it results from the necessity of a mediation. Which leads us back to the question of the political.

In the preface of the catalogue of his last exhibition, *L'Angélus de Daumier*, Broodthaers tells us, 'The political that I mean to defend – in art – is weak, individual at first and subjected to pressure . . . However, although weak, the necessity of a political attitude is indispensable today'.[66] In this circumstance, in effect, the exhibition was interrupted half an hour earlier than usual as a gesture of solidarity with the Spanish

democrats. A while later, Broodthaers commented on this decision in the interview '*C'est l'Angélus qui sonne*': 'If not, in general I would have evaded the subject of politics. It would maybe be found here, but underlying, not in a neat way.'[67]

Broodthaers often approached politics but by the bias of fiction, marking the unavoidable relation of the subject to the symbolic. So, in *Magie*,[68] he does not address himself directly to Beuys, but pretends to have found a letter in which Offenbach address himself to Wagner. Once again, this letter is then in its proper value only in relation to everything that it puts in suspense. For, 'It is truth which is hidden, not the letter'.[69]

And so, with respect to organized language, elisions within elisions, the speech of the subject tries to inscribe itself. The subject of course is the effect of the signifier, but to be this effect does not discharge it of every initiative. The subject can give its assent to what represents it, or not. In relation to the signifying articulation and its determinism, there is as a result, it must be stressed, a subjective implication which is of another register. Lacan tells us, 'From our position of subject, we are always responsible'.[70] As well, what Broodthaers tries to figure from rebus to rebus is very precisely the fact that it is not because modernity demonstrated 'the mirage of the author' that the position of a singular subject stops distributing and inscribing itself.

After Conceptual Art: Joe Scanlan's Nesting Bookcases, Duchamp, Design and the Impossibility of Disappearing

MICHAEL NEWMAN

What gave the diverse practices that came together under the name of 'Conceptual art' their unity, and connected them with the first avant-garde, was the desire to disappear as art object, whether into idea, design or everyday life. The paradox, of course, is that the very institution and discourse that permitted the enunciation of that desire prevented it from being fulfilled. What, therefore, defines post-Conceptual art – not art that imitates the look of Conceptualism but that takes its legacy seriously – is the alignment of the desire to disappear with the acknowledgement of the impossibility of disappearing. The work of Joe Scanlan involves an exemplary articulation of this aporia. In order to unfold its implications with the concentration that it deserves, my considerations will revolve around one work represented in one exhibition, a photograph of a *Nesting Bookcase* that formed part of a display at FRAC, Languedoc-Roussillon in 1998.

In 1996 Joe Scanlan gave a lecture in London on the version of Eames plastic and fibreglass chair with a traditional wood rocker base, an example of which he owns.[1] Two years later he published in the magazine *Frieze* a short comment, with picture, on the Russian AK-47 assault rifle, the most popular in the world which, designed 50 years ago, has not been superseded, 'the little black dress of the Military-Industrial complex'.[2] In neither case were these things appropriated as 'ready-mades' in a neutralization of the use or the coding of the object. What is involved, rather, is an act of identification with a collective subject and an unconscious choice that has already been made. If this choice is made to the first degree in the AK-47 – its shape, both in its functional perfection and its association with revolutionary movements, has become inscribed on the collective consciousness – it is made to the second degree with the hybrid Eames

rocking chair. Having developed the production process using moulded ply for splints as part of the war effort (the association with war is perhaps the hidden connection between the gun and the chair), Charles and Ray Eames went on to perform a self-conscious operation on the 'collective' object, bringing together a certain vernacular with modern design in order to incorporate a humanized Modernism into the marketing of lifestyle by the post-war advertising and publicity industry. This fusion comes apart again like a symptom in the plastic chair with rocker, which is at once homely and uncanny. In the very attempt to become relaxing, design is estranged.

With Scanlan's series of *Nesting Bookcases* (1989–95),[3] the aim to take things in the opposite direction: towards a pure disappearance. Is it possible for an artwork to disappear, either into function (the dream of the first avant-garde, only in this case the context of disappearance is functionalism-become-IKEA), or into vernacular (an object that disappears into type)?

In his comment on the AK-47, Scanlan writes, 'Many artists today are keen on blurring the distinction between art and design, and rightfully so, since once you admit that anything is grist for the art mill, the next logical thing is to design your own products as works of art'. However, if this were to succeed too well, the art would disappear into the design. Hence, 'Art that looks like design is considerably shy of *good* design'. This may be why the *Nesting Bookcases*, while perfectly functional, look rather awkward, not quite at home, not quite comfortable with themselves.

In a photograph of a *Nesting Bookcase* taken by a collector who had presented it to his son, the three shelves above the one that forms the base, erected and tensed with the cord that runs through a hole in the middle, become the support for a display. The somewhat odd structure of the shelves, at once monumental and offhand, determines the form of the display: the shelves run from largest at the bottom to smallest at the top. Also what is at the bottom is, relative to the upright body, less visible. With that thought in mind, the shelves take on an anthropomorphic character. Yet if they are a certain kind of body, it is an exoskeleton: imagine them empty, then the gaze would pass through, to the wall (with the exception of the cord 'spine').

The decrease of relative heights, combined with the increase in visibility, affects the arrangement of the objects on display. While the structure of the *Nesting Bookcases* and the permutation of their modes of display remain constant – they may be shown nested or braced, empty or used, against the wall or freestanding – when they are in use the particular ways

Joe Scanlan, *Nesting Bookcase*, 1995, wood, hardware, fabric strap.
Private collection, Chicago.

in which they may be filled will remain unpredictable, specific to each user and situation. Repetition – the sameness of each example of the *Nesting Bookcases* to each other – is allied with a singularity that is outside the artist's control. In this way the limits of the work, where it begins and ends, and its traditional identification with the agency of the artist, are thrown into question.

At the bottom of the *Bookcase* in this particular photograph we see tall books together with what look like files, a three-drawer cardboard storage unit, what looks like a bundle of cards and some kind of dish. This is also the most obscure part of the photograph. There is a dark object between the books and the storage unit, which looks as if it has the shape of a 'V' with blobs at each end and at the articulation, which, because it is obscure, takes on an opaque, surreal quality. Above that there seems to be a display of objects and a picture connected with space travel, and above that, together with books and pencils in a jar, a cut-out display of figures, possibly from science fiction. On the last of the cases the objects have a slightly sinister appearance: a man in black like an undertaker stands beside a box on the other end of which a large black spider is suspended from the tensing cord of the unit; the objects continue with a model bench in the vernacular style and a family photograph. These evoke a combination of threat and remembrance, unsettling the typical boyishness of the sporting and sci-fi interests evinced in the other things.

Above the shelves is a picture, which looks like a framed drawing with an inscription on the passe-partout, between the two black bands: a picture within the picture which seems to 'crown' the shelves, turning them into an altar. The effect is emphasized by the cross leaning on its side to the right of the top shelf. Are the gold sporting trophies (ice hockey? baseball?), then, gods? A portable object finds a function somewhere in between storage and an everyday, sporting-hero version of the sacred – a roundabout way towards the recovery of aura.

The placement of the shelving is against a wall (though this is not necessary – it could be freestanding) on the floorboards behind a carpet with a flower pattern, next to an open door, the frame of which has a somewhat Art Deco moulding. It looks like a good paint-job, a wealthy home. The beige box mounted on the left side of the bookcase is a motion detector, 'meant to keep one's meddling sister away from one's stuff',[4] an internalization of the kind of alarm with which such a home might protect itself. The door can be glimpsed to the extreme right, suggesting a passage beyond and behind the wall. This opens another view on to the shelves, a sideways glance and a position that we cannot occupy – a passage is

evoked, only to be blocked, an effect typical of certain Symbolist images of passages such as doorways and stairways. On the one hand, we are excluded from the life of the users; on the other, our very fixity provokes a sense of oneiric threat.

The *Nesting Bookcases* exist in a tension between display and disappearance. They are at once the object on display and the means of display that recedes into the background: both figure and ground. *The Nesting Bookcases* function as object and frame. It is as if, with respect to the objects, the bookcase functions as a support with the same status, whereas for us, as viewers of the photographs, the *Nesting Bookcase* as work of art transforms the status of the objects as well. The objects are framed as the attributes of an absent subject, a kind of portrait or a sentence written with the given.

One of the ironies of the *Nesting Bookcases* is that they reproduce the look of mass-production in an individually crafted object, an inversion of the desire that the mass-produced object be individualized. In the advertising-led consumer boom that followed the Second World War, first in the USA and then in Europe, it became the role of 'lifestyle' to mediate between the individual and the mass-produced, to 'humanize' modernity. In the practice of Charles and Ray Eames, the purity of Modernist design turns organic and meets an eclectic vernacular, with the predilection for ethnic objects in a somewhat pared-down functional context typical of mid-century American intelligentsia.[5] The attempt is to reconcile the modern and the human without loss of universality (primitivism), yet while maintaining distinction (taste in selection and arrangement) which would give the appearance of being open to everyone. The West Coast softening of the Modernist programme – ironically via the incorporation of technologies developed for the war, including the moulding of plywood for medical splints, and aircraft manufacture – can be seen in the anthropomorphic character of much of their furniture, such as the ubiquitous DCM chair. However, it is possibly only at the cost of this softening that a modern 'designer' object can achieve a generic status. Hence we find the Eameses moulding furniture to the human form while maintaining a certain rigour and austerity, and indeed a degree of hybridity, as in the plastic and fibreglass-shell chair with metal legs, taken to a slightly comical linkage of modernism and vernacular in the version that sits on a rocker base. The rocker chair seems to involve an adaptation to a chair that had become generic in order to reflect on the process of becoming-generic, and the relation between modernity and tradition thus implied.

For an object to become generic means it has to have achieved a peculiar form of visibility: a visibility that, to be more precise, involves a degree of invisibility. Generic objects need to be typical enough not to stand out as unique or 'special', yet at the same time have achieved a certain kind of perfection with respect to their type. The very idea of something 'becoming' generic, rather than simply being so, demonstrates that the status of the generic is a problem of modernity, precisely as an elision of the time of creation. However, generic objects, in the sense in which I mean them, are not traditional objects. Their purported universality is achieved in another way than by an appeal to the continuity of tradition. The traditional object manifests how things are done for a particular historical culture, and may be interpreted as a representation of a particular way of being. The generic object, while being designed for a particular situation or context, such as packaging for a product, seating for airports, a weapon manifesting an elegant and efficient form given the state of technology at the time, may be understood as the crystallization of a general code. There is no excess of the thing over its signification, nothing is reserved or withheld. Of course, both tradition and the generic involve a suppression of discontinuity. It is part of the mythology of the very idea of tradition that it cannot be created, since it is autochthonous (although traditions are constructed, and supposedly traditional objects, such as the Scottish tartan kilt and the Christmas tree, are relatively recent in their adoption as 'traditional', which thereby functions retroactively, precisely in relation to a traumatic break or discontinuity). In addition, a traditional object may be, and often is, handmade, while a generic object is mass-produced. Suppressing any implication of the relations of production, the generic object is supposed to have the quality of not having been created or produced, of just being there, like the solution to a problem just waiting to be discovered. Rather than being adopted, like a ready-made, or crafted, like a traditional object, it is, precisely, 'generated', the result of a process that involves a logic of functionality and coding, combined – and this is what the Eames office excelled at – with a way of arriving at the 'right' solution through an improvisational unpredictability. Thus the difference between the design office and the artist's studio is narrowed, which shows up the extent to which art has come to fulfil the same needs as lifestyle design.

The peculiarity of the moulded-plastic chair with the rocker base is its conjunction of tradition and the generic. What is brought to the fore is the historicity of the generic, which is precisely what the coded, synchronic character of the latter tends, if not is intended, to conceal. This invites us

to construct a history of the visibility of objects, as a visibility that has been constituted (rather than a history of objects 'as such', towards which the traditional museum tends). It is perhaps no coincidence that the Eameses were involved in exhibition design as well as photography and film: that is, in an investigation and demonstration of the modes of visibility of objects in a particular historical, technological and economic context.

To seek as an artist to produce a generic object is to court a certain invisibility: to present, in the case of Scanlan's *Nesting Bookcases*, something handmade, like a craft object or a traditional sculpture, as if it were factory-produced and bought from a showroom or catalogue; to make something that will disappear into its own inevitability, simultaneously remaining and ceasing to be art. The representation of such an object, that it will indeed be visible outside its immediate circumstance, will depend on it being reframed in an exhibition catalogue, which will allow it to be seen as a 'work of art', an object that we should notice and reflect upon in a peculiar way. An impossible demand: to be both visible and invisible at the same time, to at once constitute its space of visibility and disappear into it on the one hand, while inciting a reflection upon this very process, thereby remaining visible, on the other. Such is the contradictory desire of the work of art in modernity. As impossible as Duchamp's stipulation to himself to make a work of art that is not a 'work of art'. Duchamp's move is repeated by Scanlan, but as an inversion: not to select an generic object that would appear as art that was not 'work of art', but to make a work of art that would appear as – or more precisely disappear into – a generic object. Just as Duchamp's play required the insertion of quotation marks, so Scanlan's requires their abolition. But both acts involve a form of citation: Duchamp's a citation through displacement, Scanlan's the citation of generic-ness in an object that is not mass-produced.

We should not miss the role of the metaphorical quotation marks in this process. The Eames rocker is a chair that applies quotations marks to itself: the rockers are both functional and a quotation of a traditional chair type, which in turn serve to frame the modernity of the moulded plastic chair that sits on them. Quotation marks are a way of making a phrase visible by detaching it from its context, and in the same move of detaching the subject of the enunciation from the enunciated, hence the relation of quotation marks to irony: the subject of the enunciation is turned into a meta-subject, an over-seer. While the displacement of the

quoted has the potential to rupture the time of quotation, the role of quotation *marks* is to defuse the disruptive potential of citation and to reinstate continuity, whether according to a narrative historicism or the transcendence of a meta-subject.[6] The *Nesting Bookcases* themselves also function like quotation marks, allowing the simultaneous presentation and negation of whatever is placed upon them. In addition, as is suggested by their very structure, they are self-quoting, like a Russian doll each layer of which cites and frames the next. They produce an almost impossible operation, whereby the work is simultaneously absorbed into the ground of the everyday, while constituting the viewer as viewer-who-knows, as a meta-subject, and thereby, precisely, prevents the disappearance of the work. The quotation marks tend towards their own abolition in practice, allowing for a transformative collision of moments, while still being reinstated through the representation of the work in the institution of art, in this case through a photograph which may travel through the gallery and into a publication. Quoting is related to transferral, and we should remember that the *Nesting Bookcases* are designed to be portable in their collapsed state, with the bracing strap functioning as a handle. They are nomadic, moving in-between domestic and public space, the home and the gallery, one space and another, and one function and another, thereby demonstrating that aesthetic autonomy is itself a function dependent upon a space. It is the very structure of aesthetic appropriation that the *Nesting Bookcases* seek to reappropriate – by disappropriating or dissolving it, and then failing to do so – in their turn, thus acknowledging and inverting, by siting it in the everyday, the appropriation of the avant-garde by the institution of art.[7] It is thus that both the desire for art's disappearance and its historical failure are reinscribed in the complexity of the relation of a work to its various, different yet intertwined, mediations.

We need also to consider the photograph, as illustration of furniture in a domestic interior, as itself generic, as documentation, and in terms of its status as work or supplement.

Photographs of the Eameses' arrangements of objects raise the question of their own status. In particular, with the photographs of the Eameses' own house, domestic environment and showroom intersect. Unlike their arrangements for the Herman Miller Furniture Company from 1950 to 1966, Charles and Ray Eames' house is a domestic environment and therefore, nominally at least, a private space. Yet the house functioned, of course, as both a showroom for their own work and a

demonstration of the ethos that it was supposed to embody – arranged and tidied by assistants prior to the arrival of visitors, or being photographed or filmed – and yet also more than that, as something like a continually transformed work of art, represented through an enormous number of photographs and slides that collapsed scale and multiplied viewpoints. It was as if the destiny of the house lay as much in the photographs that represented it as in being a place to be lived in. For Beatriz Colomina, in a brilliant article on the Eames House, 'The singular unmediated view is replaced by a kaleidoscopic excess of objects. The eye that organized the architecture of the historical avant-garde has been displaced by a multiplicity of zooming eyes'.[8] The house becomes a display case and was under construction in 1949, when the Eameses were developing the Storage Units, which worked according to exactly the same principles. In a conceptual reversal, we could say that the house becomes like a storage unit, a mode of self-display through surrogate objects.[9] Scanlan's *Nesting Bookcases*, together with their photographic mediation, provide the opportunity to reflect on the symbiosis of private and public, the exchanges of lifestyle and everyday life.

That the Eames House – which as #8 of the Case Study House Programme sponsored by the magazine *Art and Architecture* was supposed to provide a prototype for a new way of living – finds its fulfilment in photographs that advertise a lifestyle anticipates two tendencies of modern art. The first is in the direction of publicity, with Warhol as the result of a process begun with popular magazine photographs using Pollock paintings. The second is towards the ambivalent role of photographic representation and documentation which becomes explicit in Conceptual art. Only through documentation can a work of art that consists of an event of limited temporal duration, or one that in some way disappears into its context, continue to remain visible and to have effects in the practice and discourse of art. Yet that very mode of visibility is one of the factors that allows the recuperation of the work by the order it would critique and transform. 'Photowork' emerged out of the crisis of documentation in Conceptual art, as a symptom of the latter's contradiction. The ontology of the object is transferred to the photograph that was supposed to have dissolved the uniqueness of the work of art. Yet photowork, rather than resolving the contradiction, displaced it, a displacement mimed and parodied *ad absurdum* by James Coleman's *Slide Piece* (1973), where aesthetic qualities and hermeneutic meaning are discovered by the stentorian voice of the critic in what may be – we will never know for sure one way or the other, an uncertainty that opens up at the same

time as it undermines the very space of interpretation – the contingencies of a documentary photograph. The endless cycle of repetitions of the interpretations, punctuated by the click of the projector that results, against the expectation of change it arouses, in the same image, undermines their authority, rendering them delirious and very funny. Yet the voice of Art, however subverted it may be, will not allow the photograph to disappear into the anonymity of the everyday. Both steps of the *Nesting Bookcases* project presuppose the double recuperation – of the object and of the photograph – that followed in the wake of Conceptual art. The *Bookcase* accepts the economic support system in order to insinuate itself into it like a parasite, and the photographs play with the supplementary status of documentation, the idea that the originality of the original, or the uniqueness of the event, is in fact dependent on the representation that is supposed to be derivative: in this particular case the photograph that is not even produced by the artist, which is consistent with the 'valorization of the amateur'[10] that was typical of Conceptual art's use of photography, as if the fetishizing character of the photograph could be mitigated by assimilating it to the use-value of everyday photographic practices, such as the snapshot.

In a note from 1913 Duchamp posed the question: 'Can one make works which are not "works of art"?'[11] This was the time when he mounted a fork and the front wheel of a bicycle on a wooden stool. During his first trip to New York (1915–17) he borrowed the English compound word 'ready-made' to described objects he purchased and displayed unaltered or slightly altered, the most notorious being the urinal rotated through ninety degrees, signed R. Mutt, entitled *Fountain* and submitted for exhibition to the American Society of Independent Artists, of which he was a founding member and chairman of the hanging committee. The Society rejected his pseudonymous submission. In May 1917 the second issue of a magazine, *The Blindman*, of which Duchamp was co-organizer, was dedicated to the *Fountain*.

This whole process can be seen as a systematic testing of the conditions for the appearance of a work of art. If one wishes to make works that are not works of art, one needs to know what exactly it is that makes a work of art a work of art. Is it, for example, something intrinsic to the form of the object? Louise Norton wrote in *The Blindman* issue, most likely prompted by Duchamp as some kind of parody of art criticism, 'to any "innocent" eye how pleasant is its chaste simplicity of line and colour! Someone said, "Like a lovely Buddha".' William Camfield, in a very infor-

mative essay, 'Marcel Duchamp's *Fountain*: Aesthetic Object, Icon, or Anti-Art?'[12] takes such remarks 'straight' and doesn't seem to consider that they might be a Duchamp-inspired parody. Would Duchamp, of all people, have been a believer in the 'innocent' eye? Duchamp claimed that the name Mutt derived from the Mott of J. L. Mott Iron Works, from whose showroom the urinal was purchased. Camfield very usefully provides a picture of such a showroom and an illustration of a urinal from 'Mott's Plumbing Fixtures Catalogue'. He also provides photographs of installations, decided by Duchamp, of two presentations of a second version of Fountain, selected by Sidney Janis and signed by Duchamp, in the *Challenge and Defy* exhibition at Sidney Janis Gallery, New York, from 25 September to 21 October 1950, and the *Dada 1916–23* exhibition at the same gallery from 25 April to 9 May 1953. In the first the urinal is hung the right way up and low on the wall, 'so little boys could use it',[13] and in the second it is suspended over a doorway with mistletoe hung from it.

We can detect here a diametric inversion of the strategy of the 1917 submission of the urinal to the Independents. At that time, the intention was clearly to test the conditions for the appearance of works of art. The outcome is to demonstrate that these conditions involved not only perceptual but also institutional factors, indeed that the institutional framework was constitutive of the meaning of the object. Louise Norton's article shows that Peter Bürger is correct in his hypothesis that with autonomous art (where form becomes content) the institutional condition for that autonomy (the separation of art and life) becomes manifest.[14] That is to say, the submission to the Independents was intended to make what is not art (what does not in its form express the genius of the individual artist, but is a mass-produced, replicated object) appear as art, thus highlighting the role of the institution (including the signature) in any such appearance, a role that could not be covered by a description of manifest, perceivable qualities of the object. The Janis installations move in the opposite direction, because they attempt to make the institutionally validated object (now Duchamp's *Fountain*-signed-R. Mutt rather than R. Mutt's *Fountain*) disappear into its surroundings, either by turning the gallery into a urinal or by hanging the urinal where it might be visually missed, and act as a kind of sexual trap. Instead of the everyday object being removed from its function, either the gallery, sanctum of autonomy, is to be made to conform with the functional connotation of the object or the function of the object is displaced to another, in this case ritualistic, role.

The attempt to make the artwork disappear proves a failure, a failure that is clearly part of the 'performative' involved in these installations.

The 'original' *Fountain* did not appear in the exhibition to which it was submitted, and through its non-appearance showed up the conditions for appearance – or exclusion – of a work of art as both institutional and historical: in that time, at that place, under such circumstances, a urinal could not appear as a work of art, even if it could be conceived as such by an artist. By the 1950s, it was no longer a case of the urinal not appearing as a work of art but of its not being able to disappear as *that* urinal, Duchamp's '*Fountain*-signed-R. Mutt', even if the particular urinal used had, in fact, vanished. What this gesture marks, as a reflection on the 1917 submission, is the impossibility of the work of art disappearing as work of art. If one aspect of the whole strategy of the ready-made was to make the work of art (as unique expression of the artist-genius manifested in visual properties) disappear as such, it has since become clear that such disappearance was not achieved. There are at least two reasons for this. The first is that the institution of art cannot be voluntaristically abolished by the individual artist, since it is economically and politically determined. The second is a more formal, and perhaps more interesting, reason that will come to condition Conceptual art: it is that the very attempt to make the object disappear itself becomes a condition for its appearance.[15] The object appears in and as its disappearing, and therefore cannot disappear. And it is this, surely, that is acknowledged in the Janis installations of 1950 and 1953. Yet it is not impossible for this non-disappearance to maintain a certain negativity: in the 1950 installation, the 'camouflage' of *Fountain* as a urinal serves to turn the gallery into a showroom for fixtures and fittings; and in the second of 1953, the re-enchantment of art as ritual (think of Pollock and the Abstract Expressionists) is shown up as an absurdity. Duchamp spans, therefore, the transition from avant-garde to a critical neo-avant-garde, from the will to abolish the work of art in its Romantic, autonomous, fetishist form, via the end of art that did not happen, to the impossibility of the work of art disappearing. It should be said that not only did Duchamp mime his disappearance as an artist into, for example, a chess player in his later career, but also, as is clear from the notes around the *Large Glass*, he was fascinated with the qualification of 'infra-thin' for an evaporating trace, or the minimum of separation, or the medium that is on the edge of disappearing into transparency or reflection, as indices of that which remains in a disappearance.[16]

What needs to be considered is the explicit relation between the end of art that did not happen and the impossibility of disappearing as an effect of that non-ending. The rendering explicit of this link requires the repetition of the neo-avant-garde in such a way that it would be connected with

the non-ending of art. What demands to be repeated, in other words, is not the disappearance but the failure of that disappearance. It is precisely in this that the importance of Scanlan's *Nesting Bookcases* may be understood. The end of art that did not happen is implicit in the anamnesis of Constructivism in both the morphology and the functionalism of the shelving units: the reminiscence of a tower structure contains a very distant echo of Tatlin's *Monument to the Third International* (1920–21); and more obviously there may be detected an allusion, conscious or not, to Rodchenko's 1925 design for a workers' club, exhibited in the Soviet pavilion at the *Exposition Internationale des Arts Décoratifs et Industriels Modernes* in Paris. The morphology could carry us into the neo-avant-garde moment through a reference to the ziggurat structures favoured by Robert Smithson.[17] In these comparisons we can discern a melancholy devolution, from revolutionary public art, through monuments and ruins in the desert, to the homes of private collectors. This concern with private, domestic space which is then brought in relation to the gallery distinguishes much of Scanlan's work from that of Michael Asher, who has also been concerned with the 'disappearance' of the work,[18] but in a way more faithful to the Constructivist avant-garde. Like Asher, John Knight and Dan Graham[19] have explored the relation of art to architecture and design, in each case haunted, like almost all the Conceptual art of the mid-1960s, by the desire to make art disappear – into architecture, into text, magazine articles, posters, into the land, into public urban functions, into air – while at the same time depending upon precisely the conditions which prevent its disappearance. Similarly, Scanlan's *Nesting Bookcases* recall and maintain open an unrealized possibility for art to transform everyday social life, occupying private space like a secret graft. However, for the time being, the double destination of the *Nesting Bookcases* lies in the collector's home and the photographs that represent them as works of art in the process of disappearing, and thus appearing *as* disappearing, so not disappearing.

The *Nesting Bookcases* may be shown 'nested', with the fabric rope bracing used as a carrying handle, a portable object, its role as yet undetermined, capable of occupying, temporarily, all sorts of places; or they may be shown stacked but empty, a formal sculpture implying both the withdrawal from function involved in the aesthetic and the abstraction of place into space. We might recall here those things of Scanlan's which began life with a functional role in his then Chicago apartment and ended up as works of art in the gallery, still bearing the traces of an absent space and a role, now hard to determine, that had been left behind like a

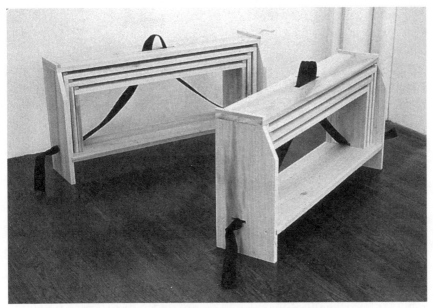

Joe Scanlan, *Nesting Bookcases*, 1994, wood, hardware, fabric strap.
Private collection, New York.

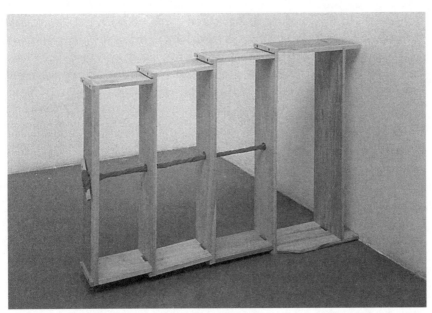

Joe Scanlan, *Nesting Bookcase*, 1995, wood, hardware, fabric strap.
Private collection, Paris.

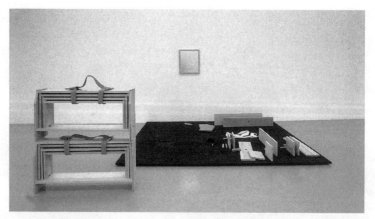

Joe Scanlan, *Free Assembly*, 1995, bookcases, bookcase parts, platform, mirror, installation at Le Nouveau Musée, Villeurbanne, Lyon.

memory that can't quite be grasped.[20] When used in one way or another, the *Nesting Bookcases* are capable of disappearing into the everyday. Left empty in an art gallery, they would be suspended in a state of potential; filled in an everyday space, they are in a state of actuality, having made possible certain decisions which are nonetheless not predetermined, and therefore transform the appearance and meaning of the *Nesting Bookcases*. In this movement back and forth between possibility and actuality, it becomes possible to glimpse for a moment the idea of *unrealized* possibility, that the way things are is not the only way they could have been, and that what might be is not predetermined in the present, and indeed, that the present itself, in its very determination as indeterminate, remains open. Thereby the hold of the generic is broken and the world becomes questionable, but not quite in the form of the overthrowing of tradition by the first avant-garde.

We could consider the uses of the *Bookcases* as acts of enunciation: not reducible to language, the enunciation involves a degree of unpredictability. To present photographs of the *Nesting Bookcases* in use forces the confrontation of a creativity that is legitimated by the institution of art with an everyday creativity that would otherwise be hidden, lacking its own institution. The photographs make visible an 'art of practice' that would otherwise be invisible.[21] The arrangements could be understood as 'readings' of objects. However, the limit of this move, imposed by society and not something over which the artist has control, is apparent when we consider that this visibility remains dependent on the institution of art: these are bookcases made by an artist, in the homes of collectors, pho-

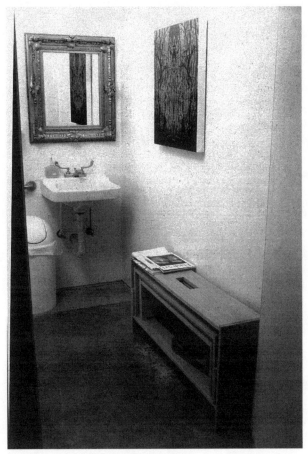

Joe Scanlan, *Nesting Bookcase*, 1996, wood, hardware,
fabric strap. Private collection, Los Angeles.

tographs of which are displayed in an art gallery and a publication, made visible, therefore, thanks to economic and power relations. The enunciation is detached from its circumstances, so sinks back into language, or becomes a phenomenon of 'popular culture'. Nonetheless, in drawing attention to the conditions under which an art of the everyday may be represented, this approach both implicates itself and circumscribes a space of absence. This absence is that of the conditions under which art would be able to disappear. One of the things that the 'end of art' that did not happen opens us to is the enigmatic status of the work. After Conceptual art the work returns . . . as a question. What is a work? How does it occur? Where does a work begin and end?

References

Introduction

We wish to thank Helena Reckitt and the Institute of Contemporary Arts, London, for hosting the conference 'Who's Afraid of Conceptual Art?' on 19 March 1995 out of which the idea for this book emerged.

1 *Global Conceptualism: Points of Origin 1950s–1980s*, exh. cat. by Luis Camnitzer, Jane Farver and Rachel Weiss; Queens Museum of Art, New York (1999).
2 Lucy Lippard, *Six Years: The Dematerialisation of the Art Object from 1966 to 1972* (New York, 1973).
3 A prior text, 'Paragraphs on Conceptual Art', appeared in *Artforum*, v, 10 (June 1967), pp. 79–81.
4 Peter Wollen, 'Global Conceptualism and North American Conceptual Art' in *Global Conceptualism*, pp. 73–85.
5 For a full discussion of this, see Douglas Crimp, 'Pictures', *October*, 8 (Spring 1979).
6 In *Art After Modernism: Rethinking Representation*, ed. Brian Wallis (New York, 1984).
7 Tony Godfrey, *Conceptual Art* (London, 1998).

1 *Anne Rorimer, Siting the Page: Exhibiting Works in Publications – Some Examples of Conceptual Art in the USA*

1 Sol LeWitt, in *Sol LeWitt*, exh. cat.; Museum of Modern Art, New York, p. 139.
2 Bernice Rose, 'Sol LeWitt and Drawing', *ibid.*, p. 32.
3 See Dieter Schwarz, ed., *Lawrence Weiner Books, 1968–1989: Catalogue Raisonné* (Cologne and Villeurbanne, 1989).
4 Lawrence Weiner, in 'Art without Space', WBAI-FM symposium, 2 November 1969, in Lucy Lippard, *Six Years: The Dematerialization of the Art Object from 1966 to 1972* (New York and Washington, 1973), pp. 131–2.
5 Vito Acconci, in *Vito Acconci: A Retrospective, 1969 to 1980*, exh. cat.; Museum of Contemporary Art, Chicago (1980), p. 10.
6 Vito Acconci, in *Vito Acconci: Photographic Works, 1969–1970*, exh. cat.; Rhona Hoffman Gallery, Chicago, Brooke Alexander Gallery, New York, and Galerie Eric Franck, Geneva (1988), unpaginated.
7 *Ibid.*

8 Vito Acconci, 'Installment (Installation): Move, Remove', in Maria Diacono, *Vito Acconci: Dal Testo-Azione al Corpo come Testo* (New York, 1975), p. 98.

9 See Brian O'Doherty, *Inside the White Cube: The Ideology of the Gallery Space* (Santa Monica/San Francisco, 1976), for background on the use of this term.

10 Dan Graham, 'My Works for Magazine Pages "A History of Conceptual Art"', in *Dan Graham*, exh. cat.; Art Gallery of Western Australia, Perth (1985), p. 8.

11 Dan Graham, in conversation with the author, December 1995.

12 See Anne Rorimer, 'Reevaluating the Object of Collecting and Display', *Art Bulletin*, LXXVII, 1 (March 1995), pp. 21–4. Paradoxically, three decades later this work has necessarily become scarce – and thus valuable – by virtue of its disposability and circulation outside the art gallery system. None the less, its thematic intent remains unchanged.

13 See Jack Flam, ed., *Robert Smithson: The Collected Writings* (Berkeley, Los Angeles and London, 1996).

14 Joseph Kosuth, 'Art as Idea as Idea: An Interview with Jeanne Siegel', in *Art After Philosophy and After: Collected Writings, 1966–1990* (Cambridge, MA), p. 50.

15 Kosuth, 'Art After Philosophy', *ibid.*, pp. 19–20.

16 Kosuth, '(Notes) on an Anthropologized Art,' *ibid.*, p. 99.

17 Joseph Kosuth, in *When Attitudes Become Form*, exh. cat.; Kunsthalle Bern, Bern (1969), unpaginated.

18 See Adrian Piper, 'Xenophobia and the Indexical Present II: Lecture', *Out of Order, Out of Sight* (Cambridge, MA, 1996), Vol. 1, p. 255. Piper states that her 'area of interest is xenophobia and racism' and that 'xenophobia is about fear of the other considered as an alien'.

19 *Ibid.*, p. 4. See also p. 241. Piper writes, 'Sol's sensibility in general has influenced me enormously. I see less connection with other Conceptual artists working at that time. For me my earliest conceptual work succeeded in so far as it illuminated the contrast between abstract atemporality and the indexical, self-referential present.'

20 *Ibid.*, p. 5.

21 See Claudia Barrow, 'Adrian Piper: Space, Time and Reference, 1967–1970', in *Adrian Piper*, exh. cat.; Ikon Gallery, Birmingham, and Cornerhouse, Manchester (1991/2) for further discussion of Piper's early work.

22 The other artists included in this publication are Carl Andre, Robert Barry, Joseph Kosuth, Sol LeWitt, Robert Morris and Lawrence Weiner.

23 Douglas Huebler, in conversation with the author, June 1994.

2 *Peter Wollen, Mappings: Situationists and/or Conceptualists*

1 First published in Chombart de Lauwe's massive *Paris et l'agglomeration Parisienne*, I (1952).

3 *Peter Osborne, Conceptual Art and/as Philosophy*

1 See Pierre Bourdieu, *The Political Ontology of Martin Heidegger* (1988), trans. Peter Collier (Cambridge, 1991), Chapter 2, 'The Philosophical Field and the Space of Possibilities'.

2 See, for example, Arthur Danto, 'The Philosophical Disenfranchisement of Art', in his *The Philosophical Disenfranchisement of Art* (New York, 1986), Chapter 1.

3 See, for example, Michael Newman, 'Conceptual Art from the 1960s to the 1990s: An Unfinished Project?', *Kunst & Museum Journal*, VII, 1–3 (1996), pp. 95–104; John Roberts, 'Photography, Iconophobia and the Ruins of Conceptual Art', in *The Impossible Document: Photography and Conceptual Art in Britain, 1966–1976* (London, 1997), pp. 7–45.

4 See Joseph Kosuth, 'Art After Philosophy', in his *Art After Philosophy and After: Collected Writings, 1966–1990* (Cambridge, MA, 1991), p. 18. The expression 'all art after Duchamp' is deliberately ambiguous. It refers at once both to art *produced* after and in the wake of the reception of Duchamp's works and to all art *tout court*, in so far as what an artwork is, is retrospectively determined by the subsequent history of works. That is, its reception is ontologically constitutive; its afterlife is part of its life.

5 See Pierre Bourdieu, 'The Field of Cultural Production; or: The Economic World Reversed', in his *The Field of Cultural Production: Essays on Art and Literature*, (Cambridge, 1993), Chapter 1.

6 See Danto, 'The End of Art', in his *Philosophical Disenfranchisement of Art*, Chapter 5. This leads Danto into the contradictory waters of an 'art after the end of art', not in Hegel's sense of a continuation of art after it has ceded its culturally formative role to the 'higher form' of philosophy – which is a continuation of art in its 'old', and for Hegel its only sense, although without its former power; but in the sense of a newly philosophical kind of art, the very idea of which belies the idea of art's end. See also Arthur Danto, *After the End of Art: Contemporary Art and the Pale of History* (Princeton, 1997). Oddly, it is not Conceptual art which Danto has in mind in this discourse of the end of art but Warhol. For Danto's personal distance from Conceptual art as a movement in the New York art world of the late 1960s and early 1970s, see his remarks in the interview 'Art and Analysis', *Radical Philosophy*, 90 (July/August 1998), pp. 33–41.

7 I attempt such an elaboration in the survey essay which opens my *Conceptual Art* (London, forthcoming 2001).

8 Sol LeWitt, 'Paragraphs on Conceptual Art', in *Art in Theory*, ed. Charles Harrison and Paul Wood (Oxford, 1992), p. 834.

9 Henry Flynt, 'Concept Art', in *An Anthology*, ed. La Monte Young (New York, 1963).

10 Harrison and Wood, *Art in Theory*, p. 835.

11 Robert Morris, 'Anti-Form' (1968), in his *Continuous Project Altered Daily* (Cambridge, MA, 1993), pp. 41–3 (emphasis added).

12 Harrison and Wood, *Art in Theory*, p. 835.

13 Flynt, 'Concept Art'.

14 Harrison and Wood, *Art in Theory*, p. 836.

15 Sol LeWitt, 'Sentences on Conceptual Art', in *ibid.*, p. 839.

16 *Ibid.*, pp. 834–6 (emphasis added).

17 *Ibid.*, pp. 837–8.

18 Adrian Piper, interview with Peter Osborne, March 1998, New York. I benefited greatly from this interview in conceiving the structure of this essay. Piper's writings have been collected as *Out of Order, Out of Sight. Volume 1: Selected Writings in Meta-Art, 1968–1992* and *Volume 2: Selected Writings in Art Criticism, 1967–1992* (Cambridge, MA, 1996).

19 Kosuth, *Art After Philosophy and After*, p. 18.

20 The distinction between an abstract, and hence indeterminate, negation and a concrete or determinate negation – in which the determinacy of that which is negated is carried over into the product of the negation – derives from the two-stage account of negation in Hegel's dialectical logic. Such a logic is essentially retrospective in its establishment of determinate connections between historical forms. My claim that Kosuth effectively treats the idea of the propositional nature of art (artwork as proposition about the nature of art) as a determinate or 'second' negation of the aesthetic conception of art is thus a retrospective, interpretative one, rather than a description of his self-understanding.

21 See Ad Reinhardt, 'Art as Art' (1962), in his *Art as Art: The Selected Writings of Ad Reinhardt* (Berkeley, 1975), pp. 53–6.

22 Pierre Cabanne, *Dialogues with Marcel Duchamp* (New York, n.d.), p. 77.

23 Kosuth, *Art After Philosophy and After*, pp. 20, 26.

24 *Ibid.*, p. 14.

25 *Ibid.*, pp. 16, 20.

26 *Ibid.*, pp. 19–20.

27 Charles Harrison, 'The Conditions of Problems', in his *Essays on Art & Language* (Oxford, 1991), pp. 93–4.

28 Kosuth, 'Art as Idea as Idea: An Interview with Jeanne Siegel', in *Art After Philosophy and After*, p. 53. Kosuth uses the multiplicity of Ad Reinhardt's practices as his example here, in conscious contradiction to Reinhardt's own idea of 'art as art'.

29 Seth Siegelaub in Lucy Lippard, *Six Years: The Dematerialization of the Art Object 1966–1972* (Berkeley, 1967), p. 125.

30 Jeff Wall, *Dan Graham's Kammerspiel* (Toronto, 1991), pp. 100, 102.

31 Something confirmed by Adrian Piper (interview with author, New York, March 1998) who saw them as 'creating a kind of private language'.

32 Introduction, *Art-Language*, I,1 (May 1969), p. 10.

33 *Art-Language*, I,4 (November 1971), pp. 13, 27.

34 For a retrospective rationalization of these contortions as knowing strategic performances, see John Roberts, 'In Character', in *Art & Language in Practice*, vol. 2, *Critical Symposium*, ed. Charles Harrison (Barcelona, 1999), pp. 161–75.

35 See, for example, 'the astonishing but inescapable conclusion' of Michael Thompson's 'Conceptual Art: Category and Action' in the second issue of the journal: 'namely, that the seemingly erudite, scholastic, neutral, logical, austere, even incestuous, movement of conceptual art is, in fact, a naked bid for power at the very highest level – the wrestling from the groups at present at the top of our social structure, of control over the symbols of society', *Art-Language*, I,2 (February 1970), p. 82.

36 See the remarks by Terry Atkinson explaining his decision to leave the group, in his *The Indexing, The World War One Moves and the Ruins of Conceptualism* (Cornerhouse/Irish Museum of Modern Art, 1992).

37 Harrison, *Essays on Art & Language*, p. 75; see also p. 61.

38 Fredric Jameson, 'The Vanishing Mediator; or, Max Weber as Storyteller', in his *The Ideologies of Theory: Essays 1971–1986. Volume 2: The Syntax of History* (Minneapolis, 1988), p. 25.

4 *William Wood, Still You Ask for More: Demand, Display and 'The New Art'*

1 Anne Seymour, 'Introduction', *The New Art* (London, 1972), p. 5.

2 The others were: Keith Arnatt, Michael Craig-Martin, David Dye, Barry Flanagan, Hamish Fulton, John Hilliard, Keith Milow, Gerald Newman, John Stezaker and David Tremlett.

3 Seymour, 'Introduction', p. 7.

4 *Ibid.*, p. 5.

5 *Ibid.*, p. 7.

6 Robin Campbell and Norbert Lynton, 'Preface', *The New Art*, p. 4.

7 Seymour, 'Introduction', p. 5.

8 *Ibid.*

9 See 'Some Concerns in Fine Art Education', *Studio International*, 182 (October 1971), pp. 120–2. See also Charles Harrison, 'Educating Artists', *Studio International*, 183 (May 1972), pp. 222–4, and Anthony Everitt, 'Four Midland Polytechnic Fine Art Departments', *Studio International*, 184 (November 1972), pp. 176–81.

10 Seymour, 'Introduction', p. 5.

11 Lucy Lippard, *Six Years: The Dematerialization of the Art Object* (New York, 1973), p. 263.

12 Seymour, 'Introduction', p. 6.

13 Frank Whitford, 'You're the Tops', *Studio International*, 184 (December 1972), pp. 211–12. Bongard's ranking, prepared for the West German business magazine *Capital*, used a point system according to auction prices, museum purchases and appearances in public exhibitions and the art press.

14 These cover prices are taken from *Art-Language*, 1,2 (February 1970) (12s. 6d.) and *Studio International*, 180 (July/August 1970) (17s. 6d.). The exchange rate for American dollars to sterling stood around 2:5 in the early 1970s and is used for the equivalents given in parentheses.

15 See the account in Terry Atkinson to Paul Maenz, 22 February 1972, Artists' Correspondence, Galerie Paul Maenz Archive, Getty Center for the History of Art and the Humanities, Los Angeles.

16 See the account in Paul Maenz to Victor Burgin, 30 November 1971. Artists' Correspondence, Galerie Paul Maenz Archive, Getty Center for the History of Art and the Humanities, Los Angeles.

17 The records for these works, *Sculpture Untitled June 1968 England*, and *Sculpture for Conte Panza di Buimo*, 1969, form part of the mostly photocopied and photographed archives of the Panza Collection Archive, Getty Center for the History of Art and the Humanities, Los Angeles. Reproductions are in Christopher Knight, *Art From the Sixties and Seventies: The Panza Collection* (New York, 1988), pp. 257–8.

18 See Geraldine Norman, '£9000 for Constable Drawing', *The Times*, 19 November 1971, p. 3.

19 Burgin, 'Situational Esthetics', *Studio International*, 178 (October 1969), p. 119.

20 Victor Burgin, 'Margin Note', *The New Art*, p. 25.

21 Charles Harrison, 'Virgin Soils and Old Lands', *The British Avant-Garde* (New York and London, 1971), p. 3.

22 Carl Andre, quoted by Seymour, 'Introduction', p. 6.

23 *Ibid.*, pp. 5–6.

24 *Ibid.*, p. 6.

25 *Ibid.*

26 *Ibid.*

27 *Ibid.*

28 Richard Long, 'Nineteen Stills from the Work of Richard Long', *Studio International*, 179 (March 1970), pp. 106–11; Richard Long, 'Retrospective', *Avalanche*, 1 (Fall 1970), pp. 28–33; *From Along a Riverbank* (Amsterdam, 1971); *Two Sheepdogs Cross In and Out of the Passing Shadows, the Clouds Drift Over the Hill with a Storm* (London, 1971); *Richard Long im Park des Museum Haus Lange, Krefeld* (Krefeld, 1970); *Richard Long: Skulpturen England Germany Africa America 1966–1970* (Mönchengladbach, 1970).

29 See *Richard Long: Skulpturen*, unpaginated.

30 See *The British Avant Garde*, pp. 24–5, and front cover.

31 'Richard Long', *The New Art*, p. 101.

32 See, for examples, 'Victor Burgin', *Studio International*, 180 (July/August 1970), p. 28, for the instructional text later titled *Any Moment*, and Victor Burgin, 'Margin Note', *The New Art*, pp. 22–5.

33 Anne Seymour, 'Victor Burgin', *The New Art*, p. 74.

34 Burgin, 'Margin Note', p. 22.

35 'Introduction', *Art-Language*, I, 1 (May 1969), p. 10.

36 Anne Seymour, 'Art-Language', *The New Art*, p. 72.

37 Terry Atkinson, 'From an Art and Language Point of View', *Art-Language* I, 2 (February 1970), p. 41.

38 Charles Harrison, 'Richard Long at the Whitechapel', *Studio International* 183 (January 1972), p. 34.

39 Seymour, 'Introduction', p. 6.

40 Frances Wyndham wrote of the 'feat of endurance' in his profile, 'Gilbert and George', in the *Sunday Times Magazine*, 10 January 1971, p. 21. The changes in presentation style were first noted in Barbara Reise, 'Presenting Gilbert and George, The Living Sculptures', *Artnews* 70 (November 1971), pp. 64, 91–2.

41 'Gilbert and George', *The New Art*, p. 94.

42 William Feaver, 'London Letter', *Art International*, XVI, 9 (November 1972), p. 38.

43 Robert Melville, p. 247.

44 Feaver, 'London Letter', p. 39.

45 *The Times*, 6 July 1972.

46 Art-Language Institute, 'Suggestions for a Map', *Documenta 5* (Kassel, 1972), Section 17, p. 18.

47 Charles Harrison, 'Mapping and Filing', *The New Art*, p. 14.

48 Art-Language Institute, 'Suggestions for a Map', Section 17, p. 18.

49 *Ibid.*, p. 16.

50 Harrison, 'Mapping and Filing', p. 15.

51 Art-Language Institute, 'Suggestions for a Map', Section 17, p. 17.

52 Harrison, 'Mapping and Filing', p. 15.

53 Germano Celant, 'The British Avant-garde', *Domus*, 513 (January 1973), p. 47.

54 R.H. Fuchs, 'More on "The New Art"', *Studio International*, 184 (December 1972), p. 194.

55 Celant, 'The British Avant-garde', p. 48.

56 Burgin, 'Margin Note', p. 24.

57 Melville, p. 248.

58 Feaver, 'London Letter', p. 39.

59 Charles Harrison, 'A Very Abstract Context', *Studio International*, 180 (November 1970), p. 196.

60 Burgin, 'Margin Note', p. 25.

5 *Jon Bird, Minding the Body: Robert Morris's 1971 Tate Gallery Retrospective*

1 Robert Morris, 'Notes on Sculpture: Part IV', in *Continuous Project Altered Daily: The Writings of Robert Morris* (Cambridge, MA, 1995), p. 69.

2 Anton Ehrenzweig, *The Hidden Order of Art* (London, 1967), p. 95.

3 David Sylvester in conversation with Michael Compton, *Tate Magazine* (Spring 1997).

4 Michael Shepherd, *Sunday Telegraph*, 9 May 1971. All correspondence and information relating directly to the exhibition comes from the Robert Morris File in the Tate Gallery Archives (TGA: RM file).

5 *Neo Classic*, b/w, 16mm film, approx. 12 minutes's running time. Tate Gallery, April 1971.

6 Robert Morris, 'Professional Rules', *Critical Inquiry*, 23 (Winter 1997).

7 Letter to Maurice Compton, 24 May 1970 (TGA: RM file)

8 Quoted in Morris Berger, 'Wayward Landscapes', in *Robert Morris: The Mind/Body Problem* (New York, 1994), p. 21.

9 For a full discussion of this see Maurice Berger, *Labyrinths: Robert Morris, Minimalism, and the 1960s* (New York, 1989), pp. 93–5.

10 Letter to Michael Compton, 19 January 1971 (TGA: RM file).

11 Morris's interest in Wittgenstein's philosophical writings is well documented by W. J. T. Mitchell in his catalogue essay 'Wall Labels: Word, Image and Object in the Work of Robert Morris', in *Robert Morris: The Mind/Body Problem*, pp. 62–79.

12 Robert Morris, 'Some Notes on the Phenomenology of Making: The Search for the Motivated', in *Continuous Project Altered Daily*, p. 92.

13 The relationship of Morris to dance and choreography is explored by Berger in 'Wayward Landscapes', pp. 18–33.

14 Letter to Michael Compton, 5 March 1971 (TGA: RM file).

15 The writings of the structuralist anthropologist Claude Lévi-Strauss were frequently cited by Morris. In the essay 'The Science of the Concrete', Lévi-Strauss differentiates between the scientific method of deductive design and that of the '*bricoleur*' who employs apparently random or devious methods to obtain his goal, which is essentially formulated in the process of employing the methods. Morris's monumental installations at the Corcoran Gallery and the Whitney Museum and, to some extent, in the Tate retrospective, utilize the techniques of the *bricoleur*.

16 For the implications of C. S. Peirce's system for a semiotics of the visual arts, see M. Iverson, 'Saussure versus Peirce: Models for a Semiotics of Visual Art', in *The New Art History*, eds A. L. Rees and F. Borzello (London, 1986).

17 *Ibid.*, p. 31.

18 *Ibid.*, p. 68.

19 'Dematerialization' first appeared as a theoretical concept in the 1968 essay by Lucy Lippard and John Chandler 'The Dematerialization of Art'. In this account the suggestion is of an absence of material rather than object which was corrected in Lippard's later anthology, *Six Years: The Dematerialization of the Art Object* (London, 1973). The attack upon the object is theorized somewhat differently by Rosalind Krauss in her influential essay 'Sculpture in the Expanded Field'. For Krauss, artists in the late 1960s were primarily interested in the negation of sculptural form and space through the object's proximity to previously excluded categories, such as 'landscape' and 'architecture': 'The expanded field is thus generated by problematizing the set of oppositions between which the modernist category *sculpture* is suspended', *October*, 13 (Spring 1979), p. 38.

20 *Ibid.*, p. 61.

21 'In creativity, outer and inner reality will always be organized together by the same indivisible process . . . My point will be that unconscious scanning makes use of undifferentiated modes of vision that to normal awareness would seem chaotic', Anton Ehrenzweig, *The Hidden Order of Art*, p. 5.

22 Smithson's connection to Ehrenzweig is explored by Gary Shapiro in his *Earthwords: Robert Smithson and Art After Babel* (Los Angeles and London, 1995).

23 See W. J. T. Mitchell, 'Wall Labels'.

24 In 1969 Morris also organized *Anti-Form*, an exhibition at Leo Castelli's Warehouse Gallery in New York which included, besides his own work, pieces by Richard Serra, Eva Hesse, Claes Oldenburg and Bruce Nauman. A precedent for this was Lucy Lippard's 1966 exhibition *Eccentric Abstraction* at the Fischbach Gallery, New York.

25 *Ibid.*, p. 32.

26 *Ibid.*, p. 42.

27 Morris, 'Notes on Sculpture: Part IV', p. 69.

28 Bruce W. Ferguson, 'Exhibition Rhetorics: Material Speech and Utter Sense', in *Thinking About Exhibitions*, ed. Reesa Greenberg, Bruce W. Ferguson and Sandy Nairne (London and New York, 1996), p. 178.

29 Letter to Robert Morris, 13 May 1971 (TGA: RM file).

30 Berger, *Labyrinths*.

31 David Antin, 'Have Mind, Will Travel', in *Robert Morris: The Mind/Body Problem*, pp. 44–5.

32 *Ibid.*, p. 121.

33 Richard Neville, *Play Power* (London 1970). Neville also mentions R. D. Laing, Bakunin and the Situationist manifesto as important references for the radical discourse of the 1960s counter-culture movements. Herbert Marcuse's writings provided an important and influential reference for American artists on the left, particularly in relation to counter-cultural notions of freedom and liberation. Berger points out that Marcuse's 'An Essay on Liberation' was concurrent with Morris's development of his

concept of 'anti-form', and Berger, *Eros & Civilization* had a direct bearing on Morris's reaction to the repressive authority of the art institutions.

34 The critical literature on the museum and its displays is now extremely extensive. In relation to these issues, see Carol Duncan, *Civilizing Rituals: Inside Public Art Museums* (London and New York, 1995; Douglas Crimp, *On the Museum's* (Cambridge, MA, 1993); Eileen Hooper-Greenhill, *Museums and the Shaping of Knowledge* (London and New York, 1992); Daniel J. Sherman and Irit Rogoff, eds, *Museum Culture: Histories, Discourses, Spectacles* (London, 1994); Greenberg, Ferguson and Nairne, *Thinking About Exhibitions*.

35 In fact, the making of the film seems to have been something of an afterthought. Certainly it was not an element within the design until a very late stage during the construction of the installation.

36 Kuhn's book, along with A. J. Ayer's *Language, Truth and Logic* and Wittgenstein, were primary references for the development of Conceptual art in Britain and America. Kuhn's notion of science progressing through 'paradigm shifts' became a model for early Art & Language critiques of the physical-object status of the work of art: for example, see Terry Atkinson and Mike Baldwin, 'On the Material-Character/Physical-Object Paradigm of Art', *Art-Language*, II,1 (February 1972). For a full discussion of the philosophical aspects of Conceptual art, see Peter Osborne in this collection.

Thanks to Michael Compton for sharing his recollections of the exhibition and its aftermath with me.

6 *Helen Molesworth, Cleaning Up in the 1970s: The Work of Judy Chicago, Mary Kelly and Mierle Laderman Ukeles*

This is the first stage of a longer project dealing with the influence of feminism on 1970s art and the current reception of those diverse bodies of work. I would like to thank Miwon Kwon and Cecile Whiting for an invitation to speak at the University of California at Los Angeles, where this work was first delivered.

1 In the past few years numerous exhibitions have taken place: Mary Kelly's *Post Partum Document* has been reassembled in its entirety by the Generali Foundation in Vienna, Austria (25 September–20 December 1998); Mierle Laderman Ukeles's *Maintenance Art* series was shown in its entirety at the Ronald Feldman Gallery; Judy Chicago's *The Dinner Party* was the centrepiece of an exhibit at the Hammer Museum, Los Angeles, California (24 April–18 August 1996); *Division of Labor: Women and Work* was held at the Bronx Museum, New York (1996); and the *Bad Girls Exhibition* at the New Museum in New York (14 January–27 February and 5 March–10 April 1994), to name but a few. So too books and journals have proliferated: the journal *October* dedicated an entire issue to the question of feminism, replete with questionnaire and round-table (*October*, 71 [Winter, 1995]); Laura Cottingham produced *Not for Sale* (1998), a video essay designed for teaching feminist art; *Feminism and Contemporary Art: The Revolutionary Power of Women's Laughter* by Jo Anna Isaak's appeared (London, 1996) and *The Power of Feminist Art* brought together in one volume a commanding overview of American feminist art of the 1970s (New York, 1994).

2 Here I am referring to artists and critics such as Judy Chicago, Miriam Schapiro, Faith Wilding, the artists involved in Woman House and the Feminist Art Program, Harmony Hammons, Ana Mendieta, Faith Ringgold, Lucy Lippard, Norma Broude, Mary D. Garrard and Mira Schor.

3 I'm thinking here of the work of Mary Kelly, Griselda Pollack, Victor Burgin, Barbara Kruger, Cindy Sherman, Silvia Kolbowski, Laura Mulvey, and Lisa Tickner.

4 Kate Linker, 'Representation and Sexuality', in *Art After Modernism*, ed. Brian Wallis (New York), p. 392.

5 Critics have condemned Chicago for her inability to image the sexuality of black women in *The Dinner Party*, seeing it as emblematic of the blindness to issues of racial and ethnic difference on the part of white American feminists. See Alice Walker's 'One Child of One's Own: A Meaningful Digression within the Work(s)', in *In Search of Our Mother's Gardens: Womanist Prose* (San Diego, 1983). See also Amelia Jones's discussion of these issues in 'The Sexual Politics of the Dinner Party: A Critical Context', in *Sexual Politics* (Berkeley, 1996).

6 Kelly refers to this practice as 'scripto-visual': see Mary Kelly, *Imaging Desire* (Cambridge, MA, 1996).

7 Lisa Tickner, *October*, 71 (Winter 1995), p. 44.

8 Griselda Pollock, 'Painting, Feminism, History', in *Destabilizing Theory*, ed. Michele Barrett and Anne Phillips (Stanford, 1992), p. 154.

9 Faith Wilding, 'The Feminist Programs at Fresno and CalArts, 1970–75', in *The Power of Feminist Art*, ed. Norma Broude and Mary D. Garrard (New York, 1994), p. 35.

10 Heinrich Wölfflin, *Principles of Art History*, trans. M. D. Hottinger (New York, 1950), p. 6.

11 *Ibid.*, p. 11.

12 Schor also registers resentment at a debate whose terms have been largely set by others: see Mira Schor, 'Backlash and Appropriation', in *The Power of Feminist Art*.

13 See Jones, 'The Sexual Politics of the Dinner Party'. This is the most exhaustive and comprehensive article to date on *The Dinner Party* and Jones takes great pains to fairly and adequately register the criticism of work.

14 This is the effect of Laura Cottingham's video essay, *Not for Sale*. For a critical account of how it fosters and preserves the problems of an isolated and marginalized version of feminist art, see Helen Molesworth's 'Not for Sale', *Frieze*, 41 (Summer 1998).

15 Mary Kelly has frequently argued against the category 'feminist art'. See the exchange between her and Silvia Kolbowski in 'A Conversation on Recent Feminist Art Practices', *October*, 71 (Winter 1995).

16 Moira Gatens, 'Powers, Bodies and Difference', in *Destabilizing Theory*, p. 124.

17 *Ibid.*, pp. 124–5.

18 Moira Gatens, *Feminism and Philosophy: Perspectives on Difference and Equality* (Bloomington, 1991), pp. 122–3.

19 For an elaboration of this argument, see Carole Pateman's *The Sexual Contract* (Stanford, 1988). This critique elaborates upon the problem of 'equality' within liberal thought which, when combined with the inability of capitalism to function without the unpaid labour of maintenance, can open on to a critique of democracy's historical dependence upon slavery. Here the implications of political theory are indispensable for thinking through the perennial blind spot of both Anglo-American and continental feminism, i.e. the problematics of racial and ethnic difference.

20 Gatens, 'Powers, Bodies and Difference', p. 131.

21 *Ibid.*, p. 135.

22 For a reprint of Ukeles's 'Maintenance Art Manifesto' in its entirety, see 'Artist Project: Mierle Laderman Ukeles Maintenance Art Activity (1973) with responses from Miwon Kwon and Helen Molesworth', *Documents*, 10 (Fall 1997).

23 The dearth of critical writing (or mere art-historical appraisal) of Ukeles's work may be due to the way in which the *Maintenance Art Performances* fall outside a clear-cut group or discursive field.

24 Rosalyn Deutsche, *Evictions: Art and Spatial Politics* (Cambridge, MA, 1996), p. 273.

25 Pateman, *The Sexual Contract*, p. 144.

26 Frazer Ward, 'Performance and the Public Sphere: Vito Acconci and Chris Burden', PhD thesis, Cornell University, 1999.

27 For the fetishism of surface in Chicago's work, see Laura Meyer 'From Finish Fetishism to Feminism: Judy Chicago's Dinner Party in California Art History', in *Sexual Politics*.

28 Benjamin Buchloh, 'Conceptual Art 1962–1969: From the Aesthetic of Administration to the Critique of Institutions', *October*, 55 (Winter 1990), p. 107.

29 Frazer Ward, 'On Some Relations between Conceptual and Performance Art', *Art Journal* (Winter 1997).

30 For a more elaborate account of Ukeles's work as a means of foiling work, see Helen Molesworth, 'Work Stoppages: Mierle Laderman Ukeles' Theory of Labor Value', *Documents*, 10 (Fall 1997).

31 Miwon Kwon, 'In Appreciation of Invisible Work: Mierle Laderman Ukeles and the Maintenance of the "White Cube"', *Documents*, 10 (Fall 1997).

32 Fredric Jameson, 'Periodizing the 1960s', in his *The 60s Without Apology* (Minneapolis, 1984), p 179.

33 For more on the importance of privacy, see Drucilla Cornell. She despatializes privacy by insisting upon the idea of an imaginary domain. This is the site (both imagined and actualized) where persons are free to articulate their desires with the historical protections of the idea of 'privacy'. By despatializing privacy, she is able to unhinge it from notions of private property which have legally been disadvantageous to women (with regards to domestic violence, for instance). See *At The Heart of Freedom: Feminism, Sex, and Equality* (Princeton, 1998).

34 Gatens, *Feminism and Philosophy*, p. 129.

35 Cornell, *At The Heart of Freedom*, p. 24

7 David Campany, Conceptual Art History or, A Home for Homes for America

1 It seems clear that at every moment in the history of photography in art, a very wide range of concerns and practices has been pursued. What I wish to track here is the mechanism by which certain practices have been accorded vanguardist status.

2 It could be argued that Conceptualism's interest in the photograph was perhaps more epistemological than ontological. Nevertheless, approaching the matter ontologically can be fruitful, particularly given the photograph's distinctive relation to reproduction.

3 As I have argued elsewhere, the fitful career of art photography takes place against the backdrop of the medium's much more reliable employment as the silent vehicle of all art and art history. Photography can never really hope to be sustained as art anywhere near as consistently as art is sustained by photography. See David Campany, 'Art Photographed: Some Thoughts on Painting and the Book', in *Postcards on Photography*, ed. Naomi Salaman and Ronnie Simpson (Cambridge, 1998).

4 'In more ways than one photography today is closer to literature than it is to the other graphic arts. (It would be illuminating, perhaps, to draw a parallel between photography and prose in their respective aesthetic and historical relations to painting and poetry.) The final moral is: let photography be "literary"', Clement Greenberg, 'The Camera's Glass Eye: Review of an Exhibition of Edward Weston' (1946), in *The Collected Essays and Criticism, vol. 2: Arrogant Purpose, 1945–1949* (Chicago, 1986), p. 63.

5 See Szarkowski's *The Photographer's Eye* (New York, 1966), a Modernist photographic ontology that suggested all photographs can be measured by their capacity to excel (or not) in one of five possible categories: 'The Thing Itself, The Detail, The Frame, Time or Vantage Point.'

6 The catalogue of London's Royal Academy exhibition *The Art of Photography* (1989), 'celebrating 150 years of photography', opens with a year-by-year chronology of the medium in which 41 of the 150 entries are events in photographic publishing.

7 Similarly, much of the photography of the nineteenth century that was repositioned as art photography in the second half of this century had to be torn (often literally) from its textual place on the pages of scientific, architectural and literary publications. Carol Armstrong's *Scenes in a Library* (Cambridge, MA, 1998), provides an excellent account of the early photograph's relation to the book, while Douglas Crimp's 'The Museum's Old, The Library's New Subject', *Parachute*, 22 (Spring 1981), examines its later repositioning as art.

8 Victor Burgin, *Work and Commentary* (1973). Although the commentary comes first and prepares the reader for the work, the book isn't called *Commentary and Work*. While the work demands some kind of foregrounding, it is still positioned as primary.

9 One would have to place the typewriter alongside the camera itself in the same category of tools made available by the rapid post-war diffusion of communications technologies that are given pivotal functions in Conceptualism.

10 Of course, the desk was also a key trope of the analytical philosophy that preoccupied many Conceptualists. (Husserl, Russell, Wittgenstein and Merleau-Ponty all offer the desk privileged positions in their thought.)

11 Similarly Victor Burgin's 'Art Common Sense and Photography' (published in *Camerawork*, 3 [July 1976]) has much of the graphic and typographic pragmatics of his own photo-text work that appropriated mass-media imagery.

12 Roland Barthes, 'Rhetoric of the Image' ('Rhetorique de l'Image'), Communications, 4 (1964), in *Image-Music-Text* (London, 1977), p. 14.

13 'Visualizing Theory: An Interview with Victor Burgin', in *Visualizing Theory*, ed. Lucien Taylor (London, 1994), p. 460.

14 At present it is the Conceptual book works of Ed Ruscha that seem to be the most reproduced in art history. And it is in reproduction that one is most likely to encounter them. See, among many others, Tony Godfrey's *Conceptual Art* (London, 1998), *Public Information*, exh. cat., San Francisco Museum of Modern Art (1995), Goldstein and Anne Rorimer, eds, *Reconsidering the Object of Art: 1965–1975* (Cambridge, 1995), all of which, incidentally, had larger print runs than Ruscha's originals. No doubt it is repeated reproduction that is in part behind the high market value of Ruscha's books, despite, as Clive Phillpot put it, their 'instant dispelling' of the aura of artworks.

15 Benjamin Buchloh, 'Conceptual Art 1962–1969: From the Aesthetic of Administration to the Critique of Institutions', *October*, 55 (Winter 1990).

16 What seems to characterize art after Conceptualism, after the direct entanglement with language, is a much more acute awareness of the functions of art's print infrastructure that allows for the mediation of complex artistic programmes.

17 Dan Graham, 'My Works for Magazine Pages: A History of Conceptual Art', *Kunst and Museumjournaal*, IV, 6 (1993), as reprinted from *Dan Graham*, exh. cat., Art Gallery of Western Australia, Perth, (1985).

18 Accounts of Graham's intentions for this work are endemic in recent art surveys. Perhaps the most useful are to be found in Graham's anthology *Rock My Religion*, ed. Brian Wallis (Cambridge, MA, 1988) and Jeff Wall's *Dan Graham's Kammerspiel* (1991).

19 D. Graham, 'Homes for America: Early 20th-Century Possessable Houses to the Quasi-Discrete Cell of '66', *Arts*, XLI, 3 (December–January 1966–67).

20 Thomas Crow, 'The Simple Life: Pastoralism and the Persistence of Genre in Recent Art', *October*, 63 (1993).

21 Quoted by Benjamin H. D. Buchloh in his article 'Moments of History in the Work of Dan Graham' (1977) in *Dan Graham Articles*, exh. cat., Stedelijk Van Abbemuseum, Eindhoven (1977). The line later resurfaced as part of the supporting statement with which Graham accompanied the article 'My Works for Magazine Pages: A History of Conceptual Art'.

22 See Goldstein and Rorimer, eds., *Reconsidering the Object of Art*, pp. 126–7, which contains reproductions of the mounted panels (tellingly, they credit the photographer of Graham's flat artwork, Paula Goldman), while within the same volume Jeff Wall's article 'Marks of Indifference: Aspects of Photography in, or as, Conceptual Art', includes a photograph of part of the original *Arts* magazine layout, as well as a reproduction of a lithograph of Graham's original layout for the *Arts* magazine project.

23 By way of a parallel, consider the billboard interventions of the group AVI (whose name was specifically invented as a focus for media coverage of their public work). Opting to rework existing public billboards through subtle additions of computer generated 'detourning' text, the work effectively hijacks its audience, which is unaware of any direct intervention. In *print*, however (national newspapers, advertising trade papers, art journals), the work is presented to an audience for much more conscious consideration – as anecdote or reportage rather than détournement. See my interview with AVI in the journal *Transcript*, III,1 (1997).

24 Graham's photographs can also be seen as part of a loose artistic subgenre of banal architectural taxonomies that includes several of Ed Ruscha's book works, and finds its apotheosis in the serial studies of Bernd and Hilla Becher.

25 See Dan Graham, 'My Works for Magazine Pages: A History of Conceptual Art'.

26 See William Jenkins, ed., *New Topographics: Photographs of a Man Altered Landscape* (New York, 1975), and *William Eggleston's Guide* (New York, 1976). While Graham's images predate the published appearance this work by almost a decade, their rather delayed reception has to some extent been framed by them.

27 See Gregory Battcock, 'Photographs by Dan Graham', in *Minimal Art*, ed. Gregory Battcock (New York, 1968).

28 The Evans image that was used by the editors of *Arts* magazine, 'Wooden Houses, Boston, 1930', was of Victorian architecture. (Modular domestic housing predates both modular sculpture and post-war suburbia by quite a few decades.)

29 See Battcock, 'Photographs by Dan Graham'. Here the photographs are reproduced independent of the *Homes for America* layout, 'illustrating Minimal-type surfaces and structures as they are found by the artist in nature – particularly in the suburban landscape'. For further discussion of the discursive and institutional mobility of photojournalism, see Abigail Solomon-Godeau, 'Who is Speaking Thus?', in *Photography at the Dock*, (Minneapolis, 1991), John Tagg, 'The Currency of the Photograph: New Deal Reformism and Documentary Rhetoric', in *The Burden of Representation*, (London, 1988), and Allan Sekula, 'Traffic in Photographs', in *Photography Against The Grain*, (1984).

30 The former quote is from Thomas Crow's 'The Simple Life: Pastoralism and the Persistence of Genre in Recent Art' (*October* 63 [1993]) and the latter from Jeff Wall's essay 'Marks of Indifference: Aspects of Photography in, or as, Conceptual Art', in Goldstein and Rorimer, eds, *Reconsidering the Object of Art 1965–1975* (Cambridge, MA, 1995).

8 Alex Alberro, A Media Art: Conceptualism in Latin America in the 1960s

I would like to thank Mari Carmen Ramírez for initially introducing me to much of the material discussed in this essay, and Nora M. Alter and John Scott for their editorial advice.

1 The refusal of artists working in Latin America to rely entirely on linguistic structures to theorize the construction of the subject, and their taking into consideration broader mythical structures, surely have to do with the fact that the dominant language (Spanish or Portuguese) was itself culturally and socially problematical, being symptomatic of the ruling class.

2 See Manuel Castells, 'La Urbanización Dependente en América Latina' (1971), in his *Imperialismo yurbanizacion en América Latina* (Barcelona, 1973), pp. 7–26. Written in the early 1970s, Castells's essay asserts that 'Latin America has a rate of urbanization almost equivalent to that of Europe, and a rate of metropolitanization greater than that of Europe' (p. 7). See also T. Lynn Smith, 'Why the Cities? Observations on Urbanization in Latin America', in *Latin American Problems* , ed. P. L. Astuto and R. A. Leal (New York, 1964).

3 See Eduardo Costa, Raul Escari and Roberto Jacoby, 'Un arte de los medios de communicación (Manifiesto)' in *Happenings*, ed. Oscar Masotta (Buenos Aires, 1967), pp. 119-122.

4 *Ibid.*, p. 121: '*En una civilización de masas, el público no está en contacto directo con los hechos culturales, sino que se informa de ellos a través de los medios de comunicación. La audiencia de masas no ve, por ejemplo, una exposiciónsino que ve su proyección en un noticiero ... En último caso, no interesa a los consumidores de información se realiza o no; sólo importa la imagen que de este hecho artístico <u>construye</u> el medio de comunicación.*'

5 *Ibid.*, pp. 121–2: '*De este modo nos proponemos entregar a la prensa el informe escrito y fotográfico de un happening que no ha ocurrido. Este falso informe incluirá los nombres de los participantes, una indicación del lugar y momento en que se realizó y una descripción del espectáculo que se finge que ha ocurrido, con fotos tomadas a los supuestos participantes en otras circunstancias ... Una obra que comienza a existir en el momento mismo en que la conciencia del espectador la constituye como ya concluída. Existe, pues, una triple creación: 1) la redacción del falso informe; 2) la transmisión que de dicho informe realizan los canales de información; 3) la recepción por parte del espectador que construye – a partir de los datos recibidos y según la significación que en él adquieren estos datos – el espesor de una realidad inexistente que él imagina verdadera.*'

6 See Roland Barthes, 'Myth Today' (1957), in *Mythologies*, trans. Annette Lavers (New York, 1972), p. 135. This passage is cited in Roberto Jacoby, 'Contra El Happening' (1966), republished in Masotta, *Happenings*, p. 126.

7 For an account of the particular location of the placement of false information by these artists, see Roberto Jacoby and Eduardo Costa, 'Un arte de los medios de comunicación', in Masotta, *Happenings*, pp. 113–18. For a description of one of these projects, entitled *Happening para un jabalí difunto (Happening for a Dead Wild Boar)*, see Jorge Glusberg, *Art in Argentina* (Milan, 1986), p. 14. Perhaps not surprisingly, the publication of the manifesto 'Un arte de los medios de communicación' derailed the realization of the project of its authors because once the media targeted by the artists discovered the falseness of the scheme they refused to publish any art notices related to the misleading artists.

8 According to Andrea Giunta, 'Arte y (re)presión: cultura crítica y prácticas conceptuales en Argentina', *Arte, historia y identidad en América: visiones comparativas*, vol. III, ed. Gustavo Curiel *et al.* (Mexico, DF, 1994), p. 881, there are two opposite strands of avant-garde art in 1960s Argentina. One, represented by Jacoby, Costa and Escari's 'Media Art', takes up 'the optimistic and festive character of Pop art', while the other, represented by artists such as Leon Ferrari, is much more 'critical of the fundamental premises of Western art'. For an informative overview of the relationship between art and politics in 1960s Argentina, see John King, 'Art and Cultural Development: Argentina 1956–1976', in *Art from Argentina, 1920–1994*, ed. David Elliot (Oxford, 1994), pp. 66–73. The account of social, economic and political developments in 1960s Latin America presented in this paper is indebted to Tulio Halperín Donghi's highly informative study, *The Contemporary History of Latin America*, trans. John Charles Chasteen (Durham and London, 1993), esp. pp. 292–337.

9 See G. Fantoni, 'Tensiones hacia la politica: del homenaje al Vietnam a la Anti-Bienal', *Rev. Sisi* (Buenos Aires), II, 2 (1990), p. 34; as cited in Lisa Roberts, 'Pablo Suárez: A Portrait of Resistance', in *Art from Argentina*, ed. Elliott, pp. 107–8. Córdoba is a city in central Argentina.

10 Ruano had made an exact replica of the showcase housed in the United States Information Agency's (USIS) Lincoln Library in Buenos Aires; it also featured a portrait of John F. Kennedy.

11 Later the same month, the artist Pablo Suárez distributed a short, manifesto-like text – a gesture that, in the spirit of Conceptual art, he termed an aesthetic act – at the annual *Experiencias* exhibition at the Instituto Di Tella in Buenos Aires. In it, he articulated his serious concerns about the repression of artists, the censorship of their work and 'the institution which represents cultural centralization, homogenization [and] the impossibility of appreciating things in the moment in which they happen in their environment' (Pablo Suárez, copy of the original letter in Andrea Sueldo, Silvia Andino and Graciela Sacco, *Tucumán Arde* [Rosario, 1987], p. 41, as cited in Roberts, 'Pablo Suárez: A Portrait of Resistance,' p. 108).

12 From a copy of the original statement, dated 23 May 1968, as cited *Ibid*. See also Glusberg, *Art in Argentina*, p. 18.

13 See María Teresa Gramuglio and Nicolás Rosa, *Tucumán Arde* (Rosario, 1968), unpaginated. See also Sueldo et al., *Tucumán Arde*. The participants in the Tucumçn Arde project included, from Rosario, Noemí Escandell, Graciela Carnevale, Maria Tera Gramuglio, Marta Greiner, María Elvira de Arechavala, Estela Pomerantx, Nicolas Rosa, Aldo Bortolotti, José Lavarello, Edmundo Guisa, Rodolfo Elizalde, Jaime Rippa, Rubén Naranjo, Norberto Puzzolo, Eduardo Favario, Emilio Ghiloni, Juan Pablo Renzi, Carlos Schork, Nora de Schork, David de Nully Braun, Roberto Sara, Óscar Bidustwa, Raúl Pérez Cantón and Sara López Dupuy; from Santa Fe Graciela Borthwick, Jorge Cohen, and Jorge Conti; and from Buenos Aires León Ferrari, Roberto Jacoby and Beatriz Balbé.

14 This development was accompanied by the decision to draft a manifesto articulating the aims and methods of the Group. Collectively written and first published as a mimeograph by the CGT, the 'Tucumán Arde' manifesto postulates that the first step to a genuine 'revolutionary art' is the 'awareness of the actual reality of the artist as an individual inside the political and social context that surrounds him'. See Gramuglio and Rosa, *Tucumán Arde*.

15 According to the 'Tucumán Arde' manifesto, '*El circuito sobreinformacional ... tiene como intención básica promover un proceso desalienante de la imagen de la realidad tucumana elaborada por lost medios de comunicaciónes de masas*', *Ibid*.

16 *Ibid*.

17 *Ibid*.

18 The politicization of these forms in Argentina makes an interesting contrast with their use by Pop artists in the USA and Great Britain. One can speculate that in the Argentinean context their employment to communicate a political message was related to the problem of literacy.

19 Hélio Oiticica, 'General Scheme of the New Objectivity' (1967), in *Hélio Oiticica*, exh. cat. by Guy Brett et al., Witte de With, Rotterdam (1992), p. 110.

20 As recounted by Cildo Meireles, in Nuria Enguita, 'Places for Digressions (An Interview with Cildo Meireles)' (1994), in *Cildo Meireles*, exh. cat. by Bartolomeu Mari and Nuria Enguita; IVAM Crentre del Carme, Valencia (1995), p. 161.

21 Cildo Meireles in António Manuel, 'Ondas do corpo', interview transcribed and edited by Eudoro Augusto Macieira in 1981, as reprinted in Mari and Enguita, *Cildo Meireles*, p. 174.

22 Meireles has discussed the aims of the *Insertions into Ideological Circuits* on a number

of occasions over the years. See, for instance, Enguita, 'Places for Digressions (An Interview with Cildo Meireles)', pp. 13–34, 160-66; Manuel, 'Ondas do corpo' (1981), in Mari and Enguita, *Cildo Meireles*, p. 174; and various previously unpublished statements by the artist compiled in *ibid.*, pp. 98–106, 175–6. The first reception of this series in New York took place at the 'Information' show, organized by Kynaston McShine for the Museum of Modern Art in 1970. Meireles's account of this event, written in notes from 1988 and published for the first time in the Valencia exhibition catalogue, is worth quoting at length: 'For "Information" I sent *Inserções em circuitos ideológicos* consisting of two projects: 1. The *Coca-Cola Project*: recording information, opinions and criticisms on the bottles and putting them back into circulation. 2. The *Cédula Project*: recording information and critical opinions on bank-notes and putting them back into circulation. For the exhibition catalogue I produced the text 'Cruzeiro do Sul (April, 1970). This is the scenario: in the synthesis-centre of Western Civilization – at a special moment in its history – a Brazilian artist aged 21–22 felt driven to produce a work that considered three points simultaneously, amongst others: 1) The painful political-social-economic reality of Brazil, a product (consequence) to a large extent of 2) The American way of politics and culture and its expansionist/interventionist, hegemonic, centralizing ideology (philosophy), without losing sight of the 3) Aspects of language, formal, in other words, from the perspective of the history of art, the need to produce an object that thought productively (i.e. critically, moving forward, going deeper), among other things, about one of the most fundamental and fascinating of its projects: Marcel Duchamp's ready-mades; the *Inserções em circuitos ideológicos* explain 1) and 2), and emphasized especially the problems of language contained in the work of 3)', pp. 175–6.

23 For an overview of the Marxist cultural resistance to increasingly authoritarian conditions in 1960s Argentina, see Andrés Avellaneda, *Censura, Autoritarismo y Cultura: Argentina 1960–1983*, vol. I (Buenos Aires, 1986), pp. 7–103. Also see Marta Traba, 'A la búsqueda del signo perdido', in *Dos décadas vulnerables en las artes plásticas latinoamericanas, 1950–1970* (Mexico, DF, 1973), pp. 154–62, excerpts of which are published in translation under the title 'Two Vulnerable Decades in Latin American Art, 1950–1970,' Mari Carmen Ramírez, *Aligning Vision: Alternative Currents in South American Drawing* (Austin, 1997), pp. 224–6.

24 Roland Barthes's 'The Death of the Author' was commissioned by Brian O'Doherty in early 1967 to be included in a special issue of the journal *Aspen*, edited by O'Doherty. The essay, first translated by Richard Howard, appeared in *Aspen*, 5–6 (Fall–Winter 1966–7), unpaginated.

25 See, for instance, Armand Mattelart, *Transnationals & the Third World: The Struggle for Culture* (South Hadley, MA, 1983), pp. 109–11.

26 For a good overview of Conceptualist strategies of resistance against the military dictatorships of Latin America in the 1960s, see Mari Carmen Ramírez, 'Blueprint Circuits: Conceptual Art and Politics in Latin America', in *Latin American Art of the Twentieth Century*, exh. cat. by Waldo Rasmussen; Museum of Modern Art, New York (1993), pp. 156–67. As Ramírez points out, 'The constitutional government of Brazil was overthrown by a military coup in 1964. And the nation was subsequently ruled by military dictators until 1985; Uruguay was ruled by a de facto military dictatorship from 1973 to 1985; Argentina experienced a succession of military governments after the coup of 1966; and Chile was governed from 1973 until 1989 by the dictator General Augusto Pinochet. Peru was under military rule from 1968 to 1980, Bolivia from 1971 to 1982, and Ecuador from 1972 to 1980', p. 166, fn. 16.

27 Meireles, in Manuel, 'Ondas do corpo' (1981), in Mari and Enguita, *Cildo Mereiles*, p. 174.

28 McLuhan's writings clearly had a substantial impact on Latin American artists in the

1960s. See, for instance, Oscar Masotta, 'Los medios de información masa y la categoría de "discontinuo" en la estética contemporánea', in his *Happenings*, pp. 52–3; and Marta Traba, *Art of Latin America, 1900–1980* (Baltimore, 1994), p. 134.

9 *Desa Philippi, Matter of Words: Translations in East European Conceptualism*

1 Václav Černý, 'Don Quixote and Quixotism', a lecture delivered in Prague on 23 April 1966. In German it was first published in *Individualität*, 24 (1989), trans. Max Rohr. Václav Černý was born in 1905 in Jizbice and died in 1987 in Prague. He was a writer, university professor and influential literary critic who helped pave the way to reform in the 1960s.

2 I use Eastern Europe as a convenient general category for those countries with a shared historical predicament of post-Stalinism. While the social and political situation differed somewhat from country to country, the political system in the former Soviet Union and its satellites produced major similarities, especially on the level of state institutions.

3 With few exceptions, such as Jaroslaw Kozlowski's work from the early 1970s, Conceptual art rarely existed in the pure form of first-generation Conceptualism in the West. In the 1970s, the categories of Conceptual art, land art and performance were blurred and often collectively referred to as 'actions'.

4 'Entretien de Bernard Lamache-Vadel avec Roman Opalka: *OPALKA 1965/1-∞ La Différence*', Centre de Création Contemporaine, Tours (1986), p. 36, my translation.

5 Gerhard Storck, *OPALKA 1965/1-∞*, Museum Haus Lange, Krefeld (1977), unpaginated.

6 *Ibid.*

7 Mariusz Hermansdorfer, *Polnische Gegenwartskunst Nationalmuseum Wroclaw*, 1975, Kunsthaus Hamburg, Kunstverein Hannover (1975), p. 5.

8 An English translation from the German has appeared: Pavel Kohout, *White Book Adam Juráček*, trans. Alex Page (New York, 1977).

9 I am referring to the artist's book which first appeared as a Samizdat publication, *Il'ja Kabakov, V našem ŽEKe*, in Moscow in 1982. I am using the German edition: Ilja Kabakow, *Shek Nr. 8, Bauman-Bezirk, Stadt Moskau*, trans. and ed. Günter Hirt and Sascha Wonders (Leipzig, 1994).

10 *Ibid.*, p. 108.

11 *Ibid.*, p. 112.

12 Bohumil Hrabal, *Too Loud a Solitude*, trans. Michael Henry Heim (London, 1993). All quotes are from this edition.

13 For a list of techniques, see 'Verzeichnis der Techniken (Auswahl)', in *Jiři Kolář unterwegs ins Paradies*, Gutenberg-Museum Mainz (1980), pp. 63–5.

14 Quoted in *Concrete Poetry: A World View*, ed. with intro. by Mary Ellen Solt (Bloomington and London, 1968), p. 22.

15 *Ibid.*, p. 42.

16 I am grateful to Pavel Büchler for introducing me to J. H. Kocman's work.

10 *Stephen Bann, Giulio Paolini*

I am glad to acknowledge the generous help offered to me in the preparation of this essay by Henri-Claude Cousseau, and the excellent library resources of the CAPC, Bordeaux. Martine Aboucaya and the Galerie Yvon Lambert were equally helpful in locating and providing illustrations, and Alain Mousseigne enabled me to document the Toulouse Métro project.

1 Although there have been many catalogues devoted to Paolini's work, there is as yet no satisfactory monograph covering its development up to the present decade. The most

useful source in English is probably *Giulio Paolini*, exh. cat. By Harold Szeeman and David Elliott, Museum of Modern Art, Oxford and Stedelijk Museum, Amsterdam (1980). However, the most substantial documentation of his work, which includes an overall classification by the artist and many of his texts, is Giulio Paolini, *Suspense: Breve storia del vuoto in tredici stanze* (Florence, 1988).

2 See *ibid.*, pp. 205–14, section entitled 'Vertigo'; the top-hatted figure also appears in *Ritratto dell'artista al buio* (1985), p. 137.

3 See Carter Ratcliff, 'Dandyism and Abstraction in a Universe Defined by Newton', *Artforum International* (December 1988), pp. 82–9.

4 *Giulio Paolini: Del bello intelligibile*, exh. cat. By Suzanne Page; Musée d'Art Moderne de la Ville de Paris (1978), p. 1.

5 See Paolini, *Suspense*, pp. 200–201.

6 *Ibid.*, p. 200 (my translation).

7 Giulio Paolini, *Idem* (Turin, 1975), with an introduction by Italo Calvino, p. vii.

8 *Ibid.*

9 Michael Newman, 'Conceptual Art from the 1960s to the 1990s: An Unfinished Project?', *Kunst & Museumjournaal*, 7,1–3 (1996), p. 96.

10 Here it may be mentioned that Paolini's work does not figure in probably the most ambitious of all exhibitions of Conceptual art to date: *Global Conceptualism*, which opened at the Queens Museum of Art, New York in 1999.

11 See Eugen Gomringer, 'From Line to Constellation', republished in *Concrete Poetry – A World View*, ed. Mary Ellen Solt (Scarborough, Ontario, 1968), p. 67; and Jacques Derrida, *La dissémination* (Paris, 1972), pp. 356–8.

12 *Giulio Paolini: Le 'opere a venire'*, published text of a meeting held on 28 April 1981 at the Accademia di Belle Arti 'Pietro Vannucci' (Perugia, 1982), p. 6.

13 See *Italian Art in the 20th century*, exh. cat., by Emily Braun; Royal Academy of Arts, London (Munich and London, 1989), p. 302, for Castellani: biographical notes are also included on Pistoletto (pp. 444–5) and Schifano (p. 448), as well as Paolini himself (pp. 442–3).

14 Franco Fortini, 'Culture as Crisis: The Predicament of Post-war Italy', *20th Century Studies*, V (1971), p. 22ff.

15 Umberto Eco, 'The Death of Gruppo 63', *ibid.*, p. 63.

16 *Ibid.*

17 Paolini, *Idem*, p. 34 (my translation).

18 *Ibid.*, p. 29. The work is illustrated in Paolini, *Suspense*, p. 131, and *Italian Art in the 20th Century*, plate 201.

19 For an account of the nature of vision and its relation to representation which illuminatingly parallels that of Paolini, see Norman Bryson, *Vision and Painting: The Logic of the Gaze* (London, 1983). It is worth noting, though without any implication of influence, that Jacques Lacan's collected writings, *Ecrits*, were first published in 1966, a year before *Young Man*.

20 Paolini, *Idem*, p. 41 (my translation).

21 Newman, 'Conceptual Art', p. 98.

22 Illustrated in Paolini, *Suspense*, p. 23.

23 *Ibid.*, p. 82 (my translation).

24 *Ibid.*

25 *Giulio Paolini*, Oxford Museum of Modern Art catalogue, p. 5.

26 *Ibid.*

27 Quoted by John Barrell, *The Political theory of Painting from Reynolds to Hazlitt* (New York and London, 1986), p. 229.

28 *Giulio Paolini*, Oxford Museum of Modern Art catalogue, p. 51 (translation modified in accordance with the Italian version published in Paolini, *Suspense*, p. 112).

29 Bryson, *Vision and Painting*, p. 106.

30 *Ibid.*
31 Eco, '*Gruppo 63*', p. 63.
32 *Giulio Paolini*, exh. cat., Musée des Beaux-Arts, Nantes (1987), p. 35.
33 *Ibid.*, p. 36.

11 *Birgit Pelzer, Marcel Broodthaers: The Place of the Subject*

1 Jacques Lacan, *Ecrits* (Paris, 1966).
2 Interview with Irmeline Lebeer in *Marcel Broodthaers: Catalogue* (Brussels, 1974), pp. 64–8, 'Ten Thousand Francs Reward' by Paul Schmidt, in *Broodthaers: Writings, Interviews, Photographs*, ed. Benjamin H. D. Buchloh (Cambridge, MA, and London, 1988), pp. 39–48; the manuscript was part of the work shown at the MTL Gallery in Brussels in 1970 and is currently at the Centre Georges Pompidou, Paris.
3 'Me I say I Me I say I the King of Mussels', in Marcel Broodthaers, *Moules Oeufs Frites Pots Charbons*, Wide White Space Gallery, Antwerp, 1966.
4 Birgit Pelzer, 'Recourse to the letter', in *Marcel Broodthaers: Writings. Interviews. Photographs*, pp. 157–81.
5 'Ten Thousand Francs' Reward', p. 39 (trans. modified).
6 Marcel Broodthaers, *Moi aussi je me suis demandé si je ne pouvais pas vendre quelque chose . . .*, Galerie Saint-Laurent, Brussels, 1964.
7 For this passage, see Jacques-Alain Miller's 'Ce qui fait Insigne', a course given in 1987 at the University of Paris VIII, transcribed by Jacques Péraldi.
8 *Scilicet*, 4 (1973), p. 5 (translated by Robert Vallier).
9 Lacan, *Ecrits*, p. 892.
10 I thank Anny De Decker for her help on this subject.
11 '*Ce conte s'adresse à l'intelligence du lecteur qui met les choses en scène elle-même*', in Stéphane Mallarmé, *Oeuvres Complètes*, eds Henri Mondor and G. Jean-Aubry (Paris, 1951), p. 433; Eng. trans. = S. Mallarmé, *Selected Poetry and Prose*, ed. Mary Ann Caws (New York, 1982), p. 91.
12 *Ibid.*, p. 427.
13 'Ten Thousand Francs Reward', p. 42.
14 *Ibid.*, p. 45.
15 See Benjamin Buchloh's study, 'Open Letters. Industrial Poems', in *Marcel Broodthaers: Writings, Interviews, Photographs*, pp. 67–100.
16 *Ibid.*, p. 96, note 31.
17 Roman Jakobsen, *Questions de poétique* (Paris, 1973), p. 17.
18 See Anne Rorimer, 'The Exhibition at the MTL Gallery', in *Marcel Broodthaers: Writings, Interviews, Photographs*, pp. 101–25.
19 MTL manuscript, part A, p. 4.
20 '*J'aimerais qu'on ne lut pas cette note où qu parcourue, même on l'oubliat*', in Mallarmé, *Oeuvres Complètes*, p. 455; Stéphane Mallarmé, *Collected Poems*, trans. Henry Weinfield (Berkeley, CA, and London, 1994), p. 121.
21 *Ibid.*, 'Notes et Variantes', p. 1582; Eng. trans. = Paul Valéry, 'On "A Throw of the Dice"', in Leonardo, Poe, Mallarmé, trans. M. Cowley and J. R. Lawler, vol. 8 of *The Collected Works of Paul Valéry*, ed. J. Mathews (Princeton, 1972), p. 308.
22 *Ibid.*: '*Il me sembla de voir la figure d'une pensée, pour la première fois placée dans notre espace. Ici, véritablement, l'entendue parlait, songeait, enfantait des formes temporelles*'; Eng. trans. = Valéry (as in note 21), p. 309.
23 See Jacques-Alain Miller's course '*Les Divins détails*', established and transcribed by Jacques Péraldi.
24 Jacques Lacan, *Le séminaire, encore, livre* XX (Paris, 1975), p. 110.
25 Mallarmé, p. 456.
26 MTL manuscript, part A, p. 4.
27 *Ibid.*, p. 3.

28 See, in particular, Jacques Scherer, *Le 'Livre' de Mallarmé* (Paris, 1957, expanded 1977), and Jacques Scherer, *Grammaire de Mallarmé* (Paris, 1977).

29 Mallarmé, 'Le mystère dans les lettres', in *Oeuvres Complètes*, p. 387; Eng. trans. = S. Mallarmé, Selected Prose Poems, Essays and Letters, trans. B. Cook (Baltimore, 1956), p. 34.

30 *Ibid.*, p. 363; Eng. trans. = Caws, *Selected Poetry*, p. 75.

31 *Ibid.*, p. 381; Eng. trans. = Caws, *Selected Poetry*, p. 83.

32 Scherer, *Grammaire de Mallarmé*, p. 236.

33 *Ibid.*, p. 70. '*Ce poème où coexistait la Parole.*' Eng. trans. = Mathews, *The Collected Works of Paul Valéry*, p. 309.

34 Mallarmé, 'Le poème est sans nouveauté qu'un espacement de la lecture', *Oeuvres Complètes*, p. 455; Eng. trans. = Weinfield, Selected Poems, p. 121.

35 Scherer, *Grammaire de Mallarmé*, p. 231.

36 Mallarmé, 'Une ponctuation qui disposée sur papier blanc déjà y signifie', *Oeuvres Complètes*, p. 655.

37 *Ibid.*, p. 407. '*Je préfère selon mon goût, sur page blanche, un dessin espacé, de virgules ou de points et leurs combinaisons secondaires, imitant, nue, la mélodie – au texte, suggéré avantageusement si, même sublime, il n'était pas ponctué.*'

38 Cited by Scherer, in *Grammaire de Mallarmé*, p. 222.

39 Scherer, *Le 'Livre' de Mallarmé*, p. 53.

40 *Ibid.*, p. 56.

41 Mallarmé, *Oeuvres Complètes*, p. 380; Eng. trans. = Caws, *Selected Poetry*, p. 82.

42 Scherer, *Le 'Livre' de Mallarmé*, p. 95.

43 Mallarmé, *Oeuvres Complètes*, p. 427.

44 Scherer, *Le 'Livre' de Mallarmé*, p. vii.

45 Mallarmé, *Oeuvres Complètes*, p. 366; Eng. trans. = Caws, *Selected Poetry*, p. 75.

46 *Ibid.*, 396.

47 Scherer, *Le 'Livre' de Mallarmé*, p. 74.

48 *Ibid.*, p. 127.

49 Lacan, *Ecrits*, p. 25 (French edition); Jacques Lacan, 'Seminar on "The Purloined Letter"', trans. Jeffrey Mehlman, in *The Purloined Poe: Lacan, Derrida, and Psychoanalytic Reading*, ed. John P. Muller and William Richardson (Baltimore and London, 1988), p. 40.

50 'Ten Thousand Francs' Reward', p. 44.

51 Jean-Michel Vappereau, *Etoffe: Les surfaces topologiques intrinsèques* (Gembluox, 1988).

52 'Ten Thousand Francs' Reward', p. 44 (trans. modified).

53 See Dieter Schwarz, 'Look! Books in Plaster', in *Marcel Broodthears: Writings, Interviews, Photographs*, pp. 57–66.

54 'Ten Thousand Francs' Reward', p. 66.

55 *Ibid.*(trans. modified).

56 Edgar Allan Poe, 'The Purloined Letter', in *Thomas Ollive Mabbott, Tales and Sketches 1843–1849, vol. III of Collected Works of Edgar Allan Poe* (Cambridge, MA, and London, 1978), pp. 974–97.

57 In this case Philippe Edouard Toussaint, owner of the Galerie Saint-Laurent in Brussels. The announcement, '*Moi aussi je me suis demandé si je ne pouvais pas vendre quelque chose . . .*' followed by '*Si je vends quelque chose, il prendra 30%. Ce sont paraît-it des conditions normales, certaines galeries prenant 75%.*'

58 'Ten Thousand Francs' Reward', p. 45.

59 *Ibid.*

60 *Ibid.*

61 Lacan, *Ecrits*, p. 25 (French edition); Lacan, 'Seminar on "The Purloined Letter" ', p. 40.

62 *Ibid.*
63 'Ten Thousand Francs Reward', p. 45.
64 Jacques Lacan, *Le Seminaire: Le moi dans la théorie de Freud et dans la technique de la psychanalyse, Livre II* (Paris, 1978), p. 226; *The Seminar of Jacques Lacan, Book II: The Ego in Freud's Theory and in the Technique of Psychoanalysis 1954–1955*, trans. Silvana Tomaselli (Cambridge, 1988), p. 192.
65 'Ten Thousand Francs Reward', p. 40.
66 Marcel Broodthaers, *L'Angélus de Daumier*, Musée National d'Art Moderne, Paris, (1975), Part 2, '*Notes sur le sujet*', p. 3.
67 Interview with Stéphane Rona, *+-o* (12 February 1976, Brussels), p. 19.
68 Marcel Broodthaers, *Magie-Art et Politique*, (Paris, 1973).
69 Lacan, *Le Séminaire: Le Moi*, p. 236; trans., p. 202.
70 Lacan, *Ecrits*, p. 858

12 *Michael Newman, After Conceptual Art: Joe Scanlan's Nesting Bookcases, Duchamp, Design and the Impossibility of Disappearing*

1 At the Slade School of Fine Art, at my invitation.
2 'Picture: AK-47', *Frieze* (January–February, 1998), p. 35.
3 The series of *Nesting Bookcases* ends when Scanlan moved from Chicago to New York.
4 Joe Scanlan, fax to the author, 6 February 1998.
5 The information on Charles and Ray Eames used in this text, although not always the interpretation, derives from Pat Kirkham, *Charles and Ray Eames: Designers of the Twentieth Century* (Cambridge, MA, and London, 1995) and *The Work of Charles and Ray Eames: A Legacy of Invention* (New York, 1997).
6 For a discussion of the implications of Walter Benjamin's idea of 'quoting without quotation marks' for the relation of history to the present, see Andrew Benjamin, *Present Hope: Philosophy, Architecture, Judaism* (London, 1997), pp. 48–55.
7 See Peter Bürger, *Theory of the Avant-Garde*, trans. Michael Shaw (Minneapolis, 1984). For Bürger the absorption of Duchamp into the museum is the moment of the conversion of the avant-garde into neo-avant-garde: 'Once the signed bottle drier has been accepted as an object that deserves a place in a museum, the provocation no longer provokes; it turns into its opposite. [. . .] Since now the protest of the historical avant-garde against art as institution is accepted as art the gesture of protest of the neo-avant-garde becomes inauthentic' (pp. 52–3). For a critique of Bürger's account of the neo-avant-garde as simple reappropriation, see in Hal Foster, *The Return of the Real* (Cambridge, MA, and London, 1996), Chapter 1, pp. 1–32, where the relation of neo-avant-garde to avant-garde is interpreted through the psychoanalytic distinction between trauma and 'deferred action [*Nachträglichkeit*]': 'On this analogy the avant-garde work is never historically effective or fully significant in its initial moments. It cannot be because it is traumatic – a hole in the symbolic order of its time that is not prepared for it, that cannot receive it, at least not immediately, at least not without structural change.' The neo-avant-garde would thus be the deferred action of the return in the form of repetition *from the future* of the project of the avant-garde (p. 29). Presumably this means that it remains avant-garde in opening up the present to its unrealized possibilities, such that the present becomes non-identical with itself.
8 Beatriz Colomina, 'Reflections on the Eames House', in Kirkham, *The Work of Charles and Ray Eames*, p. 144.
9 According to Colomina, pp. 143–4, last-minute changes which produced the final form of the Eames House resulted from a visit by Charles Eames to the exhibition *Mies van der Rohe* designed by Mies himself at the Museum of Modern Art in 1947: The shift was from a bridge-house based on Miesian architectural design to a house

based on Mies's approach to exhibition design – in other words, incorporating the idea of display and a photographic consciousness.

10 John Roberts, 'Photography, Iconophobia and the Ruins of Conceptual Art', in his *The Impossible Document: Conceptual Art in Britain 1966–1976* (London, 1997), p. 25. The paragraph concludes, 'Conceptual art's amateur is the direct descendant of Productivism's dissolution of aesthetics into artistic functionality' (p. 26) but Roberts goes on to suggest that this comes to be coupled with a critique of photography that disallows the transparency of reportage. Concerning Conceptual art photoworks, he writes of a 'D.I.Y. space' and the requirement that 'the work looked as if it could be made by anyone' (p. 30), setting avant-garde art using photography apart from avant-garde photography.

11 'Peut-on faire des oeuvres qui ne soient pas "d'art"?', in Marcel Duchamp, *Duchamp du signe*, ed. Michel Sanouillet (Paris, 1975), p. 105.

12 In Thierry de Duve, *The Definitively Unfinished Marcel Duchamp* (Cambridge, MA, and London, 1991), pp. 133–78. See also Thierry de Duve's important discussion in *Kant after Duchamp* (Cambridge, MA, and London, 1996), pp. 89–143, as well as his discussion of the generic in art, pp. 145–279.

13 Letter from Sidney Janis to Camfield, 18 August 1987, quoted in *ibid.*, p. 156.

14 Bürger, *Theory of the Avant-Garde*, pp. 24–7.

15 I thank Rebecca Comay for this formulation.

16 See *Marcel Duchamp, Notes*, arrangement and trans. Paul Matisse (Paris, 1980), notes 1–46.

17 There are numerous works by Robert Smithson relating to layered ziggurat and stacked forms, including *Ziggurat Mirror* (1966), *Mirror Stratum* (1966), *Glass Stratum* (1967), *Shift* (1967), *Pointless Vanishing Point* (1968), *Leaning Strata* (1968) and *Alogon #2* (1968). Scanlan's series of works *The Potting Soil* (1989–95), involving the production of earth or dirt using coffee grounds, sawdust, eggshells, masonry waste, Epsom salts, bonemeal and cigar butts, presented in piles, are also reminiscent of Smithson, although in Scanlan the soil is produced by the artist, whereas in Smithson it is displaced from landscape site to gallery. Smithson is also an important model as an artist who makes works and writes, and does both in an investigative and experimental way. While I have focused here primarily on the relation of Scanlan's practice to Duchamp and the Eameses, another approach could be in relation to Conceptual art in the USA, in particular through Smithson and Dan Graham.

18 Michael Asher's first exhibited work, consisting of a column of pressurized air, which he had developed in 1966–7, was in *The Appearing/Disappearing Image/Object* at the Newport Harbor Museum in Newport Beach, California in 1969. See Ann Goldstein and Anne Rorimer, *Reconsidering the Object of Art: 1965–1975* (Los Angeles and Cambridge, MA, and London, 1995), p. 58.

19 A key reference point is Dan Graham's *Homes for America*, published in *Arts Magazine* (December 1966–January 1967).

20 For examples of such work, see the artist's first one-person show at Robin Lockett Gallery, Chicago, January 1991 (see *Artforum*, XXIX, 10 [Summer 1991], p. 119); his installation at Documenta IX (see *Joe Scanlan*, exh. cat., Kaiser Wilhelm Museum, [Krefeld, 1996], p. 28); and his exhibition at Galerie Micheline Szwajcer, Antwerp, April 1994 (see Luk Lambrecht, *Blocnotes*, 7 [Autumn 1994], p. 76).

21 See Michel de Certeau, *The Practice of Everyday Life*, trans. Steven Rendall (Berkeley, Los Angeles and London, 1984)

Bibliography

For bibliographies that are more complete, see two exhibition catalogues – *Reconsidering the Object of Art 1965–1975*, by Ann Goldstein and Ann Rorimer; The Museum of Contemporary Art, Los Angeles (Cambridge, MA, 1995), and *Global Conceptualism: Points of Origin 1950s–1980s*, by Luis Camnitzer, Jane Farver and Rachel Weiss; Queens Museum of Art, New York (New York, 1999) – and Tony Godfrey's recent book *Conceptual Art* (London, 1998).

BOOKS

Alberro, Alex, and Blake Stimson, eds, *Conceptual Art: A Critical Anthology* (Cambridge, MA and London, 1999)

Battock, Gregory, ed., *Idea Art: A Critical Anthology* (New York, 1973)

Buchloh, Benjamin H. D., ed., *Marcel Broodthaers: Writings, Interviews, Photographs* (Cambridge, MA, and London, 1995)

Buren, Daniel, *Les Ecrits* (1965–1990), ed. Jean-Marc Poinsot (Bordeaux, 1991)

Burgin, Victor, *The End of Art Theory: Criticism and Postmodernity* (London, 1986)

Celant, Germano, ed., *Art Povera: Conceptual, Actual or Impossible Art?* (London, 1969)

Crow, Thomas, *The Rise of the Sixties: American and European Art in the Era of Dissent* (New York, 1996)

de Duve, Thierry, *Kant after Duchamp* (Cambridge, MA, 1996)

Graham, Dan, *Selected Writings and Interviews on Art Works, 1965–1995*, ed. A. Zevi (Rome, 1996).

Guercio, Gabriele, ed., *Joseph Kosuth: Art After Philosophy and After, Collected Writings 1966–1990* (Cambridge, MA, and London, 1993)

Harrison, Charles, *Essays on Art and Language* (Oxford, 1991)

——, and Paul Wood, eds, *Art in Theory 1900–1990* (Oxford, 1995)

Kelly, Mary, *Imaging Desire* (Cambridge, MA, and London, 1996)

Kossuth, Joseph, *Art after Philosophy and After: Collected Writings 1966–1990* (Cambridge, MA, and London, 1991)

LeWitt, Sol, *Critical Texts* (Rome, 1995)

Lippard, Lucy, *Six Years: The Dematerialization of the Art Object from 1966 to 1972* (New York, 1973)

Meyer, Ursula, *Conceptual Art* (New York, 1972)

Mollet-Vieville, Ghislain, *Art minimal et conceptual* (Geneva, 1995)

Morgan, Robert C., *Art Into Ideas: Essays on Conceptual Art* (Cambridge, 1996)

Morris, Robert, *Continuous Project Altered Daily: The Writings of Robert Morris* (Cambridge, MA, and London, 1995)

Stangos, Nikos, ed., *Concepts of Modern Art* (New York, 1981)

Traba, Marta, *Art of Latin America 1900–1980* (Baltimore, 1994)
de Vries, Gerd, ed., *On Art: Artists' Writings on the Changed Notion of Art after 1965* (Cologne, 1974)
Wall, Jeff, *Dan Graham's Kammerspiel* (Toronto, 1991)

JOURNALS

Art-Language, I/1– (May 1969–)
The Fox, i/1, eds Sarah Charlesworth and others (New York, 1975); i/2, eds Mel Ramsden and others (New York, 1975); I/3, ed. Art & Language and [Provisional] Art & Language (New York, 1976)
Interfunktionen (Cologne), nos 1–13 (1970–75)

EXHIBITION CATALOGUES

Xerox Book, by Seth Siegelaub and John H. Wendler (New York, 1968)
When Attitudes Become Form: Works–Concepts–Processes–Situations–Information, by Harald Szeeman; Kunsthalle, Bern, and ICA, London (1969)
Conceptual Art and Conceptual Aspects, by Donald Karshan; New York Cultural Centre (New York, 1970)
Information, by Kynaston McShine; Museum of Modern Art, New York (New York, 1970)
Software: Information Technology – Its New Meaning for Art, by Jack Burnham; Jewish Museum, New York (New York, 1970)
The British Avant-Garde; New York Cultural Center (New York, 1971)
The New Art, by Anne Seymour; Hayward Gallery, London (London, 1972)
A Survey of the Avant-Garde in Britain, by Rosetta Brooks; Gallery House (London, 1972)
Art Conceptuel 1, by Jean-Louis Froment; Musée d'Art Contemporain de Bordeaux (Bordeaux, 1988)
L'Art conceptuel, une perspective, by Claude Gintz and others; Musée d'Art Moderne de la Ville de Paris (Paris, 1989)
Conceptual Art Conceptual Forms, by Christian Schlatter; Galerie 1900/2000, Paris (Paris, 1990)
The Impossible Document: Photography and Conceptual Art in Britain 1966–1976, by John Roberts; Camerawork, London (London, 1997)
Chemical Traces: Photography and Conceptual Art, 1968–1998, by David Alan Mellor; Ferens Art Gallery, Kingston upon Hull (Kingston upon Hull, 1998)
Out of Actions: Between Performance and the Object 1949–1979, by Paul Schimmel and others; Museum of Contemporary Art, Los Angeles (Los Angeles and London, 1998)

ARTICLES IN JOURNALS

Buchloh, Benjamin H. D., 'Conceptual Art 1962–1969: From the Aesthetic of Administration to the Critique of Institutions', *October* 55 (Winter 1990)
'Conceptual Art and the Reception of Duchamp' [round-table discussion], *October* 70 (Fall 1994)
de Duve, Thierry, 'Echoes of the Readymade: Critique of Pure Modernism', trans. Rosalind Krauss, *October* 70 (Fall 1994)
Newman, Michael, 'On Conceptual Art in the 60s and 90s', *kunst + museum journal*, VII/1–3 (1996)
Ward, Frazer, 'Some Relations between Conceptual and Performance Art', *Art Journal*, LVI/4 (Winter 1997)

Photographic Acknowledgements

The editors and publisher wish to express their thanks to the following artists and photographers or other sources of illustrative material and/or permission to reproduce it:

ARS, NY and DACS, London © 1999: 18, 37; Robert Bean: 110; Jon Bird: 70; courtesy of the Archivio Alighiero Boetti, Rome: cover; Prudence Cuming: 77, 80; courtesy of the Anthony d'Offay Gallery, London: 73, 77, 80; DACS © 1999: cover, 34 bottom, 158, 187 bottom left, 188 bottom right, 201; courtesy of Robert Del Principe: 55; courtesy of Ronald Feldman Fine Arts, New York: 116; Tim Flood 208; Christopher Grimes: 221; courtesy of the Mary Kelly Studio: 110; courtesy of the Lisson Gallery, London: 82; André Morain: 172, 184; courtesy of Alain Mousseigne: 181; courtesy of Giulio Paolini and the Lisson Gallery, London: 175, 178; Adrian Piper: 55; Adam Reich: 219 top; Tate Gallery Archives: 93–5, 97, 99, 103; courtesy of Through the Flower, © Judy Chicago 1979: 109; courtesy of Joe Scanlan: 208, 219, 221; by Joe Scanlan: 220; Donald Woodman: 109.

Index